The Many Lives
of Andy Warhol

The Many Lives of Andy Warhol

Stuart Lenig

ROWMAN & LITTLEFIELD
Lanham • Boulder • New York • London

Published by Rowman & Littlefield
An imprint of The Rowman & Littlefield Publishing Group, Inc.
4501 Forbes Boulevard, Suite 200, Lanham, Maryland 20706
www.rowman.com

6 Tinworth Street, London SE11 5AL, United Kingdom

British Library Cataloguing in Publication Information Available

Library of Congress Cataloging-in-Publication Data

Names: Lenig, Stuart, author.
Title: The many lives of Andy Warhol / Stuart Lenig.
Description: Lanham : Rowman & Littlefield, [2021] | Includes
 bibliographical references and index.
Identifiers: LCCN 2020046529 (print) | LCCN 2020046530 (ebook) | ISBN
 9781538137024 (cloth) | ISBN 9781538137031 (epub)
Subjects: LCSH: Warhol, Andy, 1928-1987—Criticism and interpretation. |
 Warhol, Andy, 1928-1987—Psychology.
Classification: LCC N6537.W28 L46 2021 (print) | LCC N6537.W28 (ebook) |
 DDC 700.92—dc23
LC record available at https://lccn.loc.gov/2020046529
LC ebook record available at https://lccn.loc.gov/2020046530

Contents

Acknowledgments

Thank you to my good friends and colleagues who read and made notes regarding the chapters. Your contributions were brilliant and invaluable.

Dr. Jessica Evans, English
Dr. Thomas Flagel, History
Dr. Victoria Gay, Dean and English
Dr. Barry Gidcomb, History
Prof. Shane Hall, English
Prof. Jeff Hardin, English/Poetry
Prof. Liz Hufford, English
Dr. Erin Kealey, Philosophy
Prof. Greg Mewbourn, History
Ms. Carolyn Schmitz, painter, graphic artist, illustrator
Ms. Anne Scott, Librarian
Prof. Robert Thym, English

Introduction

Warhol: An Unknowable Man

The artisan readily understands these passions, for he himself partakes in
them. In an aristocracy he would seek to sell his workmanship at a high
price to a few; he now conceives that the more expeditious way of getting
rich is to sell them at a low price to all.[1]

Perhaps part of the confusion of our understanding of Andy Warhol is our inability to see him for the diverse craftsman he was. Artist, illustrator, author, record producer, director, advertiser, entrepreneur, filmmaker, publisher, sculptor, performance artist, actor, model, and more; Warhol enjoyed being many things to many different people. Although he cultivated a public persona: the spaced-out, glamour-obsessed, gay, gossip, clever but mercurial artist, he wasn't too interested in retaining one guise for too long. He could easily morph into another identity if an interest or opportunity presented itself to him. When making art wasn't bringing revenue, he quickly adapted to the role of filmmaker. By 1966 when that wasn't netting strong film sales, he moved into managing the Velvet Underground, adding the singer, Nico, and managing one of the first complicated and multifaceted light shows in rock, the Exploding Plastic Inevitable.

His porousness, his fluidity, and his hunger to find new avenues for his many interests and talents took him through many projects, avocations, businesses, and interactions. As a modern person, he wasn't one man but many men. As Alexis de Tocqueville pointed out, the new American artisan was a different character than the conservative artist of the old world, who worked for a small select set of wealthy patrons. Warhol always saw himself as a nationalistic artist, as an American artist, perhaps not as a political statement nor necessarily espousing American standards and values to the world, not as a jingoist, but rather as a point of cultural identity. Though there are definitely

1

elements of the European and the world about him and his work, he was an artist undoubtedly shaped, nurtured, and transformed by the institutions of America: the media, advertising, the marketplace, capitalism, and the arts community. He was someone who deftly traversed the waters of competition, public mood and temperament, shifting trends and movements and business cycles to remain prominent, engaged, successful, and publicly prescient for more than three decades.

De Tocqueville also recognized that the marketplace for the American artisan had changed, and perhaps more than any other artist of his time, Warhol was sensitive to critical, market factors, philosophical orientations, political leanings, and the temperament of society. Part business, part culture, part aesthetics, part philosophy, and *always* media-centric, Warhol postulated a new identity for the artist as a figure engaged in constant surveillance in a society that itself was beginning to realize the value of responding to surrounding and variable conditions.

Still, this description only tells us about his profession and his orientation. What is a Warhol? What does it mean to be this artist specifically? Is he a construct, merely an image or a media simulation? The wide range of writing about him suggests that he has become THE artist, a la mode. He is for each successive generation what is fashionable for *that* group. As he was in life, he is not one thing but many sides of a prism. Wayne Koestenbaum called him, "one of the most magnanimous producers of the twentieth century."[2] Stephen Koch described him as a "greatly gifted, wonderfully ingenious imp of the perverse (that) had been at the center of those interlocking worlds of society and art."[3] Warhol referred to a critic's description of him in *The Philosophy of Andy Warhol* as, "the Nothingness Himself."[4] Robert Hughes referred to his hunger for publicity as "he went after publicity with the voracious single-mindedness of a feeding bluefish."[5] *Newsweek* called him, "the Peter Pan of the current art scene."[6]

Of course, that's what makes Warhol scholarship so tantalizing and ultimately so frustrating. He appeared so different to so many people that understanding the man beneath the layers becomes harder and harder, and the amazing amount of scholarship regarding him, pop art, and the sixties era accumulates at an alarming pace, perhaps owing to the legendary status of that era and so many twilighting baby boomers who are unaffectedly nostalgic for the bygone era of hippies, good rock, and art that modeled itself on pop culture. The accretion of so much debris obscures the soul of the artist.

One reads endless amounts, but he arrives in many guises. He is Shiva, a master actor, a trickster, a distillation of the avant-garde, a keen marketer, and a product of a technological culture. It may be the times he lived in and the quantity of pronouncements that have rendered him transparent or clear

and, at the same time, elusive and impenetrable. In fact, like with many people, there may be something in him that is unknowable, unfathomable, and ineffable at center. While he used the press to generate interest and sales, it could be said that a part of Warhol's life was intended to be private and was not meant for public display. For example, for the last fifteen years of his life, he owned a beach house in Montauk on the Eastern tip of Long Island. He wrote, "I dread going there. I hate the sun. I hate the sea. I hate slipping between those damp sticky sheets."[7] There are several pictures of him there, and it may be that despite his protestations, he liked his beach cabin. On the other hand, it might have just been an investment. It is a mysterious part of his life. In any event, Warhol generated much publicity, and this may have worked as a smoke screen. It was noise he hid behind. Warhol said, "I am neither bothered by what is written about me or what people may think of me reading it."[8] He also said that artists should count the inches devoted to them in a review. The content wasn't important. In any case, Warhol maintained an intricate relationship with the press using the media, his own magazine *Interview*, and multiple regular staged appearances to keep himself and his art before the public eye. Perhaps he would appreciate all the books written about him, the need for so many people to examine, decode, and parse his posthumous record and the work to unravel his deeper meaning.

I think many people are engaged by the mystery of Warhol and trying to solve it. A lot of the writing channels Orson Welles's multipronged investigation of William Randolph Hearst in *Citizen Kane*. Even with his multidimensional split narrative, there is still something at the center of the man, mysterious and unobtainable. Welles and Herman Mankiewicz concocted a character that couldn't be summarized neatly. Like Warhol, he was an indefinable part of the twentieth century. Some see Rosebud as pivotal, but Rosebud is merely a McGuffin, a fiction, a figment of the real person. As the reporters speculate aimlessly at the films' end, "If you could have found what that Rosebud meant that could have explained everything." The lead reporter answers honestly, "No, I don't think so. No, Mr. Kane was a man who got everything he wanted then lost it. Maybe Rosebud was something he couldn't get or that he lost. Anyway it wouldn't have explained anything. I don't think any word can explain any man's life."[9] We might go further and say, can one explain anyone, even in a book? What instead we might be able to offer is a complicated prism that reflects many sides of a man, many different and varied portraits.

Part of the mystery was probably intentional and created to keep people guessing about Warhol's life and was an effort to keep himself interesting to the press. He lied regularly to the press and misled them where possible, and the press hungrily lapped up each pronouncement, no matter how far-fetched or incorrect it might have been. In a famous interview with Gretchen Berg

from 1966, he might have said one of the most intentionally misleading remarks of his career. This one segment forced people to go back and look at his work again and again to see if indeed his words were accurate. He said, "if you want to know all about Andy Warhol, just look at the surface of my paintings, and films, and me. And there I am. There's nothing behind it."[10] Of course such statements encouraged critical reassessments right from the start. Warhol made such pronouncements to encourage an investigation of his work. There are few artists who had so many precedents to all their work. Warhol was a skilled student of art history, a connoisseur of art as a collector of a massive personal collection of treasures, a curator of several shows, and rigorously schooled for more than a decade in the myriad manifestations of American advertising design. Sadly for the poor critics, there is literally *everything* behind his work; one might argue it encompasses a personal history of art.

THE WORK OF THE WORKS

Still, we are left with someone who was a wide-ranging professional who could be misleading, How do we better understand someone who is an unreliable narrator hosting an often complicated and perhaps unreliable narration? In film theory, the notion of a film and film text is often tied to the idea of the shot, and Robert Kolker reminds us that, "a shot has no meaning until it is put in contention with another shot in a montage structure."[11] If we look at Warhol's life and work as a series of shots in conjunction with a larger movie, a bigger narrative, it might help us to understand the artist and his work. Much fog can be lifted if we just revisit the many innovations he accomplished. I think the comment about superficiality was taken too literally by too many scholars. They believed the artist's pronouncements alone and solely. That is always a dangerous thing to do with even the most reliable witness. His transitions suggest significant reimaginings of his profession. From proficient student and successful graphic artist in the fifties to seer, pop prophet, and underground filmmaker in the sixties, to ringmaster and impresario at the Factory performance art space, to a postassassination rebirth as a seventies' minimalist entrepreneur to an eighties' postmodern video/publication media maven, Warhol excelled at his many professions and transformed the definition of the modern artist. Further, it also helps to look at associated media, trends, influences in his life, and exterior and historical art movements that existed around his time or earlier that might have influenced Warhol. Surprisingly, despite how many books there are on the artist, few of the books on Warhol have gone into the various trends, movements, and styles either

existing contemporaneously with the man or lingering currents from previous historical or geographical movements that may very well have impacted his thinking.

Still the noise of many contrasting and differing visions has rendered Warhol as a shadow figure. It is as if he were an object at an auction himself, only he doesn't get a bid. He has no agency in the process of his own reclamation. He has become the appropriator, *appropriated.* It is an irony that might amuse the artist himself. Here we seek to integrate the man, to make Warhol whole again. Rather than parse him as a gay, pop, publisher, photographer, Dadaist, or printmaker, we hope to celebrate his many ideas, projects, and productions that accounted for a remarkable career in business and the arts. As is often the case, today we need not celebrate the singular to appreciate the miraculous diversity, uniqueness, and narrative that was Warhol. What once might have been troubling in a portrait, that he was many-sided and diverse, may be easier to accept in a postmodern world where diversity, multiplicity, and even the posthumanism is championed.

In the end though, deciphering the totality presents challenges. Do we know that the Warhol we are uncovering is an accurate statement of his works and attitudes? Like archeologists who scrape the barnacles from the hull to reveal the ship beneath, we must be careful not to tear everything out. We might dislodge the hidden portrait of the man allowing him to elude us again. We also run the danger of rebooting Warhol like a Batman movie, remaking him for each era. First a television program, a large budget film, and then the figure passes from character to business-owned franchise. The singular is lost in its multiplicity. We need to see the parts and the whole.

OUR JOURNEY

The Genesis for this investigation was Peter Wollen's essay in *Who Is Andy Warhol?* titled "Andy Warhol Renaissance Man."[12] That essay described Warhol as a hybrid of renaissance qualities including an interest in technology[13] and the establishment of a court culture developed in the fashion industry and the various glamour magazines that employed Warhol. Wollen praised him for creating his own little renaissance era saying, "the Warholian Renaissance indeed repeated, in miniature, many of the features that Burckhardt saw in the Florentine Renaissance—a breaking down of cultural barriers, an exuberant neo-paganism, the rise of the artist as celebrity, a fascination with a certain kind of court culture."[14]

This particular multisided view of the man is revealing. Warhol wanted to be many things and succeeded at most. The fact that he was an American. The

fact that he was hard working and striving. The fact that he was ambitious and that he wanted a lucrative business practice. The fact that he came from poverty and that he worked endlessly to make everything he touched into some sort of saleable product. The fact that he was rebuffed by high society, that he was underappreciated by the snotty art world, that he was unlucky in love, that he could be difficult and demanding, that he could be a whiner and complainer, all color the not-so-perfect loner, artist, and capitalist. It all makes for an enticing challenge. Here we look at some themes: Byzantine art, influential modernist artists, a Freudian concept of the uncanny, specific movie idols, cross-currents of other art movements floating about Warhol (surrealism, postmodernism, minimalism, and modernism itself) to shed some light on how multiple influences, art practices, and ideas may have shaped his world. Like Warhol himself, they don't easily transform into a holistic portrayal. Once again, I don't think they need to. Warhol was a man of parts, of multiple influences, and moods. I don't think he felt any need to be consistent, to be singular, to be bound to one school or set of axioms. We may not uncover all of his various guises, but perhaps we can learn more about things that inspired his work; hidden attitudes about art that may emerge when discussed in comparison with his objects. After this, we will consider why he still is appealing. Maybe he was a master of disguise, and perhaps he still is.

In chapter 1, we examine the media salad of his early years. He emerged from a mixture of film stars (Shirley Temple and Charlie McCarthy, significantly a child and a puppet), comic strips and comic characters, religious iconography (Byzantine Catholic faith), and exposure to avant-garde art and artists in the atelier of Carnegie Tech's (modernism) progressive environment. Even as a child, he had an interest in drawing and his early sketches illustrate a facility not unlike Jean Cocteau, Ben Shahn, and Henri Matisse. He shows an affinity for sophisticated art styles, a veneration for nostalgia icons, and mixes devotion to contemporary pop culture figures with religious iconography.

The young artist emerged in New York as a sponge of popular culture, advertising media, new technical skills, and a deep connection to the city's first avant-garde at the dawn of the twentieth century. Warhol quickly connected to a rippling current of Dada and surrealistic thought, severe modernist design, and the emotional works of abstract expressionism. He quickly made friends and found work in the advertising of women's fashion, specializing in the drawing and design of shoes. In advertising media, Warhol's delightful work was fresh and perhaps a little Dadaistically playful. In the whimsical world of fashion design in the fifties, there was a delight in design that hoped to captivate modern women after decades of Americans suffering from material poverty. He may very well have found a strong parallel between his work

serving the kings of advertising and the often reviled work of the French rococo artists of the eighteenth century.

Warhol exploded in the sixties' pop period arriving as an artist deeply involved with European pop, conceptual ideas, and marketing savvy. Warhol had seen that items from the popular culture were starting to be incorporated into a new type of art. This exploding pop market was similar to the work he was doing in advertising design working for *Vogue, Harper's Bazaar*, and other magazines. Further, he saw the emerging pop movement as a means to connect to the European theatres of modern art. His initial work was in the reproduction of comic strips and comic book recreations, but there were other competitors in that field. He settled upon artwork based on the sorts of advertisements everyone had seen daily. Having been a lifelong user of American products like soup and corn flakes the inspiration was natural to his own inclinations toward the common and every day. Warhol emerged as the prophet of pop but also in the clutches of European histories, primitive impulses, and the massive influence of emerging media. During this time, he made some images that were winsome and warm, some that were disturbing, and some that were frightening. His work took common objects and began to toy with making things ultra-real and close to reality. Some aspects of this work approach the idea of the uncanny in modern art, art that approaches reality so closely it can make people feel uncomfortable. He also began to develop a new sort of film, something based on stagnant and unmoving objects or people. This new form of cinema participated in the emerging avant-garde cinema that had been erupting through a variety of filmmakers in the postwar period. These independent filmmakers influenced Warhol's work in film, and in the mid-sixties, he began to drift away from static artworks on canvas or paper and moved to static films in the 16-mm format.

In the next segment, we see Warhol's arrival at a new identity in the seventies. In this period, although associated with beach houses, night clubs, and New York's aristocracy, Warhol turned his work to a minimalist critique of American culture. Warhol's work in the midcentury had seen him surrounded by a variety of artists and galleries and museums presenting new artists and new movements. His work in the fifties for magazines was clever, fun, and applied itself to decorative and mostly realistic if carefully abstracted images. His work was in stark contrast to the grim and serious and philosophically based work of the abstract expressionists like Franz Kline, Jackson Pollack, Mark Rothko, and others. His emerging work in the sixties found parallels with pop art, op art, conceptual art, and minimalist art. Warhol, having already tasted fame with pop objects, began to return to painting. However, this was painting in subtly different guise, a new fashion that began to generate objects that were less obtrusive and more conditioned by the experience of

minimal art, where objects were subsumed by the idea behind them. Many of the minimalists did little to treat or personalize their bright shiny fabrications or their simplistic, untouched, unvarnished works from natural objects. Warhol enjoyed the aesthetic of simplicity and uncomplicated untooled objects and began to render works in graphics and painting that shared that same aesthetic.

The great unwavering passion of his life was to be successful in film, a cosmic irony because films rarely paid back the investment in time and energy. A further irony was that he became more of a star in films, advertising, and graphics than any of the superstars he carefully nurtured. He was a leader in the revolt of underground film. His early art films caused excitement. His camp films illustrated an ennui with affectation and the artifice of film production. His later video projects brilliantly informed the rise of reality television and foreshadowed the cool era of insinuating, leering, voyeuristic, video culture. In the film projects, Warhol acted as a true rebel demanding an uncompromising affinity to his untouched style. Warhol refused to focus on conventional avenues of contemporary film and demanded that his actors create a situational reality that was, at the time, a new orientation to the film process. We see this immediacy enacted regularly in reality television programming today like *Real World* and *Big Brother*, but Warhol's film projects projected the common and every day, the natural soap operas of life on the screen in films that borrowed ideas from Henrik Ibsen's notion of fourth wall realism. Warhol's work plunged deeper into a film that mirrored natural life. Many times, he accomplished these complicated experiments in new filmmaking with few trained actors and primitive equipment. The results were raw and forced audiences confronting the films to see cinema in a new way.

Was Warhol a secret surrealist? A trait of Warhol's work is a natural instinct for raw, primitive design, psychological understanding of how art works on the unconscious, and a deep set of symbols and personal iconography. He was engrossed in the psychology of his factory entourage and later transferred an interest to the personal lives, careers, and eccentricities of his staff at *Interview*. Warhol used his artwork to look into what could be termed *dream images* for a commercial society. In that sense, his dream images are based on advertising, but they are filled with ideas that derive from ad culture. Further, he was always interested in art styles and historical periods. He had a continuing appreciation of art that emulates the natural art of indigenous people. From American folk art and crafts to avant-garde styles that engaged the surreal, Warhol developed techniques that responded to the psyche regardless of the medium. He liked it raw and unfiltered. Even in a highly technologized environment, he tended to invert the massive power of technology to pursue it as a raw, handmade technique.

Outside of the public eye, Warhol did enjoy a private collector's world. In chapter 7, we look at his voracious appetite for collecting in the modes of primitive art, folk Americana, kitsch, and esoteric elements of the avant-garde.

In chapter 8, we view Warhol as a lifelong professional designer and how his design work impacted his art, silkscreens, portraits, collaborations, *Interview*, and exhibitions. Warhol's fine artwork always remained rooted in strong design principles. Brillo boxes, flowers, cow wallpaper, and print collections were items that had strong commercial qualities. Warhol's work appeared as comfortable on a grocery store shelf as in a gallery.

In the eighties, Warhol's work began to alter to accommodate the influence of postmodern design ideas. Warhol emerged as a leading video artist transitioning to mainstream video, pop video, and collaborative works in the postmodern street scene of the cityscape. A reflection of his sixties' work, Warhol is routinely seen as a patron to the new energy of young artists, multithemed art, diversity, and media art.

In the last section, we discuss how Warhol might currently be seen and how contemporary audiences might respond to his work. He speaks to a world of diversity, multiplicity, eccentricity, niche audiences, youtubers, and people that cherish the idea of artistic fame more than then realization of the ambition. Today is a society of breakout artists who may be manufactured by the media, may be tossed into public attention from a game show or a talent search, or may slowly pursue a niche audience on Twitter or Snapchat, Warhol would be in his element finding his way into that conversation and developing his own approach to the latest media. In that quest, he remains an inspiration.

So, how can we view this human puzzle? Through one story. In 1949, Warhol submitted a painting to an exhibition conducted by the Associated Artists of Pittsburgh (AAP), a local artists guild. The group had brought in one of the most famous caricaturists of his day, the elderly George Grosz, a famous German expressionist who had masterfully lampooned pompous upright and decayed German aristocrats in the expressionist explosion that occurred in Germany following the debacle of Germany's defeat in World War I. Grosz apparently saw the brilliance of Warhol's precise social criticism. None of the other jurors saw any. He protested the decision to exclude Warhol's social commentary from the show. Warhol's humorous self-portrait was of a young man proudly and deftly picking his nose directly at a crowd of onlookers. The comical image reflected Warhol's assurance that while society may desire to reject the critic and the artist, the artist generally has something vital that society may need. The painting titled, *The Lord Gave Me My Face, But I Can Pick My Own Nose*, was later submitted to a student art exhibition at Carnegie Tech and caused quite a stir.[15]

Chapter One

Warhol: The Assemblage

Time as it grows old, teaches all things.

—Aeschylus, *Prometheus Bound*

The title refers to the fact that maybe the best way to see Warhol and his works is as an assemblage or a collage of various divergent parts. The term *collage*, "comes from the French word *coller,* meaning to stick two pieces together, or to paste."[1] Lisa Ketteall uses the term when describing her technique of making art objects from various scraps, leftovers, or found objects. Perhaps part of the misunderstanding of Warhol starts by not understanding his origins and not understanding those scraps. Warhol was complex and derived his work from many different and diverse sources. Much of that story is occluded. How was Warhol obscured and misreported? Warhol himself was awkward and uncomfortable with various aspects of his youth. That he was poor, sickly, and felt himself unattractive bothered him. The legends, the amount of media coverage, and pronouncements of Warhol himself may have helped to make his record murky and unclear. He often lied and made up his background in interviews. He role-played with the press. He acted a version of a ditzy artist that obscured the deeper levels of his work. Much of Warhol's childhood was not known until later in his life when critics and biographers discovered his humble immigrant origins. For a lot of reasons, Warhol wanted his past to remain a mystery, and in large part, he succeeded.

Unraveling young Warhol's influences is further complicated by the fact that he mixed and merged influences in such an egalitarian, random, and unconscious fashion that it is difficult to separate the genesis of the images, to tear them apart. This is probably true of most artists, but few seem to take into account the role of his influences in his work. Many see him as merely

copying the culture around him. In reality, his mature work is a blend of different, contradictory, and competing influences that merge and mingle religious iconography, commercial illustration, unconscious association with a mythic past (Carpathian legends) and a mythic present (comic strips and comic books), and Hollywood-promoted stars. Interestingly, these are merely influences from his youth, and a wider set of interests may have influenced him as a mature artist. Further, it is hard to speculate about what influenced him the most. Warhol's artistic origins are less a continuous path in a direction and more a series of coordinates thrown in a blender.

CHURCH ANDY

Few would have understood the strong influence of a religious background where Warhol was nurtured in a Catholic household and remained devout and quiet about his devotions throughout his life. His mother took Warhol regularly to church, and the heavy and baroque iconography of the Byzantine Catholic Church provided Warhol with a series of icons that rivaled the outpouring of pictures, art, advertisements, and comics that was erupting from the vibrant American popular culture.

Also few have considered that Warhol's brand of Catholicism was distinctly different than mainstream American Catholicism. Byzantine Catholicism arose from a group of people from the Carpathian mountain region, a gateway to Eastern Europe and comprised of people from multiple countries including Hungry, Poland, Slovakia, Romania, and Ukraine who were known as Rusyns, a group on the border between middle Europe and Russia. The church also has a special designation among Catholic sects as being *sui iuris* or somewhat independent in organization, governance, and liturgy. These churches are more Eastern and more image-immersed than many would imagine.

Warhol may have been poor, but Julia Warhola was determined that her family would not depart with their old ways and traditions, and she persuaded her children to attend a nearby Eastern Catholic Church that purported to celebrate the faith in the manner of her experience growing up under Eastern European repression and communism. The church was Saint John Chrysostom Byzantine Catholic Church on Saline Street in Pittsburgh, Pennsylvania. The Church's website describes the place's spiritual origins succinctly. It offers, "they came from the Carpathian Mountains and found a home in Rus'ska Dolina, the "Rusyn Valley."[2] This church began as a meeting house in Pittsburgh's Oakland area for the poor miners, steelworkers, and their families who had immigrated to the United States in the early century to work back-

breaking mill jobs. The first pastor was Father Alexeksij Petrasovich, and the Carpathian mountains was a region of various subcultural groups known alternately as Carpatho-Ruthenia or Carpatho-Russians. The inhabitants were mountain people, still burdened with feudalism, little industrialization, and village provincialism where people were shepherds, farmers, or loggers.[3]

The Byzantine Church is a subculture of Catholicism directly influenced by the art of Byzantine era when the Roman church, pursued by bandits and hostile tribes decamped to Byzantium, later rechristened Constantinople for the Emperor Constantine, and exists today as the Turkish city of Istanbul. The move reestablished the Christian Church in a region with a vast array

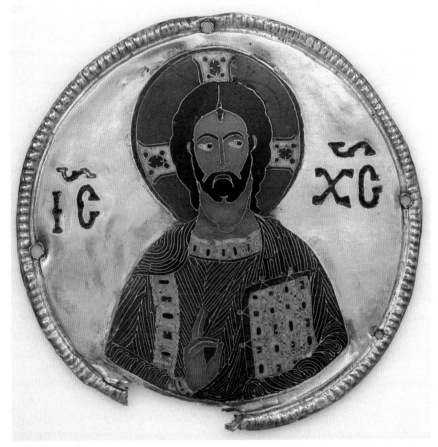

Figure 1.1. Warhol was constantly exposed to the highly iconic art of the Byzantine Church in Pittsburgh. His mother and father both were immigrants from the Carpathian mountain region in central Europe.
The Metropolitan Museum of Art

of religious, political, and military powers vying for supremacy. The church remained vibrant and meaningful through adapting to prevailing conditions and incorporating many forms and manners of local culture. Eclecticism was the rule. The Byzantine Church resulted in a different aesthetic than the earlier Roman church and integrated an assortment of Middle Eastern and Asian cultural differences and art styles.

Byzantine art was different than the art of classical Rome and manifested its origins in a hybrid culture in which Islamic, Christian, Jewish, Zoroastrian, Buddhist, Hindu, and other faiths might intersect in the crossroads of the Silk Road that carried people from Eastern cultures to Western kingdoms. The Byzantine world was a wondrous and curious world, whose traditions and means of seeing the world were radically different than visualization in the West, and such traditions no doubt impacted young Warhol.

Throughout his career Warhol's work was strongly attracted to large iconic images whether they be of *Mao, The Last Supper, Marilyn or Dick Tracy*. There is a strong precedent for this type of image-making in the Byzantine tradition. Fred Kleiner in *Gardner's Art Through the Ages* discusses the enormous influence of iconic art on Byzantine illustration saying, "icons ('images' in Greek) are small portable paintings depicting Christ, the virgin, or saints (or a combination of all three). Icons survive from as early as the fourth century. From the sixth century on, they became enormously popular in Byzantine worship, both public and private."[4] So immigrant families like Warhol would naturally have icons laying about, and it is clear that Warhola collected icons, religious and secular. Though young Warhol was born and nurtured in the United States, enough of his mother's old worldviews may have prevailed through the church, and her attitudes to have colored his vision of art and design.

One small example here might suffice to distinguish this worldview from that of conventional images of the arts in this culture. In Andre Graber's *The Art of the Byzantine Empire*, he writes that, "In order to appreciate these values, enhanced through the eyes of faith because they draw nearer to the unalterability of things divine—this art made use of frank rhythm with a regular cadence, a purified line, restful symmetries, a stability which cancels out contradictory movements. The eye is made to distinguish between these grave and harmonious images and the everyday material world, and to recognize in them the divine."[5] Graber suggests that the Byzantine mind didn't like arbitrary, changing, or altering bits of reality. What Graber refers to as the accidental. To the Byzantine mind, the accidental was not the mark of god or the divine but an accident, a mistake, and not something worthy of consideration. Therefore, the Byzantine artist might very well overlook the flawed, the specific, or the realistic in favor of the artwork or the symbol or the template that was eternal, consistent, and harmonious with other symbols.

The Byzantine world valorized the generic, the iconic, to the exclusion of the specific. Thus, when Warhol later favored the serial to the specific or individual, this philosophy of ignoring difference and specificity may have had some influence on his theory of art production. In the search for the divine one ignores the individual mistake for the more general divine form. Critics and writers, DiYanni and Benton, Kleiner, and Graber see the generic, iconic, and idealized image as preferred in Byzantine culture, and this depiction of reality, figuratively based, idealized, and ethereal may have influenced Warhol's image production.

SON OF ADVERTISING

Few have regarded the crazy salad of advertising that Warhol saw as a youth. He read the newspaper, had comic books, cut out dolls, picture books, and drew things around the house. In the postwar era, advertising was everywhere. Advertising was so ubiquitous and insidiously present in every aspect of American society, it is nearly impossible to think of a time when advertising didn't govern American consciousness, more so than government, entertainment, professions, family, and even the companies that advertising routinely promotes. Warhol grew up in a world where the power, the reach, and influence of advertising and images from advertising were saturating the public in an unprecedented manner.

A debate erupted as Madison Avenue began to manipulate the culture of a growing consumer society to its needs. Dwight MacDonald in a famous essay in 1953 framed it as, "western culture has really been two cultures: the traditional kind—let us call it high culture—that is chronicled in the textbooks, and a 'mass culture' that is manufactured wholesale for the market."[6] The nation was recognizing advertising's new power. Many, like MacDonald, saw the world of this new popular culture tied to advertising images as the enemy of culture. Popular culture and media were seen as the enemy and the opposite of the world of art. Leo Lowenthal wrote in 1950 that, "the counterconcept to popular culture is art. Today artistic products are losing the character of spontaneity more and more and are being replaced by the phenomena of popular culture, which are nothing but a manipulated reproduction of reality as it is, and in so doing, popular culture sanctions and glorifies whatever it finds worth echoing."[7] Lowenthal and other critics felt the quick and disposable images of advertising and popular culture impeded a meaningful deeper culture.

Warhol, who grew up in the middle of popular culture in the media, never seemed particularly flustered by the debate over popular culture; he simply

accepted it as part of the visual environment. Warhol reported that he copied pictures out of books and the teachers thought that was fine. There was no prejudice against images floating around in Warhol's daily life. He said, "the teachers liked me. In grade school they make you copy pictures from books. I think the first one was Robert Lewis Stephenson."[8] Warhol was completely enthralled by images from the media. Characters in films and cartoon figures in comic strips were friends he had never had in real life and for him were a necessary replacement for his loneliness. Warhol was comfortable around the nurturing world of newspapers, magazines, and comics. For him, they were a repository of ready ideas and images. Media was everywhere for Warhol. Though poor, Warhol's family learned English and became fluent in their adopted country by reading the news, buying magazines, and subscribing to the elements of popular culture: the comic strips, comic books, women's magazines, and movie fan magazines. Warhol's mother was a treasure trove of iconic ideas: indoctrinating Warhol into the church, sitting him in her kitchen when he was sick and having him sketch, and giving him her movie magazines to read and absorb when he was home.

Gene Swenson in an interview with Warhol in 1963 asked Warhol if he thought pop was a bad name for the art of the sixties. Warhol suggested that the whole debate over individual ideas and originality was simply irrelevant saying, "everybody just goes on thinking the same thing, and every year it gets more and more alike. Those who talk about individuality the most, are the ones that object most to deviation."[9] Warhol seemed quite comforted by the fact that society presented him with uniform goods and packages that resembled each other. Warhol apparently believed that commodification was a benefit to society and uniformity was a great thing. Walter Benjamin wrote about "Art in the Age of Mechanical Reproduction," and he discussed the philosophical ramifications of what happens when art is copied. For one thing, art becomes democratized and becomes spread around the culture more easily and fluidly. He also said, "the presence of the original is the prerequisite to the concept of authenticity."[10] Warhol's exposure to advertising and popular culture images at an early age changed him and the culture in general. Warhol never really accepted Benjamin's idea of authenticity. For Warhol, it never mattered that a work was authentic. Further, Benjamin said an original work contained an aura that made it unique. Warhol would have discounted that idea as well. He was far too pragmatic. If an image was available to a person it could be copied and appropriated. This today may seem a simple and easy concept in the age of free flowing Internet images, but Warhol's idea that the whole of Western culture was a grab bag of easily obtainable images was something new for society.

EARLY INFLUENCES: FAUVES AND MATISSE

Though not a lot of images from Warhol's early life exist, a few suggest significant influences in the world of art. There is a delightful drawing of a concert scene from around 1940 when Warhol was twelve years old. The sense of perspective is presented from the eye-level view of spectator. Warhol is in a concert hall, perhaps Heinz Hall on a field trip with his school. It is a view from the audience of the concert stage. It has an abstract use of space but is vividly colored and painted. Brilliant colors suggest the Fauves and Matisse. In early-twentieth-century art, the Fauves were a group of painters led by Henri Matisee that applied paint wildly with bright vibrant colors. Thus, they were known as the Fauves or the wild ones. Richard Brettell credited them with, "an idea of the picture as a pictorial surface that communicated certain emotions through the interaction of colour independent either of nature or our visual perception of it."[11]

The Fauves painted in a primitive style; their figuration resembled a children's drawing and an outstanding vision of space and location. The Fauves were deeply tied to modernism, and their wild colorations transformed everyday environments and images of people into some new vision. Warhol's concert hall featured a deep saturated blue, orange, and red. The auditorium is the focus and less important elements are colored in tan and yellow. The drawing avoids realism and introduces a level of abstraction. Amusingly, the back of someone's head is at the center of the picture portraying comically the annoyance of the young Warhol behind someone else and having his vision of the stage moderately obscured. The characters in the audience are brightly colored and arranged decorously. There appears to be a quartet on stage although they are partially obscured by the large head. The stage is lit with a bright orange color. There are subtle figures playing in a chamber ensemble on the stage. It has an emotional expressionistic quality suggesting the work of social surrealist Ben Shahn. There are further elements of abstraction as the hall itself surrounds us: We can see the 360 curve of the circular hall and the seats, but Warhol allows us to see beyond a normal line of sight. Warhol's work occurs at the time of the beginnings of the World War II when he was safe at home. He even portrays box seats on the stage. The qualities of expressionist abstraction, the bright use of nonrealistic color, and the amusing presence of a head in front of the action on the stage portray the wonder and annoyances of attending live performances.

THE BOY AND THE DOLL: CHARLIE MCCARTHY

Aside from his engagement with ads, art, and religious icons, Warhol also was influenced by a variety of Hollywood imagery. A special part of his

vocabulary was his relationship to doll images and children. When he was a child, his mother purchased a Charlie McCarthy doll for him. The doll/puppet appeared lifelike and perhaps crossed into that uncomfortable realm of *the uncanny valley* where creatures that appear too close to human form start to make people feel uncomfortable. At least that is what happens to normal people. Masahiro Mori wrote an essay on our experience of the feeling of the uncanny in 1970. He provided an example of something that could be creepy or uncanny, like a human hand, but a hand that is not really a real human hand. He writes, "however, when we realize the hand, which at first sight looked real, is in fact artificial, we experience an eerie sensation. For example, we could be startled during a handshake by its limp boneless grip together with its texture and coldness. When this happens, we lose our sense of affinity, and the hand becomes uncanny."[12]

The uncanny is also a term that is used in Freudian psychology, and Freud's writings on the uncanny inspired some surrealistic studies of the relationship among surrealism, dreams, and the supernatural. Freud looked at the writings of Jentsch to better understand the uncanny in literature. He wrote that, "Jentsch has taken as a good instance 'doubts whether an apparently animate being is really alive; or conversely, whether a lifeless object might not be In fact animate,' and he refers in this connection to the impression made by wax-works figures, artificial dolls, and automatons."[13] Warhol who was a lonely child with few friends may have been more accepting of this nearly human replica then some people simply out of his need for companionship.

However, Mori points out that the similarity to something human triggers a fear factor as the level of humanity rises to a level that rivals the human capacity for appearing alive and animated. Disney studios have famously treaded near the line of the uncanny in their films. Early animated films like *Snow White* emulated human movement closely, and early animators studied the anatomical films of Edward Muybridge to make their animated characters move as much like humans as possible. Studios like Warner Brothers made their characters substantially different than humans. Bugs Bunny and Daffy Duck were extremely cartoonish and surreal. By comparison, McCarthy was extremely realistic in his appearance and could come close to a human appearance in film. Samareh Mirfendereski describes why we are both excited but somewhat worried by the presence of a puppet saying, "the very presence of the puppet object provokes uncertainty in the observer, uncertainty about the puppet's being a reality or a dream; because the puppet becomes alive before their eyes and performs both ordinary and extraordinary deeds."[14] As Mirfendereski points out, the puppet character makes us nervous because we are not sure what the character is. We question our own waking state in its presence. Further, if the puppet performs beyond the level of human capacity, it makes us more fearful because it could supersede human capabilities.

Poor Warhol, who suffered from nervous afflictions and a condition known as St. Vitus Dance, a disorder that would make him unable to control his movements, might have found a creature that he could move as ordered, a kind of wish fulfillment. Imagine someone not being able to control his or her own movements, but having access to a doll that could be controlled. Such a creature might have inspired Warhol to produce an entourage that he might direct, entering the field of filmmaking, and creating projects with a series of assistants. All of these activities might well derive from the act and art of puppeteering without Warhol himself ever becoming a puppet master. Perhaps a young person that can't control his or her own movements might be naturally drawn to a doll puppet that also cannot control its own movements and is manipulated by another. At any rate, Warhol owned a McCarthy doll, and it apparently was a prize possession of his early years. For a forlorn, unhappy, poor, and friendless child, the doll might have been an animated version of a friend.

As a professional application, we might also see in the McCarthy doll perhaps Warhol's early impulse toward creating cinema images in which the inanimate are animated by the manipulator, the director, the controlling force. If one looks at the eight hours of Warhol's *Empire*, a steady and continuous unmoving shot of the Empire State Building from late afternoon until after midnight, the sense is that Warhol is trying to see the building as a moving object, although it appears stationary to an audience. Apparently Warhol wasn't the only one that had issues stemming from a doll. Candace Bergen, daughter of Edgar Bergen, also had to contend with her father's famous partner and puppet. She described the tempestuous issues in *Woman's Day* explaining that:

> The puppet had his own room in the Bergen household—his was bigger than hers. She recalls sitting down to breakfast on one of her father's knees, Charlie placed on the other. "A gentle squeeze on the back of my neck was my cue to open and shut my mouth so he could ventriloquize me. Charlie and I would chatter together silently, while behind us Dad would supply the snappy repartee for both of us," she writes.[15]

Warhol perceived the world of filmmaking as the mystical process of the star galvanizing audience attention. It was for him a surreal process of audience's being magnetically and unexplainably drawn to the object on screen. Warhol himself seemed to be pulled to the creepy experience of the virtual and surreal presented as real: his posing of the Velvet Underground, his static films, his aligning products as images, like on a grocery shelf. All of these ideas replicated taking life out of *real life*, revivifying the objects, and restaging them on his own private stage in his own private world. This

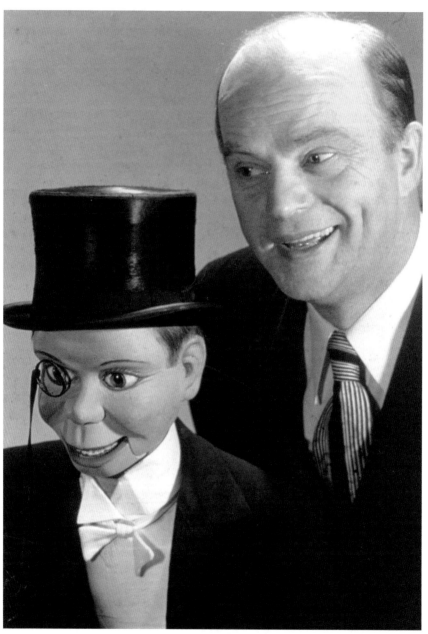

Figure 1.2. Warhol's mother Julia bought him a Charlie McCarthy doll. Edgar Begen's wooden companion became the young frail Warhol's sole playmate on occasion.
Photofest

is not uncommon for animators. Disney did it. Mr. Rogers did it. Pixar does it. When the world is chaotic and unrewarding, the fictive stage can be more manageable. Animators like Disney enjoyed creating their own worlds, and one can imagine Warhol sick and in bed holding conversations with his near-human doll.

Perhaps for Warhol having a puppet friend was a sort of therapy. Victoria Nelson, in her *The Secret Life of Puppets*, argues that our relationship to the imaginary or posthuman automata can allow us to have more power and more agency. She writes in regard to films like *Dark City* and *The Matrix* that the heroes, "have dared to break the bonds of their fabricated personal histories. . . . 'transgressing the laws of nature' does not damn them it sets them free."[16] Perhaps Warhol felt similarly empowered by his robotic little friend. Not only was a doll something he could control, but it could also help him to understand that he could move himself and that he could have control and agency over matter. He could conjure images and life himself. We often think of this dilemma with people who are disabled. How do they see themselves in a world where people are fully able to move? The abilities of others must make it difficult for them to go through life. Consider President Franklin Roosevelt who was alive in Warhol's early years. Roosevelt was a young man in the prime of life when he lost the use of his lower body as a result of polio. Roosevelt worked eight years just to master the appearance of being able and physically capable to hold public office. Imagine the challenge of a young person like Warhol: different, differently abled, gay, and friendless. An inanimate playmate doll might have been the only friend he could find.

Warhol's engagement with manipulating little figures was not simply something he approached in childhood. As an adult, he collected art including a vast collection of cookie jars, many aimed at a child audience.

THE BOY AND GIRL: SHIRLEY TEMPLE

Warhol had a passionate obsession with the image and concept of Shirley Temple. As a youth, he wrote to her in the studio and received an autographed picture of the child star that remained a prized possession for life. Temple was an icon of the depression years, arriving like an antidote to the gloom in the years following the massive decline in the economy. In John Kasson's *The Little Girl Who Fought the Depression*, he writes that,

> at a time when movie attendance knit Americans into a truly national popular culture, they did not want a mirror of deeper deprivation and despair held up to them but a ray of sunshine cast on their faces. In fact, such conspicuous demonstrations of confidence characterized the great depression, as President

Roosevelt extended the politics of cheer deeply into the private lives of citizens and Shirley Temple did so into the private lives of even the youngest consumers. The complex and paradoxical effects of these efforts are with us still.[17]

As Kasson reinforces throughout his text, Temple was more than a formidable child star and popular movie icon, she was a symbol of joy, triumph, and resistance for a nation facing economic and more problematically, emotional depression. Kasson explains the painful dynamics of Roosevelt's own battle with polio the crippling disease that robbed him of mobility in 1920. He wrote, "for the next seven years, and, to a lesser degree, for the rest of his life, Roosevelt dedicated himself to his recovery."[18]

Kasson makes the case that Hoover's dark dour image haunted the country and Roosevelt's jaunty, cocky smile emboldened the people and helped people to endure the hardship of the depression with bravery and kindness.

However, Temple's debut on the American scene was in a series of films called the *Baby Burlesks*, and these awkward little films placed children in adultish roles aimed at adult audiences wearing adult-suggestive clothing and singing adult-suggestive songs. The work, though obviously parody, slid close to child exploitation and skirted the issue of sexualizing infants and exploiting kids in lewd vehicles. She won a part in *Stand Up and Cheer!*, and this upbeat comedy offered Temple a chance to dance and sing. America immediately embraced the indomitable little child star. Perhaps Temple's most important work was in transforming elements of American regionalism into a world culture. She did two films about the Civil War, *The Little Colonel* (1935) and *The Littlest Rebel* (1935). Both dealt with images of the South in the minds of Americans. The South, long marginalized after the peace of 1865, was finally being given electrification and a series of films after D. W. Griffith's *Birth of a Nation* in 1915 had not only lionized Southern heroism and the notion of the doomed lost cause of the Confederacy but had also elevated the status of Blacks who had suffered generations of injustice under slavery, were still being victimized in all parts of the nation, and suffered disproportionate pain during the depression with high employment and less opportunities than White citizens. Temple was something of a liberal leader serving the fight for full equality. She danced with Bo Jangles Bill Robinson, one of the stellar tap dancers and film favorites in the thirties and forties, becoming the first interracial dance couple in film history. In *The Little Colonel*, Temple has to win over her cold-hearted grandfather who will not accept her and her mother because the daughter had married a Yankee. Temple, though still not ten years of age was in films that addressed race, prejudice, meanness, and bad fortune, but throughout, the plucky, talented, smiling, and charming Temple managed to endure and succeed mostly on her talent, perseverance, winning personality, and a melting smile. Kasson argued that much of her

Figure 1.3. Young Warhol idolized Temple as much for her pluck and can-do attitude as for her charm and good personality.

Library of Congress, Prints & Photographs Division, photograph by Harris & Ewing, LC-DIG-hec-24776

allure came from the fact she appeared as a real child with real childlike in-
nocence. He designated this quality as her cuteness saying, "cuteness invited
the beholders responses on various levels: aesthetic delight, moral protec-
tion, and possessive desire. It powerfully combined elements of sentimental
reform and the rise of modern commercial culture."[19] Temple transformed
the role of the child performer making her a character with agency and an
emotional focus for a struggling nation. Warhol was in awe of Temple even
as an adult, and he emulated her gee-whiz enthusiasm, particularly for all
things related to praising and supporting society, capitalism, and indigenous
culture. Warhol learned from Temple to be a cheerleader and though people
might have found his interview personality endlessly optimistic and positive,
he truly wished to project that a belief in enthusiasm, energy, hopeful wishes,
and self-confidence could make the difference in an event.

Warhol's relationship with the star was multileveled. A child of the
depression himself, he was the same age as Temple and saw her as his per-
sonality in the body of a female. He imagined himself with the pluck and
drive that Temple exhibited, and he saw in her lessons for his own career
and persistence. Further, while Warhol suffered from illness and felt him-
self unattractive, pasty, and white, Temple was the robust fulfillment of a
physicality that he didn't possess. When Warhol began to assert agency in
his artwork, he referred back to the images he found in Temple's movies.
He named one of his films with Edie Sedgwick after Temple's *Poor Little
Rich Girl* (1936). The Temple vehicle offered the spectacle of a little girl
lost in the city. For the thirties, it was an idea of *Home Alone* only reversed
to in the city alone. Temple is a lost heiress alone in the city. She cannot
find her family. The story was a significant emotional issue for audiences
in the depression. Families were uprooted by poverty. Families had to move
to find work. The great dust bowl sent hundreds of thousands of people to
California in search of labor, and there, they were treated like untouchables.
John Steinbeck's *The Grapes of Wrath* details the horrific conditions of
that time. Eventually in *Poor Little Rich Girl*, Temple finds some itinerant
performers and gains two families of loving parents. She is not only loved,
needed, and finds a home, but she also finds two sets of families A winning
recipe for an American population without enough for everyone. It also of-
fered Temple another chance to dance and sing. Warhol's Sedgwick vehicle
found the neurotic performer, lounging, trying to prepare for the day, dress-
ing, and complaining on the phone about her miserable day and personal
problems. She was the antithesis of the self-reliant, always smiling, and
plucky Temple character.

While Warhol participates in the narratives of Temple movies, he does not
think such narratives, such as the heroism of *Wee Willie Winkie*, are sustain-

able. He doesn't buy their perception of American culture and its general goodness. His historical time period paints American culture as more dissonant and fragmented. There is no centrality often arranged arbitrarily by plot as in Temple movies. Warhol, realizing that the film images he had in his mind must be rewritten for a new generation, was left to create situational contexts for his actors. For his artworks, he was uncertain of what is genuine in a product world of advertising and the narrative becomes the narrative the audience brings to a Brillo Box or an advertising illustration. The narration or the specific meaning is no longer embedded in the producer's product but the meaning emerges from the producer's display of the product and the richness the observer brings to the product. We see this in Warhol's projections of film characters like Elizabeth Taylor or Elvis Presley or Marilyn Monroe. Unhinged from their filmic representations they become ghostly doppelgangers, not moored or tied to anything. Veronica Hollinger comments that when artists or writers reach this stage they are reaching, "an overwhelming fascination, at once celebratory and anxious with technology and its immediate—that is unmediated—effects upon human being(s) in the world, a fascination which sometimes spills over into the problematizing of reality itself."[20] Warhol wrestled with the images of Temple and how she argues for a harmonious and consonant society that he saw as changed in his time. If nothing else Warhol sought to restore that level of consonance to American culture but he found products and labels the only remaining carriers of these ideas. Temple and her contemporaries have moved on, and all that he could produce, in their absence, was ghosts. Temple may not appear in any of Warhol's films, but the antithesis of many of the themes she delineated in the thirties haunt his film and graphic work of the sixties and later.

Vincent Fremont, one of the executives at Andy Warhol Enterprises and a close associate of the artist, wrote an essay celebrating Warhol's work drawing children and dolls for a 2005 exhibit titled, *Andy Warhol's Small World*, which was on display in 2005 at the Jablonka Gallery in Koln, Germany. He said that "strangely haunting and eerie, Andy Warhol's drawings of children look as if they could have stepped out of the Sci-Fi horror film, *Village of the Damned.*"[21] Clearly Warhol's association with Temple and McCarthy are wrought with anxiety. The artist uses these image from the past as a sort of avatar to remind him of a kinder, gentler, and more comical America, but the juxtaposition of a doll and a child movie star suggest a darkening of the fabric of American society. For many, Warhol's work provides a problematic re-envisioning of modernist themes and origins, but sadly for him and for us, the innocent world of Temple or even the more complicated world of McCarthy and his multiple layers simply do not exist, and Warhol's answer was to reveal their decay.

ICONOGRAPHY OF THE SECULAR

Carnegie Wise Men: Greene, Lepper, Rosenberg, Worner, and Twiggs

Few investigated what a Carnegie Tech education was and what ideas were floating in that postwar academy. Warhol had an elite education with the finest in critical and theoretical ideas surrounding him. Victor Bockris described the rich environment that was Carnegie in the forties, writing, "Carnegie Tech, on its beautifully landscaped campus in Oakland, near the rows of mansions where the Pittsburgh elite lived, was a zone of culture distinctly separate from the workaday life of the city. The University's standards were high, the courses competitive, and hard work was stressed."[22] However little of that privileged genesis was evident in New York where for many residents, little outside the city existed.

Few Warhol books have painted the complicated climate of postwar American graphics and the slow simmering impact of the early-twentieth-century avant-garde in the artist's life. Warhol was trained in the best graphic techniques of his era, and he had a keen grasp of media techniques and excellent drafting skills. He could draw, paint, print, stencil, copy, transfer, photograph, and film before he was a professional artist. He was a well-trained student with a varied skill set. Coupled with marked ambition, pluck, and a wondrous set of capabilities, Warhol's success was not totally surprising. Though he routinely downplayed his education, he was an assiduous student with a profound grasp of all the currents of avant-garde movements that had impacted the culture of the twentieth-century art world and markets.

Warhol was the recipient of first rate instruction at Carnegie Tech, and while his instructors were not the central figures of the New York abstract expressionist school, they were significant and successful artists, theorists, and teachers in their own right in the thriving, bohemian environment of postwar Pittsburgh. Although it is uncertain that Warhol had all of these professors as teachers, he was ensconced in the student milieu, belonged to the dance club and the art club, and likely knew of all of the instructors and their work.

Worner: Master of Industrial Design

Howard Worner was an industrial design artist, and his beat was covering the progress and growth of an industrial city. Worner's work was almost a living autobiographical design cityscape of industrial processes and a record of the progress of the steel industry in the city. He had attended the Philadelphia College of Art and first worked in advertising and commercial art. He worked for the Armstrong Cork plant but relocated to Pittsburgh where

he could make art and design that displayed the city's rise in the progressive early twentieth century. Working for steel plants, Alcoa, Westinghouse, and others, Worner was the court painter of the growing mill town and the powerful creation of steel that made the region and country an industrial center. He joined Carnegie Tech in 1947 and was a new faculty member during Warhol's time at the college.

Worner, like Warhol, was involved in a lot of commissioned work, and he did a series of paintings worldwide for Wean Engineering to draw and paint equipment in various countries. Worner was a strong worker and produced more than fifteen hundred paintings in his time. He created a subgenre of factory paintings that depicted the midcentury industrial life of the region. While a part of business and industry, these works also constituted a strong connection to the folk culture of the times, illustrating a scrappy little mill town and its people. His son remarked that, "the old mills Pittsburgh was known for are no longer there. His paintings depicted a lot that was never brought to light before."[23]

According to an article on Worner,[24] Warhol was in his class and clearly was exposed to and absorbed Worner's ideas that (i) industrial or product design was an important art form and not secondary and that (ii) practical design was a potent medium for invoking the qualities of a significant, erupting, democratic, and dynamic society that the United States had become. There was no reason to be anything but proud of such a legacy. It was proper for art to go about praising the rise of the industrial era. Warhol emulated this promoter role and used his artwork in both the commercial world and often in the fine art world to publicize American culture and industry.

Russell Twiggs' Abstract Expressions

Russell Twiggs was one of the art department at Carnegie Tech's abstract expressionists. His work was exhibited widely during his lifetime and his styles were diverse. A work titled *The First Act* from the 1950s is in the National Gallery of Art in Washington, DC, and explores extremely abstract imagery but in a playful and almost proto-human primitivist manner. The colors are bright and attractive, the design is clear, and the composition guides the viewer through the piece. There is a sense of playful surrealist mystery in the work as if one were visiting a childlike fantasy world created by Paul Klee or Joan Miró. Other paintings also cross over into surrealist landscapes with shapes and images that suggest flat planes from another dimension. Still others are vibrant color studies reminiscent of the work of Sonja and Robert Delaney. His work included preparing and hanging shows at Carnegie Tech. He was also an expert lithographer and may have influenced Warhol's

interest in printing methods to speed up the execution of his work. Twiggs advocated for Warhol in his early days at Carnegie and prevented the young artist from being discharged. Several of the faculty didn't see Warhol as talented or generating quality material because of his already pronounced tendency toward pop and ironic subject matter. Twiggs defended the young man arguing that his diversity was good for the institution. Twiggs contribution to keeping Warhol at Carnegie reminds us that classism was not just an issue for racial minorities but also for people that had some noticeable disability. In reality, the United States did hold, and still does, many barriers for talented young people that happen to be born poor, and Warhol's success (against the odds) reminds us of the difficulty that Warhol and other poor but talented kids still face in this culture.

Sam Rosenberg

Many of Warhol's instructors were immigrants like the young artist (or the children of immigrants). Samuel Rosenberg was an immigrant from Austria-Hungary and had learned to draw while staying in a settlement home. Rosenberg had a number of good art instructors who, like him, had fled bad conditions in Europe to the relative safety of the United States. He learned from Jacob Coblens, a Parisian that drawing from memory could be helpful to one's craft, and he incorporated memory techniques into his style of painting. He was a social painter and drew and painted many scenes from the impoverished Hill District in Pittsburgh. He also was comfortable with abstraction and painted *Becoming* in the 1950s, which resembles an homage to Marcel Duchamp's *Nude Descending a Staircase*. Rosenberg was a beloved teacher for five decades at Carnegie Tech, and it is reported that along with Twiggs, he saved Warhol "from expulsion in 1947."[25] He taught at the Young People's Hebrew Union along with Carnegie Tech and had a prolific art production career making more than five hundred paintings. His work was exhibited in the Whitney, the 1939 World's Fair, and the Museum of Modern Art (MOMA) in New York. Rosenberg was an abstract painter but never definitively broke with total reality, and many of his abstract works still have real people and clear images in them. Rosenberg urged his students to have, "a firm grasp of realism before venturing in to abstraction."[26]

Rosenberg was likely a hero to students like Warhol not only because he saved Warhol from expulsion but also because he was a productive artist in a university setting, and although his work was uncompromising, it boldly staked out a careful line between representational and abstract art. Rosenberg's work often appears to be influenced by Asian design in that it is minimal, bright, and attractive and alludes to unknown and unexpressed subject matter.

Robert Lepper

Professor Lepper was an artist at Carnegie Tech, a founder of the industrial design program and a founding member of the Abstract Group later renamed Group A. Lepper saw that industrial design was professionalized at the university. The Tech program was the first such program in the nation. He was also involved in art theory and took the seven elements of design (line, space, value, etc.) and found corresponding equivalents in the world of industrial design so that students had design parameters in their work. He influenced Warhol by explaining that industrial design, advertising, architecture, or sculpture were no different than regular fine art and had equal value.

Balcomb Greene: Fine Art Abstraction and Elegant Design

Balcomb Greene's work combined the elegance of painting and the richness of a wide range of creative endeavors. He had studied psychology and literature and had taught English at Dartmouth. He arrived at painting in his thirties and studied it by sitting in cafes in France and observed people passing. He was influenced by Pablo Picasso, Matisse, and Piet Mondrian. In the thirties, he was the first chair of the American Abstract Artists. He worked for the Works Progress Administration (WPA) in the 1930s and made murals in medical schools, a housing project, and a stained glass window in the Bronx.[27] Greene and his wife bought property in Montauk, Long Island (something Warhol did in the 1970s and lived close to where his former teacher had settled on the beach). In an important exhibition on *The New Images of Man* presented by the Museum of Modern Art in 1959, Greene wrote that, "man is difficult to present in painting because it was done so badly by the end of the last century, but also because he seems to our disillusioned minds not worth presenting. . . . Great art must give him more energy, and more virtue of a kind or more heroism, than we commonly find in him."[28]

DRACULARIZATION

One element that arises with Warhol is his connection to his middle European roots. Was he in some way a Dracula character, some sort of psychic vampire? After shooting Warhol, Valerie Solanas made the claim that he had too much influence over her. The level of influence that Warhol exerted over his Factory cohort is debatable, but there has been some suggestions that he was weirdly charismatic and that he could induce his followers to act in his stead. Many point to an otherworldly quality as if Warhol was distant and not really there. In his book on *America*, he reported that he'd like his tombstone

to refer to him as a "figment."[29] Sadly the connection between Warhol and Dracula has been seen as a joke. However, the similarly may not be so superficial. Warhol may very well have gravitated toward qualities of courtly life, the role of the arts in culture, aesthetic patronage, and production styles that derived from ancient Carpathian traditions. Warhol developed cliques and a sort of a court structure to his work and business. Warhol said little but expected fierce loyalty. Warhol paid little but demanded work in return for his friendship. He placed the production of objects as a higher priority than relationships. All of these may relate back to age-old traditions from the Carpathian mountains that in some way intersect with the mystic, symbolic, and supernatural stories and folklore of the region.

In Bram Stoker's *Dracula*, Stoker makes a statement about the background of people from the Carpathian region saying, "I read that every known superstition in the world is gathered in the horseshoe of the Carpathians, as if it were the centre of some sort of imaginative whirlpool."[30] It is overlooked that Warhol's cultural background was also this Middle European district of the continent and filled with fantastical folkloric legends of Dracula and a wide range of mystical, historical, and disturbing figures. Professors Eva Thurry and Margaret DeVinney in their *Introduction to Mythology* discussed the idea that such folklore stories for Freud gained power by their association with the uncanny. They write that, "he links the power of the uncanny to anxiety deriving from our repressed fears: those relating to the body, like the loss of vision or limbs, or castration, and those relating to the fear of the 'uncanny' events: being buried alive, falling under the influence of dead creatures."[31]

Warhol's appearance was always a concern to him. It somewhat derived from the appearance of a pale, Dracula-like character. Stoker described the count as,

> the mouth, so far as I could see it under the heavy moustache was fixed and rather cruel looking with peculiarly sharp white teeth, these protruded over the lips, whose remarkable ruddiness showed astonishing vitality in a man of his years. For the rest, his ears were pale, and at the tops extremely pointed; the chin was broad and strong, the cheeks were firm though thin. The general effect was one of extraordinary pallor.[32]

Warhol had the fixed mouth, the angular face, the blotchy red cheeks, large pointy ears, a broad and strong chin, and the pale face of some European royalty.

These ideas of a Dracula character who mesmerizes and enchants minions to do his bidding do pertain to Warhol and his personality. As Thurry and DeVinney point out, we find many Freudian fears and fantasies in the stories of the uncanny, and particularly so in *Dracula*. Warhol had deep body im-

age problems and thought of himself as ugly. Warhol, like the Count, was obsessed about his appearance, something prominent in the mythology of vampires. Vampires are dead and decayed creatures. The idea of the beautiful and glistening vampire is a recent invention of a society obsessed with youth and beauty. Vampires admire the beauty of the living but don't have it in their own lives or deaths. But in the mythology of vampires, most see the creatures as decadent and using blood to reverse the work of decay. Dracula is always disguised, disguising his age, his lust, and his wickedness. Warhol used a variety of lotions, astringents, and makeup to make his blotchy pale skin look more attractive. He wore a wig to disguise his lost hair. He played the role of the artist to make himself appear more attractive to possible student workers. He lured people to his shop and engaged them in his enterprises, often for little or no pay. The early Factory existed as sort of a court performance where a group of loyal fans served and supported Warhol and his projects.

Dracula discussed his view of people and his relationship to his fellows saying,

> Here I am a noble; I am boyar; the common people know me, and I am master. But a stranger in a strange land, he is no one; men know him not and to know not is to care not for. I am content if I am like the rest, so that no man stops if he see me, or pause in his speaking if he hears my words, "Ha, ha! A stranger." I have been so long master that I would be master still or at least that none other should be master of me.[33]

Warhol had spent a decade being the compliant worker and sought to exert some mastery of his kingdom.

Thus, vampires and people like Warhol are really a contestation of modernity. The new modern social structure creates a culture of production and leads to postmodern concepts of hyperproduction with its new means of creation. Santiago Lucendo writes that, "From the very beginning, the vampire has occupied a culturally 'stitched' body, reflecting the historical, political, and social frameworks surrounding it, and it has served, both racially and geographically, as a space in which the fears and desires of a particular (i.e., dominant, "ruling") culture can be played out."[34] Warhol participated in this. He didn't have to produce films with stars to make superstars, he just designated people as superstars, and they appeared as stars to him.

Warhol also mined the popular culture references to his Carpathian heritage in a variety of manners. He was jokingly called Drella by his Factory coworkers, a combination of the names Cinderella and Dracula. He made a *Batman/Dracula* film in the early sixties starring underground filmmaker Jack Smith as the ostensive vampire and superhero character. Finally, he leant his name to Paul Morrissey's direction of *Andy Warhol's Blood for Dracula*

Figure 1.4. Warhol has a lifelong attachment to inanimate or interstitial figures that appear partially alive but yet frozen and suspended. It is a tendency that reoccurs in his photography, catching not life but a sort of half life.
The Metropolitan Museum of Art

in 1973, an arch and camp parody of the original Dracula material suffused with humor, blood, and guts. Beresford remarked that there was little that tied the many myths of vampires together. He wrote that, "It is the author's opinion that there can be seen to be no defining link in *all* examples of vampirism except for the aspect of fear, and it is this point that the fundamental elements of any doctrine must be based upon."[35] Perhaps Warhol's underlying relationship to these superstitions was an uncalmed fear of the world. Perhaps becoming something of a vampire himself was his way of retaliating against the menace of finance and the danger of capitalism.

Chapter Two

Warhol: The Mad Man

In the kingdom of mass culture; advertising is the prime minister.[1]

The maelstrom of American advertising in the fifties captivated the world as people across the globe were in the thrall of America's powerful advertising machine. Everyone learned of new products, and around the world everyone wanted the magnificent products that the American economy could produce with an outpouring of creativity, initiative, and zest for producing consumable objects. Record players, television sets, jukeboxes, stereos, and tape recorders took off and made the United States the center for new markets and new consumers. Everyone wanted what the United States was selling. Warhol was at the backbone of this industry producing a wide range of attractive designs to support a new generation of new fashions. At the same time, Warhol was a clever and synthetic rebel who had grafted together the concepts of a bright decorative and attractive art and drawing style with a delight in clever, funny, and comedic illustrations that often lampooned and undercut the institutions and markets that he served. At once, he was influenced by the highly decorative and frivolous style of the French rococo artists of the eighteenth century while subtly applying the antiart criticisms of the early-twentieth-century Dadaists who consistently chastised the art world. While his intent may have been to support the work of manufacturers in his illustrations for advertising, Warhol found himself in the fifties straddling the twin styles of rococo and Dada art.

The fifties was a remarkable time in the world of advertising. The industry had grown exponentially and money was flooding into the advertising trade that was mostly headquartered in New York City. *Advertising Age* reports that, "throughout the decade, advertising expenditures increased to unprecedented levels. J. Walter Thompson Co., for example, saw its billings

increase from $78 million in 1945 to $172 million in 1955 and $250 million by 1960. Overall, the decade saw gross annual ad industry billings grow from $1.3 billion in 1950 to $6 billion in 1960."[2] Advertising had jumped in value after World War II. Veterans had returned home after five years of torturous war and deprivation. American society had been rationing and preserving tactical goods so that metal, fuel, rubber, and munitions could be used in the war effort to combat Adolf Hitler, Benito Mussolini, and Hirohito, the Axis powers. Prior to World War II, the country had endured one of the longest and most costly economic downturns in the nation's history, the Great Depression, which robbed people of land, farms, and homes. Combined the country had endured more than fifteen years of intense loss with periods of 25 percent unemployment and a stagnant economy. Warhol's family had been poor, but they were not alone; the entire country had been ordered to save, do without, and build nest eggs for a brighter future, and the explosion of advertising in the fifties invited fledgling consumers to indulge their inner shopper and purchase a wide array of products to placate their long suffering families.

By the fifties, Americans were not only keenly aware of advertising and its presumed influence on them, they were becoming increasingly worried about the influence of the advertising world. This didn't keep them from watching ads, buying products, and feasting on a society that had sold the notion to the people that not only could the good life be bought, but it could also be bought cheap because there was a sale going on right now! Vance Packard's text, *The Hidden Persuaders*, which described the problem with advertising as, "large-scale efforts are being made, often with impressive success, to channel our unthinking habits, our purchasing decisions, and our thought processes by the use of insights gleaned from psychiatry and the social sciences. Typically these efforts take place beneath our level of awareness; so that the appeals which move us are often, in a sense, 'hidden.'"[3] Packard argued that psychiatry, itself a popular new phenomenon that emerged after the war to help people understand and control their neuroses and compulsions, was being used to mine our hidden desires and our underlying motivation for buying. He blamed market researchers as being the spies that discover our wants and needs. These entities were part of a conspiratorial mechanism that sold information to firms that desired to exploit our weaknesses. He argued that the practice of advertising has entered politics and family life as politicians were being marketed as products to sell. He wrote that the head of the Public Relations Society of America (PRSA) commented that, "the stuff with which we work is the fabric of men's minds."[4] For the most part, Packard accepted that advertising had a worthy and necessary role in American economic structures to market and move goods appropriately, and to this corner of the business, he offered praise and argued that the business was worthy and respectable.

On the dark side, he found the "depth boys," or the researchers that probed deeper, looked for vulnerabilities, exploited weaknesses, and penetrated our psychic defenses, finding ways to violate our inhibitions against buying and attacked us in exposed regions of our psyche. For Packard, the stakes were high. He explained that, "the average American had five times as many discretionary dollars as he had in 1940."[5] There was a lot of money at stake.

On the other hand, advertising provided work. Warhol arrived with perfect timing for the advertising industry. When he and roommate Philip Pearlstein descended on New York, Warhol was an energetic, well-trained, and confident young artist. He saw a city that had replaced Paris as a world art mecca. Warhol had embraced the teachings of his instructors from Carnegie Tech. He agreed with Howard Worner that industrial design and objects were just as important as figurative work . . . and just as beautiful. He accepted the whimsical playfulness of Russell Twigg's expressionism. He saw the potential for abstracting the human presence in Balcomb Greene's figurative but abstract paintings. In fact, the young men sublet a flat from a student of Professor Greene. Warhol was an aggressive marketer and within a few days he won an important full page commission. Philip Pearlstein explained, "'On Andy's fourth or fifth day of interviews, he landed a major assignment for an important fashion magazine: a full-page drawing of several women's shoes on the rungs of a ladder.'"[6]

DUCHAMP AND DADA

Many have commented on Warhol's tendency to call on past avant-garde's in his work, and an often mentioned influence was the Dada artists of the early twentieth century. Robert Short in his *Dada and Surrealism* explains the origins of the word saying, "Dada represents a revolt against art by artists themselves, who, appalled by developments in contemporary society, recognized that that war was bound to be a product, reflection and even support of that society and was therefore criminally implicated."[7] Short is commenting on the original Dada artists and their rejection of the First World War and the society that caused it. Their general disgust at all things produced by their society erupted in a form of art that rejected nearly everything that was tied to rational schools and conventional ways of thinking. The Dadaists wanted none of that. They wanted the freedom to go their own direction, to reject society, and to produce an art that was a bombastic protest of the commonplace. One of the principle instigators and provocateurs of the Dada group was the French artist Marcel Duchamp, who made what he labeled as *readymades*, found objects that were already completely composed that he reassigned new

names. They were named as artworks, and that appeared to be their only link to the art world. Warhol practiced a similar canonization of the everyday as a work of art continuing Duchamp's manner of questioning what society sees as art. He took already existing items and assigned them as artworks even though their difference from the source material was marginal at best. Warhol made readymades of paintings of Campbell's Soup Cans and actual sculpted wooden boxes to replicate the cardboard boxes that carried Brillo steel wool pads for cleaning pots and dishes. Like Duchamp, Warhol was believed to be something of a prankster, doing copies of objects to insinuate that the strenuous efforts of the art community to make something original was a waste of energy and that the actual object or a readymade was a far superior art work because it didn't require fabricating and was already available usually in serial form. Things like chairs, tables, or other manufactured objects such as Warhol's shoes, clothing or Campbell's soup cans were modern-day equivalents of the readymades that Duchamp had developed half a century previously. In his text on Duchamp, Calvin Tomkins mentions Warhol as a spiritual heir to the Dadaist Duchamp. Tomkins wrote that, "the famous Campbell's Soup Can is the embodiment of the dictum: 'I paint things I always thought beautiful—things you use everyday and never think about.'"[8]

However, Warhol's Campbell's soup cans were not the first of Warhol's experiments in Dada. For example, Dada artists often used collage and found objects of previous paintings or drawings in their collage works. Warhol had been making collages with found objects since his college years. Further Dada had an affinity for using images of machines or mechanical parts and Warhol was accustomed to producing images of all manner of industrial products. He produced a wide range of car ads in the fifties, and he created a wide range of fetishist car images and displays to turn cars into mythological items. A number of Dada artists worked in the field of collage, taking found objects and arranging them in a design to show the absurdity of a single discrete image. Warhol similarly unleashed collages at *Harper's Bazaar*. One image titled *Fabricology* illustrated a comical caricature head with patches of different fabrics applied to the hairline.[9]

One of the mainstays of Warhol's artistic practice was drawing shoes. One could find few items as conventional and simple as shoes, yet Warhol strived to find ways to make shoes fashionable, attractive, and eye-catching. For Warhol, drawing shoes was an assignment like some of the abstract tasks he had been assigned at college. He was by now accustomed to make a work for hire or on demand. Further he had studied the avant-garde, and he recognized that while the prevailing and emotional style of the abstract expressionists held sway in New York in this era, there had been a different vision of arts and psychology a few decades back.

Warhol could see the work of artists like Duchamp as being similar to the tasks laid out by advertising. Unlike the abstract expressionists, the Dadaists used real concrete objects, but they just reimagined them in some fanciful way to call attention to absurdities in society. Duchamp began producing readymades, objects that were found and presented as art, forty years before Warhol entered the scene. Duchamp bought a bottle rack and scandalized the art world in 1914 by displaying it as it was, as a work of art. He thought of it as "solving an artistic problem without the usual means or processes."[10] Warhol was intrigued by the notion of creating things that were new, novel, and whimsical, but at the same time not too far from reality. He wanted to lodge a humorous protest at the art world while still working in a society of advertising production. Warhol was a paradox, someone with high art ideals, and a nature that leaned toward critique and philosophical commentary, but he also delighted in fresh and comical approaches to advertising. The Dadaists with their streak of anarchism were a natural touchstone.

If Warhol and his generation were not consciously channeling the ideas of the Dadaists they certainly had a natural sympathy with their revolt at the turn of the century. Duchamp was too poor to visit New York when the Armory show made him a star in 1913 for his controversial, abstract, and cubist painting, *Nude Descending a Staircase*. The effort scandalized the art scene, and many wrote angry reviews saying the painting didn't look like a nude or a staircase or anything. Duchamp delighted in such controversy. A colleague wrote of Duchamp that he possessed, "a limpidness, an easiness, a swiftness an unselfishness, an openness to everything that seems new, a spontaneousness and a boldness."[11] Warhol longed to be that person, an innovator, a leader, a jokester, and a prankster in the art world. At the same time, he had to incorporate his commentary, his humor, and his critique into the confines of the industry or else he could not work, he could not be successful, and worst of all, he would be unprofitable. While Warhol liked the idea of an avant-garde and an antiestablishment revolt, he found little he was naturally against. His frame of mind was not critical in conventional sense. He was able to appreciate a wide spectrum of work, and it always puzzled him when someone else could not find value in new work. The movement of Dada launched a wide-ranging protest against nearly everything. The conventional, the steady, the boring, the typical, and the conservative, all were targets. Dada didn't just attack reactionary trends in the art world, it bit at the reigns of society that nurtured it. Warhol might interject satire, but he would never attack his masters directly. He recognized the roots of patronage, and he understood that a frontal assault from the advertising industry would never be accepted. Dachy called it, "a protest, explains Tzara, a revolt, adds Arp, against 'the puerile mania for authoritarianism(which) would use art itself for the stultification of

mankind."[12] The Dadaists loved to stage prankish events to secure publicity and interest in their revolt. Arthur Craven, an artist, poet, and boxer agreed to do a lecture for the Dada group in 1917 in New York on the topic of art. He proceeded to become drunk and started to undress in front of the crowd. The police arrested him, and the headlines roared at his abuse of the audience, Did the Dadaists have a point with this sort of behavior. Mostly they presented an attitude that the conventional should be avoided, that the new should be lauded, and that anything that resembles the past must be scorned and excoriated in the task of inventing a new and enticing form of art.

Warhol shared with Duchamp the notion of solving artistic riddles by moving to a simple and obvious solution. If a client wants something new, why bother to create it, why not implement an already existing readymade item that can serve the function without the need for excessive new work or design parameters. Tomkins explained that the readymade, "reflected the notion of taking a common object out of its customary setting and placing it, verbally or visually, or both, in a new and unfamiliar one. The readymade could simply be selected or it could be assisted by the artist."[13] Tomkins explained that Duchamp disliked making money from his pranks, but he enjoyed art stunts. In a 1916 show where three of his readymades were displayed, he insisted that the objects be hung in a coat rack, and in fact, none of the audience at the show ever took notice of his contribution. For Duchamp, calling attention to the semiotics and branding of what we title as art was a high calling. If nothing else, he sought to dismantle long-held definitions of art and replace them with a new awareness of objects. Warhol was a more subtle rebel. If people took shoe ads for granted, Warhol would glorify shoes in a Dadaistic way, making shoes bigger than life, louder, funnier, and more personified than ever before. Few understood Warhol's subtle shoe revolution. Warhol moved shoes from the back of the ads to the front, making women envy the new shoes and desire the footwear that made these clever ads clamor with life.

Warhol also enjoyed the whimsical and prankish side of making art. For a fifties' advertisement assignment, he delivered a two-page spread of a girl on a ladder for the short article, "Success Is a Job in New York." On the opposing page in the picture layout, Warhol had a series of women's fashionable shoes arranged on a set of display ladders. The everyday melded with a clever advertising design. The attractive shoes were framed against the everyday and workman-like ladders. The common place and beautiful worked in tandem. Warhol incorporated the attractive shoes that appear in an empty surreal landscape in some small way added a comical Dada touch to what might be otherwise an average assignment focused on clothing.

An element of Warhol's success in New York could be attributed to the massive growth in the advertising industry in the fifties. As advertising dol-

lars spread from radio and magazines to television and FM radio, the growth of youth culture with its journals and FM radio that began playing nonstop pop and rock hits created an entire culture based on what young people desired and bought. Advertising spending quadrupled between 1950 and 1960, and consumers' income rose to match it. As they had in the early days of advertising, many products were geared toward a female audience. Makeup, clothing, lifestyle, and home appliances were pitched to a generation of American women who wanted to live a good life based on greater freedoms, panty hose, birth control pills, new job opportunities, and an enhanced vision of women's roles beyond wife, mother, and homemaker. Warhol was a part of a generation of advertising people that appealed to this arriving female market. Women wanted products that reflected a new, easy, and faster lifestyle. They still wanted products that reflected their desire to be attractive and needed by society, but more often than not, they also needed to tend to their inner need to feel useful as people in their own right. Warhol's work in simple ads for shoes and other products made him a favorite of advertisers. Whether it was his feminine sensibility, his gayness, or his synthesis of abstraction and the notion of readymades as art objects, Warhol brilliantly and effortlessly captured the zeitgeist of the advertising world and its focus on youthful, independent, and female consumers. Warhol's shoes had the feeling and design characteristics of a cartoon, something whimsical and light and uncluttered like the light and frivolous animation style of the Jay Ward Studios that produced Rocky and Bullwinkle, a popular children's show aimed at a crossover audience of children with their adult parents. Ward practiced a double game of humor at two levels, jokes for kids and a satirical humor engineered for adult viewers. Ward's signature style in cartoons like Hoppity Hooper and Fractured Fairy Tales featured gleefully drawn characters with wildly exaggerated and caricatured faces and often blocky and partially formed bodies. In these cartoons, based on folktales and children's stories, the satire was often leveled at advertising and consumer culture.

Warhol's assistant in the fifties and early sixties, Nathan Gluck commented that, "Andy's fame was really based on those fabulous shoe ads. They attracted a lot of attention because they had a lot of white space and the drawing was so beautiful."[14] Warhol had an easy natural understanding of the semiotics of advertising. Again, his preparation in illustration at Carnegie Tech had prepared him well for a career in which abstract art objects, the images of American industry, commercial illustration, figurative drawing, and harmonious design all merged. It wasn't so much Warhol's specialization in shoes that made him remarkable; it was his incredible versatility and willingness to engage in any number of styles or assignments that marked him as unique among his peers.

Warhol innately understood the commodification of desire that advertisers were selling. He was excellent at producing attractive and whimsical illustrations of objects like shoes. He could give them a comical almost human personality, and therefore, his shoes and other common objects seemed more friendly and alive. Women weren't necessarily needing another shoe, but if they could find a fun, clever appealing appliance that would make them feel more happy, alive, and popular, then a shoe purchase might encourage both a stronger self-image and a sense of playful fun. This tied into his Dada consciousness that art itself should be satirical, comic, and playful. Warhol understood the signs of desire that were enacted in that simple shoe purchase. Massik and Solomon in their *Signs of Life in the USA* discuss the way advertisers work and commented that, "associating a logically unrelated desire with an actual product (as in pitching beer through sexual come-ons) can be called the commodification of desire. In other words, desire itself becomes the product that the advertiser is selling."[15]

Massik and Solomon described a key principle of advertising in the modern age. Advertising is not about showing or demonstrating a product and its usefulness. Rather advertising is associating products and services with things we want: attractiveness, security, family, shelter, and prosperity. A classic example of this was an old AT&T ad that associated calling someone on a phone with a feeling of family warmth. A girl calls her father on the phone and he theorizes the call is a plea for money at college, a report of some disaster with the family car, or some personal crisis. Instead the girl reassuringly tells him she just wanted to talk to her dad. Such a connection to family propelled the brand of AT&T more than the actual phone service.

For Warhol, who suffered a youthful life of poverty and lack, idealizing objects was common place. He had found idols through the church, through his mother's secular worship as a movie fan, through his own interaction with a Charlie McCarthy doll, his own paper dolls, and his interest in movie stars like Shirley Temple. Warhol was innately primed and directly situated by his upbringing to be a natural at turning objects into desirable products. Warhol's shoes flirt, cajole, and wink at an audience. They beckon the viewer to take them down from the ladder and try them on. Further his ad offered the promise that if you build a closer relationship with this shoe, it will grow to love you, as you love it.

Professors like Robert Lepper trained students like Warhol in the means of making objects for a diverse marketplace in a series of technical problems in his design class at Carnegie Tech. In the two-semester course, students were assigned problems in design that overlapped issues in economics and social concerns. Problem two was titled "goods and services," and its purpose was to, "sharpen the students' capacity to observe and analyze meaningful social

patterns as valuable data for creative artists."[16] Here we see that via problems like this, Warhol learned to accommodate his work to the needs of industry and advertising.

ADVERTISING AND SEMIOTICS OF CONSUMPTION

Warhol's work in advertising also explored the growth of America's consumer society. Up until World War II, the United States had been a producing culture and made profit by selling items to others, but after the war, advertisers and economists recognized that the engine of the consumer could keep the economy strong. By producing need for items among consumers, economists and marketing people could presume the domestic audience of consumers were producing enough sales to offset the added costs of purchasing cheaper products from developing foreign markets like Japan and Southeast Asia. Added to this, advertising was segmenting markets into popular everyday consumers and elites. Warhol grasped the large market that advertising sought to reach, and his ability to render shoes crossed many market boundaries. Shoes were transcendental. Everyone wore shoes and needed shoes for daily activities. Drawing shoes connected Warhol to a basic fashion commodity and deeply engaged him in the pursuits of popular culture. Not only were shoes popular (especially with female audiences), but they were nearly endlessly diverse and thanks to the unending fashion cycle continually changing in size, style, and shape. Drawing shoes might have seemed routine, dull, or rudimentary, but in reality it was diverse, continually changing, and situated Warhol in a fashion industry and magazine culture that would provide new connections, art directors, gallery directors, and opportunities for a wide assortment of design commissions.

Shoe illustration also allowed Warhol to straddle the complicated territory of populist and elitist design. While shoes were a staple of fashion and a universal appliance of wardrobe, they also had intrinsic hierarchies of producers and consumers. Everyone from Chanel to Macy's designed a wide assortment of baby shoes, classic footwear, and the newest in designer fashion footwear. Warhol was included in the entirety of this design work. Further, all associated shoe work and its association with fashion in general provided new avenues for growth. Individual drawings also led to larger layout and spread work where the opportunity to work with other artists, photographers, models, and art directors presented itself. Shoes by themselves may not have been a prestige industry, but they were a gateway drug to expanded opportunities in the massive fashion advertising market and extremely catalog-oriented work of New York fashion advertising and magazine production.

It was thought back in the sixties and seventies that Warhol did some commercial magazine work early in his career. That presumption of limited interaction with the commercial world perhaps has something to do with our presumed assumption of elitism, that fine art work is somehow more noble and more important than commercial work, the old contest between elitism and populism. Warhol's formidable magazine and commercial work has lately been revealed and archivists are finding hundreds of projects that Warhol crafted not only in the fifties but well into the sixties when he had to underwrite his films, his publicity campaign to launch his fine art work, and his public hosting of crowds at the Factory. In *Andy Warhol the Bazaar Years, 1951–1964*, an exhibition catalog from a 2009 exhibition at the Hearst Tower in New York, Charlie Scheips explains that, "few know that Warhol created literally hundreds of illustrations and dozens of artist-designed spreads between 1951 and 1964 for the magazine."[17]

If sociology played a role in advertising it also played a role in employment. Carmel Snow, the editor and chief at *Harper's Bazaar* in the sixties, bought a drawing from Warhol and gave him work illustrating for the magazine after Warhol laid out his paper bag portfolio for the editor and a cockroach crawled out.[18]

Warhol's work was forever pivoted on the twin horns of American consumerism and fine art elitism. Jack Solomon writing in "Masters of Desire" argued that American culture is contradictory in its basic nature and causes great distress in people trying to untangle its roots in both populism and elitism. He writes that:

The American dream, in other words, has two faces: the one communally egalitarian and the other competitively elitist. This contradiction is no accident; it is fundamental to the structure of American society. Even as America's great myth of equality celebrates the virtues of mom, apple pie, and the girl or boy next door, it also lures us to achieve social distinction, to rise above the crowd and bask alone in the glory.[19]

Warhol's work in the field of advertising reckoned with this contradictory nature in a variety of designs. In a large three-page spread for *Harper's Bazaar* in December 1960, Warhol presented a series of potential Christmas gifts in a design that focused on elegant apparel and royalist stylings but also catered to customers that saw themselves as aristocrats. Items as simple as flowers and a thimble are framed in a crest design with lions and deer surrounding the products with decorative lettering, a cloth ribbon design and doves encircling the frame.[20] These Christmas gifts are for the elite. But in other designs such as the two-page spread for an article called "Fabricology," a cartoon caricatured head is covered with various forms of fabric where his hair should be.

Like Warhol commenting on his own baldness and use of wigs to cover his head, the figure is an impish figure smiling as numbers point to various fabrics ornamenting his large bulbous and bald head. In this amusing illustration Warhol use caricature, humor, and an everyman façade to build an image that fits the egalitarian model of advertising.

Warhol interacted in a world of design that profited from its engagement with American dream culture. He worked primarily in women's magazines that participated in the growth of the women's movement toward roles of wider acceptance power and freedom for women. There was an emerging youth movement characterized by a new postwar generation that wanted pop music that reflected their tastes. Rock music emerged to challenge the power of blues, jazz, pop, and country swing. Horror and science fiction films proliferated and teen antiheroes in the shape of Marlon Brando, James Dean, Dennis Hopper, Natalie Wood, Rita Moreno, and others emerged. Girl groups began to stake a claim to the rock field, and minority voices both male and female emerged from centuries of abuse and prejudice in the United States, forming a new sort of protest music, soul music that won fans with both White and minority communities. Warhol's work in advertising began to decode and unravel these emerging subcultures of youth and rebellion, and throughout while participating in advertising's work, Warhol also began to build a response to the power of advertising and its ability to enthrall and enslave consumers.

Warhol's fifties work filtered in that new audience. Warhol illustrated record album covers from the fifties to the time of his death. In the fifties, he did covers for classical albums featuring music of Prokofiev, Ravel, Tchaikovsky, and works by Arthur Fiedler and the Boston Pops, jazz by Count Basie, Joe Newman, Artie Shaw, Cool Gabriels, and Thelonius Monk, spoken-word albums on the rising drug crisis among youth, and into the sixties and seventies, works by the Velvet Underground, the Rolling Stones, John Cale, Paul Anka, Liza Minnelli, and Diana Ross. It was notable that Warhol worked across genre areas. Jazz and classical music had elitist audiences and rock appeared to be the democratic music of the people in that era. Warhol's cover work included photos, Polaroids, typography, attractive drawings, decorative designs, and a wide range of styles for a variety of audiences.

WARHOL'S SOFT REBELLION: MATISSE AND SHAHN

It is easy to see Warhol as merely a pawn of the advertising world in the fifties, marking time and doing piecework to establish credentials, build connections, and pay the bills. But Warhol was rigorously more ambitious than that. He had seen his work from the beginning as following a line of art

Figure 2.1. Warhol was captivated by the bright colors and designs of the Fauves and this tendency toward bright coloration occurs not only in his early student work but in his prints and portraits of the seventies and eighties.
The Metropolitan Museum of Art

movements toward the present era. His sixties work in the Factory evoked many references to the early avant-garde in the United States championed in the famous Armory Show of 1913. Alfred Stieglitz had an informal salon at 291 in New York to perpetuate a dialogue about the value of modern art. Warhol tried to create his own personal avant-garde world at the Factory. The first critic to perceive early rumblings of other avant-garde movements in Warhol's work was Rainer Crone who was a German PhD student in the sixties and saw a deeper purpose in Warhol's supposedly superficial art. He was also one of the first critics to refer to Warhol's work and painting style as primitive. He wrote, "these paintings in particular were executed in a style often referred to as primitive and naïve."[21] He explored the works of Warhol as similar to the delicate and evocative line work of Henri Matisse. Matisse had an expressive flare for attractive compositions, vibrant colors, and beautiful interiors. He was obsessed with bright colors and had managed to make the Fauves one of the first protest movements of the twentieth century, arguing for a new brighter art. Similarly, Matisse was a technician and knew that new brighter formulations of color, the growth of acrylic pigments, and the use of

brighter materials in oil shades were allowing brighter colors to be captured on the canvas, in cutouts, and elsewhere. Brighter colors were a technological advancement in his time, and by Warhol's era, the bright glossy paper and printing style allowed a new level of light, bright color, and sheen to enhance newspaper and magazine art.

Like Matisse, Warhol was deeply concerned with decoration and decorative content. It is not so much that there are people in a scene doing something, for Warhol it is often important that they are pretty decorative people doing something in the scene. Matisse's dancers are marked by a nearly Asian quality and a rich ovular line that paints them as dancing and jovial but not fussing or fretting. In many of his paintings, there is a pleasant kitchen or room scene and the outdoors or flowers are prominently displayed to add to the décor of the room. People are decorative and characters and objects are arranged in space to make a statement about a surreal location of things in a field of planes. Later Matisse's cutouts become even more abstract and the line quality of Matisse's and Warhol's work share similarities in direction, playfulness, and texture. Crone indicates that Warhol's attempt at delicacy is more a product of decoration, whereas Matisse draws simply from nature. He writes that, "Matisse's drawing looks if it was prepared from nature, whereas Warhol's appears to have been borrowed from a photograph in a fashion journal."[22]

Despite having different origins and Warhol having greater exposure to contemporary fashion journals, both artists tend to frame the female figure with a minimum of lines and elegant economical compositions. Neither artist seeks to draw the entire details of the subject but suggests the subject in an impressionistic way through a few lines, lots of white space, and an outline of the person. Warhol's technique may be from magazine illustration where there is a tendency to crowd every inch out to the margins with images to continually sell products. However, Warhol's tendency to reign in overly detailed depiction shows he is fighting the tendency to make crowded designs to "fill" the page. At the same time, Warhol's figures seem to be more whimsical, more conscious of an audience, and appear often to be staring back at the observer. It is as if the figures require approval from the magazine audience to validate their existence. Matisse's figures require no reassurance to indicate their arrival. In fact, his later drawings and cutouts and his 1947 book, *Jazz*, explained in the printed book medium that the characters are alive, engaged, and are virtually leaping from the medium. Both Warhol and Matisse also shared an affinity for folk and religious art, and near the end, Matisse did a paper cutout stained glass window and Warhol attacked a version of Leonardo Da Vinci's *The Last Supper*.

BEN SHAHN

Ben Shahn was an artist like Warhol who also worked regularly in the commercial world. However, the two represented different sensibilities. While Shahn responded to social conditions by creating work to reflect the needs and problems of the working American, Warhol, himself a strong working person in the art community, feared making any commentary that could be construed as negative and might impact sales. In her *Ben Shahn New Deal Artist in a Cold War 1947–1954*, Frances Pohl called him, "an artist that had emerged as the defender of socially relevant content, and as the Champion of the poor and oppressed."[23] While Warhol manifested little of Shahn's social concern, the two artists drew in a similar slightly abstracted way with large eyed, child-like, figures. Shahn's work delved into social issues. He made posters urging voters to vote to avoid losing their rights. He was equally comfortable with fine art style and posters and graphic media for contemporary causes. Like Warhol, he had an interest in printing and spent much of his career working in the realm of graphics. During World War II, he worked from the War information Office, but his posters lacked genuine jingoistic flare, so few of his designs were used. Shahn was devoted to the pursuit of peace, and though he was willing to work for American causes, he was not enthusiastic about encouraging killing and death. Many of his paintings reflect the use of graphic techniques and printing techniques. Like Warhol, he was also a photographer, and many of his paintings were inspired by his photos.

WARHOL AND THE KITSCH

While Warhol was responsible for a wide array of delightful colorful designs in fashion magazines of the fifties and sixties, Warhol also had clear historical referents that informed his work. He possessed a strong historical affinity to the kitsch. Kitsch can be defined as a work that possesses low quality or stems from an artistic tradition that has succumbed to parody or over-repetition and has been weighed down by excessive copying and exhaustion and extreme stylization. It might be popular or it may have once been popular, but the original antecedents seem to have disappeared from the original source and all that is left is the inferior copy and its inferior elements. Often the work is received by the uneducated classes as a form of art, but their evaluation of it is uninformed and leads to the dissemination of more inferior craftsmanship. Obviously such definitions of kitsch are rooted in issues of elitism and class and cultural values, but Warhol in his use of cherubs and angels and children and pets seems to actively court the term in his work of the fifties. In his fore-

word to a group of drawings by Warhol, titled *Andy Warhol Fashion*, Simon Doonan wrote that, "Andy loved flowers. And Ladies shoes. And drag queens and shopping and Russell Wright China and Florine Stettheimer and Carmen Miranda and gossiping on the phone and American culture and Liz and Marilyn and cookie jars and flirty boys and naughty girls."[24] Warhol enjoyed camp as a way to ridicule things that already appeared ridiculous. Warhol probably feared that his work in shoe illustration might be regarded as kitsch, but he stepped away from the work and transformed his love of factory-produced objects into objects of art. There is an added dimension to kitsch which is something tacky that also causes camp delight and glee in certain audiences, and Warhol due to his poor genesis, his exposure to good and bad art, and his predilection for camp and camp humor found in kitsch works great delight, playfulness, and fun. *The New Yorker* reported that abstract expressionist Mark Rothko described his paintings as being about, "tragedy, ecsta[s]y, doom and so on," in 1956. There were reasons why Warhol was attracted to kitsch. It sounded less gloomy.

Warhol's commercial work in the fifties delighted in kitsch. He lavished attractive bright colors on commissions of whimsical figures of cupids and cats and dogs and butterflies and flowers. In the little overview of Warhol's commissioned work titled *Andy Warhol Drawings*, Christian Demilly remarks that it was through commercial work that Warhol discovered his style, saying, "paradoxically, however, it is in these commissioned works that Warhol finds his style and manifests his imagination. Under these constraints he felt free. He adored projects in which the client could say yes or no, or might demand changes. He enjoyed the feeling that he was merely executing a task."[25] Kitsch thrives on the sense of fun and frivolity. It presents a sense of delight and produces a sense of gaiety. For Warhol who had grown up in the dark dank confines of industrial Pittsburgh, Pennsylvania, being able to produce works that could stimulate delight and charm and laughter must have seemed like a welcome relief.

By 1958 he was experimenting creating lithographed books of his own whimsical work. His little twenty-page print book, *The Bottom of My Garden* offered angels, chubby little putti playing in the garden and frolicking. There are angels lounging and resting, and decorative handwritten titles and dialogue boxes. In one frame two chubby little angels hold up a flower. In another two winged angels nervously are perched on a flower looking at each other. In another, three angels are being mounted by an angel in a hat. In another eight blue-winged angels are dancing in a circle. In another a winged angel wearing a cape is carrying a cat in a bag with the caption, "do you see my little pussy?" The end graphic has two winged angels hugging while a third turns its buttocks to us. The butt has printed on the butt, "The End."

Warhol enjoyed humor, and his privately published little books for friends and clients were meant to delight an audience that wanted charm, decoration, and humor. Warhol's kitsch work was created for simple enjoyment and refused to conform to the standards and interests of high art.

WARHOL AND THE ROCOCO

Many of the aspects of Warhol's kitsch work drift into the rococo style. A short-lived highly ornamented style of art tied to the baroque, rococo style was popular in the middle of eighteenth century and would sacrifice coherence, complex subject matter, and social commentary for the values of decoration, bright coloration, and an affirmation of the ruling elites of France during the era. However, although Warhol could turn to less serious art practices to entertain his close friends, he did nurture an interest in past art forms, and a favorite format that he investigated frequently was the highly ornamental style of French art known as rococo. Widely derided by art critics as being derived from the excesses of an effete French ruling class, it has often been described as, "in the eyes of many, entirely decadent and self-serving . . . commissioned by the same powerful aristocratic French families who were seen as suppressors of the peoples' freedom. It's abundant extravagance was interpreted as a reflection of its patrons' self-aggrandizement."[26] This eighteenth-century format did have defenders and recent scholars find it more idealistic and nature serving than self-promoting. This era was often censured for being light, decorative, erotic, self-congratulatory, and totally frivolous painting of an elite enfeebled aristocratic class that came of age just in time to have their heads lopped off during the French revolution. However in recent years, the reputation of the rococo has been rehabilitated as a means of portraying a break from the heavy neoclassical leanings of the French Academy and the highly academic style of painting that left little room for expression or the people. Rococo painting expressed a sense of joy, of nature and of the natural pleasures of life, frolicking nudity, food, love, and simple pleasures such as walking, communing with nature, being with family and loved ones, and eating with friends and enjoying good stimulating conversation. In a book on the rococo, Watteau and his successors are described as painter(s) illustrating, "a noticeable relaxation—art reacted to it with intimate, decorative and erotic motifs and mythological scenes. The pleasures of the flesh celebrated in his pastoral pieces were perhaps really a glorification of true love . . . they portrayed the most hedonistic joys of life."[27]

Perhaps the most famous of the rococo paintings is Jean-Honoré Fragonard's *The Swing* that features a woman pushed by a servant on a swing

Figure 2.2. Warhol's work of the fifties benefited from his keen understanding of the playful, decorative style of the French artists of the eighteenth century. Rococo art favored decorative scenes, romance, and pastel colors. The style worked brilliantly in the decorative post-war environment of Madison Avenue advertising.
The Metropolitan Museum of Art

and her dress flies up, exposing her to a suitor sitting on the ground beneath the swing and simultaneously she kicks off a shoe. The picture suggests the sumptuous pleasures of court life but also reflects the simple pleasures of love and romance. Similarly, the picture illustrates the power of decorative pastels of blue and green and pink. Flowers and nature adorn the scene, and there is nothing ugly or unattractive in all the people. It is a picture of beauty and love and adoration.

Warhol's *At the Bottom of My Garden* takes a similar tack. Crone explains that Warhol's *At the Bottom of My Garden* is directly related to drawings by Jacques Stella's *Les Leux et plaisirs de l'enfance*, an important book from 1657 describing the history of games for children. Crone writes, "Warhol has taken a number of scenes from this book, and in some cases transferred them directly using the blotted line method."[28] However, despite Crone's description of Warhol deriving ideas from a seventeenth-century baroque manuscript, he does not explore Warhol's seemingly lifelong fascination with the rococo period and his ability to frame many later works within this fanciful frivolous and attractive era. Warhol exhibits a continuous interest in this playful, folkish, and less serious art through his use of color, his line drawing, his development and continual use of caricature, and his interest in light decorative scenography.

Warhol shaped many of his portraits as rococo works, using bright blues, greens, pink, and orange colors. His advertising portfolio series from 1985 used bright colors and renditions of ads filtered through deeply saturated colors. Further examples of a rococo interest in decoration, bright colors, and playful activity are active in much of his work. The Flowers series from 1964 and 1970 show a series of prints of flowers that are in bright and saturated colors. They are unobtrusively decorative. There is little hidden subtext of message in them. They reflect a simple joy of living within nature. People might not see the content of Warhol's work as reflecting the exact same content of rococo stuff. Rococo art has many images of nature and forested environments. The people are middle class or aristocrats. Their pursuits are walks in the park, swinging on a swing, or meeting for a brief love encounter. But in works like *At the Bottom of My Garden*, Warhol shows a similar indulgence in the themes of pleasure, fun, joyful, and light park-like environments. Other work may seem far afield from that, but taken as following the program of rococo art, to be delightful, light and decorative, Warhol's work can be seen to be in line with those objectives.

His 1953 portfolio collection of twenty-five lithographed drawings titled *Love Is a Pink Cake*, uses a clever punny series of drawings around the theme of love. Foremost in the collection is a series of drawing that derives largely from eighteenth- and nineteenth-century-style images. The first frame is a

caricature of a putti reminiscent of the angel figures from *In the Bottom of My Garden* collection from 1955. The angel stands majestically like a cool and classical renaissance figure, but it is so pretty and decorative that it resembles angels from rococo art. The angel seems to be turning the page of the book to invite us in. He or she is of undisclosed gender with a small tuft of genital hair to keep the angel's sexuality mysterious. The angel is winged attractively, and the figure has the blotted line technique with wavy hair and a garland of some sort and some form of headdress or helmet. Why the term "love is a pink cake?" Perhaps, because in Warhol's eyes love is luscious, attractive, tasty, and a wonderful surprise. The plates are a series of commentaries on love starting with a humorous meeting of George Sand and Frédéric Chopin in which Chopin tries to grab her hand, but in it she holds a cigar that can burn him. A second frame also deriving from the eighteenth-century-themed view of love shows a love scene between Jean-Jacques Rousseau and his wife. A third is a caricature of Napoleon Bonaparte. Napoleon is comically portrayed as loving Josephine, but he never gave the girl his heart, and Warhol concludes, "such a man was Bonapart."[29] He ponders a man seducing a maid, Desdemona and Othello, Elizabeth and Sir Walter Raleigh, Anthony and Cleopatra, Catherine the Great, Oscar Wilde and a younger man, Daphne and Apollo, and three more untexted caricatures. However, this attractive and pretty set of images ends with the story of Daphne and Apollo. In mythology the story is striking for its tale of frustrated love. Daphne was a devotee of Apollo's sister Artemis, the goddess of the hunt, and she neither craved nor wished to be married but instead wished to pursue the woodland pleasures of hunting and living in nature. But Eros had smitten Apollo, and he chased her and pursued her until she could run no further. To save herself from being sacrificed to the aggressive god, she prayed to her father, Peneus, to transform her to something to avoid the fate of being Apollo's whore. To this wish, he complied and turned Daphne into the laurel tree and Apollo sated by his worship of the girl that had become nature, pledged to keep her sacred, and made sure that she would bloom eternal as the evergreen laurel tree. Something about these stories not only points to Warhol's own sexuality and developing gay identity; it also refers to the changing sexual revolution arriving in the United States. For Warhol, the story of the odd boy raised by Oscar Wilde calls into question his revelation in court that he had had an affair with a young nobleman. But more striking is the story of Apollo and Daphne, suggesting that Warhol knew he would never find happiness or security in a relationship with a gay man and that his life would be a constant task like Apollo of worshipping the beautiful thing that does not want him back and always stands remotely at a distance. In a larger sense, this metaphor may stand as a metaphor for the impending sexual revolution occasioned by the

birth control pill, the growing economic and social power of women, and the change of how advertising reaches and fetes women as customers. Women now have growing economic clout and the ability to make choices about mates and birthing practices that were often subscribed to them by society. We tend to think that the media exists outside the economic system, but actually media and economics are intimately related, particularly in the messages they convey and prepare for a public's consumption. Christin Mamiya's *Pop Art and Consumer Culture* explains that, "economically the media exist because of and for advertising . . . the dependence of the media on advertising for revenue created a problematic situation in the postwar period because of the unbiased image the media were trying to project, especially in terms of their function as disseminators of news and information."[30] Artists like Warhol understood the relationship between their work and the demographics of a female audience that wished to be treated as consciously empowered and liberated figures able to massage society for their own ends and goals. Not only did Warhol see this played out in the society of New York where strong women were rising, but he also observed it in his role as serving the publicity machines that were sending these messages to new America. Like many artists, Warhol learned to assess his patrons and their needs, and he was more than happy to support that audience and their needs if it helped him in his quest for wealth and success. As the decades progressed, Warhol grew beyond working to define women and their position to being a siren for an emerging youth culture of which he was a part and a culture that was threatening the establishment culture that supported his work. Warhol became emboldened by not only his art, but also by his ability to speak to and define ideas of presentation and the visual world for a generation of people that had less ideas about visual stereotypes and practices than Warhol did. He realized that not only did they constitute a new market, but in this realm he could also play a leadership role, guiding a pop revolution.

Chapter Three

Warhol: The Pop Artist

Cavalier: What is the future of Pop Art?
Warhol: It's finished.[1]

When most people think of Andy Warhol, they think of pop art. But Maria Pachon immediately dispels that illusion in her 2001 text on Warhol, aptly titled "Andy Warhol: More than a Pop Artist."[2] Pachon selects a radically different set of Warhol's work to discuss, and she explains ideas that have often escaped American critics, such as that, "Warhol was obsessed by concreteness, the material world, that is visible and tangible objects."[3] Further, her selection of images denotes a distinctly different artist in orientation. According to Pachon, Warhol is not the artist of a "quintessential paradigm of the frivolousness and banality of that period."[4] No for her, something far deeper and darker emerges in the work of Warhol, an art of decay and disaster.

Pachon shows a disturbing early painting of Warhol's borrowing an illustration from a medical manual of a male hernia. While comical and clearly meant to shock, the drawing is disturbing in that it shows the male sexual apparatus. Still more worrisome is that the portrait portrays the pathology of a hernia, and it clearly suggests darker aspects of the human body. Further, a quarter of the images Pachon provides are images of death or dead people. Pachon makes clear the relationship between Warhol and grotesque images, images that suggest uncanny otherworldly objects, and images that suggest that Warhol is using images to project a view of a tangible concrete world and something intangible that lies just out of reach. As she said at the start of her essay, Warhol was more than a pop artist, but pop expressed everything going on about the artist, including movements that were happening at the same time, movements that came before, and movements that appeared later.

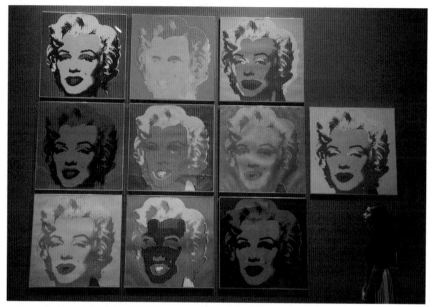

**Figure 3.1. Warhol completed his series of Marilyn prints months after the actress'
suicide, posing the question that rather than a vapid fan paean, the print portraits were
a cautionary tale about he allure of fame and glamour.**
"Getty Images News / Carl Court / Staff"

If Warhol wasn't a pop artist, he may have been a prophet of everything to
come in the late twentieth century.

ABSTRACT EXPRESSIONISM

Warhol was a product of the post–World War II boom. World War II cre-
ated a great bounty for American material society. Much of the world had
been ravaged by the war, but the United States, largely unscathed, was the
breadbox of world markets and profited from its position as the West's most
productive country. However, socially the war had planted seeds of mis-
trust. The Soviets used the opportunity of the war to solidify their hold over
Eastern Europe, and in the United States, the investigation of communists in
Hollywood had led to a climate of fear and anxiety. Difference whether it
was ethnic, sexual, social, religious, or aesthetic was decried. Women, gays,
comic books, teens, rock music, films, and filmmakers were all under siege
either by subtle conformity or more extreme and obvious forms of outright
repression and prosecution. It was hard to find a popular style of art in such
an environment. Anything could be construed as subversive from Marlon
Brando to superhero comics to *MAD magazine.*

Clement Greenburg, a critic and populist of the emerging postwar style of abstract expressionism lauded it saying, "in tapping subjective experience to arrive at their art, the artists employed improvisation or, as they often put it, 'direct painting.' Even Barnett Newman, whose painting was less improvisational than that of his fellow artists, insisted, 'I am an intuitive painter, a direct painter. I have never worked from sketches, never planned a painting, never 'thought out' a painting. . . . I work only out of high passion.'"[5] Abstract expressionism with its apolitical, psychiatric, and emotionalist stance was politically safe, significantly cerebral, and ambiguously formless enough to amass a large following. The abstract expressionists were opposed to realistic form and worked to create original and novel shapes that they claimed arrived from their psyche. Their painting was mostly a process of looking inside the artist, his thoughts, influences, and feelings and drawing painting from this inner world. Mystical, mysterious, and totally individual, the abstract expressionists also received cover from charges that their painting was subversive or in some way corrupting. How could it be? It came purely from the inner workings of the individual mind. American art had moved from regional influences to the ideas of European abstraction and geometry in its surge of experimentalism. A group influenced by aboriginal art were dubbed the mythmakers, and they were profoundly influenced by primitive and tribal formats. But even this group, more interested in an art that had formal antecedents, depended strongly on an emotional response to events. Sandler wrote that, "although the Mythmakers felt a bond with 'primitive' peoples because of shared feelings of terror and fear, they did not think that they had to reuse aboriginal images, although occasionally they did. On the whole, they employed improvisation to invent personal images, symbols, and signs."[6]

Finally, a highly abstract form of painting that featured color, brush strokes, and less formal images called *Field Painting* rose in popularity, and the abstract expressionists embraced a sort of early American individualism and libertarian ideal derived from Ralph Waldo Emerson who wrote, "nothing is at last sacred but the integrity of our own mind. . . . What I must do is all that concerns me, not what the people think."[7] Over time artists like Jackson Pollock adopted a field painting cum gestural painting improvisational approach that focused on the feelings and internal reactions of the artist. The painting was intellectual, dramatic, powerful, and personal. But for people like Warhol that approach to art left little of interest. Warhol had been trained to paint things, objects, and reality. He understood abstraction, but what abstract thing could he paint that would stand out and make him noticed?

Warhol wasn't alone. For some, particularly in Europe, abstract expressionism lacked significant images, a relationship to the current scene, and a disregard for a rising modernity and technological innovation. For many critics it was a style cocooned in time and in the precepts of psychology and personal symbology. For many it rejected the world. Abstract expressionism

was fine if you lived in a Zen monastery on a mountain top, but if you didn't, it didn't matter. It was a type of art that left out the people, and Warhol wanted people to notice him and his art.

THE RISE OF POP: BRIT-POP

A think tank that dubbed themselves the Independent Group were meeting in London seeking to understand the changes arriving in society that were altering the conditions of contemporary life and by extension the arts and media. They were architects, teachers, painters, and media specialists, and they wanted to frame the experience they saw all around them in a new bonding philosophy. By 1956, they had organized an exhibition that sought to express the divergent streams that were creating a new modern society, it was titled, *This Is Tomorrow.*

The genesis for the exhibition and much of what was arising in British art circles was a strange curiosity and interest in the way American society was developing in the fifties. The British were intensely interested in how this new culture was manifesting itself in American advertising, and they were studying it with rapt enthusiasm. This new excitement had not manifested itself in England where deprivation and shortages plagued the economy. Yet what they were studying in the United States seemed impressive. They were seeing changes wrought in global culture, global images, and a change in art interests arising in the American sphere. Richard Hamilton one of the early leading figures in British pop art and one of the first pop artists to make a sustained and effective series of collages and images based on these pop concepts had discussed the ideas with other members of the Independent Group. Hamilton corresponded with members Peter and Allison Smithson in early 1957, and Hamilton synthesized what he imagined to be the salient characteristics of the new movement. He wrote that, "pop art is: popular . . . transient, expendable, low cost, mass produced, young . . . witty, sexy, gimmicky, glamorous, big business."[8] Pop's mantra seemed to be diametrically opposed to the insular, private, personal, and aesthetic closure of abstract expressionism, an art form that rarely looked outside the self. Pop by comparison deeply embraced the world around it, often to the exclusion of there being anything inside.

Hamilton's description explained the basic territory of pop but not how society arrived at these characteristics. In the United States, the rapid move to a consumer society had redirected productive energy focused on production of goods for a world market to the more insular pursuit of what to consume or a consumption economy. The emphasis moved from what Americans could make for a world market to what they could consume. This might cast Ameri-

can culture as generally hedonistic, but if you consider the awful effects of the depression, America was really in recovery from loss. The spirit of consumption was to console a society after nearly two decades of extreme sacrifice during a worldwide depression and a worldwide conflict. But Hamilton's diagnosis went further and explained some fifties' phenomenon that were lost to American critics. Pop was transient. Many later critics saw pop as a static movement fixed in time. Hamilton was keenly aware that pop qualities might transfer, wane, and change over time. This did not mean that pop ceased to be, but that pop reacted to the world around it. More so than abstract expressionism, which held that individual expression was paramount, pop subscribed to the notion that art reflected what was happening in the culture around it. Thus, pop is a reflexive expression of energy and culture. Think of pop as a dynamic form, and one finds that pop can still be a vibrant style. Pop is a highly adaptive style. Pop music is still pop; however, the basis has moved from big band to rock to country to rap and other forms. Pop as a format is dependent on things going on around it. Similarly in art, pop that focused on everyday items in the sixties might still focus on the everyday, only today the objects may be different. For Hamilton, it was attractive ads of furniture and décor, for Warhol food and household items, and today, for Jeff Koons it is balloon animals and Michael Jackson. Pop, if it still exists, has become reflexive and in programming like *Stranger Things*, pop's tropes, and visual displays of eighties' culture were interrogated in the same way Warhol scrutinized sixties' social practice. Directors like Quentin Tarantino use it in films like *Once Upon a Time in Hollywood* to channel images of the late sixties into a modern film about the power and value of classic Hollywood themes and ideas. Warhol's work evolved with pop, and much of his pop art of later decades may have been mischaracterized because pop itself had evolved new concerns.

Richard Hamilton's *Just What Is It That Makes Today's Homes, So Different, So Appealing?* was a lightning rod for the pop movement. This, one-foot collage arrived as the poster and focus for the groundbreaking exhibit, *This Is Tomorrow* at the Whitechapel Gallery in 1956. This was the first show acknowledged as exploring the concept of pop art and culture. Hamilton and members of a nascent theory and practice group called The Independent Group understood that the new world of pop art would be quick, young, and ever-changing and would embrace multiple media with the goal of starting something new. Warhol, while thousands of miles away in New York, was singularly in keeping with this agenda. He wanted fame and fortune and was surrounded by the icons of the industrial and media world and saw that his talent and skill could propel him into that realm. In Britain, the Independent Group were interested in a cross-disciplinary axis of different groups working together to achieve a new form of art.

This Is Tomorrow assembled twelve different groups that represented three to four artists per cell. Each group had a location in the Whitechapel Gallery to display their aspects of tomorrow. The plan was for writers, theorists, architects, painters, and sculptors to work together to form a corporate vision of the new image universe. Stonard writes that the *This Is Tomorrow* exhibit was a motley crew of artists. He explains, "eleven teams of three or four individuals were formed, each with the task of constructing a display for the exhibition . . . on ideas that enabled cross disciplinary discussion between architects, artists, and philosophers."[9] The British approach was analytical, using nonprofit resources and teams that focused on constructivism in their designs and displays. Alistair Sooke writes that people like Hamilton were interested in all aspects of culture, and they believed pop could be weaved from the different elements of art and design all around us. He wrote that, "the sort of thing they talked about at the ICA (Institute of Contemporary Art) encompassed a wide range of topics, from the aesthetics of aircraft and car design and the notion of proportion to science fiction, Hollywood cinema, fashion magazines, and the 'magical' strategies of advertising."[10] The Independent Group's insistence on the contemporary matched Warhol's mandate that art must be about now.

A centerpiece was Hamilton's bright and funny collage, "*Just What Is It That Makes Today's Homes, So Different, So Appealing?*" The title reads like ad copy. The images reflect the world of American advertising and the layout explored not just the content but the form of such an advertisement. It is a room design and could easily be a design from an attractive fashion magazine of the era but for its multiplicity of images. The technique is collage or paste-up and replicates the way layout was done in the era. Simple images were cut out and waxed and arranged on a grid with art directors and designers positioning pages on Bristol board backing to see where items would fit best. The ceiling is a celestial body, maybe the Earth or perhaps the moon above us. To the left there is a beautiful young woman using a modern vacuum cleaner to vacuum wall-to-wall carpet stairs. In the lower right corner, there is a red vinyl sofa with a recent newspaper strewn across the arm. On the floor sits the latest model of a home reel-to-reel tape recorder complete in a portable box. On the left is another vinyl couch, this one with an attractive model wearing a lamp shade and caressing her breasts adorned with diamond pasties. Behind her is a plant with a large twenty-five-inch screen television. On a coffee table there is a packaged canned ham still in the tin and cups of tea situated on the table. On the wall there is a portrait of a nineteenth-century figure next to a large framed poster of a comic book. In particular, the comic book cover is a Jack Kirby drawing from the forties representing the new style of romance comics for women, this one, titled *Young Romance*, and in the cover story

described as, "True Love," a man is pleading with a woman while another character grins as he regards the scene. At center there is a black and white carpet, an end table, a lamp with a giant Ford car symbol stenciled, another vinyl couch, a poster or window looking out on a movie theatre showing Warner Brothers 1927 talkie smash, *The Jazz Singer*. Just past center there is a figure from a body building advertisement buffed, flexing, and posing his physique and holding a candy Tootsie Pop. The Tootsie Pop illustrates the first time the word *pop* was used in connection with this new form of popular art and design. It is as if Hamilton created a template for Warhol. Nothing is altered. All the images are appropriated and the collage like Warhol's copies of ads are not transformed but allowed to speak for themselves. What distinguishes Hamilton's work is his masterful combination of so many elements into one elegant frame where the contemporary presides over the design. The world of the modern becomes the subject. Warhol and Hamilton want us to look at the physical items we encounter everyday only in a more focused, analytical, and organized fashion.

British and European approaches to pop were seen as a critical vocabulary in which pop could be used to designate new approaches to building, new ideas for modernist design, and new ways of perceiving art. A group called Banham Archigram proposed a series of drawings for a new style of architecture called the *plugin city*. The plugin city was thought to contain structures that could be assembled for fast and easy transport so that human communities could be assembled and disassembled at various locations. Anyplace could be home. Alison and Peter Smithson discerned a new hyper-Bauhuas style of severe architecture they termed *brutalism*. Hal Foster described the rise of what he calls the "pinboard aesthetic,"[11] an older version of Pinterest culture where composers working in the pop style would compile collages based on a series of images they would compile from images cut out from magazines in newspapers. Today the collaging process might be done electronically where people select images they have found online and place them in a collection, but at the end of the fifties, the process of collecting images was largely an analogue process. Warhol regularly read the art journals in his field and likely had seen the British experiments in pop where compositing of different materials were developing modern collages focused on magazines, newspapers, and other images.

An early innovator and a possible guide to Warhol may have been Peter Blake, one of the early pop artists interested in sampling a variety of images for pop ideas. His 1961 *Self Portrait with Badges* showed the juxtaposition of Blake, the saturnine artist celebrating the collision of British and American cultural ideals. Blake stands in the self-portrait, in a run down English garden wearing a jean jacket, tennis shoes, and blue jeans with rolled up cuffs. All of

these clothing choices reflect his love for the hip American rebel culture, but his selection of badges shows a more mixed parentage of images. There are badges for Boy Scouts, there is a magazine featuring Elvis, there are union jacks and stars and stripes, and images commemorating World War I, one of Blake's favorite icons. He delves back into the time of Edwardian England for his memorable album cover for the Beatles' *Sgt. Pepper* album where the Beatles salute their favorite idols on the cover. The irony of idols celebrating idols was not lost on Blake who placed images of wax Madam Tussaud's figures of the Beatles next to the group live. Blake crammed more images in the gatefold sleeve, including badges and stickers reflecting colorful images of early twentieth century British nostalgia and band concert memorabilia. The Beatles took the idea of a turn-of-the-century marching band as a starting point for the concept of the album.

The British approach to pop was founded on pulling out a wide range of examples and illustrating the changes that industrialization and consumer economics was creating in society. Their analysis was nearly numerical in its way of using objects to explore the transitions in society and like scientists they wished to uncover the evidence of society's change. Foster writes that they were seeking, "a spatial compilation of found figures, commodities, and emblems that is 'tabular as well as pictorial.'"[12] For the pop artists, anything that was new and commented on the society currently was fair game, and most importantly, one did not have to put their own personal stamp on the work for it to make a statement. In fact, for the pop artists it was better if technology and the media were the stars and the artist was merely reporting on the form. Mario Amaya wrote that,

> where as the Abstract Expressionist of a previous generation relied on his sub-conscious and his alienation from a hostile society to demonstrate a personal gesture on the canvas-arena, the new artist relies for visual and emotional impact on widely accepted trivia of the commonplace world, as seen and under-stood through movies, television, comic strips, newspapers, girlie magazines, glossies, high fashion, car styling, billboards, and other forms of advertising.[13]

For the Independent Group, the pop artists in America, and Warhol, the trivial was the newly relevant material for fine art. In pop, the trivial became the spectacular.

Warhol quickly saw the opportunity to enter the art world through the design of pop images that replicated the world that appeared in advertising and pop literature. It could be argued that his first pop images were made right after he arrived in New York in 1949, but really he began producing canvases that employed the subject matter and technique of the pop advertising world around 1960. In 1961, he exhibited the first of a series of art works associated

with comic books. His Superman image shows a panel from *Lois Lane*, issue 24 from April 1961. Warhol was using not only comics but recent contemporary comics, and the cover might have had more camp value than the featured sequence, which shows Superman using super breath to blow out a fire. The work that Warhol chose not to portray is perhaps more luridly popular. The actual cover is an amusing piece of midcentury culture. Lois is appearing in front of a television camera participating in a game show titled *People Are Wacky*. The left side of the panel features a room-sized computer, and the moderator behind a microphone is telling Lois that the computer has picked the perfect husband for her. Hidden behind a partition is Clark Kent while Lois smiles and dreams in a thought balloon of Superman. The audience in the studio shares our audience vantage point. The comic book cover is clever and knowing and shares a bond with the comic-reading audience. It is a smart comic book saturated with subtextual meanings for its young and impressionable audience. However, Warhol chose a much less coded image and imbued it with more coding by blowing it up and making it, rather than a passing action panel, a central focus on his painting. Thus, the most trivial of the trivial is emphasized and placed in our field of vision to make us reflect on the trivial elements and not the more elevated messages like that same issue's cover.

Warhol followed the British vision of pop that was art for display and functional purposes and included the Superman canvas with four other canvases that featured either comic strips or cheap newspaper/magazine ads recreated in large canvas sizes. His series of five paintings adorned the Bonwit Teller store on Fifth Avenue in April 1961. Soon after, Warhol saw Roy Lichtenstein's versions of comic strip panels and stopped painting them. He argued that Lichtenstein did it better than he did, so he looked for other subject matter. Warhol was immediately associated with the movement of pop and made a variety of different pop paintings. Critics quickly perceived this new era contrasted with the severe asceticism of abstract expressionism. It was new, it was fun, and it was (at least superficially) easy to understand. Steve Madoff wrote that, "it projected an air of intoxication; a sense that here in New York, on the rising elation of the Kennedy years (and the in the nostalgia for that elation after the president's assassination) a world of plain sharply colored objects, of Brillo Boxes and billboards, spelled out the youthful buoyancy of America's unchecked global climb."[14]

Warhol quickly produced a remarkable series of paintings using the techniques from graphic art and printing he had learned in the advertising world. After ten years of mass producing lots of images, working with a host of assistants, and producing thousands of pieces on commission, the trained and primed artist was happy to produce a wide range of objects. He produced the *32 Campbell's Soup Cans* series using casein and metallic paints on canvas.

The objects were arranged like items on a supermarket rack and shoppers or consumers could pick them up just like real cans of soup and carry them off. He turned his enthusiasm for film stars and glamorous images into the diptych of Marilyn Monroe just months after the actress' suicide. On one side the images are brightly painted in vibrant pink, green, yellow, and orange but on the left the printing process begins to decline and the images are monotone black and white with smudging and eroding ink values having the Marilyn image fade out by the far right prints of the image.

Warhol's 1963 images include the black and white printed *Triple Elvis* where Elvis from one of his western films, *Flaming Star*, is drawing his gun in three different prints all capturing the same moment in repetition. He also covered the image of Elizabeth Taylor in that year. Taylor was already a famous actress, remarried several times, an Oscar winner, and a significant celebrity. She was in the news again for the long and bloated filming of the epic *Cleopatra* with Rex Harrison and Richard Burton. Rumors abounded that Burton and Taylor were having an affair, and Taylor had major health problems and almost died during the production. Warhol chose the star for her massive notoriety. She was famous for popular reasons and great ability as an actress but also famous for circumstances beyond her control that rendered her a celebrity. Although beautiful, she also suffered from an image of tragedy. She had lost a husband in a plane crash. She had been desperately ill. She was someone who was photogenic but tortured by constant attention and media scrutiny. She fed off the press and the press fed off of her image. Warhol understood this deeply symbiotic cross-nurturing of celebrity images that were devoured by the press. Some of the images of Taylor were shown in conjunction with the Elvis images at the Fergus Gallery, one of the first places that Warhol was able to show and sell his work. But Warhol's approach to the trivial, the common and the celebrated was anything but conventional. Warhol's approach to the pop subject was far darker and more complex than critics imagined. Warhol had a secret darker agenda.

WARHOL AND THE GROTESQUE

Although Warhol's work celebrated celebrity, fame, and common products there is a strong undercurrent of the grotesque in Warhol's selection of subjects. Wolfgang Kayser in his *The Grotesque in Art and Literature* comments that the grotesque is often ill-defined but can be thought of as a moment of, "surprise and horror, an agonizing fear in the presence of a world which breaks apart and remains inaccessible."[15] Warhol felt uncomfortable in the world of fine art. He felt like an outsider, and during his era of breaking

through his work portrays the tension of two worlds in conflict. Warhol's private world of iconography was tentatively being shared with a larger and more complicated gallery community. He and the other young pop artists were already staging an assault on the hierarchy of abstract expressionists that had dominated the art scene for nearly twenty years.

Many of Warhol's early works, particularly during the pop period, start to emulate elements of the grotesque. Warhol's Superman image or the early Dick Tracy image, although not horrible, do evoke surprise and suggest a world we cannot easily enter or exit, it is a cartoon universe where the rules are altered. Master detectives, superheroes, and cartoon strip characters live in a world of fantasy and are not subject to the laws of the regular universe. Things in Warhol's world are disproportionate when they should be small they are large. When they should be large they are unusually small. Some of Warhol's Campbell's soup can paintings are six feet tall. He made a set of Last Supper's titled *Sixty Last Suppers* in which DaVinci's painting is shrunken and nearly unrecognizable.

Warhol naturally transforms things, and he expects his audience to decode his own special language. Things that are inanimate become animated while things that should move become stationary. When Warhol made early films, he produced screen tests that were literally nonmoving pictures. Actors and artists were instructed to stay still for minutes at a time. These film portraits had an uncanny and eerie feel to them. Nobody alive would remain that motionless except in the gaze of Warhol's dead camera. At the same time, many of Warhol's actors in the later films, move too much and drift out of focus and out of frame, always marauding. There is something disturbing about the many Campbell's soup cans in Warhol's wall displays of serial portraits of cans. They are there but left unopened as if waiting for an audience to devour them. Warhol's objects inhabit a dead world where the creator no longer exists. The objects are set adrift and lack the agency to move on their own. It as if the everyday objects exist in some postapocalyptic world.

Warhol's work is rarely seen as a special private world but is widely accepted as a reflection of reality. The comment is often made that pop artists reflected the new world all about them. They were fascinated with objects, with technology, with new fashions, and the postwar culture reflected in American advertising. There are many examples of this in pop art. But Warhol always possessed a critical philosophical bent as much as he sought to hide it or avoid it. His choices betray a more critical analysis. His objects are not just a variety of haphazardly arranged products, but a carefully selected set of icons that describe a private world of objects and associations. There is something of a sense that we, the viewers, are intruding on a private and difficult world, something akin to Lewis Carroll's *Alice in Wonderland*, where

the architect has crafted individual rules for existence. Warhol is creating his own special world, an environment in which he controls the rules of time and space.

If we look at Warhol's pop images of the sixties, we can see things like comic images, film stars, celebrities, and products but we also see the objects as critiques of those institutions. Warhol, the permanent loner, unfriended, and uninitiated artist stands apart from the controls and powers of society. He is outside the realm of elite products, fame or popularity, all things that even simple products like Brillo can claim. Brillo may have been a common product, but it achieved massive popularity and market dominance. Warhol's work is not merely an appreciation of such power, although he frames it as such with statements like pop is about liking things. Warhol leaves out that the mechanism of pop is not only to call attention to the popular and like it, but also to perceive the objects as products and people that exert a hegemonic dominance over society, in fact over reality. Warhol's objects make clear a hegemonic order of representation. As Warhol's admits in the amusing *30 Are Better Than One*, people can look at one *Mona Lisa* or they can view a variety of prints for more of the same experience. Warhol takes thirty different prints of the *Mona Lisa* and mounts them on one canvas. His humorous title suggests that if one is good, thirty are better.

Warhol doesn't necessarily set out to frighten us to make us afraid, but he does place a series of images before us that portend dark things and make us reflect on issues of fame, tabloid journalism, and stardom as these issues relate to death and dissolution. Consider the *Marilyn Diptych* made months after the actress' suicide. The bright overaccentuated lipstick is like a morgue shot, where the corpse has been cosmetically altered for the viewing. There is a sense that we are watching the dead Marilyn, not the images from the publicity still or any of the films where she enacts living action, we are seeing the guise of the corpse, something that is postlife. We can reference this because Warhol fades her from the scene in the second print of the diptych where the actress's image fades from black and white to grey to nearly invisible, a spectral figure, a ghost. The methods of the grotesque are not always direct or specific. They are often indirect and referential. It isn't what you see in the haunted house that frightens you, it is what you *don't* see that could be lurking out of sight or reach. The grotesqueries deal with issues of degree, strangeness, and evocation of a mood. If one is in the room with even a Campbell's soup can, an element of surrealistic transportation and can start to arise. S. T. Joshti wrote in *Unutterable Horror* that "many weird writers' emphasis is elsewhere. It is not that they are uninterested in the portrayal of character or of interpersonal interaction, but that their focus is largely upon the psychology of fear as it affects individuals and groups."[16] Warhol con-

stantly lived in fear, not necessarily in fear of the spectral or supernatural, but a fear of the notion of fame, a weariness and stunned state toward adulation and a smitten stunned state toward celebrity.

The technique of ridicule or undercutting a character is not uncommon in satire, parody, and in the grotesque. Edgar Allan Poe undercuts the notion of royalty in his story, "Hop Frog." Russian writer Mikhail Bakhtin writes of the technique of Rabelais, the French writer who used parody and satire in his writings to ridicule the high and to form grotesques from the most exalted of characters. This technique is referred to as the carnivalesque. Thus, characters can exchange places between the high and the low during carnival time. The king can go disguised among the people wearing a masque and the commoner could insult the king through ridicule, theatre, and displays of indecency and get away with it during the carnival period. Bakhtin comments on the way carnival treated the figure of the king. He writes, "in such a system the king is a clown. He is elected by all the people and is mocked by all the people. He is abused and beaten when the time of his reign is over, just as the carnival dummy of winter or of the dying year is mocked, beaten and torn to pieces."[17] For Warhol, it is he that is *carnivalizing* the celebrities and subjecting them to a public bearing by transforming them into puppets, giant prints that satirize and diminish them. A mistake that is commonly made regarding pop is that artists such as Warhol are uncritical in their display of pop images, but pop's mirror to society is often grim and judgmental.

WARHOL, POP, AND THE UNCANNY

Although the work of pop is generally thought to be associated with popular culture, popular media, and popular new techniques of art, there are also aspects of pop and particularly works of Warhol's that participate in the work of the uncanny. We would think that pop would celebrate life and popular aspects of the society that generates attractive consumer items such as Richard Hamilton's collage, *Just What Is It That Makes Today's Homes So Different, So Appealing?* featuring an attractive room of furniture, a vacuum, a muscle man, a Tootsie pop, and a comic book cover. But besides the wonder and joy of commercial items such as Warhol's celebration of universal consumer items like the ubiquitous Campbell's soup can and the Brillo boxes, there is a dark and morbid side to pop that attracts viewers at a different perhaps subconscious level. We have discussed the grotesque and the fact that there can be hidden ugliness and a critical interest in Warhol's choice of subjects. Rather than praising glamour and fame through these works, Warhol might just as easily be interrogating our dependence on stars and the iconography

of fame. His work may be carnivalesque and in some deeper way ridiculing such concepts by highlighting them in massive images of fame, just as the advertising world would feature movie stars on billboards.

In fact, at a conscious level there are darker messages to be read into Warhol's guileless gushing over consumer products. The Campbell's soup can represented his family's attempt at nutrition when funds were inadequate and a poor immigrant family had to be maintained on the skimpiest of food products. Campbell's was the diet of the underserved in capitalist society. Further Brillo boxes or the Brillo pads they contained inside were used for scrubbing and cleaning. In the households of cockroach-infested immigrant families living in ghetto environments, maintaining a clean house while working menial day labor jobs at low wages was difficult. So even at a conscious level, Warhol's pop works were filled with aspects of social commentary.

However, the grotesque and the carnivalesque were techniques at a conscious level. They acted as a form of commentary about the work and its place in society. The uncanny was another aspect of Warhol's work that appeared to address audiences at an unconscious dream level much as the surrealists sought to bypass mental processes by reaching into the unconscious with their images. The uncanny takes pop production to a deeper level and perhaps suggests a more ghoulish aspect to Warhol's productive rituals. Freud wrote of the uncanny in 1919 saying, "The subject of the 'uncanny' is a province of this kind. It undoubtedly belongs to all that is terrible—to all that arouses dread and creeping horror; it is equally certain, too, that the word is not always used in a clearly definable sense, so that it tends to coincide with whatever excites dread."[18] Freud ties the word to things that produce fear but also the notion of familiarity. For example, Freud associates the uncanny with the "unheimlich" or the opposite of the German word, "heimlich" meaning familiar or native to the home. Something that would be "unheimlich" would be something unfamiliar or something not found in the home or something strange or not familiar. Freud reports that in T. A. E. Hoffman's strange love story "The Sandman" there is an example of the uncanny. Freud's vision of this tale explains how Warhol's use of an uncanny image could work, being both literal and evocative simultaneously. In the Hoffman story, our hero Nathaniel falls deeply in love with a girl named Olympia who seems to respond to his poetry readings and plays a beautiful piano. When he goes to her house to ask her hand in marriage he finds two men fighting over her body. She lies on the floor, and Nathaniel is horrified to find, she is not what he thought she was. Hoffman described the event saying, "Nathaniel was stupefied—he had seen only too distinctly that in Olympia's pallid waxed face, there were no eyes, merely black holes in their stead, she was an inanimate puppet."[19] He is horrified to find that the woman he loved was not a real woman at all but

a doll with eyes that could be torn from their bloody sockets and fought over by two alchemists who claimed possession of the large lifelike toy. Of course, the revelation that what he thought was real was merely a clever fiction of life enough to drive Nathaniel mad. Freud sees the loss of eyes as being related to some castration fantasy and fear and ties the story to neuroses and sexual dysfunction, but the story of the uncanny has a double meaning for an artist like Warhol. A representation is merely a picture at a surface level but on reflection the image conjures life where life does not exist. We perform this alchemy when we watch an old motion picture featuring long dead Hollywood stars. The picture reanimates the dead and conjures morbid visions as well as reviving the illusion of youth, beauty, and agency. All are illusory visions of life. Warhol's works often arriving with photo-realistic exactitude are always slightly off reminding us that what we see is no longer alive but a representation of life. Remember Warhol lived with an image of himself as an unattractive person, and the people he envisioned as exemplars of beauty or attractiveness are portrayed subjectively and perhaps satirically. Also, from a business standpoint it might have been difficult for Warhol to discuss his works as critical portraits or critiques of individual people because a good part of his business practice was portraiture in later years. If a subject recognized that their portrait may have been intended as a criticism, it is possible it might have negatively impacted Warhol's business practice.

Can we make the assumption that Warhol participated in some uncanny operation in his art? First, the uncanny and its opposite the campy were playing out in the field of popular culture around the time Warhol was making a leap from commercial art to fine art. *Weird Tales* a publication that featured stories like Hoffman's tale, "The Sandman," regularly had been published through the fifties. Horror writer Robert Bloch in 1950, around the time Warhol arrived in New York had written his version of an uncanny tale, "The Weird Tailor" in which a man fashions a special fabric to bring his son back to life. By mistake the suit is placed on a broken dummy in the tailor's shop named, Hans. When the tailor's wife is threatened by her husband, a mean-spirited and vengeful character, the tailor's suit brings the dummy to life, and Hans, the dummy saves her from the violent tailor. After murdering the tailor, he returns to her saying, "It's alright Anna, I am here, and you and I can be together."[20] Perhaps too much love for an inanimate thing. The story was filmed for the Boris Karloff *Thriller* television series and appeared on NBC in 1961.

All of this suggests that in Warhol's life there was a growing significance of the uncanny perhaps perpetuated by the horrors of World War II, Korea, and the growth of teen-oriented horror movies of the fifties and sixties. It is also significant that the growth of horror had reached a crescendo by 1960 with the arrival of significant entries in that period, William Castle's *House*

on Haunted Hill (1959), Michael Powell's *Peeping Tom* (1960), Hammer Studio's Freudian *Brides of Dracula* (1960), and of course, Hitchcock's Robert Bloch penned opus, *Psycho*. Though Warhol didn't know all particulars of the genre, the iconography of pop and the semblance of the uncanny were prevalent at the time. After a decade of science fiction, the energy of posthuman literature and cinema was directed toward horror and the supernatural. Elements of the uncanny permeated the visual landscape. In fact, it isn't necessarily required that a work aspire to the iconography of the uncanny. The uncanny can exist in works that might unconsciously participate in the uncanny.

In any case, after considering the disturbing energy of the posthuman uncanny image circulating in the popular culture perhaps participating through the media as youth culture, as kitsch culture, or even as camp culture, but there just the same, one sees the potential for images like comic book images of Superman or Dick Tracy or garish hypercolorized versions of Marilyn, Liz, Elvis, or Jackie Kennedy to participate in that sense of the uncanny. These large screen-printed images subtract just enough humanity from their original subjects to render them bloodless or lifeless or even some measure of an automaton. Further, many of the images flirt with death and life. There are many of these images caught between death and life. There are the dark portraits of First Lady, Jaqueline Kennedy; Jackie, of course, caught as the widow on the day of her husband's assassination. Marilyn just died as a victim of suicide, months prior to Warhol's image; Liz, a performer who despite her beauty was always in ill health; and Elvis had experienced a certain sort of death crossing over from rebel, disruptor, popular music icon to a pop family-friendly screen image, the death of threat and agency of a rock instigator.

PERFORMANCE ARTIST

Warhol saw many of the elements of the avant-garde played out at Carnegie Tech. One important aspect of the modern art scene was the influence of a group gestalt. He joined the art club and the dance club and saw the value of group work in creating a new art orthodoxy. While Warhol was in college he read about the art experiments at Black Mountain College with Merce Cunningham, John Cage, and others. He had read about the Bauhaus school in Germany and the attempt to merge arts and crafts manufacturing with mechanical ballets. All around Warhol, art was coming off the canvas and out of the gallery and assuming a new living model. Warhol interacted with film and theatre groups and had done illustrations for *Theatre Crafts* magazine. Warhol, like many of his peers, was innovative in his creation of works and

experimented with a wide range of approaches and materials. Paint, sculpture, and media were all in his mind. Calvin Tomkins's wrote, "the younger generation was also utterly open-minded with regard to the question, 'what is art?' and it was therefore natural for its members to look with increasing reverence in the direction of the most open-minded artists of the century."[21] Many saw Marcel Duchamp, an important artist in the first avant-garde who provoked public attention with readymades, painting, and performances as a guide.

Warhol saw the value of performance as creating another form of art, based in time and space. Warhol and other pop artists were influenced by Duchamp and the Dadaists. The surrealists and Dada artists had a sense of humor and enjoyed making art fun for audiences. Tomkins writes that, "in 1936 Salvador Dali suggested that a London show be publicized by having a girl roam Trafalgar Square with her head enshrubbed in roses."[22] The show was a huge success, bringing in fifteen hundred patrons a day.

Performance art had had famous scandals like Picibia and Satie's Ballet *Relache* in 1924. Dancers danced at the front of the stage in front of a giant display of metal disc sculptures. The audience sang a popular drinking song for students, "the Turnip Vendor." Vignettes were played out. Duchamp and a woman stood at the back of the stage naked as classical models for a depiction of Adam and Eve. Cinema segments were inserted in the center of the play. The second act had more dancing and the show ended with Satie driving around the stage in a mini car with posters proclaiming him the world's greatest musician. Ferdinand Leger described it saying, "Ralache had broken the water tight compartments separating ballet from music hall."[23] In fact, it went further. It disengaged the separation of fine art gallery work, performance, music, and design.

Warhol used his Factory studio in downtown New York as his lab and launching place. In April 1965, Lester Persky, a photographer and advertising figure, hosted a "Fifty Most Beautiful People Party" at the Factory and Hollywood stars (Judy Garland and Montgomery Clift), writers (Tennessee Williams), and dancers (Rudolph Nureyev) attended. Warhol was in the background, but the event made the Factory and Warhol's crew a phenomenon.

Warhol found devices for drawing attention. If he himself was uninteresting, he would find and populate the Factory with fascinating personalities and make the venue a performance lab for visitors and onlookers. The Factory became its own gallery and laboratory. He discovered the Velvet Underground playing in New York and agreed to manage them. Their loud and chaotic sound amused Warhol, and he put together a traveling touring show with the band, lights, film, and public relations kit called the Exploding Plastic Inevitable. During concerts, the EPI would create a light show to support the

Velvet Underground. Gerald Malinga and Edie Sedgwick would dance at the show as sort of a go-go disco tech couple. Warhol perceived music and live performance as a means of making his work more accessible to a wider market.

Warhol also used fashion as a form of pop art performance dressing people up in paper dresses and stenciling prints over them. Peter Wollen wrote that, "Warhol experimenting with fashion during this period, envisioned people as moving artworks wearing clothing based on his S & H Green Stamps, Fragile, and Brillo images."[24] Warhol saw circulation as an important means of marketing. While his performance was a part of his theatrical approach to marketing his works, he also used his surrogates or actors to carry his brand. Sometimes an inanimate object like the Empire State Building in the film *Empire* would be a substitute for Warhol and his ethos. In any event, Warhol's use of persona to market his work was strongly influenced by branding.

Part of the performance art approach was the fashioning of a highly theatrical persona. He affected a fey, highly artificial style of speaking, like a whispery, coy sort of Marilyn Monroe voice. He played a character that was often mindless or appeared so as a caricature of the artist. He wanted society to see him as a type, an image, and a character like someone they might watch on a television program. Warhol was also involved in movement and dance arts and worked for dance magazines had dance associates and did many drawings and paintings of dancers. Stephanie Aquin wrote that, "Warhol often addressed the theme of dance in his work which included illustrations for *Dance Magazine* in the 1950s; his Dance Diagram paintings from 1962, his Screen Tests and other 1960s films, such as Paul Swan and Jill Johnston Dancing; his series of Shadows paintings from 1979, and his many portrait paintings of dancers."[25]

In the sixties, many artists were questioning the authenticity of the canvas, of the artwork in a singular location. Roselee Goldberg wrote that, "only ten years after a debilitating major war many artists felt that they could not accept the essential apolitical content of the overwhelmingly popular Abstract Expressionism. It came to be considered socially irresponsible."[26] Warhol was not political in that he did not see performance as a means of redressing an ill in society, but he saw performance on stage, in the studio, and in film as a reflection of life problems. Therapeutically, Warhol was enacting people's issues and allowing them to vent their socially constructed personas. Warhol liked the climate of tension and anxiety prompted by out-of-control characters. Warhol used them to stand in for his own personal absence. Warhol's art and particularly his performance art, like Hitchcock's, was an art of voyeurism, of creating an image for an audience and standing back to behold the image and the audience.

Conceptually, Warhol viewed the idea of a gallery show as a means of putting things, not only art works, but also the people, and the scene on display. By the seventies, the people were no longer coming to see him and his art; they were objects in his circle. By 1970, Warhol was out at parties and events circulating and performing his Warhol persona to supply his print and portrait business. The performance art model had evolved from a standard location to a more ambient Warhol, who was mobile and visited the patron. As society became more mobile, Warhol broke from the gallery mode into a new way of creating and responding to art. The new art reflected his interest in a mobile technology that was not bound to one location. Pop not only succeeded; it grew legs and moved with him.

Chapter Four

Warhol: Master of the Minimal

The effect with this appropriation of a minimalist aesthetic and a grafting of it onto a startling spectacle is of a kind of minimalism of advertising. Its advertising marrying Minimalism and having a gruesome baby that is only partly shocking.[1]

After near death, Warhol regrouped in the seventies with a different aesthetic. He retained a sardonic take on prevailing themes of popular culture and energetically embraced new media in the production of art, but he shifted from an actual presence to a remote or ambient posture to the art world. Recognizing the dangers of an unstable class of collaborators, Warhol recalibrated for a new audience and refocused his business operation on a more patrician class of clients. Warhol, himself often the victim of prejudice in the tightly stratified social scene of New York, exploited his newly established contacts in high society[2] to leapfrog social classes from the marginalized, disenfranchised, and bohemia substrata to the entrenched, elite intelligentsia he had sought in the fifties. With contacts in the gallery and museum world Warhol transformed his practice using the Factory as a business center for juggling parties and social invitations, running *Interview* magazine, sorting and responding to film and video offers, and as a studio space for the production of a series of commissioned commercial art pieces and prints. The Warhol Enterprises operation of the seventies was a sleeker and nimbler affair. With the addition of technician cum designer/director and assistant Jed Johnson who lived with Warhol and was his lover for some years, Warhol approached a level of social and personal stability.

Professionally, Warhol was always a nose-to-the-ground entrepreneur sensing the changes in pop art practice and saw the opportunities and challenges of the minimalism movement sweeping the gallery scene in New York. As

Matthew Collings wrote in his description of seventies' art movements with which the chapter began, minimalism grafted itself onto the framework of advertising and shocking subject matter merging minimal and often nonexistent material with creepy or dehumanized content. Minimalism emerged as a style because of an attraction to new materials and a desire to see the artist disappear from the work. Warhol, who had already attempted to disengage the human element in his machine-oriented work, was attracted to any style that was subtractive and simplifying. Daniel Wheeler wrote that "for all its involvement with common industrial modularity, elements of less artist interaction with materials, more style that was partially minimalist, fabrication and materials—not only steel and fluorescent lighting, but also fiberglass, plexiglass, chrome, plastic, firebricks and Formica—minimal sculpture originated."[3] Warhol saw these simplified works in galleries, and as he had already participated in Duchamp's notion of readymades in his paintings, he thought he could use technology to minimize his effort in photography, painting, and filmmaking. This intersected with his professionalized business profile that saw the Warhol Enterprises label emerging as a marketable art brand.

However, the ideas of minimalism would challenge Warhol, who sought to incorporate the aesthetics of minimalism into his work but still required the fabrication of art objects to make marketable content. Robert Morris writing about sculpture said that, "if the hieratic nature of the unitary form functions as a constant, all those particularizing relations of scale, proportion, etc., are not therefore cancelled. Rather they are bound more cohesively and indivisibly together."[4] Warhol like Morris didn't want to eradicate the art object but to distill it down to essential parts. Warhol's purpose in making minimalist paintings, designs, his most abstract art forms, portraits, and other pieces was largely lost on an audience that had been drilled in the shock aesthetics of early pop art. Still, Warhol forged bravely ahead of audiences, blending minimal content with techniques and subject matter acquired in the pop era.

THE ART OF BUSINESS: THE BUSINESS OF ART

After the chaotic and near fatal sixties, Warhol focused attention on business practice. Warhol had spent more than a decade in private practice as a commercial artist. He found clients, accepted commissions, worked to a brief, served and worked with art directors, learned the practice and procedures of the industry, hired assistants, and solicited more and bigger commissions. He had become successful in the industry winning three art director awards and was well-known as the "DaVinci of Shoes," a humorous reference to his focus on shoe designs for I Miller Shoes and his substantial body of work

in the fashion industry freelancing for *Vogue*, *Harper's Bazaar*, and other magazines. Warhol's work and business flourished in the 1970s, even if his public persona as a bad boy of art waned. He had carefully avoided painting from 1966, claiming he had retired from the practice, and his reputation moved from artist to publisher and filmmaker in the 1970s. There were concrete reasons for this. Television and its immediacy had been blunted by demographic advertising and product pigeonholed to specific audiences. Film had emerged as a looser and more vibrant medium in the seventies, reflecting public interest in a growing wave of crime, police procedurals, liberal approaches to the mainstreaming of pornography, and a largely rebellious populace that confronted government programs and wars with suspicion and resentment. Art and still images were passé and moving technologies were attractive and dynamic. However, Warhol increasingly saw the machine of Hollywood marketing to be largely intractable and presented insurmountable obstacles to maverick, marginalized, abstract, underground cinema.

Like America, Warhol had to reconsider what had been accomplished in the production of the sixties, sort it out, re-edit it, and remount it for the audiences and concerns of the seventies. If anything, Warhol's production was more varied, more diverse, and more numerous in the *me* decade, but public acclaim alluded him. The critical problem was Warhol's sixties' work included his staged blank portrayal, the artist as cypher. The newer work lacked the artist. Little in his seventies' practice was transgressive in a society where nearly everything (drugs, sex, crime, murder) had become widely permissible and arguable. Ideas like people having sex had been done by mainstream pornography, which was becoming widely available through video. The pornography industry had compromised Warhol's ability to shock. The bad boy who wanted to film and explore the prurient still existed, but Warhol found the ability to shock audiences with anything waning. He turned to concerns of literary production, magazines, books, and catalogs of things he collected and curated. He became enamored of new emerging technologies.

Warhol was seriously injured in the Solanas attack, hit with multiple bullets rupturing or damaging a series of internal organs. Miraculously, he survived, and his next ten years were spent in a period of consolidation and reassessment of his work. Warhol decided on a course of art action that involved him less conspicuously and theatrically in the city's life and the work of the art world. Yet for an artist who preached that he wanted to be a machine or a figment, the one marketing benefit that he possessed was his presence. His distinctly offbeat personality marked him as a good publisher and interviewer for his own *Interview* magazine. His public appearances continually caused a stir. He was able to chat up clients at parties and sell portraits. For an artist that preached invisibility, it was his own distinct presence that salvaged his

career. The cult of the artist transformed his work from inconsequential to iconic merely because he had produced it. He had become the standard for advertising and fame that he had previously glorified. Like the United States recovering from an overindulgence in liberal politics and the Vietnam war, Warhol redediced his priorities and deduced that a different less direct form of art and intervention might net him more money at less personal risk. He was still active, still social, still shocking, and still shockingly productive, but he perambulated the town in a more invisible fashion.

However, the explosion of interest in Warhol's fine art in the sixties had netted few sales and little profit. In the next decade, he carefully managed and attended to his reputation. He began to produce a remarkable variety of art in a variety of styles over the next twenty years. At the same time, Warhol focused his professional practice. He streamlined his operations. Rather than attack every opportunity, he decided to focus on his publishing venture, *Interview*, which could support itself with proper ad revenue and specific and targeted writing and editing to become precise and profitable. He would use his social contacts to enter the world of glamorous high society in New York. This was begun with the contacts he had made in the fifties as an art director and illustrator and in the sixties where he had made important friends and colleagues in the gallery business, museum curators, gallery owners, agents, collectors, and publicists. He would use his contacts in New York society to infiltrate the rich elite circles and find projects to exploit these contacts through new artwork, mostly portraits and private commissions. Then he would work with a professional class of assistants. His helpers in the sixties were perhaps more creative and more devoted to Warhol personally, but he was looking for a professional staff to better manage a professional office. He hired people like Ronnie Cutrone, a talented and energetic artist, to produce a series of prints and commercial projects that would reintroduce Warhol to the arriving and lucrative New York museum and gallery world. Finally, he would struggle to create a better formula for producing, marketing, and securing a popular basis for film production.

Warhol's ambitious objectives required a tight, well-organized, machine for achieving recognizable and scalable goals. He needed to shed the sixties' hippie, boho, image and the personnel that did not fit the new business model. First, something already in progress when he was shot was the move to new, more secure, and opulent studio and office spaces befitting a more professional art marketing organization. The new facilities were more expensive but more controllable and Warhol could secure the space and have privacy, protection, and more freedom from the demands of his hyperdependent and needy entourage. A new staff were installed to make the transition. Fred Hughes, who began work for Warhol cleaning up at the old Factory space,

proved himself worthy by introducing Warhol to the wealthy de Menil family from Houston who had a fortune in oil money, were connoisseurs of the arts and patrons of a new generation of artists like Warhol, and were keen to be recognized as benefactors in the art world. Hughes had secured lucrative portrait commissions for Warhol with the de Menil family and their circle, and Warhol immediately grasped that Hughes contribution meant instant and tangible revenue that could stem the bleeding in his chaotic organization. Further, Hughes who had a background in the arts but was a smooth financial planner could line up backers to support the ailing *Interview* venture and make it profitable. Finally, Hughes was progressive, clean cut, and attractive and looked the role of an administrator. He dressed the part, and Warhol needed such a presence in his organization. Warhol began to follow Hughes in style and clothing choices and arrived less the artist and more the director of a wide-ranging arts organization, which was what Andy Warhol Enterprises was becoming. Frank DiGiancomo of *The Observer* writing on Hughes passing said, "although Leo Castelli was Warhol's dealer, it was Fred Hughes who (quoting Bob Colacello) 'launched the commissioned portraits gold mine, drove up the sales and prices of the sixties paintings, expanded the limited edition print biz, cultivated important new collectors and dealers, especially in Europe.' In 1971, Mr. Hughes also rescued *Interview* from financial ruin by lining up new backers."[5] The leather Warhol of the sixties was transformed into a slick, clean, collegiate partygoer in the seventies and eighties thanks to Hughes's attractive dress and demeanor.

Vincent Fremont was another notable attribute. He had also been a studio assistant. Arriving from San Diego, Fremont worked for Warhol for nearly twenty years, serving as managing director at the Factory, and the executive head of Andy Warhol Enterprises. His portfolio included Warhol's commissions in film, and later his productive and successful work in video. After the artist's death, he was a founding director of the Andy Warhol Foundation and responsible for the sale of Warhol's paintings, drawings, and sculpture. In recent years, he was an executive at *ArtNews* and became engaged in publishing and documentary filmmaking.

Few holdovers from the sixties were retained in the Warhol stable. Billy Name and Gerald Malanga found new opportunities in the art world. Paul Morrissey continued to contribute to the process of filmmaking as a director and editor through Warhol's last film, *Bad* in 1976. Pat Hackett served as a scribe, working for Warhol on screenplays, supporting him in the writing of *The Philosophy of Andy Warhol*, and collaborated with the author in the creation of *The Andy Warhol Diaries*, published after his death. The diary project was begun as a daily record of activities when Warhol was trying to keep track of daily expenditures for tax purposes.

Another transition was the loss of Julia, Warhol's mother, an early supporter and often coworker. By the late sixties, he had found her behavior increasingly erratic, her frequent escapes into the city more worrisome, and her general behavior more eccentric. She was sent back to Pittsburgh for nursing care. Warhol could not keep up with her needs and failing health. She died in 1972. Though she was Warhol's boarder and his mother, she had contributed to his commercial work, performed calligraphy, and even signed her son's name on projects.

Colacello was a student in the sixties, writing film reviews for Warhol's *Interview* magazine. He assumed control of *Interview* as managing editor in the seventies and worked for the magazine until after Warhol's death in 1987. Colacello's searing portrait of "the boss," *Holy Terror* (1990) presented Warhol as a fairly intense, miserly, and demanding taskmaster, but underneath the hyperbole, Warhol emerged in Colacello's portrayal as a cagey practical leader of a growing arts organization and business. Colacello, like Hughes and Freemont, was a practical contributor to Warhol's business practice and like his colleagues, he could gain work and contacts for the artist.

For Warhol, the blending of business and art making was natural and part of a career in the commercial world. However, the oil crisis, a looming financial disaster in New York and other major metropolitan cities, an inability for Warhol to successfully branch out as a film artist, and a shaky market for paintings and other collectibles pushed Warhol to find secure methods of revenue. The game was survival, and Warhol had little choice but to take business seriously. It is never easy for artists to secure their work, income, or legacy during the best of times, but the seventies was a difficult market, and Warhol, as an artist and a business man, had to contend with an evolving and volatile marketplace. Warhol stated in *The Philosophy of Andy Warhol* that, "business art is the next step that comes after Art. I started as a commercial artist, and I want to finish as a business artist."[6] Warhol carefully explained that doing good business was an art in itself and that really pleasing markets and making sure that as an artist one could sell work was an obligation of his profession.

Warhol adhered to a strict regime as a professional. He rose and spoke on the phone to Bridget Polk, Pat Hackett, and others. He ate, shopped, and arrived in the afternoon to look after the affairs of Andy Warhol Enterprises, responded to important mail, discussed appointments for lunches, interviews, commissions, or assignments that Hughes or Vincent Freeman would find for him. He explored possible film and later video projects. He supervised meetings with the *Interview* staff and kept abreast of advertising revenue. He explored social obligations and usually juggled a variety of invitations to fashionable parties and spent the early evening courting guests and lining up new commissions.

Perhaps an important part of Warhol's success was his willing, accepting vision of capitalism as a good force working to the betterment of people and helpful in American culture. As a prototypical Reagan self-sufficiency example, Warhol believed that dynamic capitalism spurred creativity and energized society. His pop art spoke to the icons of industrial culture, and he pronounced this new secular religion a positive thing. This is more surprising when we think of the mod-sixties and the narcissistic vision that capitalism was the enemy and that society would arise to the Fabian socialist tomorrow and all items would be free or low-cost. Again, Warhol was born from a family of immigrants who cherished the opportunities of a new land and the opportunities that capitalism presented for upward mobility and the American dream. Warhol's family invested in the risky venture of his arts education, and he made a knowledgeable decision to study graphic arts and illustration to advance his career and improve his chances of making an arts education profitable. He succeeded spectacularly beyond his family's wildest dreams. A large part of Warhol's phenomenal success as a commercial artist arose because he was plucky, somewhat naïve, and a wholly driven workaholic. His lack of self-esteem (at least regarding his physical appearance), his lack of friends, and his gay identity limited his interaction with society at large and contributed to his ability to concentrate on his work for long periods of time. His mother who played a large role in his early career was an obligation when she came to live with him in New York in the fifties, but she also cared for Warhol, cooked, and helped him with his artworks. He rewarded her with excellent work, progressively better living quarters, and an opportunity to engage in his enterprises at least by handwriting calligraphy and signing his works on occasion.

Warhol's pronouncements on business art have been widely quoted and even museum shows regarding his business ventures have been mounted. The Indianapolis Museum of Art presented a show in 2010 titled "Andy Warhol Enterprises" that focused on the artist's many business ventures. Andrew Goldstein in an article for the *HuffPost* reported that the exhibition was sponsored by PNC Bank. This affinity suggests that Warhol respected money and financial institutions, which in turn saw his art production as useful. One of the illusions that show sought to dispel was the prevailing concept that there was a single Warhol who changed from era to era. The truth of course is more complicated and like all people seeking to make a tempestuous living in an arts profession, Warhol was also concerned about money. Sarah Green, the exhibition's cocurator said of the exhibit, "one of the ideas that we have really tried to work against in this exhibition is that there was a turning point in Warhol's career—this idea that before he was shot there was a certain integrity to his work and after a turning point it all dissipated and he became

a servant to celebrities and society members. I don't believe that that is true. He even said later in his career, 'I was always a commercial artist.'"[7] Like most artists, Warhol was always concerned with revenue and rarely paid assistants top dollar. Sarah Green reports that, "part of Warhol's brilliance at an early age was getting people to help him for free."[8] Perhaps the thing that made it easy for people to work for him without getting paid was the fact that he worked in so many genres simultaneously. There wasn't one Warhol style but many, and Warhol was constantly recruiting experts outside his field of competence.

BOOKENDS: RAID THE ICEBOX AND FOLK AND FUNK

Despite the presumption that Warhol's work was more corporate in the seventies, he retained an interest in a wide variety of art styles. Warhol had an abiding respect and admiration for America's folk art traditions. He lived among immigrant folk arts and crafts and home spun art works in his slum neighborhood in Pittsburgh. He grew up in a world of folk art artifacts. Two events provided bookends for the seventies' era for Warhol. In 1969, Warhol came back into the art world in a show focused around peripheral collections of the Rhode Island School of Design's museum collection. This material, kept in cold storage, or basically items in the collection that largely did not obtain regular public viewings, were selected and circulated by Warhol in a series of touring shows across the nation in 1969 to 1970 ending in Rhode Island. This act of curatorship and selection of pieces for the exhibit titled *Raid the Icebox* (a pun on raiding the cold storage items in a museum collection) enlivened and enriched Warhol's perspective on what could be considered art and what was taken seriously in the art world. Simone Solandz, writing for the Rhode Island School of Design website, explained the genesis of the show and how it fit into Warhol's strategic ideas, saying, "He had been seriously injured in a shooting in 1968, had just launched *Interview Magazine*, and was in the process of shifting the focus of his practice from painting to filmmaking. An obsessive collector of everything from shoes to chairs to Native American textiles, Warhol elevated the objects he chose to display . . . in much the same way he'd elevated the status of drug addicts, drag queens, and other 'fringe elements' of NYC society."[9] What emerged from Solandz's writing is that Warhol was already a collector and curator and the growth of that activity had paid off in new works and new ways of seeing outsiders and outsider art. This trend would continue and escalate in the seventies. Sadly, people perceived a decline in Warhol's output in the seventies because he moved from merely making pop objects to selecting, curating, and producing a new style of pop object for a society and clientele that had changed.

At the other end of the seventies came the exhibit, *Folk and Funk*, that was organized by the American Folk Art Museum in New York. The museum, founded in 1961, had an objective of retaining items of American folk culture and reflecting on the move from a folk productive culture to a manufacturing and consuming culture. In 1979, the museum invited Warhol to curate a show of his own highly developed collection of folk art and kitsch art from his Manhattan townhouse. The show was a spectacular depiction of the artist's collecting mania, his interest in folk culture and craft production, and his own idiosyncratic collection of rare collectables and guilty pleasure thrift store junk. This exhibition was a step further than the *Raid the Icebox* Exhibition at the Rhode Island School of Design. Warhol's material from his own townhouse formed the basis of the exhibit, and it showcased Warhol's own eclectic collection of Americana and arcane items. Though the show had many of his own collection of folk curios, it was an important step toward his own personal curation and acceptance of his own often folk and traditional inspired-work. Rarely had Warhol's work been noted as deriving from nativist traditions, but there is an element of Warhol's work that is often crude, individualistic, folky, and peculiarly eccentric and primitivist. The great paradox of Warhol and his work is that though he praised the machine and emphasized that he liked and wished to emulate machine production, a distinct side of his work embraced the clumsy, the hand drawn, the individual, and the unique, not the machine or the readymade. The weird juxtaposition of the machine-crafted and the handmade made Warhol's work slightly loopy and obscure but also playfully flawed and human. Among the exhibits in the display was a massive door and frame. On the exhibition catalog, Warhol is caught peering through this antique door frame. The show was described as *Folk and Funk* because, as much of Warhol's personal collection was filled with folk art, much of his work was also funky, one-of-a-kind or camp items and not classifiable as part of the folk art tradition. Among the items displayed in the collection were dresses from the nineteenth century, a giant four-foot merry-go-round horse, a hand-decorated bench, a carved deer, an American flag-shaped shield, a optometrist's hanging sign, an attractive wooden cabinet, folk paintings, busts, landscape paintings from early Americana artists, a wooden cigar store Indian, a dog on some sort of rolling cart, carpets, carved castles, silhouette Indians, angels, ducks, and ornaments, a carved chicken, displays of toys, ornate fabrics, assembled Amish quilt, many shop signs, and carved pipes. Around the time of the show, Warhol gave an interview to Glen O'Brien in 1977, and he discussed folk art and its place in American society indirectly. O'Brien asked him if he thought women's liberation would bring more women in to the world of art. Warhol responded saying, 'I always think that the most artists were women—you know, the ones that did the Navajo rugs, American quilts, all that great hand-painting on 1940s clothes."[10] People

probably thought Warhol was joking and dismissing the question but consid-
ering he was doing a folk art show for the American Folk Art Museum that
year he was probably thinking quite intentionally about the role of women
artists, who even then were still largely marginalized and under-represented.
Warhol probably saw a relationship between them and his outsider status. He
also recognized the question as a connection to his own collecting and curat-
ing practice. By the late seventies, Warhol already had a sizeable collection
of diverse art, and among his holdings there would be works by Native artists,
quilt works by women artists, and a variety of hand-painted clothing pieces
from the first half of the twentieth century.

One could comfortably bookend Warhol's practice in the seventies be-
tween the *Raid the Icebox* show in 1969 at the Rhode Island School of Design
and the *Folk and Funk* exhibition at the Museum of American Folk Art in
New York. These exhibitions, the first featuring work that Warhol discovered
in the ice box, that is in storage from the Rhode Island School of Design mu-
seum, and the latter being work that Warhol loaned to the American Folk Art
Museum served to illustrate his interest in found, appropriated, and kitsch art
that had been often dismissed by legitimate society. Warhol's interest in the
cast-off, the discarded, and the ephemeral began at the start of his career and
extended to his end. His interest in forms of culture and his active foraging
and shopping for bargain goods is indicative of his art practice and his thrift
and parsimony learned from years of deprivation and poverty. Despite accu-
sations that still cast Warhol as a shallow, ineffectual appropriator of Ameri-
can culture with little love of the culture or its source material, Warhol's
blatant love and keenness for American material culture has gone a long way
toward shaping our appreciation of our own thrift store culture and unfettered
recycling of our pop culture. In both, Warhol's achievement of the seventies
can be enshrined as valorizing the artwork of common people. It reflects his
long-held antielitist and egalitarian impulses, which contrasted markedly to
his desire to participate in benefits and the glamour of elite cultures. Through-
out his career the polarizing facets of this tension were at work.

WARHOL TECH: VIDEO, CASSETTES, POLAROIDS

Warhol was always enamored of gadgets, and during the seventies, he began
to use new emerging tools in his work. Television effectively began to replace
film and offered far more benefit for an artist like Warhol that simply liked to
set up a camera and watch what happened. This voyeuristic attitude toward
filming was far more in keeping with the talking heads mentality of television
than the totally immersive world of film. A second breakthrough was the tape

recorder, which Warhol considered his *wife*, and a device that accompanied him everywhere. He liked recording conversations and keeping a record of everything he heard. In fact, such recordings were the basis for his play with Bridget Polk, *Pork*, and his *Andy Warhol Diaries* cobbled together from calls and conversations with Pat Hackett. A third new toy was the continual presence of a Polaroid instant camera. This device gave Warhol the quick easy gratification that he craved as a productive artist. While many artists worked painstakingly on canvases for many hours, Warhol loved to take quick shots and turn them into profitable portraits. The idea of his fame attracted clients, the technology of the camera provided ease, and the flattery of a portrait commanded a good fee. People wanted to have their picture taken by a trendy photographer. The camera became another appendage for Warhol, and he carried it everywhere. So in essence, through his literary output, his use of a tape recorder and camera, and his constant acts of business and curation, Warhol became a different artist in the seventies, and much of that transformation was lost to the public who had locked in perceptions of Warhol as a sixties' artist surrounded by Campbell's soup cans, Marilyns, and an entourage of drug addicts and drag queens. Warhol had evolved. His seventies' persona was steeped in elitism, high society, and nightclubs. Rather than Warhol being the scene, Warhol visited the scene, and used the social scene to produce his art.

Warhol was an avid participant in new technology. He carried around a tape recorder for years and enjoyed recording people's conversations and comments like an interviewer. Always nervous and anxious in front of crowds, he probably relished being behind the microphone rather than in front of it. The Polaroid camera used a chemical process to develop an almost instant photograph and bridged the gap from the photo processing of early photography to the more recent era of instant digital photos available immediately.

MINIMALISM, SIMPLICITY, AND SHAKER CRAFT

A further aspect of Warhol's devotion to technology was simultaneous devotion to simplicity and craftsmanship, and oddly Warhol's work of the seventies and his meditations on simplicity might identify his work oddly with the aesthetic of Shaker craftsmanship. Sharon Koomler wrote that, "critics have labeled Shaker objects as timeless. They have become a unique style. Shaker objects are reflections of the worldly design in a given period, stripped of what Shakers considered worldly embellishment. Shaker craftsmen were conscious of, but not driven by current styles and trends."[11] Warhol shares elements of the Shaker style in the simplicity and unadornedness of his

works in the period. Many of the photos are untouched or painted in the same graphic fashion, accentuated only modestly. Series of works replicate the same format and the same motifs consistently. From magazine covers to print collections to photos to other forms of display, Warhol spent considerably more time delving into the craft of printing. Unlike the more outlandish and cursory art of the period, Warhol tended to eschew ostensive shock effects more, and when he did employ shock, it was in a more subtle and moderated realm. For example, the portraits of Mao might have checked conserving the communist subject matter but the execution of the Maos is consistent with other portraiture of high-society figures of the era. Further, Warhol was enormously productive and efficient, and like the Shaker, people found this efficiency favored commerce. The Shakers were so successful in equipping their small rural communities they found they had energy and will to supply their excellent products to society at large. Like Warhol, the Shakers weren't too opposed to mechanization if it increased production. Koomler writes that despite a tendency toward unadorned works and wares, "products were 'dressed up' to make them more attractive to public sales. . . . Mechanization helped to increase production."[12] Warhol produced his photos as often raw photos sans decoration and added the merest amount of color to dress up his portraits. However, at the same time, he was highly productive and often

Figure 4.1. Oddly for a New Yorker and city dweller, Warhol was intrigued by Native American issues. He bought native artworks, and he painted American Indian activist Russell Means.
Library of Congress Prints and Photographs Division, LC-DIG-ds-10108

could do two or three portraits a day. Shakers prided themselves on a similar goal of productivity. In the nineteenth century, Shaker communities produced a wide range of superior textiles and generated many high-quality cloth products with little ornamentation and only a few colors. Warhol similarly made simple personal portraits and often only adorned them with a few strokes of color. Koomler mentions that textile production was ruled by patterns of uniformity. She wrote that, "Shaker woven goods are marked by consistency in appearance. Variations were made by subtle changes in the weave patterns and the addition of color to segments of the warp and weft. The pattern was usually done in just two colors."[13]

Warhol naturally worked in similarly limited and restrained formats while employing often controversial subject matter. Rainer Crone comments that we shouldn't be surprised by folk elements in Warhol's work because the artist had a long and warm association with American folk art. He writes that, "this marked (the fifties) the beginning of Warhol's interest in naïve art, especially American folk art, and Americana; over the years he complied an extensive collection of such items. His involvement with American folk art is reflected in the style of a number of his works—for example, the Circus series of watercolors."[14] Surprisingly few have pursued Warhol's interest in the folkish in his wide range of works, including later works in the eighties where he collaborated with younger artists who also were interested in folk art, naïve art, and primitive styles.

It is peculiar to think of Warhol as a devotee of Shaker craft or that the gay, New York, sophisticated designer would share any affinities with the modest religious craftsmen, but Warhol was a religious, philosophical, and pragmatic thinker always concerned with quality, output, and branding. Further his mission to produce was related to lifetime habits of thrift, tenacity, and frugality. At his death, it was found that he amassed a huge collection of folk crafts, and his shows at the Rhode Island School of Design, Raid the Icebox exhibitions, and the Folk and Funk Show at the American Folk Art Museum illustrated an incredible affinity for Americana craft art. *Shaker Warhol* may not have been such a contradiction in terms or temperament.

EMERGING EUROPEAN ARTIST

Despite being out of the public eye during the late sixties after an assassination attempt, Warhol's aesthetic fortunes begin to rise. There were extensive touring retrospectives of his sixties' work that reflected nascent public attention and respect. His work arrived at the Tate Gallery in London in 1970 and received positive reviews. A Campbell's soup can painting was auctioned for

$60,000, the most paid to a living artist in his time, and Warhol, who had a remarkable relationship with the press but scant gallery sales, was relieved to see work that was generated a decade previous starting to sell.

Not only did Warhol's work of the seventies often receive little reporting, his growing European fame was lost on domestic critics. Wayne Koestenbaum remarked on Warhol's diminished seventies' profile saying that, "it is a cliché to say that part of Andy Warhol died on June 3, 1968, but it is also literally the truth. Had Andy completed his dying then, he knew he would have become an even bigger cult figure than he is today. No one would need to consider his ambiguous work of the 1970s and 1980s."[15] Koestenbaum's book provided new insights into Warhol's work and also reviewed ideas about Warhol's industry in the seventies and eighties. However, images of production decline were contradicted by the wide variety of shows, activities, and accolades the artist scored in this later period. Principle among these reassessments was the European appreciation of Warhol. One of the quirkiest aspects of Warhol's thriving business practice was his enormous impact outside the United States. As early as 1964, Warhol was already having exhibits in Europe starting at the Galerie Ileana Sonnabend Gallery in Paris, from January to February 1964.

Though he had suspended painting since 1966, the growth of shows across the globe and the spread of his reputation there was strong. This began in 1970 with the Osaka, Japan *Rain Machine installation* that Warhol engineered for the Expo 70 display in Osaka. The installation was part of a project by the LA County Museum, and Warhol and founder of the Art and Technology exhibits, Maurice Tuchman, and a founding curator of the emerging Los Angeles County Museum. In 1970, they collaborated on making a water fountain that poured actual water in front of Warhol's print display of Daisy prints. The idea was to merge the technology of creating the rain display with Warhol's art, literally creating a rainstorm in a gallery with the concept of the rain nourishing the printed plants that were behind the rain display on a wall. Visitors walked past the rain into the plants. The Warhol Rain Machine has been revived in this century with younger artists adding digital rainfall to the device. However, in the seventies, Warhol's delightful display, complete with the sounds of a rain shower, created a friendly and embracing installation work and participated in the Japanese sense that nature had been included in the artwork. The display also enhanced Warhol's reputation as an international artist.

In the United States, Warhol was often viewed as an attention-mongering charlatan rather than a serious artist. However, foreign galleries saw Warhol as a foreign dignitary. He found many galleries in other countries eager to show his work. A European reputation emerged from his continued com-

mercial work and quiet unacknowledged painting activity. In February 1970, Warhol accepted a commission to paint a *Time* cover titled the "Flying Fondas" to celebrate multiple family achievements with Henry Fonda (lately in Sergio Leone's *Once Upon a Time in the West*, where Fonda tackled an atypical role as a villain), Jane Fonda who was scoring for her role as a menaced woman in *Klute*, and Peter Fonda who was sailing high on the underground film *Easy Rider* with Dennis Hopper and Jack Nicholson. The commission invoked prime Warhol engaging his interest in celebrity, film, old Hollywood, and his own practice in underground film. The cover featured Warhol's bright, saturated colors, a coherent pictorial design framed in black, striking print graphics, and dashes of color anticipating the seventies' celebrity painting style.

Warhol was celebrated in a show at the Tate Gallery in February 1971, and his recent high-priced sales contributed to positive publicity at his arrival. He was greeted as a conquering hero by the British press with *The Guardian* calling his arrival, "National Warhol Week," and the journal explained that not only was there a Warhol exhibition at the Tate, but four other London shows also featured Warhol's work that week, the Tate Show, "drawings at the institute of contemporary arts, prints at the Mayfair, and even a set of snapshot souvenirs at the Photographer's Gallery."[16] There Warhol was feted as a multimedia artist in keeping with the reputations of avant-garde artists such as Duchamp and the Dadaists. The notion of Warhol as inauthentic escaped the European press, and he was greeted as a member of an established and respected tradition. The adoration and the clear rise in market prices encouraged Warhol.

After his heralded return to painting in 1972 with the *Mao* series, Warhol had an exhibition at the Mayor gallery in London. The show featured the nine Mao prints arranged in a massive group in February and March 1973. Europe was hungry for new Warhol work and throughout the seventies shows continued there. In 1974 there were at least five foreign shows featuring Warhol's works and only two in the United States. Warhol had also made important contacts with European galleries and curators, and demand for his work continued to rise among foreign collectors looking for a hedge against rising inflation in the seventies' economic era.

In the Musée Gallieria in 1974, Warhol pushed a variation of the Mao portraits by creating a decorative wallpaper reusing the Mao images as silkscreens printed on wallpaper. It was a good example of Warhol's idea of making practical and decorative art that also fused with themes of contemporary issues and politics. Further, it showed his Shaker streak of practicality while reusing similar design elements over and over again. Like the Shakers, much of Warhol's design art used repetitious and common patterns again and again.

A successful design conservatively could bear repeating. It was art meeting political commentary that intersected with common house decoration. Warhol used such shows to blur the lines between commodities, decoration, and fine art. Mixed with that was his blending of dangerous politics (Communism) with commerce. Sadly, few critics managed to grasp Warhol's amusing juxtaposition of a titan of communism with his own commercial applications of the socialist dictator.

In 1976, the Stuttgart Urttemberischer Kunstverein presented a large retrospective of Warhol's work. With his cooperation, the show gained access to Warhol's early work as a teen. It chronicled his preprofessional work, his commercial artwork, and his pop-era breakthrough. A new generation of European scholars began to reassess his work, including German born, Rainer Crone who later produced a book titled *Andy Warhol: A Picture Show by the Artist* (1987) and situated Warhol's work in the mainstream of modern art. He related the artist's work to the era of abstraction, Matisse, social surrealist Ben Shaun, folk art, caricature (as found in the cartoon section of magazines like *The New Yorker)*, and expressionism derived from European art of the midcentury. Warhol's reputation in Europe was evolving as a modernist and postmodernist, someone skilled in media art while that style was erupting on the art scene.

PORTRAIT BUSINESS

Portraits became a surprise success in Warhol's craft in the era. He realized the party circuit was less work, and his name notoriety was gaining him invitations to top society events. At the parties, Warhol began to receive commissions for celebrity portraits. At first it was a celebrity lark to see people's homes and to do a few snapshots in a gossipy environment. Then Warhol realized the true business potential of such a move. He understood that he could work and make good money merely by attending parties and squiring wealthy patrons into his orbit. Each friend told a friend he had had a portrait made by Warhol, and that friend in turn told another friend that he had been photographed by Warhol, and the work of the portraits as a series of commissions grew throughout the seventies. People saw and photographed Warhol at these parties, and few recognized that Warhol was carefully working the parties, mining wealthy guests for portrait commissions, and building a wealth stream. Paparazzi or celebrity photographers hoping to make money from photographing celebrities at grand, catered affairs helped enable Warhol's seventies' business model by recording his continued attendance at parties. They provoked the notion that Warhol was an addicted socialite enjoying the good life. He was, but he was also working.

Warhol's process was remarkably simple. As a famous artist, Warhol knew people who knew people of wealth and stature who wanted a celebrity artist in attendance on the celebrity circuit. Warhol made himself available and was a chatty gossip who could always find an alcove for conversation and dirt. People were fascinated and flattered to be in the presence of an artist, and few had any idea that Warhol was often on a scouting expedition. Well-informed, and often assisted by assistants, friends, or people in the gallery business who knew who had money, Warhol worked the floor seeking good prospects. Warhol would chat up wealthy guests and patrons. Often these were not the most famous people at the party, but they were well-financed with disposable income. Warhol, who was not nearly as shy in private as he appeared to be in the filmed interviews in the sixties, would tell someone he could come to their place for a photo session and arranged a date for the session. He or an assistant would find that person's address and make an appointment. Once that business was conducted, Warhol would often leave the party. These fishing trips filled many evenings, and he rarely was out late unless he was already having a good time or enjoyed the food.

In the next few days, he would show up at the patron's house armed with a Polaroid camera and more than ten rolls of film. He would convivially chat with the patron, arrange the person where they wished to sit for the portrait, and begin to casually snap informal shots. He might burn through ten rolls of film setting each portrait on a counter and sometimes amassing more than one hundred images. After the whirlwind shoot, Warhol and the patron would review the day's work, and while consulting the patron, Warhol would choose a shot he favored in conjunction with the subject. The chosen shot would be sent to a specific photo lab in town where it would be enlarged to poster size and sent to Warhol's studio. In the studio, Warhol would attach it to an easel, dab it with acrylic transparent paint, often in subtle pastel colors that would retain all the elements of the original portrait with a dash of color, and finish the work. The completed standard-sized, portrait poster artwork would be framed, the work packaged and delivered to the customer with an invoice for $25,000 to $40,000. Warhol upped his price over time, realizing patrons could sell his work in a few years as collectibles and make their own handsome profit. Some didn't pay for the work; but more often than not, the consumer, flattered by the attention and Warhol's time, paid promptly, and Warhol made record amounts of money for under a half-day's work. Many of the portraits participated in the emerging neo-expressionist movement and situated Warhol with a younger community in New York.

NEW MINIMALIST PAINTING

Warhol's work in painting reemerged in the seventies. Because previous paintings were selling well, he deduced that more painting would add more revenue. Further, during the sixties and seventies, Warhol had noticed the application of minimalist techniques to art production. Artists were using unvarnished, unaltered materials and profiting from few aesthetic operations and few touches of the workman's personal hand. Warhol saw it as a return to the folk art and Shaker art he had seen as a youth, to simple and pure craftsmanship. He began to move toward simplification, first in the portraits where the unaltered photo was merely redrawn by hand, layered with acrylic, and placed in an attractive frame. Simplicity suited Warhol's ambitions as a producer and entrepreneur. Simplicity meant that he was following an aesthetic style and a popular one or minimalism at the time. Secondly such work was efficient, and finally, as he had learned in New York high society, in an overcrowded, overbuilt, and unnatural place like Manhattan, nothing suggested wealth more than space, intellectual and physical.

Warhol's eventful return to large-scale painting and subjects became oddly and effectively political in tone. Warhol used President Richard Nixon's 1973 trip to China to spur a new series of paintings of Mao Se Dong the Chinese warlord and dictator. The Mao portraits not only returned Warhol to painting in the public's mind but also provided him with another marketable image: celebrity and iconography that could be sold more effectively than films. Films needed a distribution network, a way to view them, and an audience. Warhol had none of that. But he did have a deep connection to galleries, gallerists, and art dealers. Warhol had created a formidable network for selling art. Further, the media, by focusing on Nixon and politics and China, did much of the work of selling for Warhol.

Warhol took another step toward regular conventional politics when he produced a colorful but lurid portrait of Nixon for the campaign of George McGovern. The smiling but seemingly duplicitous Nixon beams at the audience while hand scrawled script below the portrait reads, "Vote McGovern." McGovern suffered the single most consummate defeat by a political candidate in American history. Warhol was stung by his dalliance in contemporary politics. He feared reprisals from rich Republican friends. He had suffered an embarrassing audit by the Internal Revenue Service questioning his supposed business expenditures. Though he painted Mao, critiquing images of Nixon, and attempted to comment on political issues, he would quickly forego direct engagement in political issues. In later productions, he positioned art for commentary that was more philosophical than political. Ads, animals, and even political figures could be subjects, but any direct commentary on current politics was routinely avoided. It was safer and protected the bottom line.

Retreating from contemporary issues, Warhol moved in a new direction by pursuing the field of still life painting. He had produced paintings of disturbing still lives before in his series of electric chairs, and in the seventies, he returned to death themes with the *Skulls* series. Warhol revisited the theme of death that he visited eloquently in the sixties through the death and disaster series of prints. This time in 1976, he revisited the topic with a series of prints focusing on skulls. The still lives of skulls resembled the sort of dark *Vanitas portraits* popular in previous centuries where all of a person's possessions and follies are laid alongside images of death. With the *Skulls* series, the skulls stand mostly alone. Later, Warhol included himself in the images of skulls focusing on portraits with skulls included. Warhol called attention to death as a constant companion during life, and the grouped portrait of his face with a skull accentuated the fears he had of his own mortality and in a sense exorcised such fears. Remember, during this time there had been a new interest in horror films prompted by *The Exorcist* and the rise of novelist Stephen King, so horror and death seemed only natural in the popular consciousness. Further, Warhol extended the horror theme in his own late films, *Blood for Dracula* and *Flesh for Frankenstein*. Both were directed by assistant Paul Morrissey and relied on a vivid colorful and graphic sense of blood, guts, and camp humor.

While again it is common to associate Warhol and his work with comedy, irony, or satire, Warhol's growing interest in Native American issues and art reflected the growth of the American Indian Movement (AIM), the bicentennial focus on the origins of the country, and the relations of white settlers with Native peoples, who had long been abused and diminished by the dominant European culture. Warhol's work is largely direct, specific, and journalistic. He took as his subject real-life American revolutionary Indian leader Russell Means, and he brought the character to life in a series of paintings printed on canvas in 1976. Carter Ratcliff referred to it as, "thus, it is an emblem of a challenge as frightening, as alien, to some Americans as World Communism . . . they still have a threatening aura, however, all the more since pictures of the American Indian are capable of arousing pangs of colonialist guilt in Warhol's most sophisticated audience."[17] Further, Warhol used a different technique than most of his portraits of celebrities of the seventies. Warhol rendered Means with consonant colors, not the shocking pinks or blues that he might have used for a decorative New York aristocrat. Means is treated with somber blues and deep brown tones, rendering the portrait as an expressionist handling of the subject. Here, Native Americans are not marginalized or demeaned but given a more fruitful treatment than many of the more famous but ultimately, lesser subjects of the era. Warhol was sufficiently interested in the representation of Native people to return to the subject in the 1986 set of prints titled *Cowboys and Indians*. Again this time, using a more

garish set of colors, Warhol juxtaposed images of George Armstrong Custer, John Wayne, Teddy Roosevelt, and Annie Oakley with the far more diverse images of an Indian head nickel, a Kachina doll, Geronimo, and an unknown native woman with a child. Quickly we see that Warhol is commenting on the positioning of European-derived characters as individuals with personalities and traits, but the native characters are simply regarded as types, less individual and less distinguished. It is a commentary on an unconscious act of cultural imperialism. If his art of the seventies reflected less specific commentary on certain political figures, then philosophically it appeared as if Warhol was embracing new cultural studies and philosophies of problems in American history and culture.

One of the photographic series arranged by Hughes was a series of portraits of athletes. A series of athletes was selected, and a sequence of prints was to be made of their portraits and then sold. The athletes agreed because they would receive a fee of $15,000 once the portraits were sold. The assignment was not without challenges. Warhol was greeted by an hour-long rant by Muhammad Ali, who railed against crime, pornography, and sexual license in the big city. Warhol just wanted to photograph the boxer and leave.

WARHOL DEEPER MINIMALIST

Some narratives of Warhol's work today are changing due to a deeper understanding of the cultural cross currents of Warhol's era. The latter half of the twentieth century in America may not have been as chaotic as the first half of the century when international conflicts raged, but many transformations in the art world, in economics, and in culture rendered events more difficult to decipher. One fears that many devaluations of Warhol's later work may be due to the error of seeing it merely through the lens of pop, an important style, but merely one format that Warhol sampled. However, despite claims that Warhol rarely overintellectualized his work, he was simultaneously a philosophical artist and followed all the trends of the art world in his era. The diversity of his work and methods often defy simple critical analysis through one critical lens. A movement that had coincided with abstract expressionism and the rise of pop art was the form dubbed by the art community as *minimalism*. Though widely used, the term was often ill-defined but became a common shorthand for any art that was seemingly lacking in aesthetic personal traits. While Warhol might not have been a strict advocate of ideas of minimalism, its ways of communicating art impacted his production and became more prominent in the last years of his work.

Some characteristics in minimal art appear in Warhol's work. For example, his photography of the seventies can be described as minimal. That form often left things, works, materials, and objects in a primitive or inert state. Minimalist objects were often regarded as merely a record or response to a moment. Kenneth Baker in his text *Minimalism* refers to the tendency, "to present as art things that are—or were when first exhibited—indistinguishable (or all but) from raw materials and found objects."[18] Minimal art expressed an interest in inert objects or things that were often left untouched. For example, Ellsworth Kelley's 1956's *Wall Study* is basically a painting composition of a black square offset slightly in a white background. Warhol continually crossed into new media and exerted operations on that media from another discipline. It is likely that Warhol saw the untouched Polaroids and other photos of the seventies as sufficient unto themselves and needing no remediation. While much of minimalism is applied to three-dimensional objects, there is no reason to assume that Warhol could not be applying minimalist operations to the work of photography, curating, film, printing, cover art, and any variety of media. A technique may have been nominally applied to one medium, but Warhol's keen appropriating mind saw ways to apply minimalist strategies to a host of projects.

Warhol often preferred a work that frustrated audience expectations of progression or intentionality. A prime example is his early film work, where audiences, conditioned by nearly one hundred years of narrative film, expected the imposition of a narrative, literary structure. Warhol's disinterest in introducing narrative baffled critics and audiences alike. He challenged the reigning paradigm of film by introducing a film structure that denied the apparatus that gave film cohesive form for decades: a plot. Baker argues that the minimalists specifically challenged attitudes regarding a false set of cohering principles, saying, "the paring away of superfluous complexities by minimalist artists was done in order to supplant the false richness of a fragmented and fragmenting popular culture with the true fullness and continuity of perception itself."[19] Warhol delighted in objects that lacked an ability to express an active capacity to enthrall or entice viewers. It is as if the object was left to sit there and regard the audience. Further, minimalism postulated that objects were to have a minimum or absence of decorative detail. They were intended to be plain and austere. Often, they were the products or the nonproducts of art. Some of Warhol's photographs shot randomly at social gatherings may merely document the moment and seek to achieve little else. They are a record of the day, of the time, and the people in attendance and little more. Thus, they participate in minimalism.

Another notion of minimalist discourse is that often objects were created from raw materials or composed or arranged as a work of nonart, an object

lacking artifice. Many objects eschewed the qualities of art that sought to be looked at or observed. Again, Warhol produced a series of works that existed in their raw state unfettered and untethered to a larger objective. Warhol embraced the notion of art as nonart in his documentation of daily activities. He created what he termed *time capsules* that served as documents and records of work and proceedings and time spent in the office or studio but which were collected in a random manner to freeze a moment in time. The time capsules were a project that Warhol undertook during the latter years of his art practice when he had more stable offices and was able collect minutia from his daily activities in a concerted fashion. He pursued the time capsules from 1974 for fourteen years until his death, and the project involved collecting stuff sitting around his office or staff spaces into boxes and sealing the materials and leaving them in storage. Though no mandate to create a certain number of regular collections of materials ever evolved, in the end 610 boxes were amassed and stored. The boxes were opened randomly in the years after Warhol's passing at The Andy Warhol Museum in Pittsburgh.

In fact, the time capsules may have participated in art production in a number of ways. First, the capsules participated in pop art because they were collections of popular culture objects randomly assembled at the time the objects and their selection were possible. In the same way, Warhol chose to reintroduce a comic strip, Marilyn or Mao, to the world; his time capsules froze the moment that a piece of popular culture was relevant. For example, in one time capsule they found a Lou Reed album. Warhol used the time capsules to make a commentary on that fragment of reality. Secondly, the time capsules participated in the minimalist procedure of taking things from the common field of objects and presenting them as art. Karen Jones writing for *Artcritical* described them as, "a random quality to the selection of the packed contents as each box reveals an archeological object-based narrative."[20] Jones's notion that such boxes contained an archeological record of their times related the time capsules to the objective and scientific procedure of trying to remember and capture a certain period in time. Finally, the works served a third conceptual art purpose. There is an event quality to the opening of the boxes and having art critics read the debris inside. In fact, the Warhol museum staged the opening of the boxes as an art and archeology event, charging $10 to patrons to attend the opening of each box during the years. The *BBC* sent a reporter to cover the opening of one of the last boxes on September 10, 2014. The event with critics and reporters present had the aura of a performance art show, and patrons watched as the next to last of the 610 boxes was opened, and its contents divulged. Simon Elmes writing for the *BBC* explained that the surprise boxes, "include(d) everything from flyers from galleries, junk-mail, fan-letters, gallery-invitation cards, unopened letters, solicitations for

work, freebie LPs, a lump of concrete, eccentric pornographic assemblages by Warhol's friends and associates, thousands of used postage stamps that the artist tore from envelopes, packets of sweets and—inevitably—unopened Campbell's soup tins, by now rotting and hard to preserve."[21] The unveiling of the boxes created quite a stir and suggested to attendees that they would be witness to some overlooked item of hidden truth about the artist. Like learning the secret of Rosebud in *Citizen Kane*, the audience became sleuths in a performance piece where chance and indeterminance played a role. Even after death, Warhol engaged people in a minimal art piece.

He did work in forms that approached sculpture and aspects of chance and nonobjective art. The time capsules served as such. Again, these experiments portrayed an interest in the minimalist and conceptual artworks around him. Allied with an interest in minimalist techniques was Warhol's *Oxidation* series of paintings. Warhol aided by assistants found that by painting canvases with a copper paint you could make weird discolorations by urinating on the canvases. The wet copper paint would turn brown or orange or green when you sprayed highly acidic urine on the canvas, causing a chemical reaction. So, Warhol and his assistants and colleagues peed on the paintings to create the discoloration effects on the canvases. The gruesome procedure left the room smelling like an unclean bathroom, but the paintings when shown in Europe later received good reviews. Simultaneously Warhol was able to combine minimalist operations with his prurient, transgressive strategies of the past. When the paintings were exhibited, Kynaston McShine for the Museum of Modern Art retrospective in 1989 described them as "mixed mediums on copper metallic paint on canvas,"[22] The description overlooked the fact that the paintings were composed with urine. However, that fact declined in importance when the works were seen. The works often resembled Warhol's old antagonists, the abstract expressionists. The irony of Warhol's oxidation paintings is that rather than plumbing the depths of man's anxieties and emotional states, something the abstract expressionists felt a kinship to, the paintings represented the most basic functioning of the human body, the act of excreting liquid waste. Marco Livingstone, commenting on Warhol's various techniques, explained that "like the series of large Shadow paintings screen printed in the same year, these were both abstract in appearance, and representational in a literal sense."[23] Despite the fact that the paintings took Warhol's work to a more primitive technical level at a time when most of his work was highly polished celebrity portraits using photography, acrylic paint, and large blow-up reproductions, the power and directness of these "piss paintings" and the contemporary shadow paintings illustrated that Warhol still had the power to shock, make direct statements, and reflect on the history of painting in a complex and vibrant fashion. This was not just a court painter to stars but an

aggressive, often angry and restless artist who appreciated multiple techniques, could work in varied fashions, and was interested in collaboration. Although thought a master of printing, Warhol sought to prove that he was proficient in many painting styles. The urine paintings suggested that his work could be humorous, ironic, and market-conscious simultaneously.

COMMISSIONS

A neglected area of Warhol's output were the commissioned works produced in response to requests for a series or participation in a group project, usually at the urging of Fremont or Hughes. Much of this business art, he made with assistant Ronnie Cutrone is maligned. The suggestion is that because it was produced to sell, it was somehow inferior to the art of the sixties that was also made to be sold. Sixties' audiences perceived Warhol's pop work as making statements but was supposedly somehow free of the market pressures that other artists endured. A mindset of sixties activists was that musical artists like the Beatles, writers like Ken Kesey, or artists like Warhol or Peter Blake were free from market pressures. The reality was that besides grand artistic statements, all of the artists of the pop era were just as interested in sales as they were in receiving positive public reaction to their messages.

The Shadows series was an example of art and commerce merging. The installation sold for more than a million dollars as a unit. But the triumph wasn't the sale but the idea of the installation as a set that would surround and engulf an audience. Warhol, more than at any time, was trying to surround, ensnare, and impress an audience. Oddly, his work of the era benefited from the lightness, simplicity, and variety of approaches harboring elements of wit, Shaker starkness and craftsmanship, and minimalist philosophy.

Chapter Five

Warhol: Wizard of Nothing

People usually go to the movies to see only the star, to eat him up.[1]

Apollo argued with Cupid who pierced Apollo with a golden arrow, making Apollo fall hopelessly in love with the wood nymph, Daphne. She ran from his lust, but he pursued her through the forest. Fearing she would lose her virtue to the lusty god, she called out to her father, Peneus, and he protected her, transforming her into the laurel tree. Apollo regained his senses and promised to worship the tree and offered it the prize of eternal youth, making its leaves forever green. Today we are blessed with the beautiful laurel tree, a product of Apollo's fury and Daphne's constancy.

The tale of Apollo and Daphne is an example of an etiological myth, or a myth that illustrates how some custom or natural event began. The story isn't as important as the meaning of the story. It is also a good myth for its sense of stasis, description of states of being, a focus on madness and sanity, and the interweaving of gods and nature. It explains larger ideas to us in metaphor. Warhol's work offers a similarly mythological reading, through the static, symbolic, and iconic construction of his films. His films operated in a symbolic, inert, and image-saturated world, the world of an artist, his muse, outside the concerns of literary, narrative, plotted-fiction films. These factors account for his films' rare suggestive quality and ultimately their inability to court mass audiences, sustain production, and win popular appeal. Their aesthetic success spelled their popular dismissal.

Warhol presents critics with a variety of problems. Among them is the problem that he produced a multitude of works in various media and genres. Film presented art critics with problems because few artists were using film or video. Aside from Nam June Paik, few artists used that media, and as in other things, Warhol was an innovator in that area. Further, Warhol's

Figure 5.1. Warhol's *Chelsea Girls* included his long takes, soap opera confrontations, and an interesting two reel technique where two stories were running alternately for the entire three hours of the film. Warhol may have changed segments of the film nightly when it was first shown.

Film-Makers' Coop/Photofest© Film-Makers' Cooperative

explorations of film took various guises. Myth was only one of many lenses that Warhol employed in the creation of film art. Warhol and many of the pop artists were devotees of the surrealist movement which dominated European and later American art of the thirties and forties and strongly coded our pop culture. Surrealism infected America's cartoon industry via Disney and the wackier madcap cinema of Warner Brothers, cockroach terrace, Looney Toons. Surrealism was deeply ingrained in American pop culture from Saturday morning cartoon shows, to the prehistoric sitcom, *The Flintstones*, to comic book superheroes and macabre fantasy, to advertising's anthropomorphic ads of animated detergents, cars, and food items. Warhol cruised the pop culture of his era, visited the underground movie circuit, using the techniques and affectations of the underground film scene: Incoherence, complex coding, private symbology, ironic, self-reflexive camera work/editing, and disjointed narratives. All qualities that dominated the underground scene. In another sense, he provided another layer of coding. He explored the knowing, comic, gay, ironic style of camp, prominent in sixties culture' where taking anything seriously was an index of the uncool. But other influences saturated his film work. Despite protestations that he was not a theorist, he frequented sixties' theatre communities enough to understand the concept of "theatre of cruelty" techniques proposed by theatre artist Antonin Artaud, and he vigorously employed a composite *cinema of cruelty* where extremes of emotion and action were analyzed at the expense of language and reason, in the framework of exaggerated, disturbed, and psychological states paralleled with ritualized movements and responses. Finally, he used a Brechtian epic theatre frame where acted sequences were placed in the service of statements about society and its conventions. In *Chelsea Girls* he staged a group of meetings, arguments, and encounters as a composite picture of life in the fashionable and decadent art/life epicenter, New York's Chelsea Hotel. In later years he adopted his complex approach to an ironic, metareality, iconic, Russian constructivist, MTV matrix that interrogated his plotless, formless, cinema, with a deadpan, sophisticated postmodern spin on cable and conventional television. Altogether, it is not surprising that his film works incorporating a use of a mythic, underground film, camp, cruelty, Brechtian, constructivist matrix may have *confused* the reception of his films. Warhol melded many diverse movements of the time as one individual cinema aesthetic. Clearly, his ambitious offerings were never fully grasped. If we dissect and analyze the different strains in Warhol's work, it may seem more comprehensible.

MYTHMAKER

In *Chelsea Girls*, Warhol experimented with juxtaposing various sequences of conversations, dialogues, or confrontations between people in the famous

artists' residence, the Chelsea Hotel in New York. The film contains many Warhol superstars and runs two sequences of film simultaneously through a split screen technique. The six and one-half hours of footage makes a complicated viewing of more than three hours. The first set of sequences shows singer/actress/model Nico trimming her hair, grooming and playing with her son while chatting with a friend. Simultaneously, actor Ondine psychoanalyzes Brigid Berlin, and she volunteers details about her early sex life.

Many critics found the work amateurish or incomprehensible but as a mythic representation of people it is more understandable. Myth seeks to describe origins of things, it explores an old world, it reflects the acts and issues of gods and men, and it tells stories that Joseph Campbell referred to as more important and truer than history. Campbell wrote in *The Hero With A Thousand Faces*, that "as we are told in the Vedas: 'Truth is one, the sages speak of it by many names.'"[2] *Chelsea Girls* abstracts Nico and other characters. They exist in a vacuum almost like characters perched on Mount Olympus posturing about their godlike existence in the otherworldly, abstract Chelsea Hotel. Berlin's confessions to Ondine about her sex life are tantamount to overhearing a private religious confession. Myth is a grand scheme and frame for hanging the productions of a culture, and like religion, it serves as a binder and organizing principle that makes sense of the countless and often distracting phenomenon of daily life. Warhol combines that sense of eternity and stasis with the minutia of daily life. His issues are at once cosmic and universal and sadly comic and ephemeral. Consider that stories of gods are often wrought manifest as simply being and existing. Think of Apollo, Daphne, and the creation of the eternal laurel tree. Similarly, the works of the residents at the Chelsea Hotel are simply presented as tales from some vast Olympian plateau.

Warhol's association with myth began with his professional career, perhaps before. We remember that his family hailed from the region of the Carpathian mountains, a part of Europe engaged in dark perceptions of shadowy creatures and nightmarish images. In his early professional career, his rococo style using highly decorated drawings for magazines in the fifties anthropomorphized shoes making them appear as living and sentient figures beckoning women to the stores. His privately published books for customers offered putti and angels and cavorting cherubs.

As he moved into more diverse product design, he made paintings and drawings of dollar bills, money itself already idolatry to some. Products were favored as Warhol placed soup, flowers, Brillo, and Coke in the limelight in paintings, prints and sculptures. Some may have perceived these images as prosaic for folk tale items, but didn't advertising make products the modern characters and stars of television? His series of stars as portrait images

included Elvis, Marilyn, Natalie Wood, and Elizabeth Taylor, who existed as idols to millions. These figures were already fit for transforming into an immortal form, icons for a secular world of worship. In the films, Warhol invented his superstars and felt that people exhibiting strong personalities and traits could become movie avatars as Hollywood's stars had done decades previously. Warhol perceived that someone becomes more godlike simply by being on the screen. Audiences devour their image. Early films were literally ritual altars where people could watch a still image for sometimes hours and venerate it, worship as people do in prayer in churches. The performance of people at the Factory was like a large social drama conducted by Warhol, as he directed the ensemble in their activities and work lives related to his art production. One is reminded of the power of the medieval church who staged pageant plays with the help of local craftsmen to sculpt communal events where the illiterate masses would absorb the message and liturgy of the church through a series of enacted tableaus. For the most part these images were static portrayals of saints, god, and demons. The priests and nuns could be acolytes one moment offering communion and the next living effigies of characters in these mystery plays. The plays were called mystery plays not because they unraveled the mysteries of faith but because the term *mysteries* dealt with guilds. The *BBC* explained it as, "guilds were known as mysteries, hence the name of the plays. Some guilds presented plays that were appropriate to their crafts."[3] Thus, the mystery plays were symbolic entities for dispensing sacred knowledge. Warhol's workers served in a similar acolyte role. Warhol assistant, Gerald Malanga might be assisting making a silkscreen one moment and later might be doing a whip dance at a performance of the Velvet Underground and later acting in a Warhol film. Films like *Dracula* and *Frankenstein* became more overtly mythic dealing with popular cultural icons, monsters. Later Warhol used Mao and celebrity portraits to build a mythology about fame and celebrity status. He began making videos that glamorized New York, Studio 54, pop icons, public figures, the city, and pop stars who performed in music videos. With younger artists like Basquiat, Clemente, and others, he cobbled together group paintings that combined myth images from different cultures and traditions. Near the end of his career, he created images of himself as a female, self-portraits in camouflage, and variations on the last supper. If the variety of images interacting with our mythic heritage wasn't enough, he did a series of prints in 1981 titled *Myths with Howdy Doody*, a children's character and puppet, Uncle Sam, the Wicked Witch of the West (actress Margaret Hamilton), a Mammy figure from African American slave culture, Superman, and a portrait of a movie star. Most of Warhol's work was focused on some type of myth, and it seems only natural that he injected mythic images into his extensive film work. As Ralph Rosenbaum said in

THE SLEEPING BEAUTY

Figure 5.2. While we don't think of Warhol as a mythological figure or a mythmaker, his career is steeped in mythology. He was from a family who hailed from the Carpathian mountains of Romania where mythic figures (Dracula) were inspired. He loved films and their mythology and he was enamored of the concept of glamour having worked in the fashion industry and for magazines like *Vogue* and *Harper's Bazaar*. This illustration from the twentieth century shows a scene from the fairy tale of Sleeping Beauty made popular in the Disney film.

Andy Warhol, a Retrospective, "the sheer range of his subjects becomes not only international, but mind boggling in its journalistic sweep."[4]

SURREALIST FILMMAKER

Along with myth, there is something playful and dreamlike about Warhol's films, as if we are glimpsing a private dreamworld. In the film *Poor Little Rich Girl*, a sleepy Edie Sedgwick rises and speaks on the phone preparing for her day in public. Her neurotic commentary is like some internal dream dialogue dealing with her thoughts and emotions about the previous day and the coming day, a sort of session processing everything that had befallen her recently. But Warhol studied surrealism much earlier.

His youthful experiences of film were telling. As a child his mother bought him a Charlie McCarthy doll. McCarthy was a puppet, a nonhuman companion, and comical interlocutor to Edgar Bergen's comedy routine as a ventriloquist. From an early age, Warhol saw the figures in the movies as more than human and less than human. A film star was a plastic object that could be transformed into an icon of glamour. In that sense, stars were god-like, but at the same time, not real, not actually alive. On the screen, fantasy figures like McCarthy were portrayed as lifelike, but not really alive. Today, we might perceive them as special effects, but in the golden age of Hollywood studios they were magical iconic figures and audiences had little idea or inclination how Hollywood brought marvels like King Kong, Dracula, or Charlie McCarthy to lifelike but not alive status. These puppet, doll, or mannequin images existed at some half-life between reality and our perception of what is real. This divorce between the real and the filmed images that could be accepted as a sort of made-up reality made the film arts a special place, a portal between the real and make-believe, a magical liminal space where things not accepted as reality could be momentarily believed, what the critics referred to as a *willing suspension of disbelief*. Puppets like McCarthy existed in some demi-animated reality. It was a privileged world inhabited by a few in Hollywood: Disney, Paramount's Max Fleischer studios, and Warner Brothers zany jokesters at Merry Melodies. Remember, too, the surrealists mostly living in exile during the war had made New York and Los Angeles their exiled headquarters. Freud, surrealism, and fantasy quietly blanketed the war-ravaged era. While World War II became associated with an era of new realism, and a darker film noir grimness, the war era of Nazism was also host to *Snow White*, Superman cartoons, Bugs Bunny, and *Fantasia*.

Characters like Bergen's sardonic puppet characters provided a protocol for two worlds to exist simultaneously in a Hollywood film, the concept of

a fabricated reality much like our world, and a far more surreal world where any wacky occurrence might spring to life. McCarthy being both animated and yet not alive, is particularly important for a filmmaker like Warhol who frankly didn't perceive the portal between dead and alive on the screen as clearly as some. Warhol's childhood, mostly lonely, poor, and alone had few friends and few connections to society at large. For Warhol, movies were a substitution, an inversion of a society that allowed kinship and relationship with something that was more than real and simultaneously not fully alive.

When we see the character of Bergen and McCarthy in films of the forties like the small secondary feature, *Here We Go Again* in 1942, it is an incredibly surreal affair with Bergen portraying a professor/botanist seeking a plant and McCarthy portraying the carnal gregarious sidekick/dummy responding in a surly voice to commands and clearly devoted to seducing a series of beautiful woman in an outdoor camp setting. While Bergen is on the hunt for plants, McCarthy's Hyde-like alter ego is on the prowl. In a ballroom scene rivaling Warner Brother's wackiness, McCarthy has a dance sequence with eight women while singing, "This Delicious Delirium." It is as though Salvador Dalí crafted the scenario. A dancing puppet surrounded by statuesque beauties in a cabaret environment in the woods sings a love song about being intoxicated. It is a doll's dream world. The film's blend of abstract humor, the impersonation of humanity by a wooden puppet, the blending of scenes of action, romance, and lust featuring a chorus of prop women and a doll with real agency, sexual motivation, and carnal drive is by steps provocative and disorienting. Looking at just one example of the doll and human interaction makes a viewer think that viewers could imagine all film as a largely uncanny supernatural format, continually merging the human and the posthuman together. Imagine today with superhero films that emphasize superhero effects, how the sense of human and posthuman would seem natural to our young audiences. Warhol from his viewing in the thirties and forties, may have already perceived the film process as a radically different experience. Warhol owned a McCarthy doll and the character's droll larger than life character may have influenced his vision of filmmaking in which the conventional notion of a film might not have been as important.

The Bergen films were a host of surreal structures layered on top of the matrix of Hollywood that was already in the business of fantasy. Later in the film, *Here We Go Again*, McCarthy interacts with some Native American women (played by non-Natives of course; Hollywood always existed in a field of abstracted reality), and again performs the sexually aggressive animated character imperialistically seeking to control the native women. The film ends with Bergen being blown up with TNT, and McCarthy leering at the audience saying, "Anyone want to adopt an orphan?"[5] A single film in

the McCarthy cycle tells us that the films featured comical, surreal plots with elements of fantasy, American imperialism, romance, coded sexuality, and debauchery, all packaged under the harmless guise of a children's comedy. The content is more troubling for today's viewers who might find the surrealistic tropes unsettling and targeted to an adult art house market.

UNDERGROUND WARHOL

Underground film inspired Warhol's filmmaking. Warhol saw filmmaking as a means to undo more than seventy years of American film production orthodoxy, and he intended his film work to be seen as a rebellion if not an active revolution against common filmmaking practice. Warhol himself often referred to film as simply something his colleagues at the Factory thought would be fun, a way to pass the time. However, this was a ruse, in actuality, Warhol was a serious film student.

Warhol had a long exposure to experimental moviemaking. There were many experimental feature films available when he was in college. Patrick S. Smith wrote that, "among the films that were shown at the Carnegie Institute, the artist saw or could have seen classics of avant-garde cinema such as *Un Chien Andalou, L'age d'or, La Ballet Mecanique, La Belle et La Bete, The Cabinet of Dr. Caligari*, and animated short films by Norman McLaren."[6]

In the fifties, Warhol frequented the underground movie scene in New York. On various nights, he might see a variety of the best films in the surrealist style. Dalí's *Andalusian Dog* (1925), Kenneth Anger's *Scorpio Rising* image essays, and Melville Webber and James Sibley Watson's silent version of Edgar Allen Poe's *The Fall of the House of Usher* (1928).Warhol absorbed ideas from his studies of the film industry, the technique of vertical integration, and the operation of production companies; however, he had the audacious idea that he could create a new film community in New York. He believed that the new accessible technology of film made filmmaking easily within anyone's grasp. He would replace the tyranny of plot and literary models with his own emphasis on situation, Freudian scenarios, and unbridled personalities.

It is likely that some of these esoteric masterpieces of avant-garde like Webber and Watson's *Usher*, influenced Warhol's thinking. Webber and Watson's work was rich but part of the oft forgotten experimental film tradition. Sadly, these films had limited distribution, budgets, and little promotion. Webber and Watson's work offered murky sequences suffused with darkness. The siblings Roderick and Madeline Usher lived in a creepy decaying house, and Madeline appeared to die after bouts of weakness and periods of declining

health. She was buried in the family vault. Superimposed images of hands reaching out, combined with shadows as Madeline was laid to rest, give the film a creepy quality. She awakened inside the coffin to realize she has been buried alive. She struggled to free herself against a backdrop of morphing images of stairs, hallways, and phantoms that faded from light to blackness. The film blurred into a dreamlike incoherence of various macabre atmospheres. There were shadowy landscapes, unusual edits, and static emblematic performances. The effect was an aura of unease and dread. The mix of illogic, ambience, and images suggested a landscape of a monstrous dream.

Such films were heady stuff, and it is likely they appealed to Warhol's imagistic mind, but sadly audiences had not been educated in myths like Apollo and Daphne, surreal fantasies like Charlie McCarthy's comical woodland fable, *Here We Go Again*, and Webber and Watson's macabre *The Fall of the House of Usher*, so audiences were widely unprepared to experience Warhol's challenging film works. Warhol imported mythological characters and themes, he pushed activities to surreal levels, exploited amateurish and improvisational styles, and finally, connected with the techniques of pure cinema, including odd compositions, unusual perspectives, and moods instead of the hallmarks of American cinema, character and tightly structured plot. An audience looking for conventional elements of cinema in Warhol's work would struggle, but when accepted as a mythic allegory, mood pieces, or the analysis of a situation the films gain a greater power. Warhol's assemblage of sequences suggested an architectural construction of film material and less narrative structure. Warhol asked audiences to reassemble the chaotic sequences into some sort of meaningful narrative, a set of vignettes, a soap opera created over time. Smith commented that Warhol's use of the long take gave these protracted sequences their power, writing, "by means of the long take, Warhol ensures that somewhere on a reel something will strike a nerve."[7] But Warhol obscured meaning, showing his struggling superstars searching for the scene.

Warhol wanted to place audiences in a different state to alter their perceptions of reality. Barbara Creed in her essay on "Film and Psychoanalysis" commented that film operated using, "special techniques such as the dissolve, superimposition, and slow motion, (all of which) correspond to the nature of dreaming."[8] Warhol also used techniques in his films to achieve the sense of a dream state. Combined with iconology, symbols, auras, and unusual personalities Warhol hoped to revamp the industry using the model of the new underground film. Though his films appear idiosyncratic now, in the sixties, a variety of filmmakers were creating similar nonlinear structures in the emerging underground film community. Warhol was a part of this movement.

Filmmakers like Warhol felt they had to change cinema to save it. In *Subversion*, the history of underground cinema, Duncan Reekie explains that

there were reasons why artists of the first avant-garde felt they must rescue cinema. He writes, "first it was proposed that cinema when perfected could and must become art, but this could only be achieved by the pioneering work of dedicated artists and intellectuals. The creation of cinema art was conceived as not only a birth, but also as a redemption; cinema had to be rescued from its vulgar origins."[9] Here, popular entertaining cinema was perceived as the enemy and cinema that offered intellectual challenges and impeded enjoyment was considered attractive. Reekie explained that after World War II, many of the innovators who had worked in the European avant-garde cinema transplanted to the United States to work. He writes that "the work that was produced was diverse, ranging from modernist mystical synesthetic abstraction to poetic narrative, but a defining feature was an intense and personal exploration of myth, ritual, dream, and the psyche."[10] Warhol's contemporaries were using the grotesque, the ritualistic, and the dreamlike to win converts. These new filmmakers offered an antidote to fifty years of studio formula. Reekie commented that the poorly funded underground movement struggled to attract an audience and patrons.

A prime mover was Jonathan Mekas, who ran the Filmmakers Collective in New York in the early sixties in a small apartment space where filmmakers were encouraged to meet and collaborate. Mekas's loft, was an epicenter of young filmmakers who watched a variety of art films and forged a variety of collaborations. It was a cell of idiosyncratic, personal, and unconventional filmmakers who wanted to use the new emerging 16-mm phenomenon (a smaller semi-pro, grainer film format) to challenge Hollywood's hegemonic control. Mekas, a Lithuanian immigrant who was interested in expanding cinema styles, produced a series of video diaries, long before the self-referential work of Youtubers made self-documentation a part of daily life. He wrote a film column for the *Village Voice* and worked with Warhol, Yoko Ono, Salvador Dalí and curated and showed thousands of films by a variety of artists and filmmakers. Interviewed by Patrick S. Smith in 1978, Mekas described the Collective saying, "it was a very busy period in New York in the Independent Film area, and the co-operative was the meeting ground for people, during the period, where the filmmakers stopped by during the day, During the evening, I was living in the back of the Co-op space."[11]

There was much diversity in the underground community. Like Mekas, Stan Brakhage was an experimental filmmaker who used techniques such as hand-painted films and scratching the film surface to alter the medium. In one of his films, *Prelude # 1*, he illustrated a succession of painted slide stills that flashed by like a series of abstract expressionist canvases. Color, light, and abstraction combined to create an attractive experience. Brakhage viewed film as more like poetry or a visual experience. Although he made narrative

films as well, many of his films were explorations of light, shapes, and movement. One experimental film, *The Wonder Ring* featured images shot from the passenger's side in a car ride. Sometimes his films featured ambient music, while at other times there was silence or music concrete as a score. Brakhage wrote that, "any memory process . . . is electrical . . . and expresses itself most clearly as a 'back firing' of nerve endings which do become visible to us as 'brain movies.'"[12] Brakhage's obsession was with these brain movies, with the sensory experience, and the operation of memory.

A brilliant and radical voice belonged to filmmaker Maya Deren. Deren, a Russia immigrant, proposed a radical reevaluation of the way films might be produced in the 1940s. She shared many filmmaking principles with Warhol. For example, she worried that cinema was innately corrupted by its connection to profit. Further she eschewed language and opted to emphasize the power of the body. Her cinema was physical and nonliterary. Her films sought people acting with little dialogue. Warhol, too, emphasized physicality if not physical beauty or the lithe movements of Deren. Warhol used muscular actors like Joe Dallesandro or elf-like beauties like Edie Sedgwick who were selected for their physical presence to appeal to both gay and straight audiences.

In Deren's *Meshes of the Afternoon*, a woman awakens in a strange remote sunny bungalow. She wanders about and shadows erupt and follow her, and an intruder enters the space. She dances and runs about, becoming more frantic. She tours the house and finds a key in her mouth. She spies an intruder with a mirrored face and a black cloak. She sees two images of herself. She thinks the intruder will stab her with a knife, but instead a kind, handsome man awakens her with a tap on the shoulder. She goes to bed, and the man goes out and finds broken things in the room. The woman is found, lying in a chair enwrapped in seaweed and debris. Her eyes are open, and she appears dead. Central images are doubled people, shadows, fleeting movement, a key, a knife, and the image of sleep. It is intentionally obscure, visual, and symbolic. Sarah Keller writes about Deren's ideas of cinema in *Incomplete Control* saying, "Deren's respect for the idea that the balance between chaos and control makes up an important part of the purview as an art form: from the mass of details the filmmaker directs attention toward that which is significant."[13] Warhol like Deren created a world of angst and anxiety and like Deren, Warhol rarely resolved his films with neat finishes. Warhol shared many qualities with Deren: a focus on the actor and the actor's body, dance and movement as communication, and the film world as an alternative dream reality. Sadly, this agenda was difficult for audiences bred on rapidly edited, plotted, formulaic, television techniques. Though underground filmmaking influenced Warhol's filmmaking, it didn't help him find audiences.

OFF TO CAMP

Warhol dealt with a series of critical structural problems in attempting to remake film. One issue was the notion of text, the literary theatrical basis on which most films of Warhol's era were supported. Robert Kolker writes that texts are more than scripts; they are a sociological construct that binds audiences and filmmakers and films together. He writes that "the viewers' experience itself is informed by the culture in which he or she lives. A person's beliefs, understandings, and values are all activated within the context of film viewing. That is true for the people who created the film as well. They too are a major part of the text. Their beliefs, their understanding of what a film should or should not be."[14] Warhol used text as a reflection of the culture. For Warhol the text wasn't necessarily a literary device, it was involved with an affectation or a style of performance. As Warhol said, people like to devour the performer in a film. For American society, the culture of film had been built primarily on a star system and not on the literary quality of the film or its writing. Warhol wanted to remake film in the model of this star system only substituting the total engagement with stars with his superstars and their situations.

But a problem in the sixties was the notion of cool. Being actively engaged was considered uncool, so actors had to perform but remain emotionally cool. This resulted in a knowing self-referential mindset. Films of the sixties seemed to smirk at their audiences as if the two were sharing a joke. It is apparent in mainstream films of the era, the James Bond films, *Dr. Strangelove*, *The Pink Panther*, and *Tom Jones*, that there is a private dialogue between film star and audience. This condition of continual self-awareness, of constant self-monitoring made it difficult to mount cinema without an extreme degree of style. When done with smoothness as in the James Bond romps it could be enjoyable and feel sophisticated. However, when its archness and self-awareness reached a dangerously high level, the style and form could invert itself to a laughable frame known as camp.

Susan Sontag discussed it in her famous article "Notes on Camp," and she spent considerable time discussing the novel manner in which camp manifested itself as a new style, not quite kitsch or parody but sharing qualities with both. Using humor externally but within its own world, everything was carried out in a droll and deadpan manner. Sontag wrote, "camp is a certain mode of aestheticism . . . not in terms of beauty but in terms of the degree of artifice, of stylization . . . to emphasize style is to slight content, or introduce an attitude which is neutral with respect to content."[15] Warhol used camp to emphasize style and performance and to degrade the importance of scripts, which for Warhol forced imposition of an outcome, an end goal in the filmmaking act. To him, camp texts offered more freedoms for filmmakers.

For Warhol, the filmmaking process was about recreating the process of making films, and camp participated in that process. For nonprofessional actors who could not understand the theatrical notion of a fourth wall, camp allowed the actors to call attention to themselves and to call attention to their act. Anna Malinowska defined it as, "camp's tastes—theatrical, flamboyant, tacky, and deeply ironic—linked it to pop art which, although very different embodied an attitude that is related.'"[16] Pop's insistence on popular icons and images. Its preference for new materials for construction and new technologies for accomplishing art required a new sensibility for its proper reception. If one reflected on the new materials such as Warhol's soup cans as merely a retread of household items that would render them blasé, banal, and beneath notice. But camp, although not exactly pop, understood and referenced pop. As Sontag said, it placed the world in quotes. Pop demanded that the world *re-view* things in a new light. For Sontag, camp rendered a pop artwork as a "soup can," not a soup can. Placing the item in quotes and reevaluating it as an art object, made it new again and worthy of reconsideration.

CAMPING *BATMAN/DRACULA*

Even in the context of camp, there is a strong tendency to transform characters into mythological representations. Many of Warhol's actors bear a Promethean subtext. Warhol's 1964 *Batman/Dracula* features sequences of a grinning leering Jack Smith (himself an underground filmmaker) mugging his way through the sequences. In one segment, Smith leers and interacts with the camera in a tight close-up posing as the villainous Dracula. However, the projection of his evil and transgressive power is only suggested by the leer into the camera. He does little to extend the performance. After the credits there are two scenes quickly superimposed over each other. Actor Taylor Mead, one of Warhol's A men (amphetamine users), acts in a shadowy image in the background like some mad drug user needing a fix. He may appear to be Dracula's Renfield character. The early part of the film has a version of a Batman theme but not the version from the 1964 television program. This film was made months before the Batman show aired. The Mead shots and shots of a woman and man, perhaps Jack Smith in cape (the image is unclear) and one of his female helpers or vampire brides are all like commercial representations, showing and presenting but little else. The backgrounds are highly urban with tall buildings on all sides. The audience senses the claustrophobic atmosphere. After a variety of odd and changing jukebox musical edits, the film comes to an end, seemingly more of a trailer for the actual film than a film with any sort of forward progression. Things end much as they began.

Batman/Dracula operates as a series of still images with music and a collage of shots with some superimposition of images. Story disappears and is replaced by the actors, some rough camera work, and marginal editing suffused with a musical background.

Warhol's film work is focused on a variety of different values than those espoused by traditional narrative film of the era. Camp is a prominent technique. Warhol's films are relaxed and casual affairs. Sontag refers to camp art as being decorative arts, as rarely dealing with important subjects, and as mostly people who are playacting at a very low level. Sontag calls it, "the love of the exaggerated, the 'off,' of things-being-what-they-are-not."[17] In this sense camp is rather an attitude than a pure form. When we take a look at camp culture of the sixties, we see products like the *Batman* television series, where the production values are high, but the artifice is even higher. Adam West acts like Warhol's Viva and Taylor Mead in an arch and over-inflated way. All sentences seem to be punctuated in exclamation points. Melodrama codes all actions and the plot seems reduced to silly actions. The plot, for what it is worth, exists merely to bring out and display the actors in their costumes to situate the combatants on stage for their prescribed mock battles. Situations are continually inflated and the context of superheroes is constantly and internally ridiculed and lampooned in the subtext of the show. Roland Barthes, in his *Mythologies* text, described something similar in the presentation of wrestling matches. He wrote, "the virtue of all-in wrestling is the spectacle of excess."[18] No one within can take seriously the proceedings so the audience is instructed to see the happening as silly and irrelevant as well. Barthes mentions the desire to sustain the spectacle in wrestling as well, saying, "in other words, wrestling is a sum of spectacles, of which no single one is a function: each moment imposes the total knowledge of a passion which rises erect and alone, without ever extending to the crowning moment of a result."[19] For Warhol, creating the anxious state of spectacle seems to be the central conceit of this form of film.

CAMP APEX: DRACULA AND FRANKENSTEIN

By the seventies, Warhol, depressed by his inability to market film as a product, had largely withdrawn from production. Most critics today describe *Andy Warhol's Blood for Dracula* and *Flesh for Frankenstein* as Paul Morrissey films and not products created by Warhol. However, the productions, bearing Warhol's name, do convey much of the quality of camp that mark other Warhol film products. As Sontag explained, the camp sensibility may have been more important to the creation of the art in this era than the subject

matter. Frankenstein and Dracula seem to be furiously and intensely commit-ted to the horror shocks and thrills of the film, although most of the action is patently absurd. Frankenstein makes sodomizing love to his creations, cuts off heads with hedge clippers to harvest brains, and Dracula pukes nonvirgin blood when attempting to feed.

Flesh for Frankenstein composed by Morrissey, Warhol scribe and sec-retary Pat Hackett, and others creates an inverted version of Mary Shelley's *The Modern Prometheus*. Here Frankenstein is about creating a perfect race of humans by his own hand. There is a homosexual element in the concept of production because he wishes to bypass female procreation and directly create this new species by making a perfect couple of proto-super beings and having them mate to create his master race. Morrissey hints at Warhol's own sexuality, and Udo Kier's neurotic, demanding, and commanding Franken-stein appears as a hysterical screamer who likes to order about subordinates like a commander. He follows in the line of other hyperperformers from Warhol's Factory superstars. He may be styled after Warhol by his commit-ment to master plans and large-scale schemes. The plot hinges on his dream to attach the head of a libidinous youth (Joe Dallesandro) to Frankenstein's stolen perfect male body and, thus, inspire the monster to have a massive sex drive and to easily create a race of perfect Serbian creatures. Clearly, Mor-rissey is making thinly coded references to Warhol's unsuccessful sexual identity and amusingly portrays the monster as unable to perform successful sexual relations. In Andy Warhol's *Blood for Dracula*, Morrissey completes the spoofing of Warhol's own sexuality by making Dracula addicted to virgin blood. Unhappily, the vampire can rarely find a virgin, and the polluted harlot blood he does consume makes him deathly ill.

WARHOL'S EPIC ABSURDIST CINEMA OF CRUELTY

Another side of Warhol's work in film is his progression through different styles of what might be termed a *cinema of cruelty* or a *cinema of alienation*. Warhol was keenly aware of Antonin Artaud's cinema of cruelty experiments in which physical action and gesture and emotional states evolved a vocabu-lary different than the literary-bound realism and objectivity of playwrights like Henrik Ibsen. Warhol also understands the notions of Bertolt Brecht, the German playwright of the midcentury who sought a didactic theatre to teach concepts of social responsibility to audiences through a Chinese acting style of alienation and physical reminders through placards, partial settings, and music that an audience was witnessing a play and not real life. Warhol, him-self, often considered the ultimate loner, liked to create an emotional distance between himself and his entourage. This distancing effect clearly exists in his

films. Warhol reasoned that if a film was not progressed by plot, script, or linear progression then it needed another motive force, and this he found in the form of anxiety, psycho-drama, and a new heightened form of alienation effect. Performers like Ondine brought a drug-fueled intensity to the party. Edie Sedgwick brought a series of neurotic fixations and vulnerability to her roles. *Poor Little Rich Girl* featured Sedgwick and cast her as a fatally entitled, neurotic, wealthy child. Indeed, Warhol merely extends the idea of a film through an unelaborated situation rather than a full script or scenario. We simply see the acting out of the "poor little rich girl," not a scenario involving her. In the film, Sedgwick wanders around a room aimlessly searching for things and pondering her appearance. There are mythic subtexts, a suggestion of Aphrodite and gods that require worship to exist, but Warhol maintains a focus on the superstar to explore her reaction to the intense scrutiny of the camera. During the first half of the film the footage is wildly out of focus, and the figures moving in the room are a constant blur of motion. Warhol's film borrows from Brecht's alienation effect. Actors impersonate the characters but rarely are completely in the character. There is an emotional distance sometimes introduced by humor and camp, but in Sedgwick's case there is a real series of distancing effects at work. The camera reminds us we are watching a staged action. Sedgwick seems uncomfortable in the long analysis of her person. She comments on New York life, women's preparation for the day, the social aspects of life performance, the vision of a new self-absorbed youth culture, and the flourishing bohemian scene. Wilcox writes that, "that once again the focus or lack of it doesn't matter; the filming is the thing not the film."[20] Indeed, these films serve as sociological documentaries of people and their situations. If indeed he failed to transform film, he did stage a pyrrhic revolution, using myriad techniques to alter the mechanism of crafting and creating film products.

While Warhol participated in literate society (*Interview*, *Popism*, *The Philosophy of Andy Warhol*, *A novel*, *Pork*, a play, etc.), he also advocated the postliterate work, something entirely composed of image, music, and emotion. When in filmmaking mode, Warhol rebelled against the idea of the dominance of the script-based, intellectual, and literary basis for film production. Like many thinkers of the period, Warhol looked for alternatives to the literary, theatrical, narrative form for film. He found a kinship with Brecht's ideas. Brecht argued for a, "work of art (that) put the spectator in a speculative position."[21] Warhol sought something similar. He wanted film audiences to walk out of a film baffled and asking questions.

Both viewed film or the stage as a dialectical process. Conventional film or theatre brought people to the entertainment but had no mechanism to change or alter their perceptions. Brecht and Warhol both shared the sense that art could do additional work. Film or theatre had an obligation to push people,

to make them question, and to make things uncomfortable. People were read-ing Antonin Artaud's *The Theatre and Its Double*. Artaud had written that, "we must get rid of our superstitious valuation and written poetry. Written poetry is worth reading once and then should be destroyed."[22] Artaud wasn't so much criticizing literature and declaiming it as worthless, but he was say-ing that its pleasure and power were transitory. The emotional impact of the written word is limited to the one administration of its emotional power and after that its impact fades whereas the language of gesture and physical action are infinite and continually renewing. He writes that, "the poetic efficacity of a text is exhausted; yet the poetry and efficacity of the theatre are exhausted least quickly of all since they permit the action of what is gesticulated and pronounced and which is never made the same way twice.[23] For Artaud and many looking for a new kind of theatre in the sixties, the way out of the trap of a literature-bound theatre was a theatre of body, gesture, and physicality. Warhol adhered to a theatre of gesture, emotion, and physicality. Warhol pursued this same theatre of the physical in his films. He believed that scripts and conventional preconstructed structures were less interesting than the interaction between people in the moment, and he wished to preserve that momentary and real interaction between strong personalities in the structure of his film projects. Often such characters projected a nihilistic absurdism.

Critic Martin Esslin coined the phrase, "theatre of the absurd" to describe this malaise of the postwar era, and he ascribed qualities of the absurd to writers Arthur Adamov, Eugène Ionesco, Samuel Beckett, and others. Esslin wrote that while absurdism was puzzling, it was not incomprehensible, and audiences could feel it in the plays they witnessed. He wrote:

> For while the happening on the stage are absurd, they yet remain recognizable as somehow related to real life with its absurdities so that eventually the specta-tors are brought face to face with the irrational side of their existence. Thus the absurd and fantastic goings-on of the Theatre of the Absurd will, in the end, be found to reveal the irrationality of the human condition.[24]

Warhol was seeking to describe a similarly absurd universe in his films.

WARHOL'S TELEVISION

A whole day of life is like a whole day of television[25]

—Andy Warhol

The very eclecticism that doomed Warhol's film work, enlivened his televi-sion and video technique. In *The Philosophy of Andy Warhol*, Warhol started

Figure 5.3. Warhol was a consistent fan of technology. Computers, cameras, tape re-corders and other gadgets made his life fun and eventful. He carried tape recorders and cameras with him everywhere.
Photofest

by saying he calls his friend, B, every morning. He discusses how he com-pares his life to television programming. He says, "TV never goes off the air once it starts for the day and I don't either."[26] Warhol understood the methods of television and lived with television most of his life. His television quip re-vealed much about Warhol's productive working methods, and his sense that television was *the* medium of his time. It was adaptable, open, and porous, lacked the rigidity of formats the beleaguered film, and conformed comfort-ably to Warhol's quest for an elastic and plastic medium.

Perhaps of all of Warhol's production efforts, his television work is simul-taneously his most visible and most invisible. He joked that he wanted his own television show titled, "Nothing Special."[27] His experience of television extends from its beginnings as a medium into the age of cable TV and MTV. Warhol had worked doing still cards and graphic arts for television studios as part of his commercial art practice in the fifties. Warhol understood the complicated relationship between motion graphics, still graphics, visuals arts,

advertising, and television. In the exhibition, *Revolution of the Eye, Modern Art and the Birth of American Television*, Lynn Spigel makes the point that modern art and television were bedfellows, saying that, "the rise of American television after World War II occurred at a time when the United States became an international center for art and design."[28] Warhol came to video with no fewer ambitions than in his film work, and video as an industry was less established and more open than the insular film world. Video was a newer and more dynamic medium. Maurice Berger, writing for the *Revolution of the Eye* exhibition, commented that early producers, "appropriated the style and concepts of various avant-garde movements,"[29] and through shows like *Twilight Zone* brought surrealism into Americans' living rooms. But Warhol was not the only artist or even the only pop artist deeply influenced by the media. Berger reminds us that CBS maintained close ties to the modernist movement. He wrote that, "the CBS design campaign was consistently influenced by modernist art and design—from the modified Didot typeface of the signage in the company's New York headquarters to the smart and elegant CBS eye trademark, inspired by the hex symbol on Shaker barns and possibly Magritte's 1928 painting *The False Mirror*."[30] Warhol himself had been shaped in his simplified design aesthetic by the influence of Shaker design and craft work. Ambient ideas of an era can influence artists and their production even when concrete direct influences fail to exist.

EARLY VIDEO ADOPTION AND CODING

Warhol watched television regularly, and it organized his day. Television to Warhol seemed to record the daily activities of the world. He remarked in his *Philosophy* that, "they drink the same Cokes and the same hot dogs and wear the same ILGWU clothes and see the same TV shows and the same movies. Rich people can't see a sillier version of *Truth or Consequences*."[31] For Warhol, television like Coca Cola was a leveling device. It erased boundaries of class and distinction. It made everything the same. For Warhol, a bland, undifferentiated world was a good thing. He saw such a world as the egalitarian paradise where the aspiring young person with energy and ambition, a person like himself, could make good and be accepted into society. With his fear of his own unattractiveness, his poverty origins, and his outsider status, Warhol sought anything that could put him on a level field with the elites. He began with this premise that mass culture leveled culture, brought everyone to the same table. Spigel writing about Warhol's vision of television explained that, "delivered via the quotidian form of chatty personal recollection (as opposed to the burgeoning 1970s' discourse of media theory), Warhol's TV philoso-

phy is all about the medium's relation to the everyday, the intimate spaces of the home, and to a kind of "talking" cure he could not seem to find at the analyst."[32] Warhol's love of television coupled with his use of camp and parody, two techniques that through the medium of film and later video, also reduced everything down to a language and dialogue that as a gay man, as an artist, as an outsider, he could understand, gave him a measure of control over the chaos of social interactions, and more importantly, the transfer of commerce. Camp and parody were the desired discourse of his community, a community where everything was simultaneously hysterically important and mildly superficial, casual, and informal and simultaneously a command performance, a space where there was no leadership and everyone appeared to be equals, but the space produced a clear hierarchy with Warhol and his lieutenants supervising the discourse and gatekeeping the flow of madness. Television worked well for Warhol's structural approach to media production.

Warhol's video work accelerated during the seventies. Technology became cheaper and demand for video product increased. Warhol's marginal fringe hipster arts market was now a niche that cable desired. Vincent Freemont, one of Warhol's key associates in the seventies and eighties, encouraged the move into video and new media. Christina Rouvalis, writing for the *Carnegie Magazine* in 2010, wrote that, "Warhol was obsessed with new artistic media and documenting his life and world: from Polaroids to his ever-present tape recorder, and from the first time he got his own movie camera in 1963 until his death, film and video."[33]

Warhol lost none of his offbeat, deadpan kitsch, and camp sensibilities. In fact, the postmodern period of the eighties embraced more self-referential art and more humorous motifs as pop began to see the end of the rock era and accepted the absurdity of the rock guitarist-god and hair-metal bands with their massive perms and coiffures that out-Warholed Warhol's white mop. If Warhol's absurd wigs and shock of white hair standing straight on end in the eighties signaled a rupture with corporate culture and a statement of primitive activism, then the demented permed locks of Dee Snider provided the nadir to rock performance in the mid-eighties. Compared with the metal bands that copied his bogus hair line, Warhol by the eighties had become a relatively conservative presence in the media landscape.

Warhol produced three programs between 1979 and 1987, made appearances of ABC's popular romance show, *The Love Boat* in 1985, and created a trio of one-minute ads for NBC's *Saturday Night Live*. All of this production introduced Warhol to an audience that had only heard of the artist through rumor and his ringmaster act over the sixties' Factory complex. Alexxa Gotthardt describing his program, *Andy Warhol's Fifteen Minutes* on MTV, wrote that, "first, it placed an artist—rather than a musician, VJ,

or actor—in the host's role. It also brought underground artists working in all mediums onto a single show, then delivered both their art *and* their antics to a mainstream audience."[34] Further, when one looks at videos of Warhol's *Fifteen Minutes* show, it resembles the narrator-less austerity of the new millennium's PBS arts program, *Art 21*, which, cued by Warhol, simply drops artists in to talk about their work. It is a fitting tribute that an example of art programming today is inspired by Warhol's eighties' videos.

Warhol lost none of his edge in these late works. He is caustic, combative, well-scripted, and lacking an earlier reticence. He is genuinely engaging and seems to relish the spotlight position. The platform of MTV allowed him to introduce a variety of artists, musicians, and drag queens to the teen MTV demographic. If anything, the MTV venture encouraged his corruption of a whole new generation of youth on a far larger scale. Again, as he had attempted in the film medium, Warhol's goal was to pioneer a new way of communicating, a new style of video, and MTV with its preference for immediate cable, pop elitism provided an elegant vehicle to reach the marginal and fringe that enjoyed his work and stood apart from the mainstream. Technically the show prospered from postmodern sensibilities. MTV's actual studio facilities were marginal, but their staff of video technicians, effects processors, and video editors provided Warhol with the level of visual support and technical packaging that had eluded his product in earlier film and video incarnations. Spigel in her "Warhol's Everyday TV" refuted the standard argument regarding Warhol's later work. The flawed narrative places Warhol as a dynamic innovator in the sixties, then after his near-fatal shooting his work becomes corporate and more conservative and less interesting. Spigel retorts that, "but this rise and fall 'sell out' story arc does not seem to me to be a valuable way to understand Warhol's lifelong engagements with the TV medium."[35] As Spigel and other critics have discovered Warhol's late video work is crisp, pointed, and embarking on a new relationship with postmodern sensibilities. Gone are the approaches to Dadaistic avant-garde, neo-primitivist productions luxuriating in their lack of sophistication. The touches of Brecht alienation and perhaps even tones of mythic characterizations are present, but the theatre of cruelty austerity is gone. Gone are the affectations of minimalist untrained naïve folk art. Here Warhol embraces the full-throttle screech of fast-edit, hypersurreal, colorful, video sensory overload, and rapid-paced edited cutting that transformed Warhol's video work from the simplistic experimentalism of his sixties' film work. He arrived at a distilled and aggressive art product lobbed at an unsuspecting, somnambulant child/elite audience. Warhol's late counterattack on the media was so swift, massive, and overwhelming that audiences didn't know how to react or relate to the product. As Raymond Williams said of the state of flowing media in

television, "it is a characteristic for which hardly any of our received modes of observation and description prepare us."[36]

Of course, in today's media world with a preponderance of streaming media intended to overwhelm us and reduce our inhibitions to advertising and shopping the concept of binge watching whole seasons of television programming in a single evening is becoming the commonplace form of high postmodern viewing experience. Warhol's brief and late foray into MTV streaming programming in MTV's nonstop visual assault of advertising, and videos (which were also advertising) and pop bands (which were also advertisements for music through records and CDs) and commercials (advertising that was nakedly advertising), and programming like Warhol's *Fifteen Minutes* that participated in the concept of continually transforming images, guests, events, and fashion reality (an entertainment program that mirrored the elements of an advertisement and like so many other projects returned Warhol not so much to the advertisement world he had begun in, but reflected a completely transformed art and commerce world that Warhol now found himself often confounded by).

The program's values were hyperaccentuated. The editing was quick and rapid. Split-screen shots of Warhol and his guest artists punctuated the credits. Deborah Harry in a Warhol-designed camouflage dress popped on the screen. Exotic color design and video effects were dazzling and melded into each other. Warhol talked with Harry and signed her camouflage legs with a marker. Tracking shots and fast-motion shots mixed with other segments. Warhol interviewed guests or they interviewed themselves. Many of the same qualities that punctuated the film work of the sixties punctuated the video work of the eighties; however in this vehicle, the rapid-paced use of technology benefited Warhol and his drive to create a magazine, a collage of popular culture.

If we consider television as a medium for Warhol's processes, we might see it as Warhol's Disneyland, a great utopian world enterprise. Keenly aware of the media in his era, he embraced nearly every technological medium of his time. He understood emerging media theory, and more importantly, he understood how to apply theory. Marshall McLuhan wrote in 1964 that, "'the medium is the message' because it is the medium that shapes and controls the scale and form of human association and action."[37] Warhol understood that mediums placed people together and if he mistook anything, it was identifying this unifying action with film, that lacked the immediacy of video. Warhol wanted to place everyone in action to combine the forces and personalities and anxieties of his superstars into a zeitgeist or a movement. But in the sixties, the film world, as rapid as it was, was ultimately too slow to catch that rapid fire interaction. Television was better equipped to display and unify the disparate elements of society through its lens.

In a sense Warhol's film work of the sixties was a prelude to the pre-reality television movement that began to occur in the seventies. Giulia Palladini in her essay "Nothing Special. Andy Warhol, Television and the Becoming Public of the Present," explains that Warhol's work was sort of an ethnographic field recording. She says, "his mode of recording anticipates the concept of 'field recording,' so central to his cinematographic practice."[38] His work of photographing everyone and everything, his habit of recording all conversations when he obtained his tape recorder made him more genuinely connected to technology than to people. It was merely a stark part of his reality. He says, "when I got my first tv set, I stopped caring so much about having relationships with other people."[39] Warhol recognized that television could be a more reliable partner for voyeurism, titillation, and even deviance. His transgressive film and video work predated the freedom of YouTube where one's desire for endless cat videos or other mindless amusements could be fulfilled at the click of a mouse or the swipe of a phone screen. Further, Warhol's involvement in video parallels the rise of early reality television programming like PBS's innovative *American Family* program. Palladini reports that the second episode even quoted Warhol with Pat Loud going to the Chelsea Hotel in New York to visit her son, Lance Loud.[40]

In the mid-sixties, Warhol's notoriety had made him a marketing commodity, and the Norelco Corporation gifted *Stereo Magazine* with audio and video recording equipment. Warhol was already a famous figure and the magazine assumed that if Warhol was empowered to use the equipment, the magazine would derive a good story from the experiment. Thus, Warhol became an early adaptor of the technology. Warhol began to experiment with portable video recording equipment and began to tape his informal "Factory Diaries," a loose collection of some three hundred videotapes recorded off and on during the sixties and seventies. Warhol was attracted to the romance and nostalgia of film but gradually the simplicity and speed of video production won him to the newer medium. In his history of Video Art, Chris Andrews writes that:

> During the period under discussion (from about 1960) there has been an extraordinarily rapid development in electronic and digital imaging technology. Advances in the field have transformed video from an expensive specialist tool exclusively in the hands of broadcasters, large corporations and institutions into a ubiquitous and commonplace consumer product. In this period video art has emerged from a marginal activity to become arguably the most influential medium in contemporary art.[41]

Warhol began to host showings of video along with film programs. After his near-assassination, he saw the rise of video art as a more practical way

to reach people. Film required masses of people and crowds. Crowds could be dangerous and host mentally unstable people. Crowds had the potentially for disorder, a loss of control, while video only required a simple camera/microphone apparatus. Further the results were instantaneous. You either had an image or you didn't.

Warhol's experiments with video began not long after his work in film began. He simply set up the video camera in a corner of the room and allowed the video to record events at the Factory. A traveling exhibit from the Andy Warhol museum, *I Just Want to Watch: Andy Warhol's Film, Video and TV*[42] debuted in 2010 and illustrated the wide array of filmed productions that Warhol assembled over his career. Curt Riegelnegg writing for the *Pittsburgh City Paper* in 2010 argued that it was standard to, "regard Warhol as impermanent and self constructed, and my fascination with this exhibit largely sprung from the chance to unravel this inscrutable character."[43] Indeed, Warhol through a succession of video projects did reveal his intimate relations with media and his career-long interest in television as a medium. Alexa Gotthardt writing for *Artsy* described Warhol's early video experiments explaining, "those videos debuted at a party in an unused train tunnel below the Waldorf Astoria Hotel in 1965."[44]

In the seventies, video became a consumer commodity. Warhol quietly produced a soap opera series titled *Vivian's Girls* that never aired and featured semi-scripted and improvisational performances. Stephen Koch in his text about Warhol's filmmaking activities, *Stargazer*, wrote that, "Warhol had gone about just as far as he could with cinema. It also became obvious from films such as *Soap Opera, Outer and Inner Space, Since,* and *The Nude Restaurant* that he had become increasingly fascinated by video and television."[45] Koch also reported that Warhol's objectives as an artist and filmmaker had changed. Koch writes that, "He had turned his attention to making video and television, media better suited than film to his desire to record events continuously."[46]

Video coalesced with his business ventures in the seventies. His film magazine, *Interview*, was expanding into the realms of gossip, popular culture, the arts, and fashion. Video and film work allowed Warhol to connect to a larger community than the insular arts world and his aesthetic plan called for art to assume egalitarian proportions. Video work, through his *Andy Warhol's 15 Minutes*, allowed the artist to reconnect to the youth crowd. At last, he was on MTV.

Nights, through dreams, tell the myths forgotten by day.

—Carl G. Jung[47]

Chapter Six

Warhol: The Secret Surrealist

It begins with a bizarre murder with a Marquise de Langrune horrifically slain, stabbed through the throat. The intrepid Inspector Juve of the Sûreté investigates and finds a trail of theft and murder wherever he steps. Fantômas, an arch thief, criminal, and master of disguise, is eventually caught, tried, and sentenced to death by guillotine. On the morning of the execution, Juve rushes into the courtyard holding the head of the murderer, screaming it wasn't the killer after all but an actor in disguise. Fantômas has escaped.[1]

The Fantômas detective series of novels were knocked out by writers Allain and Souvestre at the remarkable pace of a three-hundred-page novel per month, and French audiences including the surrealists were fascinated by Fantômas the remarkable villain, criminal, thief, and murderer who wore a black mask and dressed in unflawed eveningwear. The novels were fantastic, absurd, and transportive. Audiences imagined themselves in some cryptic underworld adventure and the tales set the tone for the complicated borrowing of literary form, art, pulp fiction, and film noir that arose around the popular series. The editor of the series was Marcel Duhamel, a member of the surrealists circle of friends and thinkers, and he in turn was friends with the painter, Yves Tanguy. He put him up in a small house and helped the struggling painter with shelter for years, allowing the painter to concentrate on making art.

The surrealists were an odd clandestine group of writers, thinkers, schemers, and revolutionaries that practiced ideas from science and the esoteric arts in their goal of creating a better more truthful art form for the twentieth century that ventured from the world of external truth and prosaic realism to an inner truth founded on "works inspired by dreams, the supernatural, the irrational and the absurd . . . in the context of a particular period, the years between the two world wars."[2] The surrealists were involved in all sorts

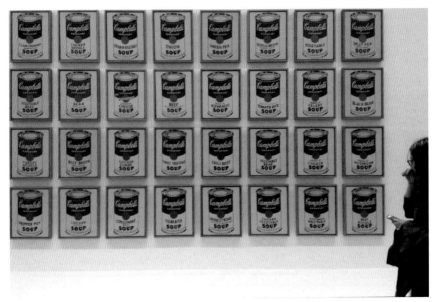

Figure 6.1. Like the surrealists, Warhol was fond of juxtapositions of the everyday and the obscure. His brilliant arrangement of sixties Campbell's soup cans arranges the paintings whimsically in the manner of a supermarket display shelf, something that comically connects to middle-class depictions of suburban opulence: abundant food. It is at once familiar, captivating, commentary, and unsettling.
"Archive Photos/Santi Visalli / Contributor"

of enterprises, films, music, theatre, novels, manifestoes, sculpture, and of course, painting. Their spirit, ingenuity, and profound desire to change the mechanism of art from the rational and representational to an inner truth based on psychology, new technologies, and games transformed the modern avant-garde practice of art. Yet the methods and techniques of the surrealists were slippery at best. Like Warhol, they worked to create a new way of creating art, and Warhol borrowed from their techniques and assault on the world of proper bourgeois art.

> In the first NY Independents Exhibition, 1917, he (Duchamp) entered a porcelain urinal with the title Fontaine and signed it R. Mutt to test the impartiality of the executive committee of which he himself was a member. By the symbol Duchamp wished to signify his disgust for art and his complete admiration for readymade objects. But R. Mutt's entry was thrown out of the show after a few hours debate.[3]

Elsa and Peter Bethanis in their *Dada and Surrealism for Beginners* explained that Dada art was distinguished by attitudes of "simultaneity, contradiction,

and paradox."[4] The Dadaists believed art should be simultaneous, as in quick and easy. It should present contradictions so that people could not perceive the totality of the work quickly. The contradictions would force the work to be absorbed slowly. Finally, the work should be paradoxical, that is saying two different things at once. Duchamp's *Fountain* qualified as simultaneous, contradictory, and paradoxical.

There were two brands or distinct visual styles in surrealist art. Of course, all the surrealists had different, distinct, and well-developed styles. However, generally they could be discussed as one of two forms of painting. The first group included more traditional painters, like Salvador Dalí who could render the world and represent reality most effectively. His paintings, apart from the strange and surreal subjects, would have been beautiful paintings in a representational fashion. The second form of surrealist technique came from painters who sought no relation to past forms and believed that they should paint from pure automism and not from preconceived codes and styles of

Figure 6.2. Warhol was profoundly influenced by surrealist design where all thing appeared normal and then something unsettling showed the entire design was unreal and impossible like something in a dream.
"Library of Congress Prints and Photographs Division, LC-DIG-ppmsca-09633

painting. They allowed the subconscious to dictate to them the shape of form. As Richard Brettell explained it, they painted with, "no clear representational function," and in their minds "the work of art is automatic, the direct communication of the unconscious mind."[5]

Warhol's work pursued similar strategies, he was a good draughtsman, and he could use the techniques of simultaneousness, contradiction, and paradox in his art and its production. Even his commercial art is a good example of this. Consider one of his famous shoe drawings from the 1950s. There is a shoe portrait called "High Heel Shoe" from 1955 that shows a lovely decorated shoe in gold with designs and straps in red. It is a traditional women's shoe, brightly colored and illustrated and attractively designed. It is alone in the center of the drawing. First the shoe image qualifies as being simultaneous. It is at once a simple image drawn in a delightfully fun and colorful style adorning the page simply manifest as it is. Simultaneously it is a commentary on the world of advertising and Warhol's promotion of the product as an attractive and practical appliance for a woman's wardrobe. Secondly, the shoe raises countless contradictions. It is an everyday appliance, yet it is a costly accessory for women to purchase, and the cost could worry the purchaser and make the purchase somewhat anxious. Further, while the shoe is delightful and attractively decorated it will quickly date and look old within a few months of purchase. Thus, another contradiction will be that the contemporary styling of the shoe is only temporary and that eventually the shoe itself will become old, outdated, and no longer an attractive item for a women's wardrobe. Further, the shoe will be simultaneously a historical item and a contemporary item, making it a paradox. It is contemporary for its period of 1955, but it soon dates and becomes an old shoe from a historical period in American advertising. It is an example of an item that lives or exists in two places at once.

While Duchamp's work originates from the period of Dada art, it is hard to find a dividing time where the work of Dada ends and surrealism began. Suffice to say, that the two styles shared many common qualities and techniques to draw public attention. Dada and surrealism overlapped, and people might still see the two existing together or simultaneously. Elsa and Peter Bethanis argued that, "as with most art movements, one can't say exactly where Dada ends and Surrealism begins"[6] However the prevailing spirit of Dada and surrealism did bring new perspectives to the way we see objects. Surrealist ideas included the notion of the marvelous, the idea of wandering or a journey, fairytale like qualities, a celebration of the gross and absurd, the relationship of the female to the unconscious, and a mixture of the organic and handmade item.

Again, looking at any object in Warhol's work can suggest qualities of the surrealist concept. Consider his *Mao* painting from 1972. First, the simple picture of the Communist dictator portrays him as a sort of serene Buddha figure. He is made marvelous by the calm and easy expression he provides. Second, he is a classic paradigm of the wanderer. He began life as a peasant and through his study, his acceptance of Marxism, and his eventual control of China, he became an important world leader. Next, his tough rise to power and his often violent control of China were often transformed into a miraculous fairy tale overlooking the violence and bloodshed of his rise. The red revolution was papered over with the more attractive stories of a strong and domineering political figure who grew to be a public leader. Warhol chose Mao at a time when the world of capitalism was diametrically opposed to the planned economic system of communist countries. Warhol's choice was amusing because it paradoxically chose as its subject for capitalistic distribution a figure that opposed the institutions of capitalism. The use of Mao as a heroic figure for poster art appeared absurd in many ways. First Mao was a despot that executed or imprisoned millions of people. Secondly, Mao was neither a natural friend nor ally to the United States, so glorifying a deadly implacable enemy and tyrant made little sense. However, in Warhol's handling the image of Mao, taken from the official published image of the leader, Mao was hand colored to make him appear lifelike and contemporary. Warhol transformed the prosaic into something striking and highly surreal in its tone.

Although Dada was often mentioned as a precursor to the pop movement, few scholars had charted the relationship of Dadaism, surrealism, and the early avant-garde in Warhol's thinking and art production ideas. However, there are strong elements of these styles embedded in Warhol's diverse work and methods. While Warhol rarely touted intellectual reasoning for his work and methods, it is certain that he was aware of these formats in his youth and was exposed to the influences of the avant-garde in his art education.

BUREAU FOR SURREALISTIC RESEARCH

In 1924, the surrealists strongly guided by writer and theorist, Andre Breton, embarked on creating a Bureau for Surrealist Research to add a scientific side to their pursuit of a new art, and to, "gather all the information possible related to forms that might express the unconscious activity of the mind."[7] The surrealists, though prone to various work methods and a mostly nonscientific pursuit of techniques that could encourage their study of a new form of art, used their group status and their manifestoes as a means to enforce an orthodoxy or legitimacy to their work.

Warhol sought to create such an aesthetic at the Factory in the sixties. He would combine and organize an entourage of people from the local arts community and host meetings with the public so that people could circulate and spread ideas and start new projects. Henry Geldzahler, a curator and friend of Warhol's, said, "it became a sort of glamorous clubhouse with everyone trying to attract Andy's attention."[8] For Warhol, the gestalt of group work inspired him, and he hoped that the interaction of many artistic personalities would generate a strong arts community. Unfortunately, Steven Watson in his *Factory Made* described the often destructive effect of drug use on Factory culture, writing that, "although speed was not yet identified as a dangerous or marginal drug, the group whose lives were devoted to its 'thrill uses.' and especially those who injected it. Were associated with the margins of society."[9]

However, later in his career, free of many of his drug-fueled comrades, a gestalt of group work more resembling the surrealist epoch emerged. Warhol's Swiss dealer and friend Bruno Bischofberger brought in the young Jean-Michel Basquiat one day and Warhol immediately began to have the automatic energy that surrealists praised in their works, works they claim came with no forethought or planning, the works simply sprang from their mind. Joseph Ketner recounts the story, explaining that, "Basquiat proposed they shoot a Polaroid of the two of them together. Much to Warhol's surprise, Basquiat's assistant returned that afternoon with a painted double-portrait of Warhol and Basquiat based on the photo."[10] Warhol was impressed by Basquiat's energy and speed and began actively collaborating with the young artist. He enjoyed painting again. The pair worked on a series of canvases together each using and applying the techniques they were comfortable with using. Basquiat and Warhol had an untitled piece unofficially called *Heart Attack* that featured painted sign letters spelling out *Heart attack* plus other letters spelling out parts of a communication. The words Jess partially obscured and the phrase, "but I'm my own." The words are there, but the sentences are incomplete. Warhol contributed a large stencil of a human heart and Basquiat adds hand-drawn world diagrams, caricatures of African masks, and scrawled private symbols. Bruno Bischofberger recounted the tale in his essay "collaborations," and reported that, "Andy . . . said: 'I'm really jealous—he is faster than me.'"[11]

Warhol was confident enough in his late career to begin to mentor and champion a group of younger artists that had arrived in the intervening years. Warhol's enterprises had become secure enough that he could work with other significant artists. He also needed to be seen as relevant, and his work in the seventies received mostly negative reviews as tepid and irrelevant. He discovered a new generation of important and pioneering street artists.

All of them shared some affinity for surreal and primitive styles. Keith Haring arrived with his quick and vibrant street art. He drew simplified figures

that seemed to be in state of perpetual movement mirroring the street people that occupied the New York streets and subways. Haring's work was inherently tied to commercial art, and he painted or sprayed designs on walls, streets, and subways. Eventually his logos found their way into packaging, and his designs, both simple and tribal in style, became popular for record covers, posters, t-shirts, and a host of other products. Haring painted clever babies, dogs, and people who were totemistically designed cartoonish logos. He was influenced by Jean Dubuffet, the French master of art Brut, who himself was influenced by children's, tribal, and surrealistic styles of art. He was also influenced by earth artist, Christo and Jean Claude that made giant designs in public places and on large tracts of land usually involving zoning rights, public permits, and a large social aspect. Both taught Haring that art should be for wide and unsegmented audiences. Haring was deeply connected to the people and felt it was his mission to make public art that spoke directly to the people in a most democratic and direct way. Haring also believed, like Warhol, that you should make a lot of art, that you should make it quick, and that it should be about accessible topics. Haring had little time for wild obscure pontificating. He wanted his art to be a direct expression to the people. His style evoked the sort of tribal shapes that one might find in an African tapestry or a work of surrealist abstraction. His work often varied from color to black and white and reflected the shapes and styles of shamanistic figuration.

Another contributor to Warhol's more surreal fraternity of the eighties was Francesco Clemente. He collaborated with Warhol and Jean-Michel Basquiat. Clemente, like Warhol, had a strong approach to figurative drawing and painting and used a wide range of media and worked internationally. Clemente is interested in transporting the figure through the use of myth narrative and eroticism into tales of ancient narrative struggles. There is a quality of the palimpsest about his works. It is as if he took the scraps from an ancient culture and painted over them. He created a series of tarot cards placing major intellectuals on each card. Photographer Fran Lebowitz adorned one, Salman Rushdie another, and Jasper Johns appeared as a pope on still another. The large playing cards painted nearly twenty inches high showed the figures as a pantheon of figures in the hierarchy of the Tarot. He painted an image of himself as an aristocrat. Clemente has made New York his home but often journeyed to India and worked there. His show *Emblems of Transformation* from 2015 featured watercolors. The principle emblem of transformation was the 102 beads found in the Japa Mala, a Hindu and Buddhist prayer bead used in meditation. Each image in the show illustrated the act of transformation through some mechanism. In one image, a Buddhist figure seemed to encompass a world inside of his body. The figure appeared to be a monk or a devotee with long ear lobes, a shaved head, and a city enclosed inside his

chest cavity. Like Warhol and Haring, Clemente made his figures simple and attractive. Another emblem showed a group of voyagers walking a rainbow path across the circumference of the earth seemingly to seek enlightenment. While the figures in costume appeared Asian, the Bridge could easily be the Midgard bridge from Valhalla to Earth. Clemente's work is figurative but often spiritual and exploring other cultures. Clemente said in an interview in 2016 that there is an issue of the duality of the sprit and the body in Western culture, but that his work in India has lessened that issue. He said, "but even in the West, in the alchemic tradition, they say you should spiritualize matter and materialize spirit."[12] For Clemente, art is the merging of the spiritual with the material, and adding the spiritual to the material. Like Warhol, he shares an enjoyment of the human figure, and he desires a relationship to other cultures. Clemente said history failed him, so he went looking for the answers to life's problems in geography. He traveled to see what other people of the world saw and how they worked.

Warhol spent time tutoring and mentoring Basquiat who like Haring, had been a street artist and painted in a rough emotional neo-expressionistic style that Warhol found inviting, immediate, and powerful. Again, the surrealists were fans of automatic writing and actions unprompted by human interaction. Warhol and Basquiat painted together for a time, but the show they produced was widely panned and the young artist distanced himself from Warhol fearing that the association would harm his development. However, Warhol was highly attracted to the young artist and painted with him to tutor and guide him. Basquiat's brusque style had elements of African art in his dynamic and often primary color palette. Basquiat used intense yellows, blacks, reds, and blues in his work. His imagery was iconic, symbolic, with noticeable figures. He also engaged archetypical patterns that could be found in the works of surrealists. Like Haring, Basquiat's work betrayed its subway and street origins in its quickness and roughness. There were private codes, messages, and languages in Basquiat's work. His figures were totemistic and tribal. His figures were incomplete and often cubistic and threatening. Jagged edges and unfinished lines protruded from his work and Basquiat's best work had a rough and unfinished quality. There were aspects of his work that looked like a wall scribble, and many of his canvases could be seen as technicolor cave art. Critics have referred to Clemente's work as having a palimpsest quality of appearing to be inscribed on other older documents; Basquiat's work seemed like something etched out over other layers of other work. There were some messages residing underneath the first layer of the work and often scratching, scrimming, and other techniques were used to make the texture of his paintings wild, rough, and rugged.

The surrealists were famous for public displays and disruption generated at their gatherings. They made various proclamations and pronouncements and

even opened a physical research shop and think tank at the Rue de Grenelle in Paris and accompanied the opening of their headquarters with an ad in the newspaper announcing a revolution and reading, "using all appropriate means aims to gather all the information possible related to forms that might express the unconscious activity of the mind."[13]

Warhol practiced a similar strategy by making his studio the Factory a locus for pop activity. Occasional parties and gatherings occurred, but little that took the specific form of actual meetings. Most of the ensemble's meetings were focused and organized around Warhol's art-making activities. Gerald Malanga would be brought in to assist with printmaking and other activities. Volunteers would be assembled for a filming project. Warhol was looking for opportunities to make a fortune, and being in the public eye was a means of staying marketable. He worked on art in public to arouse media attention. The films were another form of public spectacle, but they were not generating cash. By 1966, with little profit from film production Warhol shifted his attention to artist management. He had hoped one of his superstars would catch on, but none of them registered with the larger public. He was introduced to the Velvet Underground and thought they had an interesting sound and look. There was the brilliant English musician John Cale who played cello, keyboards, and could write beautiful pop songs. The band's leader was Lou Reed who was a tough vocalist, front man, and wrote autobiographical music. Added to the group was the German singer and model, Nico, who brought her own cold presence to the band. He spent time producing them, producing their light show the Plastic Floating Inevitable, and promoting their garage band sound. Though perhaps, not the same as the surrealist research group, Warhol's Factory crowd were productive in their own way.

Another way that Warhol interacted with surreal methods was through the technique of video. Though, Warhol's early film work was unedited, his later video productions benefited from the technique of hyperediting and like Salvador Dalí and Luis Buñuel's *Andalusian Dog*, Warhol learned that the jump cut, just like the long and extended cut, could have an exciting impact on the audience, and could create the sense of dreamy ambience. The jump cuts and quick edits made the filming of *Andy Warhol's Fifteen Minutes* seem more active, more spontaneous, and more surprising, all qualities that the surrealists supported.

SURREALISTIC CAFÉ

A way in which Warhol modeled his work on the surrealist experience was through the vehicle of a café or a meeting place. Warhol's crowd liked to find a venue for dinner, and these lavish meals were a high point of their social

experience. Many of the members of the Factory crowd had little income and when the opportunity for free food presented itself, many of the ensemble would eat. John Cale of the Velvet Underground reported that, "we'd go to the Ginger Man where Edie had an account; she'd pick up the bill. Nothing to eat during the day except milk shakes, junk food, then we'd go out and wow, steaks, hamburgers, dessert."[14]

Though Andre Breton had a mania for ordering the surrealistic movement through manifestos, locations, exhibitions, and events in the European manner of having a salon, a school, or a movement, Warhol's pop crowd were more a loose association of acquaintances in an open studio. Klingsohr-Leroy writes that, "the Surrealists' preferred meeting place was the café. . . . it was a favorite haunt of pimps, prostitutes, money-changers, and drug dealers, who, like The Surrealists themselves, went there after seeing a show at the Grand Guignol on the other side of the street. The Cyrano attracted the Surrealists as a place on the margins of society where they could mingle with outsiders and eccentrics."[15] Warhol's crowd lounged at Max's Kansas City, a dive bar and music venue. Later in the seventies, Warhol frequented the posh and popular Studio 54, a meeting place and epicenter for the seventies' hipster, drug, and cocaine culture.

Café culture wasn't just a meeting place for surrealists it was a place to make a scene to cause a disturbance. The surrealists wanted publicity and attention and the cabaret gave them a place to exert their influence on the public. They wanted to protest anything bourgeoisie or common place. At the café, the closerie des lilas on the Boulevard Montparnasse the surrealists crashed a literary gathering honoring the poet Saint Pol-Roux. The surrealists came to the event and began heckling and causing a scene. Eventually tables were overturned, and fights broke out. The surrealists were told to leave for disrupting the event. The actions of the group were condemned in the press and by learned societies. The point wasn't a protest against an actual person, thing, or event but more of a protest in general against organized and respectable society. The surrealists wished to draw attention to their cause, the absurd, the unconscious, and the irrational by acts that mitigated the authority of conventional society.

Warhol's structure at the Factory was more of a personalization of the work of Breton. For Warhol, the studio was a business, a think tank, the incubated ideas that could be turned into products, designs, or events for profit. Warhol had acquired the necessary name recognition by his public displays in the sixties and later he desired to transform that action into tangible products that he could distribute. Glenn O'Brien wrote that, "of everything that Andy produced, the Factory (or the Studio, as he preferred after the 60s) was one of his most important works of art. The [F]actory created a model for art to

survive in a world dominated by the corporation, although so far it seems no one has picked up on it."[16] For Warhol, the studio was a place to coordinate activities with his office team. Together they came up with projects for Warhol to pursue. His team arranged interviews for his magazine *Interview*, they sorted invitations to parties so that he could scout prospects for portraits. They looked for opportunities for Warhol to collaborate as a subject for interviews or as a model for advertisements. Rather than a series of independent collaborators, Warhol's workers were a business enterprise that harnessed the efficiency of capitalism to the pursuit of an art project. Warhol was seeking to make art in a more efficient assembly line fashion than the more anarchic processes of surrealism. Warhol was able to create his own visual corollary to surrealism using the massive pop dance experience of a disco with a light show and pop band. It was a living visual collage.

The surrealists created their vision of collage. When surrealist Max Ernst combined things, "he discovered the hallucinatory effects of combining graphic elements from different contexts. Clippings from department store catalogues, anatomical diagrams, and old etchings provided the raw materials for his collages."[17] Warhol understood the transportive power of collage. He realized that if you could mix a barrage of sound, a complex of still and moving images, adjust the speed and tempo of these elements, the producer of the event could transport the participants into a trance state where the unconscious mind might be unlocked and a higher consciousness invoked. The Velvet experiments in sound and light gave Warhol this kind of shamanistic power with audiences. These forms of multiple media performances made Warhol able to reach audiences using a collage technique, a mixing of media that was different than mere art alone.

PARANOID CRITICAL METHOD

Salvador Dalí became closely connected with surrealism during its later years and Breton was impressed with a technique that Dalí had developed he referred to as the paranoid critical method. According to Robert Short, Dalí had more or less willed himself to see what he wanted to see, in a surrealist sense. That is, he could practice making a common object into something else that expressed what the mind wished it to be. Short writes that it meant, "giving systematic encouragement to the mind's power to look at one thing and to see another. It was a matter of willing alternative readings into the world outside. The only determinant of the content of these readings being psychic desire."[18] For Dalí, this paranoid critical method allowed him to project into things a deeper vision, a deeper set of symbols. In his drawing for Nuits Partages, he

showed a bell tower and an archway and in the foreground another archway and a little girl happily jumping rope. Dalí could see the average and every day in an object and transform the object into something, symbolic, weird, and surreal.

Warhol exercised a similar technique in many of his works to make them weird and uncomfortable for audiences. One of his Campbell's soup can paintings at the de Menil collection in Houston, Texas, is six-feet tall and provides a strong effect on people by its size and coloring. The six-foot can makes audiences see they are viewing a common object at many times its normal size. Also, the coloration and the attention to the detail of the can makes the audience aware that it is something common and prosaic but also something strange and greater than normal. Warhol's advertising prints transform common ads into disturbing evocations of the unnatural. Warhol produced a series of prints for gallery sale in the seventies and eighties. One of his most interesting was a series of prints of famous and popular ads harkening back to Warhol's own earlier career of an advertising artist and designer. Among the ads were images of then-president Ronald Reagan in a Van Heusen shirt, a Macintosh Apple computer logo, and the image of actress Judy Garland wearing a Black Glama fur coat. The ad featuring Garland offers the type, "What becomes a legend most?" The black background offers a frozen white faced Judy Garland and a blue image of Garland and a fur wrap. She is common and iconic simultaneously, dead and alive, spectral and goddess. Warhol understood the deeply psychological abstracting process that viewers brought to bear on objects they observed. He had drawn shoes for years and learned that subtle differences in shape and design could move a shoe from being an impersonal object to becoming a lively and attractive character. Warhol was able to define objects with personality as a commercial illustrator and in a way he was identifying himself with objects in a sympathetic and transportive way that moved him from objective illustrator to someone who could intuit a life within the objects he rendered. Like Dalí, he had a strong psychological probing rapport with the inanimate that produced surprising and lifelike results.

Often Warhol's work as a portrait artist in the seventies and eighties is slighted. The presumption was that these portraits were vanity works merely created for money. But each portrait does share Warhol's own personal paranoid critical method. In his diptych portrait of artist Keith Haring and his partner Juan Dubose, he illustrates a deeper psychological understanding. Haring and Dubose are both conjured in grey tones suggesting the darkness that would prevent them from growing old and having full lives due to the outbreak of the AIDS crisis in the eighties. A second portrait repeats the couple in a cool blue tone. However, Warhol's minimalist means

reproduces the artist and his partner as a great love story and portends the duo's early end.

Warhol's portrait of fellow artist Joseph Beuys illustrates a deeply committed artist portrayed in a direct and affecting manner. The two artists, though different in style and temperament, enjoyed each other's work and met several times in 1979–1980 at openings and discussed their work together. Beuys played a shamanistic role as an artist and believed that humans should evoke emotions as well as intellectual responses to make art more meaningful. He would lecture audiences and discussed the role of art in our lives. Warhol's portrait of Beuys is stark and shows the artist as a somber and serious figure. Warhol renders Beuys as serious, intense, and spiritual. Warhol's portrait of Beuys portrays him brimming with power and focused directly on the audience. Warhol uses the medium of photography and acrylic paint, but the pose illustrates a plaintive and searching artist.

MYSTIFICATION OF THE INANIMATE

Warhol and the surrealists also shared a technique of seeking to transform the simple and inanimate objects into something mystical. Warhol does this repeatedly: The Empire State Building, common household products, pictures of cows, silver pillows, disasters, flowers, his curated object shows, album covers, shoes, and countless other items. All of these lifeless objects are re-animated and made into iconic totems of modern industrial society.

In the surrealistic work, the transformation of objects to mystical items comes from transformations often wrought on the objects. In Dalí's *Persistence of Memory*, he transforms time pieces into melting devices in a plane where odd mutant creatures appear to be dead or in repose. The transformation of common objects like watches into melting images suggests that these objects are some sort of live thing that can be brought to life and respond to environmental conditions. Further the distant horizon and the half-animal mutated creatures in the foreground suggest a form of life that has sprung from our conscious sense of what appears to be a form of life.

Surrealist Hans Bellmer was a German designer who created images and designs for the industrial world, but when the Nazis came to power he turned his attention to fine art production. He was fascinated by the relationship between the female form and the format of dolls and their creation. He made a series of photos and graphics featuring dolls in different states of animation and repose that suggested there was life in these unfinished, unfulfilled, forms. His doll forms mutilated, twisted, and reclining often suggest unawakened forms that are in the process of being born.

Klingsohr-Leroy writes that, "now surrealism was seeking the 'philosopher's stone' that would enable the human imagination to take 'brilliant revenge on the inanimate.'"[19] The surrealists were searching for the ways to animate inanimate objects as many had witnessed static objects and unliving products coming to life in their dreams. The surrealists were also influenced by the work of film and animators that had arrived at the time of their art movement. Animation offered a simple means to bring the inanimate, still pictures, to life, literally giving agency to the objects found in their dreams. The artists wondered why they might not find ways to animate their works and bring them to life. Dalí had taken inanimate dream objects and vivified them in his film *Andalusian Dog*, with artist Luis Buñuel. In fact, he even had an actress portray the act of paranoid critical method when she stared at clothes on a bed intently willing it to bring a male model to life. Drawing on the myth of Pygmalion, the artists of surrealism illustrated the power of artists to will objects to life. Again, myth images like Pygmalion played a role in surrealism and inspired psychologist Carl G. Jung in his studies of archetype and the mystical in psychology.

Warhol also shocked objects to life. His production of the series of death and disaster images used headlines and shocking pictures from the New York tabloids to make remote and horrible disasters more real to the public. *The Tuna Disaster* series showed several women who were the victims of a tuna can that contained a contaminated supply of tuna. The calm and reposed pictures of the women juxtaposed with the tuna cans turned a common image into something frightening and an existential threat. Warhol brings an image, a Sing-Sing electric chair and a man hung in a powerline, both gruesome depictions of death, ironically and horrifyingly to life by making the images completely journalistic transpositions of things rendered in real life. The people, the objects, and the photography seem so lifelike and journalistically honest it is hard to believe these items are anything but true living factual translations of the truth. Warhol's treatment renders them alive.

But Warhol intuits the surrealists' method in a deeper way. In paintings by René Magritte and others, the surrealists were looking for a deeper sort of mysticism borne of the everyday, as they put it, "the 'revelation of the remarkable symbolic life of quite ordinary, 'mundane objects.'"[20] That is, the surrealists were looking for the mystical hiding in the most simple of daily things. In one of Magritte's paintings, *The Key to Dreams*, he has images of a leaf, a knife, a sponge, and a valise or briefcase. Two of the objects were manmade and two were natural objects found in the world outside man's creation. What do these four mysterious objects mean and how are they symbolic. Each seems to be drawn in an extremely literal way. Magritte postulated the answer as each object was literally hiding another object behind it. He said more sin-

isterly, "one object suggests that there is another lurking behind it."[21] What is interesting about surrealist thinking, like in a horror film, there is little interest in realistic reasons for how something came to be, the facts are that the malevolent item just exists. There is no need to understand the overwhelming power of the mystical that is just out of reach or that we cannot penetrate. It is simply existing in its living state, lurking as Magritte puts it, simply below the level of consciousness.

A challenge for Warhol is to bring the portraits to life and to charge them with that mystical energy. Many have argued that Warhol simply served as court painter to the affluent in the seventies, but his deeper purpose was to animate people. Often Warhol's portraits are shown as a random assortment of works, but if reviewed en masse they reveal a much darker and more mysterious agenda. Along with Marilyn and Elvis there are early portraits of a young Natalie Wood and Warren Beatty, stars of Eliz Kazan's *Splendor in the Grass*, a story of doomed love between two young people from opposite ends of the social strata. Warhol may be animating films involving social conflicts and class struggles more than tagging beautiful people. Elizabeth Taylor from the same period is not only a beautiful woman and subject but also a woman who had experienced a lot of pain, several divorces, a husband killed in a plane crash, and many varied illnesses that threatened to end her life and career. There are a wide assortment of Jackie Kennedy photographs that take the president's widow from happy mother and wife to sainted widow and a woman who survived an assassination. Another set of pictures from 1964 illustrate the most wanted men in America. Warhol had been commissioned to paint something for the 1964 World's Fair in the New York Pavilion. His response was the ten most wanted men from the FBI's most wanted list. The state of New York was not amused, so Warhol repainted the Pavilion display a flat coat of silver paint. However, when viewed as a series, the portraits contain notable actors, artists, the famous and not-so-famous, and places them side by side. As Carter Ratcliff wrote, "Warhol obliquely teaches us the egalitarianism that begins with an indefatigable attentiveness, a generosity that renders everyone fascinating—hence 'a beauty' as he liked to say."[22] Although there is that element one might see Warhol's gift as not rendering his subjects clearer but darker and more disturbing. As Magritte indicted, there may be something lurking behind many of these photos and one might think that Warhol's motive is to expose the falseness of wealth and power, the lie of fame, and the deception of appearances. Warhol, himself was constantly concerned about his appearance and only later in life did he develop a level of self-acceptance about his complexion, his pale appearance, and his blotchy skin. Was his portraiture a comment on his own feelings of unattractiveness, the ugly duckling who courts the pretty friends?

However, a more disturbing concern would be his relationship to objects. The surrealists, Magritte, Dalí, and Ernst seem enamored of the posthuman object. Like a world without people, the surrealists created spaces where only monsters and objects lived. Meret Oppenheim's disturbing *Fur Breakfast* comes to mind as the sort of object that the surrealists saw as the type of object that invited strange associations in the mind. Oppenheim was one of the few women in the surrealist movement, and the *Fur Breakfast* piece is a dark commentary on food and our values. Breton wanted everyday objects to become mystified and Oppenheim managed to find a way to take a conventional teacup, saucer, and spoon and transform them into something novel by covering the entire set in fur, making them novel but completely unusable and bizarre.

Warhol's approach to the bizarre was more subtle. In his last show during his lifetime in New York at the Robert Miller Gallery, Warhol produced a series of his photographs that amplify the concept of mystery in everyday common objects. Warhol asked that four large photographs be linked together by stitching the photos into a block or square. Remarkably the shots assume an abstract and eerie sensation. There are pictures of chairs that repeat, emphasizing geometry. There are carved church doors that become massive studies in geometric form. There are emblematic Coca Cola logos that reflect a greater abstract sense. Each image brings fresh associations. There is a poster for an Asian program with faces advertised like an American television program with large typography and a group of smiling actors in costume. The multiplication of forms makes the viewer lose sight of the central object and dwell instead on the objects and their relationship to space, in the end, perhaps the most mysterious and interesting object of all.

Warhol's world surely contained many reminders of art of other cultures and by the fifties' and sixties' Western artists were starting to study folk arts and their relationship to primitive art. William Rubin responds to the notion of primitive art in his catalog to *Primitive Art in the 20th Century*. Rubin argues that many artists saw primitive art as an inspiration and a new way of working. Franz Boas in his book on primitive art in the 1950s dispelled the idea that primitive art was indeed primitive. Many artists including Vladimir, Henri Matisse, and Pablo Picasso tried to claim their work was inspired by primitive art. As Rubin points out there is probably no one discoverer of this format. Many artists were exposed to primitive and tribal art and the experience of it seeped into the collective consciousness of the western European art establishment. Boas commented that despite the notion that primitive art reflected differing mental capabilities of less developed people, he eloquently dispelled that tired notion suggesting that all artists were used to working with the materials they had at hand. If artists were tribal or not, they would

use technology effectively if they had access to it. Boas suggested that Westerners congratulated themselves on the luck that they had technology and that most of their success had little to do with a better mental ability, just an exposure to more resources. Interestingly, when Warhol and Philip Pearlstein first moved to New York and were rooming together Boas's daughter, Franziska Boas, a dance therapist working with disturbed children, became friends with the young artists. Pearlstein, according to Victor Bockris said that, "Andy especially intrigued her. During the course of that winter, she actively encouraged him to 'open himself up' and he slowly metamorphosed into Andy Warhol." Like his pictures coming to life, Boas's daughter may have helped the static surreal Warhol to become, himself, animated.[23]

DREAMS INTO ART

Dreaming played a role in the ideas of Dadaism and surrealism, and both formats influenced Warhol. Dada arrived from cabaret life in Paris in the 1890s where Richard Berrell tells us, "all manner of bizarre, anti-bourgeois behavior was encouraged."[24]The Dadaists drew on the notion of the absurdity of life and art. It was a reaction to World War I, fleeing immigrants, chaos, and instability. Surrealism, which sprung from Dada's rebellion, drew ideas from Sigmund Freud and psychology, particularly the notion that dreams are a private code. Dadaism offered images from dreams, but the Dadaists were more concerned with calling attention to the pretense and seriousness of the art world than of confronting the depths of the subconscious. Berrell explained that, "if there was an anti-movement in the history of modern art, it is Dada." Dadaism worked to inflame people and stoke their anger. Professor Herschel Chipp wrote that surrealism grew out of the impulse toward fantasy in art realized by the Dadaists at the start of the twentieth century. Chipp wrote that, 'their response took the form of an insurrection against all that was pompous, conventional or even boring in the arts.'"[25]

But Dadaism was short-lived. You could not build a movement on shock and bad dreams. You needed a deeper understanding of the unconsciousness. Surrealism grew out of the Dada movement and its desire to shock but wanted to search deeper for images inside our consciousness. Surrealism emerged around 1924 under the direction of poet Andre Breton. Breton was influenced by Freudian psychoanalysis. The surrealists looked to the unconscious mind as the source for artistic subject matter. The unconsciousness for the surrealists was the playground for all the wild unkempt and dark thoughts that had been hidden from the waking mind, and the Freudians thought that that area was the key to many perceptions that could be used in our waking life.

Freud believed that dreams had a logical and coherent aspect related to our waking world. Despite the fact that dreams might have seemed irrational in some way the dream state related to our waking consciousness. He wrote in *The Interpretation of Dreams* that "The physician must reserve himself the right to penetrate, by a Process of deduction, from the effect on consciousness to the unconscious psychic process; he learns in this way that the effect on consciousness is only a remote psychic product of the unconscious process, and that the latter has not become conscious as such, and has, moreover, existed and operated without in any way betraying itself to consciousness."[26] For Freud, dream interpretation was always a rational process that took hidden images in the unconsciousness and brought such ideas into the now. For Jung the collective unconsciousness connected man deeply to his past and made him aware of symbols from the past that often reoccur in his art works. Jung wrote in *Man and His Symbols* that, "rough, natural stones were often believed to be the dwelling places of spirits or gods, and were used in primitive cultures as tombstones, boundary stones, or objects of religious veneration. Their use may be regarded as a primeval form of sculpture a first attempt to invest the stone with more expressive power than chance and nature could give it."[27] For Jung, ancient symbols were a part of our waking consciousness now, and of course, they could appear in our art.

John Russell writes that surrealism was a freeing movement a way of allowing the mind to wonder in the modern world unhinged from reality and allowed the penetration of the unconsciousness and fantasy into everyday life. He writes, "the role of the Surrealists was to go where almost no one had gone before to disentangle the dream and to present it—infantile and grotesque and immoral as it may be, 'complete and unaltered.'"[28] Thus, surrealism was the means to awaken the dream consciousness which reflected Jung's collective unconscious, that was old communal and omnipresent.

The surrealists continued as enemies of the conventional saying that their movement was for the "total derangement of all the conventions of art as they were then known."[29] The connection between pop art, the use of everyday symbols, the reevaluation of the common as artistic, the camp laughing at the conventions of society, were well accepted strategies by Warhol and his peers, but the deeper connection to pop and a form of debunking, primitivism through surrealism was less well understood. In the same way that surrealists saw dream images as the creative force behind art, pop artists took the surreal and often laughable images of the consumer society and advertising as an equally potent force for creating a powerful and vibrant art world. Surrealism's dream states and the dream states imagined by a commercial world that demanded a waking hallucination of the advertised and made-to-desire product emphasized the power of image to evoke the dream to animate the

collective unconsciousness and to prompt commercial consumer and psychological desires.

Just look at one simple example. Elvis was an icon and a rock singer. Warhol appropriated his image for a series of prints. If we look at Elvis as a Dada figure, he is this larger-than-life sexualized boy toy thrust into a stodgy fifties' America. He shocks, destabilizes the establishment, and provokes a teen rebellion. He would be a good Dadaistic figure to arouse controversy and interest in art. As a surrealistic figure, Elvis serves as an emblem of male sexuality for a curtailed maleness after two wars. He is a dream of male potency in a country tired of war and seeking hedonistic pleasure and reward. For Warhol, he is an advertising icon that brings with him ideas of sexuality, promises of potency, a role model for young men seeking to test their masculinity with women, and a symbol of rebellion against the old order, aesthetic, or simply political.

The Surrealist impulse compared to the pop impulse may seem different until we study the imagery. There are advertisement statements implicit in Richard Hamilton's *Just What Is It That Makes Today's Home So Different So Appealing?* There are ads for nearly every item in the house and even the title of the piece is tied to the question the advertiser uses to grab an audience's attention. Magritte's 1929 painting titled, *The Treachery of Images*, offers a big painting of a pipe. Both could be construed as appealing to our psychology and both could be portrayed as ads. The psychology of Hamilton's room is it is all modern conveniences we might desire. Magritte's image shares a pipe that could offer us a soothing and relaxing smoke on the pipe. Both of course could exist as simply products.

The surrealists prided themselves on the act of automatism. Warhol liked a similar process of nonchoice. He would help his assistants and often would allow poor versions of the prints to be accepted into the series. For Warhol, the mistakes and the mis-registrations were just as striking and disturbing as the fruitful pieces. In a surreal collage composition by surrealist Jean Arp in 1920, we have the artist take bits of torn up paper and assemble them on a sheet of paper at random. Where the pieces of torn paper fall are where they are attached to the main sheet. Chance influenced the final composition. Swinglehurst wrote that, "in the sense that surrealism is an expression of the unconventional thoughts of the unconscious mind it has always existed in art."[30] Warhol used that meaning, the unconventional or perhaps in his case the too conventional to make his case for thoughts that might be overlooked or forgotten.

We don't think of pop as exploiting dreams, but in fact it does. Warhol used dreams as strategic material for his work. Warhol's work expressed longing and waking dreams that reflected on long-held desires and fantasies that a

young person might express in dreams. Warhol often drew angels, gardens, and people frolicking in a heavenly environment. For many these thoughts of a heavenly landscape, or an afterlife, might be construed as dream images.

Many of the drawings and perceptions of the surrealists mirror the images of Warhol drawn or screen printed decades later. Dalí did an "imaginary portrait of Lautreamont at the age of nineteen obtained according to the paranoid-critical method." This odd and partial drawing of a woman's face suggested an image stolen from a dream, but Dalí claimed he could visualize objects in dreams or waking trances. In fact, "Dalí once compared himself to a medium able to see images that would spring up into my imagination."[31] Warhol worked often in a similar way merely adding to a photograph or a screen of image barely changing the image, but adding a stroke here and there to complete it. The goal was to add to the existing image not to recreate it.

Chapter Seven

Warhol: The Collectible Icon

Not everyone collects. Today, we often value possessions not so much for what they are but for where they've been and who owned them before. Warhol owned a collection of cookie jars. Hundreds of cookie jars. They were bought at yard sales, junk shops, and Goodwill. Most cost under a few dollars. Gedalio Grinberg, an Italian businessman, liked Warhol's cookie jars. He bought 136 cookie jars at auction for $200,000. Collectors have their priorities.

EARLY LIFE

As has been noted in many articles, Andy Warhol was brought up by poor immigrant parents in a depressed factory area of Pennsylvania with few physical possessions. His mother had artistic inclinations and could draw. She brought with her the folk art traditions of Europe, and Warhol grew up with those traditions. She also exposed him to magazines, newspapers, paper dolls, movies and a fantasy world that she desperately tried to use to nourish a poor sick and damaged child. Warhol began to venerate toys, kitsch, and objects like totems and icons from an early age. Her European church was laden with icons of saints, Jesus, and Mary, and she venerated objects. Julia had little and coveted what she could keep. As an immigrant, she was accustomed to taking what was on her back and what she could carry with her. When she arrived in New York to live with Warhol, she brought little with her, and Warhol had to take her in. She was the first of his collections.

EARLY NEW YORK APARTMENT LIFE

Warhol himself had an early nomadic life in New York with a succession of roommates. First, Philip Pearlstein, a friend and fellow painter from Carnegie Tech, went with Warhol to New York but left and married. Warhol struggled for economic security hacking out drawings at one hundred dollars a drawing, eventually securing better apartments. Still a loner with a small circle of artistic friends, Warhol entertained himself in the big city by window shopping and picking up trinkets in junk shops. Once he secured a townhouse by the late fifties and felt a measure of economic security, he began to outfit the space in antiques, nice furnishings, and a continuing supply of kitsch purchases made in used stores in and around New York.

For Warhol and many Americans, the art of shopping is a way to reset the American clock. Americans often shop for relaxation. They are not looking for anything. They don't need anything. Shopping is a means to clear the head and simply reset the mechanism. It does not involve stress when people have ready cash and the ability to meet their bills. Of course, shopping obsessions and hoarding are other matters. In a recent book, *Andy Warhol Was a Hoarder*, by Claudia Kalb, Kalb writes, "but behind the cameras and the canvases, Warhol had another less celebrated preoccupation: he was an accumulator of epic proportions. The man loved to shop, and he did it whenever and wherever he could—five and dime stores, antique stores, high end galleries."[1] Whether Warhol was an actual hoarder is irrelevant, but he was a collector, and he did buy things mostly as investments in art and antiques, but he also had a taste for the arcane, kitsch, and folkish. His own collection was the basis for the American Folk Art Museum show, *Folk and Funk: Andy Warhol's Folk Art World*, in 1977.

WARHOL'S COLLECTING PRACTICE

Warhol was a notorious collector. He bought his townhouse, and over the decades bought a variety of antiques, furniture, collectibles, jewelry, and trinkets. He collected people in the sixties and dangerously assembled a crew of difficult and curious personalities that often filled his Factory studio space with color, but a type of productivity that included drug-fueled creation, work built on artifice, and designs based on a group gestalt. He filled more than six hundred time capsules, collections of memorabilia and junk he was working on in his office from the mid-seventies until his death. This automatic storing, keeping, and filling boxes with miscellaneous items to be crated and stored and archived for later generations to appreciate was part of his

lifestyle and aesthetic practice. His collecting obsessions included household items, antiques, and old odd pieces of pop culture, including items related to Miss Piggy and Shirley Temple. He loved unusual and unique craft and folk products from the late-nineteenth- and early-twentieth-century Americana culture. Underlying all of Warhol's collecting was a devotion to the idea of collecting and curating objects, that the act of collecting itself was a valuable procedure. Perhaps his world and art had not been collected and curated in the totality that he desired. Maybe there were things he thought he was missing that he never had. Maybe he had a need to search for items to fill that unknown need. At the same time, Warhol's collecting practice tells us something about the rich consumer-drenched culture he inhabited in America's abundant midcentury.

COLLECTING AND WARHOL

Warhol's art practice was involved in reinventing objects in the world in different media. Whether he transposed women's shoes into clever illustrations for I Miller shoes, projected twelve most wanted criminals as a display sign for the 1964 New York World's Fair, or organized bands or movie events, a lot of Warhol's discipline was about putting objects together in some sort of medium and mixing them in his palette. For Warhol, the concept of *a factory* was a way of organizing work. His studio called the Factory was supposed to function as a factory. Billy Name, the Factory general handyman and decorator who created the space's shiny silver façade, thought the silver sheen would attract patrons. Once inside the Factory crew would assemble happenings, films, bands, posters, and artworks for consumption. As much as they were colleagues, visitors, loafers, or simply the curious patrons of his work, Warhol's Factory people were often inadvertently his workers, mostly unpaid and unskilled; they became a workforce helping him to achieve his aesthetic ends. For Warhol the space existed to become a giant store generating products for an art-hungry market. The public was to consume this spectacle. Sadly, one of Warhol's possessions, the odd and disquieting Valerie Solanas was a broken part of the machine, and she used her entre to attempt to kill the Factory's conductor.

RAIDING THE ICEBOX

Rather than kill Warhol, Solanas's attack urged Warhol to become more private and more protective of his personal safety. He determined new ways of

organizing his objects. Warhol had already begun the reorganization before her attack, moving to a more secure location uptown. He acquired new crew members and a tighter and more disciplined regime to craft a more functional work environment; the new Warhol environment was more like a business office with Warhol as a corporate mogul, a situation he grew to enjoy.

The first flowering of this new concept of a corporate entity was Warhol's growing interest in exhibiting and showing his works. While recovering from Solanas's attack, an offer to reengage in the art world was given to Warhol in the shape of the *Raid the Icebox* Exhibition. Warhol had abandoned painting and claimed he had retired from physical graphic art production and was only planning to produce films. However, one can always be doubtful when hearing Warhol's pronouncements because the artist often lied.

When he was offered the opportunity to return to the gallery in 1969 during his recovery from the Solanas attack, he responded to the chance to work with a museum. The Rhode Island School of Design offered Warhol the opportunity to descend into their icebox, the cold storage for many things not displayed in the Rhode island School of Design's Art Museum. This remarkable collection of objects had sat unobserved by anyone for decades, and Warhol was tasked with choosing a reclamation of items for a helter-skelter show that was funded by the De Menil family of Houston, a group of art philanthropists and humanists that wanted to bring cultural attractions to the largely industrial Houston community.

Warhol had his pick of the museum's back catalog of items that were stored in the basement. He selected an eclectic array of unheralded oddities, undiscovered masterpieces, and unique items that might escape the notice of someone who hadn't been a commercial illustrator for a decade. For one thing, the museum/school had a wide selection of shoes from the nineteenth and twentieth centuries. Warhol was impressed by the collection and requested that whole racks of shoes be part of the show.

David Bourdan wrote an amusing essay illustrating Warhol's manner of assembling the show. The curator of the Rhode Island School of Design museum and storage, Daniel Robbins, conducted a guided tour for Warhol and his entourage. Warhol quipped when shown a Paul Cézanne in their storage, "Is that a real Cézanne or a fake? If it's real we won't take it."[2] Of course, the painting was a genuine still life by Cézanne, and Dominique de Menil prevailed on Warhol to take some real items to offset the fake and kitsch items. However, Warhol was interested in novel aspects of the collection and himself was a collector of things. He looked for things in the collection that would be unusual and things that might create a thematic assemblage of items. Robbins, the director of the museum greeted Warhol with enthusiasm saying, "We're going to have a lot of fun today."[3]

Figure 7.1. Among Warhol's collection of Americana was a carousel horse. He found nineteenth-century American folk and craft art to be an underappreciated American treasure. Few recognize Warhol's sincere interest in promoting American culture.
Library of Congress Prints and Photographs Division, LC-DIG-highsm-12604

What intrigued Warhol about the idea of the show was that it was funded by the de Menil family and that he had been asked to curate as a guest curator, offering a fresh perspective of the museum and collecting in general, as a modern artist of high publicity value. The de Menil family also learned that Warhol was already an experienced and avid collector of art. Bourdan wrote that "he had collected Americana for about fifteen years and has a fine collection of carved wooden figures, carousel horses and penny arcade machines."[4] Warhol's interest in Americana was likely fueled by the many old pieces of furniture he had seen growing up outside of Pittsburgh in the thirties when many old furniture pieces decorated his poor neighborhood. Warhol might have frolicked on an old carousel horse himself. He may have played with wooden figures like the ones he chose, and he probably had played at a penny arcade.

But Warhol always had motivations in his collecting. He wanted things largely that would accrue in value. At the same time, he could be taken by something that appealed to his sense of whimsy and kitsch. He liked silly, nonce decorative objects that served no purpose other than delight. These he selected and placed in his collection because they were largely inconsequential and delightful. When he selected for the icebox show, he presented a similarly diverse regime in selecting items. Bourdan continually referred to his desiring objects saying, "he wanted to exhibit them, 'just like that.'"[5] Warhol was very obsessed with keeping the objects in their natural state. The shoes were stored and kept in the racks that were their regular storage. Warhol wanted people to see the works as they were displayed, not staged for a special display, he wanted them in their raw state. In this selection process, Bourdan remarked that Warhol, more often than not, wanted items that were unadorned and not particularly showy. It must have been difficult for him to select. He existed in a business where life was about showing off. The question would become: How do you pick items that aren't particularly known for their capacity to call attention to themselves? How does one pick austere objects for such a show? The challenge becomes something like picking objects for a show of Shaker art. The Shaker subculture valued deeply simple and unpretentious items made for their value and longevity and not for their flash appeal. At the same time, they lacked ornamentation and were valued for their utility. Warhol desired things to be left in their natural state. They were to be left unaltered or plainly unadorned. Warhol showed an affinity throughout his career with this Shaker austerity in design and his own work while shocking often lacked any extra adornment or embellishment. It seemed that Warhol saw limits to ornamentation because he had spent a life in advertising design and gallery art watching people seek to impress each other with extravagant designs and gouache fabrications. At center, Warhol made the show

a consummate artistic challenge. How does one craft an art show of things to be viewed to be the subject of voyeuristic appeal and yet select items that eschew the sense of being viewed or wanting to be visually digested. Could such a show be Warhol's own commentary on his own presumed physical unattractiveness? Is this a reference to his own self-loathing visage? Perhaps he doesn't want things that have been altered in any way because he has found no way to alter his own disappointing appearance? Warhol may have been countering his own voyeuristic tendencies, making people look more closely at the austere, the unadorned. Warhol's choosing was an interesting example of curating and selection. It illustrated that Warhol was deeply sensitive to the visual world and that he was concerned about how items are viewed and how they would be received by an audience.

Robbins took Warhol through a variety of storage areas. Most of the storage was extremely well kept in small basement rooms. However, some pieces were kept in dusty, mold-filled rooms. Director Robbins commented that in the storage area they would find items, "many of which are falling apart."[6] Bourdan seems to point to the issue that much of what we see as raw material must be carefully curated to keep it from dissipating. Warhol's act of puling it from storage was a response to this destruction and decay. The museum staff saw his curator work as rescuing, retrieving, and restoring works that had been long lost and forgotten in the collection. What many found inviting was that Warhol rarely sought obvious treasures but searched for more obscure and idiosyncratic items.

Warhol's selections surprised the museum staff. They had a massive collection of hundreds of pairs of shoes from mostly the mid-nineteenth century to the early twentieth century in large wooden shoe racks and big French provincial cabinets. Warhol not only wanted shoes from the collection, he wanted all the shoes in their French cabinets, and he wanted the audiences at the exhibit to be able to rummage through the shoe collections. Many thought the request was strange, but insiders that knew Warhol's early career understood his affinity with shoes. His ability to draw many wild and decorative shoes in a variety of styles made him a success in the competitive world of industrial and advertising design. He keenly understood how a prosaic and little understood appliance like shoes could be gloriously underrated. They were an inspiration to his adult work.

When Warhol was confronted by a room of antique and historical costumes of people from previous centuries he was not interested in most of the wardrobe collection. But in the corner of the room he spied a series of decorative hat boxes, and though he cared little for the hats, the French-styled and attractive hat boxes from the collection intrigued him. He wanted the hat boxes and not what they contained because he liked the shape and style of the boxes.

Again, Warhol's aesthetics spoke to shape and design concept not always to practicality. Warhol understood that sometimes the container, the package itself, was more important than the thing inside. Part of his process for making the strange familiar was the act of selection or curation. He selected his odd assortment of actors and collaborators on the basis of their odd quirks and qualities often over their capabilities and strong talents. He had a zest for the odd and strange.

He was also interested in objects that had bizarre shapes and proportions. Instead of seeking beautiful examples of furniture and cabinetry from the previous century in the museum's attractive furniture collection, Warhol was fixated on a table that had a warped top so violently angled that nothing could sit atop it. His interest in the novel and bizarre trumped his ideas of craftsmanship. He also liked a selection of Windsor chairs not because they were distinct and unusual, but because of their consistent uniformity. This may have been an homage to his own liking of serial production or things that were repeated the same way over and over again to achieve a sense of machine manufacture. The Windsor chairs did differ a bit just as Warhol's prints differed a bit, but the difference was marginal and mostly there were only small distinctions from chair to chair.

When it came to paintings, Warhol's taste was for the unfit, the throw away, and neglected works. He froze on, "a half dozen large painting as in huge gilt frames, stacked in a heap against a wall."[7] The artist liked them displayed in a pile or heap with one peeking out, the corner of another revealed and the rest buried beneath. It seemed he wanted the viewers to do what he did, dig through the rubble to try to find something interesting. This may illustrate part of Warhol's collecting fascination. For the artist, it wasn't the actual item or the control of valuable material that attracted Warhol. It was the act of searching and the pleasure of discovery that made the collecting an engaging and mind-grabbing hobby. Buying fancy things with one's money was simple, but seeking out hidden treasures and finding a remarkable item at a yard sale or at a junk shop made the pursuit of collecting a game, a lively activity. Warhol valued that sort of stimulation more than the actual purchase of pricey items.

However, something no one anticipated was Warhol's profound interest in American Indian artifacts. When they came to cabinets filled with Indian baskets, Warhol requested them all. In another cabinet, there was a series of unadorned American Indian mound builder pottery. It was not decorated and it was not painted. In fact, it looked primitive and quite plain, but Warhol desired all of that again displayed in display cabinets like something left unopened, to be explored by an audience of explorers, scientists, and visitors rather than a formal exhibition where things were to be laid out in some man-

ner in some order for an audience. Warhol wanted to focus on the cultural and ethnographic rediscovery of objects by an audience. Many were intrigued that Warhol might be interested in native culture. The idea that the pop artist might have a streak of anthropologist about him seemed like an added benefit of his work as a curator. He deferred, saying that American Indian arts were an investment. However, Warhol's work focused more on ethnic issues in his later work. *Mao* portraits, the *Jewish Geniuses* prints, the *Cowboys and Indians* series, and other works reflected a broad sense of diversity. Warhol was always a broader and more wide-ranging philosophical thinker, more receptive to the under-represented, than other artists or collectors. His work championed a variety of diverse forms of art relatively unacknowledged by high society and the art world.

Warhol's selections for the *Raid the Icebox* exhibit was certainly wide ranging and included not only vintage Americana, but also a fetishist's love of antique shoes, hat boxes, decorative wallpapers, Indian blankets from Navajo, Chilkat, and Hopi tribes, sculptures from Degas, Asian, and Roman antiquity, and paintings by Henri Rousseau, Maxfield Parrish, and Cézanne. However, despite the odd eclecticism of ages, styles, and national origins there is a unifying sense of artistry, unique craftsmanship, individualistic style, and an odd assortment of items that combine individual craftsmanship and uniqueness while making a sense and value for uniformity.

COLLECTING THE TIME CAPSULE

Perhaps one of the oddest and longest lasting collecting projects of Warhol's career was the time capsules. Warhol began collecting items at his office in the mid-seventies and assembled the collected items into cardboard boxes, or time capsules of material and things he was working on that cluttered his desk and workspace. The time capsules were duly collected and placed in storage. At the end of his life, there were more than six hundred time capsules assembled over thirteen years. The contents were not disclosed, and after Warhol's death, the Andy Warhol Foundation for the Arts began to open the time capsules at yearly events. The last few were opened finally in 2014. Despite the dreams that the time capsules would reveal some underlying secrets or facts about Warhol, his life, and his strategies, the capsules are often as frustrating as other artifacts that people pour over to try to understand Warhol's thoughts, methods, and ideologies.

What scholars and critics have often found and cataloged in these quixotic boxes is simply collections of junk, news clippings, debris, and some items that offer a hint at what was happening in Warhol's work and mind. What

is left are more mysteries about the thoughts, the methodology, and the creations of the master of pop art. But would any one box have held a magic key to Warhol and his work? The Andy Warhol Museum even staged the events for paying customers. The *BBC*'s Simon Elmes described the event saying, "everyone has paid their $10 for the privilege of seeing inside the humdrum cardboard box that sits very alone on a table on stage."[8]

The time capsules were an experiment in archiving that Warhol approached with an eye to sustaining a catalog of his life, mementoes, and mysteries to intrigue audiences. At the time of his end, Warhol was likely aware that archives had become a popular topic in postmodern studies. Terry Cook wrote in his "Fashionable Nonsense or Professional Rebirth: Postmodernism and the Practice of Archives," that, "postmodernism eschews metanarrative, those sweeping interpretations that totalize human experience in some monolithic way, whether it be capitalism, patriarchy, imperialism, the nation state, or the 'western' canon in literature or philosophy—almost anything that reflects the past or present 'hegemony' of dead white males."[9]

THE PRIVATE COLLECTOR

Warhol was the most eclectic collector in the world. He collected worthless objects and masterpieces. He was obsessed with the flotsam and jetsam of contemporary society, and he was fascinated with the cute, kitsch, and ethnic. As an ethnic middle European outsider, he had an apparent sympathy with other outsider people who strived as he had strived for acceptance and inclusion in the big overwhelming American dream. His mansion at 1342 Lexington housed many of his collected works, including some of his own creations. There are images of Warhol in the residence surrounded by images of his prints and Campbell's soup cans.

He moved to a more spacious twenty-seven-room residence in the seventies and lived there until his death. Pictures of the residence at the time of his death look like an *Architectural Digest* historical home. His townhome was not filled with jazzy works of the modern or 1980s period, but stuffed with kitsch, antiques, and bizarre collectables. One second floor sitting room had a beautiful nineteenth-century art nouveau couch decorated in yellow fabric, African art and sculptures, porcelain China vases, kitsch American portraits of children, gaudy art deco lights white sculptural posts, Egyptian-style gilded sculptures, gold decorative lion sculptures, decorated chairs with cubist structures, nineteenth-century decorative sculptures, and a wide assortment of cookie jars. *New York Magazine*'s John Taylor described his eclectic collections as, "Warhol had gadgets and gewgaws and bric-a-brac. He had

masterpieces alongside what would seem to be junk of the most worthless sort."[10] Warhol understood two things about collecting. First, he liked what he liked for its shape, its oddity, its uniqueness, or its campy humor; all of these aspects impacted his decision to buy. At the same time, he firmly believed in buying and holding things as an investment. He bought artifacts, art, paintings, sculpture, and displays because they might rise in worth. He had a sharp eye for value, and he was usually right. On the other hand, he also understood the power of celebrity. Things acquired value based on who had acquired the item. An Elizabeth Taylor plate was worth more than a regular plate because it was owned by a famous celebrity. He factored in his own celebrity in the process. When he bought something, it automatically became worth more because the possession now acquired celebrity status by its association with Warhol.

Oddly little from his own era is in his collection. He relished little from the contemporary era and saw it polluted by the notion of commerce that pervaded everything in New York. For him, the past and its secrets was a glamorous era. His Jasper Johns's work titled *Screenpiece* from 1967 has the feel of an abstract expressionist work, very atmospheric and not necessarily suggestive of Johns's other work. His Egyptian revival chair appears to be a kitschy take on Egyptian culture from the nineteenth century attempting to parrot the greatness of the Egyptian empire. His Pierre Legrain cabinet illustrates his abiding and continuing interest in primitive art and the African-influenced work of French Artist Pierre Legrain from the early twentieth century.

THE RESIDENCES

Many of the things in Warhol's collection defy perceptions of the artist. In 1971, he and filmmaker Paul Morrissey purchased a distant Long island residence in rustic Montauk at the Eastern end of the island. The remote hideaway was Warhol's retreat in the seventies and eighties. The encampment of five rustic cabins built in the 1920s was described as the estate of *Eothen*, which means "at first light" in Ancient Greek. It is a bracing and sea-drenched environment, and for the rest of his life, Warhol came there to relax and entertain his elite friends. Jackie Kennedy, the Rolling Stones, Liza Minnelli, artist Julian Schnabel, and others visited Warhol in this retreat, and though it wasn't a secret, it was far enough off the beaten path to attract few outsiders. It is at the far Eastern end of Long Island and hard to find unless you are looking for it. There isn't much else there, and in winter it could be foreboding and cold. Though not known as a painter of landscapes, Warhol did a drawing of a famous Turneresque sunset from the property in 1972 apparently inspired by the beauty of the sea surroundings after his move there

in the early seventies. Warhol printed multiple prints of the view and transformed the color from bright red and orange hues to darker blues and reds creating an eerie dark and relaxing portrait of the sunset.

From 1960 to 1972, Warhol lived with his mother at 1342 Lexington Avenue. A spacious four-story four-bedroom, three-and-a-half-bath, townhouse in a fashionable and heavily trafficked part of Manhattan, Warhol's Lexington townhouse was spacious. Aside from its four stories, there was a basement where his mother lived. He had a backyard garden, a downstairs kitchen, and a playroom. On the parlor floor, there was a gallery and living room and a library office. On the upper floors, there were four bedrooms and two additional baths. After thirty years of youthful poverty, Warhol had arrived at a popular location with comfort and space.

The later residence which was purchased in 1974 at 57 East 66th Street in Manhattan's upper East side is quite magnificent. More than twenty rooms, the 66th Street space had multiple bedrooms, various parlors, sitting rooms, staff rooms, and at least eight bathrooms, a terrace, and a personal gym. More important than his places of residence were the things he kept inside them. In images of his library around the time of his passing, Warhol seemed to leave things a mess. His library had shelves, but things were strewn about at random. There were piles of books all over. Warhol seemed to find something he liked in a book and leave it dangling open. The space was non-negotiable. A person could not move through the room. There was no room for people, only piles and piles of books, magazines, and materials heaped to the ceiling. There were globes, a lonely ghost lamp, a dragon sculpture, and knick-knacks in the room, but navigating the space seemed impossible. Evidence from pictures of rooms where Warhol had books suggest the active mind of scholar, intellectual, and reader, all things widely denied by people that later wrote accounts of the artist. The photos of his library room seem to make another account of his interest in research and study. He may not have been an intellectual in the strictest sense, but his voluminous collection of books bespoke an artist with a continuing curiosity about art, literature, and current events.

Warhol became concerned about his health not only after his near-fatal shooting in 1968, but also in the eighties when many friends were suffering from AIDS afflicting the New York arts community. He wanted to look fit and robust and began working out and taking massages and training with a personal trainer in the gym. He worried about his ugly, pale, blotchy skin and took a variety of toners and astringents to work the elasticity and pliability of his skin. He had wrinkles and never succumbed to the temptation to have a face lift because that would have meant surgery, and after almost dying, he scrupulously avoided hospitals, needles, and anything that could cause harm

to his fragile body. He used a variety of Clinque, Vitabath, Cetaphil, Vidal Sassoon, Lubriderm, Halston, and any number of designer products bought from local health food and cosmetic shops in Manhattan. The variety of his beauty care regime was recorded in pictures of his residence after his passing. His razor was a multihead Norelco, and he rarely had much of a beard or stubble and always appeared hairless and clean shaven. His medicine cabinet was filled with tanning products. Apparently Warhol wanted to provide the illusion he was getting sun and lots of healthful outdoor exercise.

By the eighties, his routine was to rise, putter about and talk on the phone to friends, discuss with assistants his lunch plans, work and commissions, stroll to work on foot and with assistants, conduct shopping expeditions to the antique stores or new venues opening around the city. In the afternoon he would report to work, confer with assistants, try to work in the studio, and then depart for home having a dinner along the way or eating at his 66th street townhome. He often went out to parties taking recorders, cameras, and equipment with him to chat with potential customers and scout other artists and media moguls for lucrative jobs or painting opportunities either in portraits or other projects. These days brought more loot to his twenty-room facility, and he piled new acquisitions on the dining room table. He rarely entertained at home preferring the peace and quiet of a refuge like Studio 54 or someone else's designer apartment.

SHOPPING WITH ANDY

The question remains, how did Warhol become a collector? Certainly, an impoverished childhood and ill health kept Warhol from shopping much as a youth. In college he had no money and was at work on his art practice. In his early career, he was poor, had rent to pay, and spent most of his time generating cash. However, by the sixties and seventies, he finally had disposable income and enough spare time to devote some energy to collecting. When he adopted the habit, he pursued it with ruthless efficiency and shopping for art items became a daily ritual. Warhol was an avid shopper, and it could be argued that circulating, getting out in the city, and walking were as important for Warhol as the actual buying of objects. Further not only did he shop and secure new business, but he might also take copies of his *Interview* magazine along with him and hand out copies for free to advertise the magazine while on the fly. His friend, Baby Jane Holzer, one of the real beauties that attended the Factory in the sixties, reported that he had a real love for jewelry and said that, "jewels, darling. He adored jewels."[11] Holzer suggests that Warhol loved jewels as possibly a hedge against inflation in the seventies. Warhol

had a series of shopping friends that he took with him for company and many continued shopping with him over the decades.

One of his favorite shopping assistants was Stuart Pivar, an independently wealthy chemist who had worked in the plastics industry and taught after he became wealthy. He and Warhol shopped almost daily for a few years. They liked to buy art, and they would meet up around 11 a.m. and do a wide swath of different shopping areas looking for cheap art, antiques, or collectibles. Pivar reports that Warhol took in many locations in a day and reports that they routinely hit "Sotheby's, Christie's, Christie's East, Phillips, Doyle's, Manhattan Galleries, and Lubin's."[12] Warhol also went to the antiques sales, antique shops, junk shops, and even Goodwill. Pivar explained that sometimes they would use a car. That way they could cover more ground, review their purchases, and carry everything back to their respective homes. This was Warhol's routine for years, and after these shopping trips, Warhol would report to the Factory in the early afternoon of each day. According to Pivar, Warhol did plan to unload his massive supply of art.[13] Warhol had planned to auction or sell off his collection in the future, but at the time of his death, he was in no rush to divest of his collection and was still in the process of accumulating more art, sculptures, and junk items. Apparently if any of his shopping friends doubted his choices or referred to something as junk, Warhol would ask how much it was. Still, he might pick up a tacky item assuming it would rise in value.

ON THE SHAKER SIDE

As noted elsewhere, Warhol had a seeming affinity for Shaker style furnishings and crafts. Warhol collected in many different styles, but he often selected items that were simple and elegant. Some have speculated that he was influenced by the design ideas and simplicity of the Shaker movement in the United States. The Shakers were a religious order that preached celibacy and had ecstatic prayer services. They were a popular religious order often called the Shaking Quakers because of their frequently wild religious services. However, they were often involved in the search for a perfect communal society where all people could obtain salvation. John Kirk, in his text on *The Shaker World*, described their aesthetic as, "everything from the layout of the settlements to the design of a chest of drawers was intended to reflect and record a perfected social structure."[14] The Shaker design mode was involved in simple designs that could easily be replicated. One imagines that Warhol's interest in serialism provided him with an interest in any design system that could easily and effectively be repeated. But Warhol may also have been

influenced by their specific design technique and their vocabulary of items. Sharon Koomler in her book *Shaker Style* reports that "the drawings are colorful, organized, and reminiscent of the vernacular design seen in patterned textiles, embroidery, fractures, and Masonic art."[15] When viewed, these drawings appear similar to the naïve style that Warhol often affected in his work of the fifties, his advertising design, his privately printed books, and his later print work in the seventies and eighties. It may have related to the fauve folk art that Warhol had practiced in the commercial world and the style of American folk art that he commonly purchased.

When Warhol was organizing the *Raid the Icebox* show from the storage of the Rhode Island School of Design (RISD) in 1969, he found delightful sets of matching chairs that were austere and simple and attractive and placed them all in the exhibit. Some people at the RISD were puzzled by Warhol's choices, but Warhol went looking for simple, overlooked, and underappreciated work. The Shakers would delete ornamentation from furnishings making simple products even simpler. Kirk wrote that, "the Shakers sought to expunge unnecessary detail from thoughts, daily living, and designs. In practical terms a streamlined design made it easy to multiply similar pieces for the many new converts, while providing a sense of equity."[16] The Shaker aesthetic engaged the idea of serial production, something that Warhol saw as a value. Warhol may never have visited the Shaker faith, but he understood their aesthetic model and practiced a style of art that may have been inadvertently inspired by Shaker thinking.

MAN AND COOKIE JAR

Perhaps one of the remarkable things about Warhol's collecting style was his mixture of the profound and kitsch work simultaneously. In particular he amassed big collections of some important and valuable art objects. A wide collection of native American rugs, blankets, baskets, and artifacts are often regarded as an indication of his nascent interest in colonialism and native peoples. On the other end of the spectrum is his remarkable and, to some, his puzzling collection of more than 175 cookie jars. These odd but beautiful items have perplexed critics. Various authorities have tried to explain the collection as an interest in naïve art, the kitsch, or trash art. Some find the cookie jars with their often winsome faces and happy images as either annoying or disturbing. Like most people who collect, Warhol was surrounded by possessions he loved. Many of the kitschy objects may have reminded him of something from his youth, or they may have been objects that gave him comfort. The golden age of cookie jars, at least for someone like Warhol,

who grew up in the thirties and forties, was the era before and directly after World War II. Warhol collected memorabilia from that era and managed to amass a splendid supply of early and midcentury collectibles. At the same time, he chose other items that had little or no particular value. He may have collected items that touched an emotional chord in him or corresponded to an era. Certainly, his youth in the thirties provided him with a lens toward the remarkable and valuable of that period. However, rather than collect the art deco treasures of the era, Warhol seemed to focus on the folksy, the middle class, and common but attractive items of the era. It was as if he was equipping an anthropological museum of everyday life in the mid-decades of the twentieth century.

However, the cookie jar collection holds keys to Warhol's thinking and methodology that other valuables, collectibles, and art items do not. The cookie jars related to Warhol's beliefs and theories about art. For one thing, they are a series of mechanically reproduced works that are made in an assembly line by a factory. They replicate the process of a handmade craft item, a cookie jar assembled by craftspeople who molded the clay and fired the ceramic by hand. But in most cases, such craftsmanship had vanished by midcentury America, and though they appeared designed by craftspeople, they were products of an industrial society. Further the cookie jars though appearing to be smiling replicate the faces of people and animals like some bizarre and terrifying Disney apocalyptic project. With proper lighting and shadows the characters affronting the cookie jars can be disturbing and in some cases menacing.

The cookie jars were the products of factory workers and were produced by an assembly line. In essence they were the products of a postcraft society and in some way held nostalgic value for Warhol. Warhol, by purchasing them, was praising an item and valorizing something that came from the form of factory production. Therefore, the work of the cookie jars is an ode to factory reproductions and American machine work and not the individual craftwork that the machine era replaced. However, the early machine age, particularly in the twentieth century, still had the marks, the residue, and the handiwork of handicrafts even though the era of hand-crafted crafts was long gone. Warhol's work in collecting so many of these cookie jars was to replicate that process of remembering and rendering or re-rendering the crafts of the early twentieth century, the time when craft work gave way to machine work. In that nexus in that end of craft work and the beginnings of machine work age, lies Warhol's understanding and appreciation of the world. He was galvanized by the nexus of the machine age and the value of craft work as the two crossed over into each other and merged as one new hybrid. Warhol saw the intersection of craft design and the emerging machine era as a golden

age that retained the power of both means of production. On the one hand, the creativity and design of the designers still existed, and on the other hand, machine work punched out the designs more quickly. Thus, the product began life as a handicraft and emerged on the other end of the spectrum as a machine production. Both existed simultaneously in the same object. The spirit of craft work existed in the uncanny gulf between the craft production and the powerful and unstoppable force of machine production. There exists in them an aspect of human and personal components. These have the sense of being rendered by human and specific designers with a specific and often individualistic style. At the same time, there is a clear replicated form that marks their unnatural power as the products of machines. When shelved as a collection they appear as a robot army of brooms, animals, and cleaning apparatus escaped from Mickey Mouse's abode as the sorcerer's apprentice.

In much of Warhol's work and collection there is a veneration for this instance of the uncanny gulf, this realm between the real and the imagined, the human and the nonhuman, the juxtaposition of the living and the dead. Warhol in his theology, his philosophy, and his perception of life is constantly amazed by the power of things on the periphery, those objects that lie between living and death, between common and exceptional, between real and fictional. We see this in his pop art productions of the sixties. The Marilyns and other figures exist in a range between real, fictional, imagined, fabricated, and moribund. It may be this gulf between real and imaginary, dead or alive, fake and genuine, this interstitial zone that triggered Warhol's imagination. Thus, this act of collaging different elements may inform Warhol's collecting strategy as well. Warhol not only venerated the epic, the profound and the transcendent, but he also had a taste for Cabbage Patch dolls, signage from nineteenth-century shops, and Miss Piggy collectibles.

When we think of cultural anthropologist, Victor Turner's, idea of the liminal space, we think of events that rest between two areas. Turner talks of initiation rituals in a culture that take a person from one state in life to another. Turner describes it in *The Ritual Process* as, "liminal entities are neither here nor there; they are betwixt and between the positions assigned and arrayed by law, custom, convention, and ceremonial. As such, their ambiguous and indeterminate attributes are expressed by a rich variety of symbols in the many societies that ritualize social and cultural transitions."[17] Warhol's love of film, his affinity for the surreal and Dada art mark him as someone who appreciated and benefited from the act of collage, this standing between two objects, two states and placing things, thesis and antithesis together. Warhol's work rested in such a liminal space between popular and high art and between common and classical. For Turner, this was an important time in culture. When the spirit moves from one locale, in the society to another sphere in the

society, the individual is affected by exposure to this new space and experience. In his conspicuous habit of purchasing and amassing data and material, he is creating collages in space. While we think of Warhol's collections and purchases as discreet units, Warhol very well may have seen his collection en masse. It is a shame that his large collection of obscure, collectable, priceless, and junkyard trash items were not assembled together in one final show. It is possible that such an exhibition may have illustrated a more coherent pattern in Warhol's life and art . . . or not. His celebration of detritus and debris from Western civilization at the end of the twentieth century may have revealed something about us as a society if not Warhol as an individual. One avenue of Warhol's work that has been sadly unresearched is his work as a sociologist, his probing of the American psyche at not only a liminal period but also at a time of crisis and juxtaposition. Warhol lived at a time between the purer capitalism of the early twentieth century and the oligarchic brand of capitalism control by a few artists, companies, and businesses in the latter part of the century. Such an exhibition in this mode might have been productive.

Warhol was moving from one zone, the practical and commercial, to the artistic and aesthetic, shuttling back and forth daily, and regularly. In an almost automatic way, he is less a creator of objects and more a compositor of objects for life collages. Like New York artist Joseph Cornell, who assembled things in collectible boxes, Warhol struggled to assemble things in his life box, his home. Warhol was fascinated with the corny, the kitsch, the laughable, the odd, and the uncanny in the way that it played with, distorted, and refracted the reality that most people saw in New York as something different alien and unknown. At the heart of that experimenting with the unknown and the untamed was his work in collecting cookie jars where all the elements of the disturbing and uncanny come to rest in a simple utilitarian item that can also be a gateway to the bizarre. Further with cookie jars we cross from practical to aesthetic very quickly. The jars are not only received as a provocative art form but a great container for food. For Warhol frugality and a vital art form went hand in hand.

Perhaps one of the most provocative sales related to Warhol and his collection details the enormous emotional spiritual power of the cookie jar collection as it was purchased and amassed by collector Gedalio Grinberg, the president of the Movado Group, maker of precision and beautiful machine watches and someone with an eye for the rare and splendid item. Grindberg was fascinated by Warhol's collection, and the ideas that the cookie jars were some sort of collection of machines or devices is made clearer by his purchase of almost all of the cookie jars in the Warhol collection. The display of them before they were auctioned was stunning, and the jars seemed to have a life force of their own. They were eerie being that they seemed to speak and

regard each other like sentient beings. In a video of their display for auction, the layers of jars were arranged in a lighted glass shelf. There is one cookie jar with a human head and a farmer's hat for a top of the jar. This jar seemed to regard the other jars with a look of lust or worse a threat of violence. Another cookie jar featured an attractive female cow dressed in a milk maid's fetching outfit. She had long eye lashes, pink cheeks, and a turned up nose, She seemed to regard the eerie farmer cookie jar with a look of some suspicion and perhaps a hint of fear. The jars seemed to be reacting to one another.

It is the eyes in the figures from the cookie jar that are perhaps the most illicit and disturbing. These are figures that seemingly have sentience and agency. They have a disturbing power. Warhol wanted to will things to life in much the same spirit of Dalí's paranoid critical method of making objects alive. But the cookie jars are special in that some things exist between life fullness and death and never achieve total life-hood. The cookie jars sequestered behind glass hidden in their glass cages are unable to speak with us. They exist in the half-life and half-dead experience. After the cow milk maid cookie jar, there is an elephant cookie jar. The elephant touted for its memory and with a smile expressing the sweetness of Dumbo, still radiates a paralyzing transparency. The glaze on the ceramic figure allows it to reflect light in a glossy shiny glowing quality. The elephant cookie jar looms menacingly with its dark hollow shadows projecting fake pleasure and its piercing eyes projecting a knowing eviscerating experience of the viewer. This elephant is not what it seems, and under the guise of being a toy, a cookie jar, and a children's plaything, this device hides layers of malice.

Another cookie jar in the collection also has a translucent glaze that makes its color and skin tone more distinctive. Here Warhol finds a cookie jar that has a disturbing message about race. This cookie jar offers a black chef or servant serving up the delightful confection, but this time the level of defiance is turned up as the smile on the cookie master's face from some angles seems a look of derision and anguished response for the duties of service and to produce cookies on demand. The figure seems to be smiling defiantly as if saying, "you want me to serve you what?" Did Warhol unconsciously buy such figures because they were cute, or did he carefully purchase such items because they complied with a racial agenda of defiance that he saw depicted around him. One could equate the purchase of cookie jars that reflected racial inequality, and the Warhol that befriended transsexuals, junkies, gay people, and people of color. These decorative objects that he acquired that bespeak a camp humor also suggest a level of defiance and a response to the unfairness of the status quo. The cookie jar collection and its subsequent rise in value may be a collectible because it reveals power ideas and images that respond to Warhol's subtextual and underlying feelings about things. Warhol may

have been involved in a double game because the work bespeaks a level of subtext for an artist who often touted that he and his work worked at a superficial and surface level and had no subtext. In reality, Warhol's work was shrouded in subtextual allusions. His life as a gay man, his wigs and disguises, his secret beach residence in Montauk, his life with his mother, his poor Carpatho-Ruthenian upbringing, his association with commercial arts, his intimacy for a decade with the largest names and companies in the advertising industry, his multiple failed relationships with a variety of people both male and female, his eccentricities, his health consciousness, his secret food cravings and drinking, all were mysteries to a public who saw him as nothing more than an art odd ball. The cookies may tell us about the secret fascinations of the pop practitioner.

Another cookie jar has a delightful solemn and meditating pig with rosy cheeks and ears pondering with eyes closed and long eye lashes pronounced, suggesting that the act of transgressing the cookie jar is ok. The pig has a mate and the male and female pigs reside side by side. The male has a kerchief and flower decorated coveralls almost like a gay man's outfit of a bygone era, too ostentatious for any straight male to wear, a Village People guise of pig decorative ceramics. The female pig has a hat. Her eyes are closed too, suggesting that she will be blindly asleep when violated by the child who comes to steal cookies from her jar. She wears a flower decorated hat and has a brimmed collar that serves as a closure for the cookie jar lid. Her tunic is subtly covered in flowers, and she, like her husband, wears a blank smile and rosy cheeks and ears. They are like two victims destined to be violated again and again with their insides scraped out by each new invader waiting to devour and cannibalize their inner parts. Their fat little feet pop out from the clean white glaze of the upper parts of their bodies.

One of the most startling cookie jars is a clear depiction of Humpty Dumpty suggesting that each intrusion into the jar purports to unseat Humpty and send him flying to his doom. Each time someone eats the cookie out of the jar, the violator is threatening the life of the aristocratic egg that holds sway over cookie land and its contents. But the eroded face and paint of the Humpty Dumpty character sits happy unaware that that what he is sitting on is the prelude to his own doom. The cookie jar is literally a death trap and lethal to the ectopic character sitting astride the ceramic edifice. Yet with his fixed and somnambulant expression the character never sees or presumes to notice the danger to his own continued existence. At any moment, a careless violator could rip the top off the jar and plunge Dumpty to his doom.

Some of the cookie jars are pleasant and rehabilitative. There is a relaxed Donald Duck as a baker serving his nephews, wearing a baking cap and looking radiantly happy with a helping of cookies and a plate in hand. Another

warmer image hosts a magnanimous moon with a plate and a spoon running for cover and a child nestled into the moon's cheeks hiding behind a cookie and a warm green landscape in the underside of the jar. Adorning the moon's head is a lovely cap to the jar topped with a kitty cat looking up to greet the person sampling the contents of the jar. There are also two comical big wheel cookie trucks with large back cabs filled with a silo of cookies and a bird singing atop the truck that also serves as a handle to open the cookie carrier and pluck his loot from the truck interior.

At first, one might think that the viewer is reading darker meanings into innocent cookie jars but in reality Warhol selected each of these 175 specimens as a choice of meaning and a statement of curatorship. He was buying and amassing a collection of jars for a reason, for a purpose. Whether the purpose was to evoke fear or joy, the cookie jars represent something that at face value can appear innocent but upon deeper reflection can suggest darker meanings.

While the cookie jars are mostly modest and playful kiddie images, there are some that approach a greater degree of realism and this is where they and a fair degree of Warhol's work can approach an area referred to as the uncanny valley. We discussed the occurrence of uncanny valley images in Warhol's supposedly journalistic printing of sixties' icons and found a streak of horror lurking in his sixties' seemingly neutral and personality-less works. Warhol might have been interested in uncanny images throughout his career. He seemed interested in uncanny images when he was animating shoes in the fifties. He seemed interested in the uncanny when he revived a dead Marilyn in his *Marilyn Diptych*. In 1970 a Japanese robotics scientist, Masahiro Mori, wrote an essay titled "The Uncanny Valley."[18] His idea was that as things approached a human likeness we tended to like them more until they became very lifelike and confusing and became more disturbing. This range where something approaching human form begins to frighten or discomfort us is referred to by Mori as "the uncanny valley."[19] It's just a theory not a fact, but there does seem some evidence that humans are discomforted more by things that are very close to humanity than by things that are some distance from humanity. Things that are exact replicas or wildly different don't bother us. A cartoon of Bugs Bunny does not make us fear that someone will kill the rabbit. Similarly, a hyper-realistic dinosaur such as that found in *Jurassic Park* generates belief and acceptance that dinosaurs can be real. However, in between the accepted real and the obvious fake is the more disturbing level of the uncanny valley, almost real and nearly convincing but lacking in some ways and seemingly making us uncomfortable. Mori writes that, "I have noticed that, in climbing toward the goal of making robots appear human, our affinity for them increases until we come to a valley . . . , which I call the *uncanny valley*."[20] For Mori, the closer something approaches human but still

diverges from the original, the more people become uncomfortable with that object. He discusses prosthetic limbs as an example. Other examples could be corpses, things that were once human, but lack the power of movement, or zombies, creatures that ape human movement but are far from human in mentality and purpose. One could visit stop-motion animation such as the creatures created by Ray Hauryhausen or Willis O'Brien. It is always disturbing to watch King Kong be murdered because he is a humanlike ape but not quite human nor quite ape, something in between that somehow is murdered, though he never lived.

Perhaps, Warhol's early pop works, the comic strips, the death and disaster newsprints, and the prints of celebrities, are all means of diving into the spectrum of the uncanny valley. What was Warhol's work of the fifties if it as not merely a recreation of objects of images or desires, desired by women that read and responded to the images that captured these desires. The closer the magazine paralleled the image in their consciousness, the more power that image acquired. At some primal, unconscious level, Warhol understood the doppelganger effect of advertising and images to simulate and substitute for such desires. Other texts have argued that the closeness and approximation to the human is a key part of puppet/man/figure/image-making apparatus. Victoria Nelson's interesting philosophical examination of puppets and their manifestation, *The Secret Life of Puppets*, in the twentieth century and particularly in their implementation in films and television illustrates how humans view puppets and other objects on a scale of their approximation of humanity.[21] Nelson refers to this strange process of merging consciousness and bodies as a philosophical process. In the film *Ghost in the Shell*, a Japanese anime work, she explains how the process works as, "Project 2501, a.k.a. as the Puppet Master, has the power to take over humans from a distance and plant false identities with matching memories in their consciousness, making them, 'puppets without ghosts,'"[22] Warhol does something similar. He drains or attempts to drain the humanity out of an image and then through his collecting, curating, or production makes that figure come to life without its soul or aura. He literally brings to life the puppet without a shell. There is something about his work that is zombiefication, bringing the dead to life *without* life. It is important to recognize among the vastness of the things Warhol collected, one of his prime objects was a giant replica of a punch doll, certainly a doppelganger for his work and his journey.

Chapter Eight

Warhol: Dark Designer

Men's evil manners live in brass; their virtues we write in water.

—Shakespeare, *Henry VIII*, Act 4, Scene 2, line 45.

Shakespeare argued that good deeds were rapidly forgotten, but dark events seemed to assume a life of their own. Certainly, in his design work, Warhol agreed that dark events prompted concrete form. We think of Warhol often as the prophet of pop art and as the man who made bright colorful designs. However, Warhol was a modernist, a critic, and a thinker and used his design work to make a strong statement about society's flaws, the problems inherent in capitalism and consumer culture, our obsessions with the mundane and trivial, our dark desire for the violent and prurient content, and our inhumanity to the world. Warhol was keenly aware of the various strains of modernism around when he began work, and as his work and capability matured he became more adept at synthesizing the various primal, psychological, and diverse cultural messages that were appearing in the society as it was changing. Warhol's design work in various media was distinguished, diverse, and keenly aware of the modernist trend toward Dadaism, surrealism, abstract expressionism, and the multiple means of abstraction that had appeared in the century. Simultaneously, he was also aware of the influence of corporate and hegemonic powers that pitted reality and abstraction against each other as two strong and equal forces that waged a daily battle to control the minds of consumers. Warhol's work framed this deceptively happy America and subtly and vigorously subjected society to a deep and complicated interrogation of trends, values, and images.

Warhol was a designer before he was an artist. The public has an interest in design and the work of designers but only a partial understanding of what

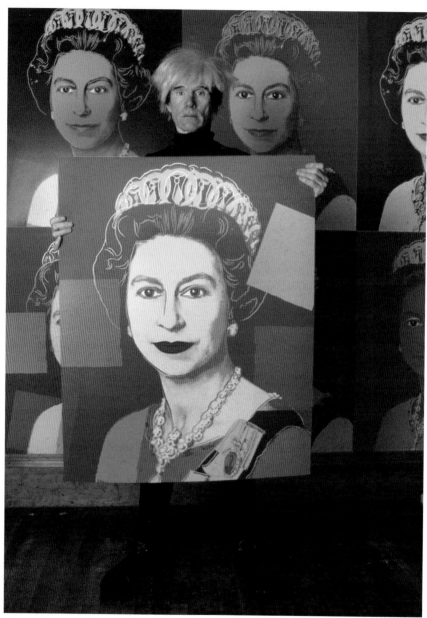

Figure 8.1. Despite claims of diminishing inspiration, Warhol attacked the eighties with renewed painting vigor and accomplished a series of brilliant and often witty prints. "The Reigning Queens" collection from 1985 was a tongue-in-cheek collection of world monarchs, including Queen Ntombi Twala of Swaziland, Queen Beatrix of the Netherlands, and Queen Margrethe II of Denmark. Featuring vibrant color, blocks of color suggesting collage, saturated pigmentation, and piercing portraits of strong women, Warhol commented on women, fame, and concepts of class distinction during the yuppie Reagan era. The works show Warhol at the height of his powers as a designer mapping the social landscape of the eighties. Here he is supporting Queen Elizabeth II.

designers do. In Thomas Hauff's *Design: An illustrated Historical Overview*, he describes it as a renaissance word from Italy, *disegno* or the "drafting and drawing of a work," or "the idea at the root of the work."[1] He explains that in the early industrial revolution the term in Germany meant product creation or "produktgestaltung,"[2] or the person that designed the product. This was the beginning of modern production design that made large quantities of mass-produced objects for large numbers of a growing middle class. This led to serial production, and he describes it as a process in which, "everyday objects such as the variety of pieces of furniture were not produced as single pieces but in larger quantities."[3] Catalogs and mailings were used to show off these products and market them. That was Warhol's business, and he saw himself as part of the industrial production of products. Many critics confuse the issues of productive commercial artists and goals of fine artists. There is a popular belief that fine artists are driven by higher goals and an arts-for-arts-sake consciousness. Production or commercial artists are driven by material profit. Warhol can be credited for transforming this perception. Warhol was always focused on profit and commercial issues. He made the public conscious of the fact that the majority of fine artists are not otherworldly figures but people that are also interested In products, financial reward, and sales. This orientation as being a working man or a cog in a larger economic model explains a lot about Warhol's relationship to industrial design, his work, and his view of himself in the larger scheme of things. Warhol was always playing a double game of situating himself as merely a compliant worker in the larger scheme of things, simply portraying himself as a mere producer but, at the same time carefully surveying the market and looking for what products will best suit the marketplace and provide him with the best chance of making sales. Thus, designers in general are concerned with aesthetics and business, and in that sense, Warhol was no different than most designers. Continually Warhol is making decisions about what to produce and offer. He is more than a designer; in essence, he assumes the role of the industrial producer and designer trying to ascertain what the market desires and then ramping up production to produce what society demands. Only his mass market is the more rarified and elite market of the New York Gallery scene. His design work shifts from the prosaic designs for newspapers and magazines to the larger gallery works that adorned walls. Part of his work evolved in scale and part evolved in quantity. But despite that change in markets, one could argue that Warhol remained at heart a designer in the business of producing industrial design for a hungry market. That sense of him and his work sometimes gets lost in the higher valorization of gallery products that though still products have an aura of something more important because as a culture we tend to ascribe more value to things produced for the elite market of gallery exhibition.

Design in our culture tends toward more prosaic origins and evaluation. This probably has something to do with the way our society values and sees art and objects. As objects have proliferated, they have become something of an entity unto themselves. They are a visual spectacle. In the past, these visions existed in larger objects such as sculpture and architecture. As the middle class developed, works of art were venerated and contained in viewing rooms such as galleries and museums. Lately the tendency has been to see objects as existing in smaller guises. Music is a good example moving from phonographs and records to cassettes to CDs to audio file players such as the iPod to phones that are, for all intents and purposes, multimedia centers contained in a four--inch block of metal, plastic, and microprocessors. Warhol was a keen observer of this transformation and quickly glommed onto all new technological methods of making and recording images and sound. Speed and usability were important to him and had he lived, it is certain he would be using microprocessors and simple electronic tools to manufacture the most art in the least time.

DESIGN MIDCENTURY

Mechanical reproduction and inexpensive techniques of distributing art transformed the process of art creation at midcentury democratizing the process of art creation and distributing art to a wider market of consumers. Elements of elitism had kept art the province of the upper classes for centuries, and the change to an egalitarian role for art was unwelcomed in some segments of the market. These elites saw art as their own special privilege, their province, the thing that separated them from the common classes. Marshal McLuhan wrote that, "we have long been accustomed to the notion that a person's beliefs shape and color his experience. They provide the windows which he frames, and through which he views all events."[4] Warhol was part of a new breakthrough generation that benefited from the forces of democratization of art. Warhol saw himself as part of a generation that surmounted the bonds of class. Through education, self-advancement, the media, ambition, the wonders of capitalism, and the American dream, Warhol's work allowed individuals to break out of the confines of class-based art. Warhol like many children of his generation saw little difference between him, his class, his society, and the mixture of all elements, and the work he was producing that was remarkably aware and ultimately transcendent of class distinctions. But just as the rich in their hearts knew and accepted that they are different, privileged, and entitled, it is safe to say that the poor always knew they were different, un-entitled, struggling, and seeking advancement to have what the

rich possessed. Alexis de Tocqueville summarized the work of the artist in a democratic society saying, "the handicraftsman of democratic ages endeavor not only to bring their useful productions within the reach of the whole community, but strive to give all their commodities attractive qualities that they do not in reality possess."[5] Warhol wasn't really bothered by the fact that he was born poor or that he was not part of the privileged class. Although snobbery and attitude could keep him from the finest museums, retrospectives, and the choicest venues, Warhol recognized that good design could open the portals to the elite and wealthy segments of society. For Warhol, this was the secret entrance to the society he admired. Certainly, an element of his work included a class struggle for recognition and to break through layers of elitist dogma. His work was a mask by which he could penetrate the elite realms. He talked about his portrait work that put him in touch with elite friends in the seventies and eighties. He said, "the Polaroids are great because people can choose the photo they want."[6] He could make designs that flattered these patrons. He commented that his Polaroid camera even, "dissolves the wrinkles and the imperfections."[7]

SPECTACLE AND DESIGN

In 1977, Guy Debord argued that the acceleration of the quantity and complexity of spectacle had changed the relationship of society to objects. He wrote in *The Society as Spectacle* that, "in societies where modern conditions of production prevail, all of life presents itself as an immense accumulation of spectacles. Everything that was directly lived has moved away into a representation."[8] Warhol lived in such a society, and by the fifties when he worked in design as an illustrator, the works he produced participated in the amassing of constant permutations of spectacles. Spectacles of clothes, of fashion, of shoes, his work participated in Debord's notion that society was moving toward replacing spectacle with representations of spectacle. That is, the people weren't even seeing the clothes or the products but only the artistic representation of those products. The consumer society had transferred the interest in the actual to the representation of the real. Warhol's work of the sixties replaced the real with a representation and his work as a designer was to make the replacement so alluring and so complete and so compelling that the real ceased to be important. The image would suffice. Warhol quickly recognized that the pleasing image was more important to the consumer than the thing itself. In a famous interview with Gretchen Berg in 1966 (with Berg supposedly interpreting some of Warhol's monologue), Warhol commented on his work saying, "I delight in the world; I get great joy out of it, but I'm

not sensuous. I've heard it said that my paintings are as much a part of the fashionable world as clothes and cars: I guess it's starting that way and soon all the fashionable things will be the same; and this is only the beginning, it will get better and everything will be useful decoration."[9] Warhol's notion of his work as *useful decoration* distinguished it from mere decoration. In this definition useful decoration was similar to the idea of simulation, a decoration that was so complete it rendered the original unneeded. For example, many have commented that the iconic status of Warhol's *Marilyn* replaced the need for Marilyn herself. That is, Warhol's ghostly portraits of the dead movie star were such a complete and capable reclamation of the star, that they excelled at *being* the star. Warhol's work started to replace the star in the public's mind. His plan was to substitute the allure of glamour for the glamorous. If there was a glamorous personage represented in art, the consumer could consume that package and have a reliable substitution for the actual star. In essence, one could buy star quality. As a designer, Warhol believed that he had packaged an important aspect of the visual environment, the sense of stardom without the individual needing to be the star.

French postmodern philosopher and critic Jean Baudrillard proposed a more radical program in which he argued that the end result of distancing simulations is, "It bears no relation to any reality whatever: it is its own pure simulacrum."[10] That is, the reality is erased by simulations which substitute for the real. He used Disneyland with its simulations of pirates, Frontier Land, and Tomorrow Land as simulations that replaced visions of reality. These simulations were so dominant and realistic, they convinced audiences that these *were* the realities. Disney's *Pirates of the Caribbean* became pirates for visitors who lost sight of the actual historically accurate version of pirates. Today, we view products on Amazon and millions of products that are totally unseen are marketed through an Internet vision of a consumable item.

As part of the tribute to Warhol's brilliant work in design, Italian author and editor Paola Varello released a text in November 2016 of Warhol's magazine work titled, *The Magazine Work of Andy Warhol, 1949–87*, through an exhibit at the Rare Books in 20th Century Arts series in Turin, Italy. Though not providing every single illustration the artist did for publications, it is an excellent addition to our scant knowledge of Warhol's complete work for magazines and contains hundreds of previously unpublished images photographed directly from existing copies of magazines from the era. Varello writes "this collection exclusively collects the numbers of the magazines that have published Warhol's works expressly commissioned by the relevant newspapers."[11] But looking at the works, often for sunny and popular American publications like *Vogue*, *Harper's Bazaar*, or *Time Magazine*, one can be struck by the ability of Warhol to insert commentary into his attractive and

clever design work. One noticeable case is the cover to the exhibit catalog, itself, a single shoe made of snakeskin that featured a writhing snake still attached to the shoe. Varello writes *"Harper's Bazaar's* (was the) eternal rival of Hearst Publications and this made life difficult for illustrators and freelance photographers as it was not allowed to work at the same time for the two magazines, that Warhol had to carefully negotiate working for different publishers who were in rivalry constantly."[12] However, Warhol's work was widely in demand and that made him able to circumvent such restrictions. The snake may seem playful, but the commentary of the snake suggests many allegorical connotations, particularly as it is portrayed as living in the shoe where a woman will place her foot.

Another piece from *Glamour* in 1962 focuses on an article titled, "The Fine Art of Concentration." In this illustration, Warhol diverts to a surreal image of a woman smiling and her head is filled with compartments of apples, presumably symbolizing the women's brain at work thinking of ideas of concentrating, also referring to the Apollonian ideal of the golden apples of thought. Although the woman is smiling and nothing seems untoward, the notion of apples emerging from her head seems surreal. In another spread for *Glamour*, this time from April 1955, an Easter issue offers a group of women in photographs wearing attractive Easter hats, but Warhol has added a drawing of an Easter bunny to the varied frames creating another surreal portrayal of live-action photo and comically drawn characters. In many of the photos, the bunnies seem to fight the women and their hats for center stage.

An article from *Park East* in March 1952 titled, "Men and What to Do with Them," offers a despondent woman throwing a wedding ring into a trash can, while angels above cover their ears. The figures are animated and visibly upset as the spouse who exists with hands outstretched in a strangling motion on the other page of the spread seems smitten with grief or rage or both. An April 1955 spread from *Mademoiselle* offers two women in beautiful frocks surrounded by Warhol's illustrations of wicked and kind stepsisters before and after the ball in a riff on Cinderella. The titles read, "with two ugly sisters who left her behind when they went to the ball."[13] Warhol has no trouble moving to adapt renditions of fables and folk tales, and his illustrations suggest a scene from the Cinderella myth. Moving toward more abstract symbols was Warhol's design for a cover of the magazine *Interiors* from June 1952, where an outlined man distinguished only by eyes and a mouth sits in a suggestion of a modern chair with a simple hint of pink color. Designs for *Dance Magazine* veer further into abstract shapes with dance shoes and an elegant woman's face gracing covers from 1958 and 1959 and interior shots of dancers in motion.[14]

The various drawings and illustrations followed tight briefs for high quality fashion and design journals and illustrated that Warhol was not just a hired

hand, but a skilled artist who was carefully able to insert subtle, abstract, and often pointed commentary into his drawing assignments. He clearly was responding to specific requests and work but simultaneously exerted a broad degree of creativity in designing covers, illustrations, and layouts that provided more than decoration. Elements of modernism and clever, comical, or insightful responses to the articles or subjects are often in the design. The snake shoes send messages that tied the shoes to early ideas of original sin and women's historic relationship to serpents. At the same time, orienting a snakeskin to commentary on religion and mythology is a complex way to code advertising for a sophisticated audience. Mythological ideas abound in the exploration of the Cinderella context, and something related to the idea of Pygmalion arrives in the apples in a woman's mind and the fortuitous and funny bunnies hopping around the women's Easter hats. Did the bunnies create the ad commentary for the women's heads? We don't know, but Warhol uses the illustration to plant extensions and completions of the advertising ideas. In any case, Warhol's early designs explore his early and keen engagement with modernism in design.

DESIGN AESTHETICS AND WARHOL

Morbid, dark, and moody might be one way to situate Warhol's pop art. Despite the notion of bright-colored images and attractive people, there was something deeply critical of consumer society in pop art. The British, who had endured nearly twenty years of austerity after World War II, realized the dark side of the pop phenomenon. The Americans were getting rich, but the British knew they were not, yet they worked hard, saved, and obeyed their government. In Britain, the Independent Group of artists and scholars argued for Americanism and American consumer values and were thought to be radical. David Hopkins writes that, "they endorsed an 'aesthetics of plenty' in a time when Britain was attuned to scarcity; postwar rationing was not lifted until 1954 and packaging on goods was uncommon."[15] Modernism in design subscribed to the aesthetic that modern design should be new and not derived from or dependent on history. In the same sense that Frank Lloyd Wright disavowed design that was based on historical tourism, Warhol grew up in an era in which the artist's originality was praised and lauded. Modernism also drew on new materials and new technologies to create its technological marvels. Modernism forgot the past in favor of the future. It emphasized the imagined splendors of tomorrow. Modernism also supported the notion of a change, increase, and progress. Warhol's work in advertising and fashion depended on design and fashion changing. This constant change provided new

work in an economy of evolving tastes. If there was a side of Warhol's work that was grim like the *Death and Disaster* prints, there was an element of his work that championed the silly, the ephemeral, and the whimsical. Whatever we know of Warhol, there is always another side, a prismatic focus befitting his complex and mercurial personality.

Mostly Warhol's work was simple and utilitarian. Often patrons and advertisers would want specific things and Warhol was schooled in responding to advertising briefs. *This, not that,* was the mantra of the professional commercial artist. In a time when fine artists were obstinate and asserting their authority, Warhol often acted as a cypher, rejecting his own original ideas and succumbing to the ideas and whims of his benefactors. Many of his works were utilitarian. He was to make a drawing of a dress. The dress should fit. The clothing should be elegant. The shoe should fit. In the end, Warhol's work was to make things simple and effective. Little else was required. Pop art began with stencils, imitative drawings, and copies of common objects. The art was not about originality but was based on what people accepted as the new ease of the modern era surrounded by gadgets like remote controls, vacuum cleaners and clever small electronics, tape recorders, radios, and record players. The emphasis was on reduced size, limited capability, and ultimately, portability.

Pop placed an emphasis on youth culture, and Warhol himself not yet thirty gravitated toward the new art that didn't require the heavy cerebrated format and emphasis that abstract expressionism required. With pop, Warhol could copy popular objects, hold them up to reevaluation and defend the culture that he had long embraced as his own. As a son of immigrants, Warhol was laying claim to a society where the immigrant class had worked its way into American culture. Pop also was a democratic and leveling movement. For a young outcast like Warhol, the spirit of pop and its notion that all things might be the same for all people was enticing and freeing. Warhol had lived and breathed pop during the fifties pouring his art into the average, the conventional, and the symbolic apotheosis of a consumer society. He worked for and built the mechanisms of the consumer culture. It was only right that he benefit from it.

Warhol's aesthetic was an evolving one. He didn't suddenly one day sit down to do pop art. He had been doing types of pop art in his commercial art all along. Clothing, fashion, children's books, posters, and silk screens were all variations of some format of popular expression or popular art. He used the materials of pop. He used the techniques of a new technological pop culture. He read comics and drew them as a child. He suffered from poverty and ate cheap Campbell's soup to remain alive and nutritionally filled. His work was often what he saw around him. In the sense that his pop art was a

reflection of his culture. he was a quiet revolutionary, a cypher who drank in the palette of American society and spit it back out to a fertile audience of patrons dying to own what he projected on them.

His work in the fifties evolved from a rococo decorative design and display, more to thrill and delight than to offend or frighten a public. Warhol was always intent on flattering and supporting his public and their needs and wants. He made Brillo boxes because patrons bought Brillo at the store to clean their kitchens. He made soup cans because his mother made him soup for years. These designs were influenced by American modernism. They praised progress, simplicity, and utility.

By the seventies, Warhol had faced the disturbing revelation that motion picture production minus distribution was a losing game, so he retreated to visual work where the price of his artworks, thanks to media saturation, and latent interest had risen. Interestingly, his absence from painting and near-death experience had resulted in a greater appreciation of his work. He began to paint and print on more contemporary topics and this time. He didn't hide the fact that he was borrowing images, copying, using existing photographs, and simply repainting what already existed.

What escapes many people is that Warhol rarely started a painting from scratch. He merely incorporated his brush strokes, toning, and blending of colors with an existing work of drawing or photography. Also, Warhol moved from the shocking headlines to simply the headlines for his motivation. He observed that regular headlines and news items were shocking all by themselves. For example, his *Mao* portrait gained a lot of notoriety because he chose a communist figure to reignite his art career. But the figure of Mao was in the news because President Richard Nixon was making overtures to China to create trilateral relations among the United States, China, and the Soviet Union. Nixon's plan was to derail Russia's role as the United States's prime adversary by making friends with another communist government and placing pressure on the Soviet regime to be a world peace player or suddenly be threatened by two connected super powers opposing Russia. Whatever the politics of it, Warhol's acrylic-toned *Mao* in a series became a popular icon and restored the power of Warhol's ability to transform common imagery into an iconic image. Nixon's move was a tactical grand slam and a wedge against Soviet domination and Japanese growth in the economy. Warhol's *Mao* worked as both a political and economic statement. If the United States could invest in China, Warhol could invest in the beneficent face of Mao, leader and spiritual mentor to China and its people. Warhol began to see the art market as a global one, and his fortunes were far better abroad than they were in the United States. In Europe Warhol was considered an important artist. In the United States, he was treated as something of a savant, a buffoon, a freak.

INTERVIEW

In the late sixties, Warhol began to grasp that film production without distribution was leading him to a commercial dead end, and he withdrew many of his films from circulation because they were not making him new wealth. Warhol said, when asked about the sixties' film work, "no, I'd rather do new stuff. The old stuff is better to talk about than to see."[16] He would refocus his design business on an organ that he could control and that would bring him advertising revenue. In 1969, Warhol attempted to get tickets to the New York Film Festival, and for once, he was denied tickets. He had always been admitted as a filmmaker, received tickets for free, and served as a supporter and participant, but the rule had come down that only respectable journalistic entities would be granted free tickets to the film festival.

Warhol decided on a lark to become the journalist the festival demanded so that he could watch the films, attend, and gain access to the newest art without buying expensive passes. With his assistant Gerald Malanga, they made a film magazine they concocted called *Interview*. It was initially cheaply designed with lots of stills from old movie stars and old images. Paul Morrissey, Warhol's resident film director, knew all the old film memorabilia shops in town and could find old stills and publicity shots from the shops quickly and inexpensively. John Wilcock, a graphic designer and printer, offered to partner with Warhol in making a magazine. Wilcock had already produced a small weekly magazine called *Other Scenes*. The deal was fairly simple, and it served the purposes of both men as entrepreneurs. Wilcock wrote, "Andy complained that he didn't have enough money to make a million dollar movie. I said, 'why don't you start a paper?' . . . we agreed that he would pay for printing and I would pay for typesetting . . . we became partners.'"[17] Wilcock later left the business, but Malanga, Morrissey, and later Pat Hackett and Bob Colacello would soldier on with the interview idea. Initially the magazine had the look of an underground publication with odd typefaces, cheap newsprint, and wonky interviews. Lucy Mulroney in her *Andy Warhol Publisher* described the first issue as a cheap print magazine attempting to resemble the underground glory of early issues of *Rolling Stone* and *Screw* magazine. According to Mulroney, Warhol's initial interest in a magazine was festival tickets and making fast cash. She writes that, "the overnight success—Andy's favorite kind—of *Rolling Stone* and *Screw* drove him crazy. 'Jann Werner is so powerful. Al Goldstein is so rich.' He moaned. . .' and both *Rolling Stone* and *Screw* use such cheap paper. Let's just combine the two ideas—kids and sex—and we'll make a fortune."[18] Later it was revamped to a slick glossy format, and Warhol began to recognize that *Interview* could cover the fashion scene and by fixating on fashions and celebrities could garner more revenue

from advertising. Warhol moved from early exclusive film coverage to more of a popular culture magazine focused on the celebrities, writers, fashionistas, and critical community that populated New York.

Fred Hughes who had become Warhol's manager and chief financial planner had an eye for making deals and financing projects. Victor Bockris explains it was Hughes who saw the potential in transforming *Interview* from a struggling film journal to a more all-purpose general culture, glamour, and gossip-oriented magazine. Hughes was talented at spotting trends and reorienting the magazine toward people in the elite classes. Bockris wrote that, "Hughes suggested: 'Let's get rid of the idea of doing an underground film magazine written by poets and artists and make a whole different magazine. Let's make it a magazine for people like us.'"[19] Hughes thought that a series of wealthy investors would welcome a magazine that was produced for wealthy insiders in the New York arts community. Hughes lined up Bruno Bischofberger, Warhol's European dealer, Joe Brant, the publisher of *Art in America*, and other wealthy backers to invest in the magazine and provide better printing and covers to give the magazine some shine. Warhol conducted several interviews with celebrities himself. The covers were fabricated to give the appearance of one of Warhol's seventies' portraits with lush saturated colors, overemphasis of features, and a strident and attractive appeal to glamour, beauty. and high style fashion design. Michael Jackson, Grace Jones, John Travolta, and David Bowie, among others adorned the cover of *Interview* during the era. Colacello wrote a vivid portrait of Warhol's merger of business and aesthetics of the time describing the business that Warhol ran in portraits and the sale of ads to support *Interview*. He wrote, "sales of both were going up, up, up, at the new Factory, and many deals were closed in the paneled dining room over box lunches from Brownie's Lunch, which usually started at one and often lasted until three or four, and was the centerpiece of Andy's day, when his kids and his clients gathered around the Ruhlmann table, and all his businesses intertwined in a tense and giddy tangle of work and play."[20]

Hackett argued that, "it was the magazine more than anything else that kept Andy from passing into sixties history. Meeting creative new people—especially young kids—was always important to him, he thrived on it.'"[21] Warhol used the *Interview* offices to recharge his energies, and he was deeply involved in the day-to-day operations of the magazine from the beginning. But by 1975, with Hughes running financial affairs, *Interview* had become a way to meet people in the elite classes, and the editor, Colacello, was instrumental in finding people that wanted Warhol portraits, and his friends in the publishing industries gave him important leads for Warhol for book publishing deals. Also 1975 was a good year for business and Warhol had enough

money to buy out Peter Brant who had been a co-owner of the magazine. Now Warhol was fully in charge of the operation, and he personally began to attend design meetings for covers and layouts, attend to matters like paper quality, personally selecting interviews in the magazine, and directing the editorial staff on his frequent visits to the office. Warhol moved from being a mostly silent investor to an active editor of a major magazine and the activity agreed with him.

The principle feature of *Interview* were the interviews. Many were conducted by Warhol himself, and he used his ubiquitous tape recorder to mechanically keep a record of what was said. Often the tape was transcribed verbatim, and neither Warhol nor the editorial staff ever changed much. Warhol rarely had planned questions. He would turn on the recorder and simply let the subject chatter on. Sometimes this technique would reveal a new side of a person, or they might blunder out things about themselves that were chatty and gossipy but at times not terribly revealing. Fran Lebowitz had a weekly column that she transformed into a book of essays and observations. Warhol's often deft and personal questions became a staple of his *Interview* interviews and in recent years, in the post–Warhol era, *Interview* would give the subject questions that Warhol had asked other subjects as a general guide.

Hackett reflected on *Interview*'s draw to young people. First, each issue featured fresh young faces and many young people read it hoping they could be discovered. *Interview* also drew a cadre of new workers. In the sixties, Warhol attracted people by promising them he would put them in a film, but by the seventies, *Interview* was a recognizable and attractive means to lure young talent. Warhol in his mid-forties also needed young people to keep other young people interested.

Many aspects of creating *Interview* were design problems. The magazine began life as a cheaply printed underground journal. These low-tech publications used cheap copying machines to make low-quality prints of the issues. The masthead changed several times from *Inter/view* to *INTER/View* to *Andy Warhol's Interview* to just *Interview* searching for the right audience, affluent, young, and interested in the arts. The size of the magazine changed as well. In its eighties' incarnation, it became a large oversize shape like *Rolling Stone*, featuring large graphics. The assumption was that large magazines could sell more attractive graphics ads and obtain more advertising revenue.

The man that ran *Interview* as the editorial director for many years was Bob Colacello. He wrote an entertaining and journalistic story of his life with Warhol as his boss titled *Holy Terror*, and it explains the amusing and sometimes goofy aspects of working for an inspired and capricious boss that enjoyed a wide variety of people and an endless series of projects. In one

part of the text, Colacello discusses Warhol leaving pornographic pictures in Colacello's office as preparation for his *Torso* series of prints. Colacello, furious with the vileness of the photos left to dry in his office demanded that Warhol take them out of his office. Warhol laughed it off and referred to the sex shots as *landscape* pictures.[22] However, Colacello and *Interview* served a larger purpose in keeping Warhol connected to current events and life in New York. Colacello commented that Warhol's constant filming and taping could make a party or render it an annoying and intrusive place to be. Colacello called Warhol, "the life and death of the party,"[23] but his continual circulation kept the magazine in the minds of people in New York and for Warhol that was the most important thing. Despite the exhaustion of life supporting Warhol and the magazine, *Interview* was vibrant in the late seventies and early eighties. Sales were strong and editorially the magazine had hit columns. Lebowitz published a book based on her columns, and Glenn O'Brien had several columns that addressed growth in the music industry. Many businesses were interested in advertising with the publication, and the reading public had embraced *Interview* as the literary equivalent of television's gossip fest, *Entertainment Tonight*, the popular television program focusing on the entertainment industry and its news.

DESIGN AND NEW EXPRESSIONISM

The eighties birthed a new era of art and young adventurous artists willing to make colorful provocative and often public work that existed for free. The new young artists arising in the seventies and eighties brought with them a new technique and a new spirit. Many of the new younger painters connected with the medium in a primal and primitive way. Keith Haring drew on subway walls and his cartoonish people were vibrant and moving. Though his art was figurative, it also contained squiggly lines that suggested motion and animation. Haring was influenced by cartoons, popular culture, and children's illustration. His work was warm, communal, and interested in building a rapport between street people, the poor, the artist's community, and the emerging suffers in the AIDS community that needed a supportive voice.

Haring was part of a Greenwich Village art scene that arose in the 1980s with Kenny Scharf, Jean-Michel Basquiat, and others. Scharf was another member of the scene who did figurative street art and used figures from popular cartoons to create a wildly embellished landscapes of pop art. His installations like the *Cosmic Cavern* at the Portland Art Museum in 2015 presents an immersive environment of Day-Glo colors, wild animated figures, and walls splashed with active patterns from floor to ceiling.

Warhol felt a kinship with the new art that was largely emblematic, flat, colorful, and at least superficially, one-dimensional. Warhol befriended young artists like Sharf, Haring, and Basquiat. He found in them a similar spirit to the art he had made in the sixties. These were artists willing to experiment and willing to use bold color and were happy to be considered commercial. Their youthful exuberance allowed them to disconnect from big art questions. They were making art, connecting with communities, and having fun. They thought about markets and commerciality, and they did not see a hard line among commercial work, pop art, and the marketplace for art.

Something had changed in Warhol, too. He was no longer surrounding himself with inferiors but was happy to find himself in the company of young artists that if anything equaled his talents and challenged the now middle-aged artist. Warhol's long time live-in boyfriend Jed Johnson had moved out. Warhol's love life was in trouble. He had a largely unsuccessful pursuit of media executive and Paramount pictures mogul, Jon Gould, and through issues of feeling unattractive and unloved began to lavish more attention and emotional attachment on his office staff from *Interview*, a group of chatty girls and the young artists of the neo-pop street movement of the eighties. Warhol felt avuncular toward the group he termed "the kids," and offered career advice and suggestions to the group of young artists. This also reflected a new period in his design work. His designs began to emulate the raw street style that his young compatriots brought to the market, neo-expressionism.

The influence of young artists attracted Warhol back to his pop pursuits and a massive outpouring of pop-oriented prints arrived. He painted dictators including Mao and Vladmir Lenin, and presidents including Jimmy Carter, Richard Nixon, and Ronald Reagan. While one might think that Warhol would have little in common with President Reagan, Colacello wrote that the two shared a lot. Both had strong mothers, and they were raised in a strict religious household. Both were poor and both worked hard to find financial freedom and security.

However, as a designer, Warhol gravitated toward the aesthetics of the eighties that were oddly influenced by his design and work in the sixties. In fact, a good way to describe the eighties is as a period deeply nostalgic about the art and ideas of the sixties. A premiere group of the eighties was Duran Duran with their chic pastel outfits, slick video presentations, and energetic pop performances. Duran Duran was light-years different than Warhol's Velvet Underground who presented a seedy grunge vibe and played loud and angry music. However, Duran Duran pictorialized Warhol's concepts. They caught his use of splashes of color on their covers, and they pursued a slick form of music that was synthetic, beat driven, and vocally aggressive. If Warhol didn't create them, he had created a design world where bright colors,

pretty young people, and slick presentation mattered. Even if Warhol himself wasn't really slick, he had championed a trivial and disposable culture, and Duran Duran's pop icon status played like a Warhol creation. In fact, when the band visited New York in the early eighties, they expressed an interest in meeting the artist and Capital arranged it. The group got on well with him, and Warhol and Nick Rhodes and his wife became good friends and went out with Warhol socially. Rhodes and Warhol had an abiding interest in art, and they all loved the New York night life and social scene. Of course, Duran Duran's pop styling, attractive costumes, colorful performances, cleverly directed pop videos, and their interest in courting the press made them clear recipients of Warhol's notions of a glamorous pop artist. The artist that did an early album cover for Duran Duran, Patrick Nagel, was subject to Warhol's influence. Nagel grew up in slick and bright Los Angeles and had a BFA from the California State University, Fullerton. A strong illustrator with an eye for drawing pretty model types, he would take an image, simplify and abstract it. He would transform his iconic drawings of women with strong washes of pure color. Some have compared his bright saturated colors to Japanese prints, but there is clearly the influence of Warhol.

A key element of Warhol's design work in the seventies and eighties was the emerging style of neo-expressionism, derived from early-twentieth-century expressionism. The format arrived in the early twentieth century as a response to the violent and turbulent changes erupting in the social and political landscape at the start of the century. Rocked by revolution, war, in-stability, and social change, artists reacted violently to the disrupting changes all around them. An example of the expressionist impulse might be witnessed in Vincent Van Gogh or Edvard Munch. Both artists were beset with mental instability. Van Gogh's life ended tragically early in suicide, and Munch endured years of therapy to relieve his anxiety. The expressionist period also reflected the influence of Sigmund Freud and the deeper understanding of the human psyche. Freud's *Interpretation of Dreams* was published in 1900 and immediately people began looking for insights into the world in their own unconscious and subconscious experience of the world. Expressionism was part of that analysis and perception. Initially the term *expressionism* was considered a way of describing new art at the start of the century but gradu-ally shifted to meaning northern European art. The term evolved over time. Ashley Bassie writes,

> The exhibition organisers and most critics emphasized the affinity of the "Ex-pressionism" of the German avant-garde with that of the Dutch Van Gogh and the guest of honour at the show, the Norwegian Edvard Munch. In so doing, they slightly played down the prior significance of French artists, such as Matisse, and steered the concept of Expressionism in a distinctly "Northern" direction.[24]

At the same time that expressionists were using vibrant color, strong emotions, thick applications of paint, and wild brush strokes they were also changing the subject matter of painting. Starr Figura in her essay on "German Expressionism: the Graphic Impulse," writes that the movement erupted from anger at the state of painting at the change in centuries. She writes, "the movement arose out of a feeling of dissatisfaction with the existing order, and a desire to effect revolutionary change. This attitude—rejecting bourgeois social values and the stale traditions of the state-sponsored art academies—was perhaps best reflected in Paul Klee's 1903 etching *Virgin in the Tree* . . . , a grotesque parody of the long convention of idealized or allegorical female nudes."[25] The German painters were also profoundly affected by the loss of Germany in World War I. Germans had deep national pride and thought their war state was ultimately superior to any foreign force. They were surprised and stunned at their defeat at the hands of the allies in 1919 and, worse, the terrible toll of the Treaty of Versailles bankrupted the economy during the twenties and plunged the entire country into a deep emotional and financial depression.

Warhol and the young neo-expressionists borrowed many of the ideas from the first expressionists but framed these paintings in a pop context. In his painting titled *Obnoxious Liberals*, Basquiat used many techniques pioneered by early expressionists. Raw bright red, white, blue, and black paint is applied to the surface. There are three prominent simplified figures in the foreground. There is a black figure with arms outstretched on the left. There is a red figure with one arm saluting at center and there is a figure in a cowboy hat to the right. The words *gold, obnoxious liberals*, and *not for sale* are scratched in the surface. The figures are crude, simplified, and emblematic. When Warhol painted with the young artist, he would insert stencils including brand names and popular icons. While Basquiat provided the emotional and deeply personal iconography Warhol provided ideas from his commentary on popular business brands and advertising design. Neo-expressionism allowed older artists like Warhol to communicate with younger artists, allowing both practitioners to use a vocabulary that was native to their work.

LATER COLLABORATIONS AND DESIGN

Warhol like all people in the arts had to deal with the rise and fall of various styles and trends in the art world. Jonathan Woodham in his *Twentieth Century Design* explains the conundrum that met most artists and designers at midcentury. He writes that,

> with a discernable shift of emphasis from production towards consumption in the changing market conditions of the postwar period, questions were raised

whether either the monolithic Fordist model which had hitherto dominated ap-
proaches to manufacture for the mass market for much of the twentieth century,
or the modernist aesthetic could cater adequately for the increasingly variegated
tastes and desires of the consumer.[26]

Warhol's work had responded to the rise in consumerism and he had seen the
erratic and shifting tastes of gallery patrons. He had shifted his practice from
commercial design to gallery art to film production to publication production
and by the seventies was engaged in video production, portraiture, and com-
missioned prints canvases and installations. Besides transitions in the forms
of work that he was producing, he began to alter his design practice via new
methods of working.

His work had also changed from a solitary nature to a team approach. He
had gained the ability and willingness to actively collaborate with a wide as-
sortment of people. His designs took on the effect of a studio of collaborators.
Warhol liked the company, and he liked the exchange of ideas in creating
projects for new work. He had secured a talented office staff. His female
assistants Tama Bobbersbach and Paige Powell led him to charity work and
giving meals at soup kitchens. His love life hadn't improved, but his feelings
about the world had softened and warmed. His work became more interested
in people and their conditions. He did a series of images based on *The Last
Supper*. He painted with Francesco Clemente and Basquiat, and they made
objects that used all three of their image styles sandwiched together on a
single canvas. Warhol liked the group productions. It cut the amount of work
for him, and it allowed him to socialize while painting.

He experimented with materials and new ways of making art that engaged
the chance methods of John Cage and allowed a team creation. His piss
paintings were an experiment in using oxide canvases. A compound was
layered on the canvas and the when people urinated on the canvas, the paint
would turn color, sometimes green and sometimes black or other shades. The
problem with the experiment was that the room would smell dreadful, and
the canvases even weeks later might drip onto the gallery floor. However,
the results were designs that were captivating and occasioned by the chance
combination of chemicals on the canvas.

Another aspect of Warhol's late work was the introduction of an element
of the casual. Rather than concocting elaborate schemes about his art and his
background, Warhol began to let casual chance art happen. The oxidation
paintings were one aspect. The collaboration with young artists was another
way in which he was welcoming less-formal methods into his work. A third
aspect was his work in video, which by its nature had to be collaborative. He
had to work with others, and often he was not in control of the situation, so
he had to cooperate. Again, this was not a problem. Warhol always found the

pose of being a creative artist taxing, and he enjoyed taking directions and following commands.

Another aspect of his work that had improved and increased was his design work in prints. He began making many editions of prints. One of the most amusing and self-referential was the series of ad prints that reflected designs found in advertisements. For someone who had come from the world of advertising and commercial art it was an amusing double commentary to see Warhol making prints commenting on advertising art. In the advertising ten-print series, he had a version of Apple's Macintosh symbol with the "bite out" symbol and in multiple colors. Next to that is an image of Donald Duck replicated marching carrying a broom like a solider. Warhol is clearly referencing Disney's war efforts to help the American cause during World War II, and his Donald next to the Apple image makes a commentary on two of the country's most important businesses of the era. Disney was going through a popular renaissance, and Apple had arrived with the popular Macintosh brand of computers. The next ad was a simple shot of the Chanel no. 5 perfume bottle. This classic design was framed with hot colors and a royal purple. Next was the Paramount movies logo. Warhol was deeply enamored of films, glamour, and the studios. It also referenced Warhol's erstwhile love interest Jon Gould, his current amour and perhaps the symbol was a flattery to him and his company. Next to that, Warhol reached back for an antique symbol of an old Mobil Gas sign, which referred to the fuel company in an older guise.

The next image was a Blackgama ad. Blackgama was a company that manufactured high-end minks for fashionable ladies. The ad was captioned, "What becomes a legend most?" The subject was the late Judy Garland adorned in a mink coat. The idea that Garland was the height of fashion wearing a mink merged Warhol's penchant for nostalgia design and his interest in star portraits. He also brought in issues of the morbid, uncanny, and surreal using the dead Garland as a model. Here, he transformed a portrait of Garland whom he never was able to portray during her life into a Warhol portrait. Again, Warhol's pursuit of glamorous images makes Garland a stereotypical subject for his ad work.

Next is the famous Volkswagen lemon ad. The company featured a Volkswagen Beetle with a caption, "lemon" underneath. This was considered a bold and adventurous ad at the time because the notion of *lemon* associated with a car could diminish sales. Volkswagen were so confident of their product that they didn't think their work could be considered a lemon so they posed the dichotomy humorously. Next, the current president (in the eighties) Ronald Reagan was featured in an advertisement for Van Heusen shirts. The handsome actor wore the shirt and appeared smiling with a headline, "won't ever wrinkle," which playfully wagged the relatively old Reagan, then sitting

as president. Next was a Japanese ad selling coolness as a concept and using the model of James Dean in a still from the film *Rebel Without a Cause*, the film that launched Dean as a teen idol in the fifties. Finally, the series was completed with a Lifesavers ad that again benefitted from a wildly saturated coloration of all the different lifesavers in a pack of candies beautifully displayed in different colors. The copy admonishes the audience, "please do not lick the page." The series was playful and referenced Warhol's extensive association with the world of advertising. The series of ads in the *ADS* print collection emphasized glamour images (Chanel, Reagan, Dean, and Garland), movie images (Donald Duck, Dean, Reagan, and Garland again), the connection of American life to commodities such as food (Lifesavers), cars, (Mobil Gas, Volkswagen), and big business (Disney, Apple, Mobil, Chanel). In a way, Warhol's new design work acknowledged and accepted his enthronement as a member of the establishment.

Chapter Nine

Warhol: Artist of the Postmodern

GSW: Do you like the machine because it is quick?

Andy: I think it's great. It's quick and everything.

GSW: What difference do you think this will have on mass art as opposed to high art?

Andy: Mass art is high art.[1]

O'Brien: Do You Believe in the end of the world?

Warhol: No, I believe in *As the World Turns*.[2]

Warhol entered the eighties rethinking his strategy. He had made good profit on the portraits of celebrities and wealthy people. That helped to fund print-making, *Interview*, and offices and salaries for Andy Warhol Enterprises. He was well-received in Europe. However, he was concerned that his work wasn't contemporary. It wasn't central anymore. There were young artists on the street. Warhol said in 1977, "We're getting all these kids from the different countries in Europe, and they're creative and bright and rich, and you get these different people here, and they're all so talented and there's just so many."[3]

The hot ticket in the early eighties was the Mary Boone Gallery. The young attractive gallery owner had bought a space in Soho and attracted young artists to the space. *The New Yorker* did a profile of Boone in the eighties and commented that the seventies' art market was unproductive. They mentioned that, "but generally things flagged. The artists wanted to create uncollectible work and successfully created uncollectors."[4] The emphasis was on land art, conceptual art, and installations. Artists like Christo were making brilliant designs on public and private property, but these projects were funded by

governments or private grants and though beautiful, no tangible product was produced. For many artists the idea of no product was the point. The minimalists placed structures in arrangements often having the audience experience or walk through the construction. Robert Morris commented that, "the better new work takes relationships out of the work and makes them a function of space, light, and viewer's field of vision."[5] *The New Yorker* wrote, "But the current scene was a mess. The voguish word was 'pluralism' meaning 'anything goes.'"[6] The art market had become a market where the supply of galleries needed a constant supply of marketable product and the interest in conceptual art was negligible. Further because most concept art was just a concept there was no product to sell. Artists that had created pop products in the sixties were selling well because they had created saleable canvases, sculptures, drawings, or other products, and only so much of it existed. This led to a resurgence of retro art, which led to the emerging spirit of postmodern art, which was interested in styles of art from previous eras, and more extreme forms of modernism.

Warhol saw that things were moving in a whole new direction. The gap between various disciplines was closing. The qualities that had defined modernism: Experimentation, abstraction, unconscious processes, fantasy, and departures from reality were under attack by a movement toward a new diversity and variety in art. Warhol began to engage in painting again. He had employed the use of stencils and printing on canvases since the sixties, but now his stenciled work was merging with new mark making. Warhol was using brushes on canvas again and the results were an exciting return to the medium.

In 1975, Italian art dealer, Luciano Anselmino suggested that Warhol do a series of prints about drag queens. The gallery director had commissioned a hundred prints of Warhol's photograph of surrealist artist, Man Ray. The market for the prints were strong. He thought prints of drag queens from the Hispanic and African American community would explore many different issues of class, race, and marginalization in American society. Writer Bob Colacello from *Interview* was assigned to find subjects for the series. He attended a transvestite bar in Greenwich Village called the Gilded Grape. There he found a group of transvestite performers willing to pose for photos. Colacello offered the performers fifty dollars for each person willing to pose for the series of photographs. Warhol was interested in drag performers and how men went through the ordeal of performing as women. He had had a series of transvestite performers attending the sixties' Factory scene, and he was curious and wished to tell their story in the prints. Warhol questioned how they could perform another gender. He wrote, "I wonder whether it's harder for 1) a man to be a man, 2) a man to be a woman, 3) a woman to be a woman,

or 4) a woman to be a man. I don't really know the answer, but from watching all the different types, I know that people who think they're working the hardest are the men who are trying to be a woman. They do double-time."[7] The portraits were shot with the Polaroid technique that Warhol had used so effectively in his seventies' portraits of high-society New York sophisticates. Here however, Warhol captured a group of transgender men who had been marginalized and ostracized from polite society.

The drag queens were allowed to dress as they pleased. Many came wearing their drag outfits for performance, and they vogued appreciatively for the camera. Warhol set up his Polaroid camera for the models and photographed each in a variety of poses picking the best shots for the series. The faces are usually turned in three-quarter profile shots and many of the subjects were smiling or grinning with delight. Many of the performers were extremely beautiful and attractive, and a few were not attractive but comical and showed the qualities of comedian. Most had long false eyelashes and beautiful painted on lipstick. However, Warhol's work wasn't the same as previous portraits. He was exploiting new techniques. Warhol painted over the blown-up prints in extremely thick layers and used heavy brush strokes that were widely evident in his work. Unlike some of the society portraits that were attractive and subtle, these were different. Often Warhol used pastel colors and many of those portraits were decorative. These portraits were not subtle. Paint was layered on thickly and one could often see actual brush strokes on the print. Vincent Fremont, one of Warhol's administrators at Andy Warhol Enterprises, discussed the experience of working with the models. Freemont wrote, "I would hand the subjects a check and send them over to the bank. Usually they would not have any identification, so the bank would call me and ask if I knew a Helen or a Harry Morales! I do not remember if they knew who Andy was, but the photo sessions were wonderful for every one of them. They were able to do their favorite poses and act glamorous for Andy's camera."[8] The portraits were in bright, stunning coloration, and Warhol used a new vigorous more aggressive painterly brushing that made the work more vibrant.

Warhol was interested in painting again and using emerging new techniques of printing, and in the *Ladies and Gentlemen* series, we see a variety of new ideas. In several of the series there were bright pieces of paper seemingly applied over the performers like confetti glued to the prints. The splashes of color seemed to decorate some figures like a rain shower, and in other instances, the paper cutout effect adorned eyes, mouths, and hair. The application of paint or cutout effects drew attention to the parts of transvestite performers that were fabricated. The hair, mostly wigs, were accentuated. Exaggerated eye lashes and eyebrows were a strong feature. Noses, hands, and mouths were focused aspects. There were coy looks captured as the models

become vamps in front of the camera. As opposed to Warhol's celebrity portraits, there is a real intensity. These are not wealthy people conveying their
everyday status as entitled individuals captured with their prized possessions.
These are working men, gay, and transvestite performers of color who are on
a paid assignment in Warhol's studio portraying a role. They are performing the female vision for an artist, and they are enacting a character. There
are grimaces, smiles, coy looks, flirtation, and subtle relaxed poses. Warhol
is making a statement about identity, and he is using new techniques that
explore new ways of making colorful, decorative, but also revealing prints.

Although espousing a simplified rhetoric and not claiming to recognize
specific art movements in his work, Warhol showed himself to continually
be a keen student of art history, not only of contemporary styles, but of the
entire range of aesthetic styles. In fact, Warhol's education and extensive
knowledge and awareness of the different forms of art all around him mark
him and his work as existing at the start of the postmodern period where a
collapse of art formats and historical styles begins to occur. Although Warhol perhaps did not see himself as such a pivotal knowledgeable or professorial figure, his work illustrated a clear understanding of various historical
styles that he could arbitrarily appropriate when needed. One example of
the strong ability to enjoin various movements was the insights shown in
the *Ladies and Gentlemen* series of prints. Warhol clearly begins to model
his work on the work of expressionist painters in the early days of the twentieth century. The expressionist flowering was brief and mostly centered in
Germany, starting around 1905 and existing as a sharply conceived style
through the twenties. However, expressionism never had completely disappeared, and its vibrant emotionalism was evident throughout the twentieth
century. The first group of painters were "Die Brücke" ("The Bridge").
Artists like Fritz Bleyl, Ernst Ludwig Kirschner, Erich Heckel, and Karl
Schmidt-Rottluff had no one style but shared many common characteristics in their work. They wished to free themselves from academic painting
where all things were lined up in an orderly fashion in extremely planned
compositions. They used vibrant coloration and wild and exuberant brushstrokes, often mixing the use of palette knife with thick impressionistic dabs
and brushes loaded with excess paint. They showed scenes from real life
including wild dances, naked bodies, and abstracted and distorted forms.
Mostly the group wished to express a new naturalism. Dietmar Elgar writes,
"what the Expressionists depicted was a simple organic symbiosis based on
the rhythm of nature alone."[9] Besides the desire to be free, to paint what
they liked, to explore the wild and natural in man, the expressionists also
loved French painting and the beautiful use of brush strokes and color of the
impressionists. If they were less technical in their use of light and color and

they were interested more in wild and abstracted images and landscapes, so much the better for their appropriation of French techniques. Der Blaue Reiter (The Blue Rider) movement was more extreme and more varied. The authors of this form of expressionistic painting were more diverse and thought, "that all the artists were aiming to integrate not only their impressions of the outside world, but also their inner world, and to do so with a new artistic form of expression."[10] There were antecedents for the der Blaue Reiter. There was a journal by that name that had already published some of the new art, and many adherents were interested in the new total art movement described as art nouveau or the new art. Der Blaue Reiter movement expressed more interest in folk art and design movements from the folk traditions of Germany. They also started to break up forms and experiment with Cubist manners of seeing the landscape. Finally, there was a nearly equal distribution between scenes of the outside world and inner portraits of their dreams and anxieties, their inner world.

Warhol knew much of this history and began to see the ways that his work could use these techniques from the early avant-garde and make not only that style new and relevant again, but perhaps he could use the inspiration of an old avant-garde to spur the children of the new avant-garde.

In his *Ladies and Gentlemen* prints, he used the wild and bright colors that were often the tones splashed on the canvas by expressionist painters. While the expressionists often showed extreme facial expressions, emotions, anguish, or pleasure in their figures, Warhol conjured bright and upbeat poses from the transvestite models of the series. These are extreme and jubilant characters acting for the camera in their full drag regalia. The expressionists rarely showed the average or every day in their images, and Warhol emphasized the heightened exaggerated guises of the performers in *Ladies and Gentlemen*. Also, Warhol, like the expressionists, cut color up into blocks of tones and placed one extreme unmixed and exaggerated nonrealistic tone next to another. In his color selection, his portrayal of heightened emotion, his use of nonrealistic color, his tendency to exaggerate and exemplify unnatural and extreme poses in his models, and his use of heightened non-naturalistic people, transvestites as subjects, Warhol participated in a rebirth of expressionistic techniques for a new generation.

Warhol courted young artists and became friends with Keith Haring, Francesco Clemente, and Jean-Michel Basquiat. Warhol and Basquiat had the most rapport and appeared in photo shoots together. After a photo session, Warhol liked several of the shots and suggested that the two paint together. They did a group portrait called *Olympics* from 1984, the year of the Olympic competition in Los Angeles. The large canvas (75 by 120 inches) portrays themes central to both artists and offers opportunities to introduce a strong

neo-expressionistic style. There is the brightly colored stenciled logo from Warhol across the painting showing the interlocking circles that symbolize the Olympic competition. There are images of a profile that appear to be Ronald Reagan's head. Then there are acrylic heads painted in a tribal style by Basquiat that are in bright yellow, brown, and red. These characters show African American faces, large eyes, grimaces, brightly colored teeth, lines, and shapes painted through the design. Basquiat and Warhol illustrate contemporary themes of fame, celebrity, characters, and color all merged together in a lively composition supported by a sea of heads. His collaboration with Basquiat and others revived his interest in painting and spurred him to new ideas in creating images as the eighties progressed.

PERFORMING WARHOL

Warhol had suggested that much of life was a performance like watching something on television, only it occurred in real time. In his last decade, he mentioned that he was doing more appearances and live work. He said, 'I'm a Zoli model now. I'm doing a Barney's ad for the *Times*, I'm actually trying to get the Polaroid commercial, but that's so hard to get. And we're doing that TV Fashion show once a week."[11]

Warhol began to fashion a new public persona in the eighties. Directed by financial advisor, Fred Hughes, Warhol adopted a more dapper demeanor. Ties, Ralph Lauren, and Calvin Klein styles replaced jeans, turtlenecks, and leather. Warhol, a lifelong devout Catholic, met the Pope, and when he did, he gushed with enthusiasm. He brought his camera to the event to snap pictures of the pontiff. Warhol courted a public personality and liked to be photographed out and about regularly. In 1976 he did an interview on Thames television for the disastrous *Pets* exhibition in which Warhol had done portraits of pets for a gallery show in London. When asked why he had switched to doing portraits of pets, he quipped, "I got tired of doing people."[12]

In the eighties, there was an ABC *20/20* Special on Warhol and his art. He was now a mainstream figure, a blue chip stock. Host and commentator Hugh Downs described him as "a publicity shy publicity whirlwind, he uses his shyness to superb effect . . . he gets to know everyone."[13] The ABC special referred continually to his "bizarre world" and emphasized his shyness.[14] During the special, he agreed to paint Farah Fawcett's portrait, and Fran Lebowitz discussed his impact on the concept of fame. Warhol nurtured a public image that was seen as remote and shy, but he used that persona to make himself a recognizable brand.

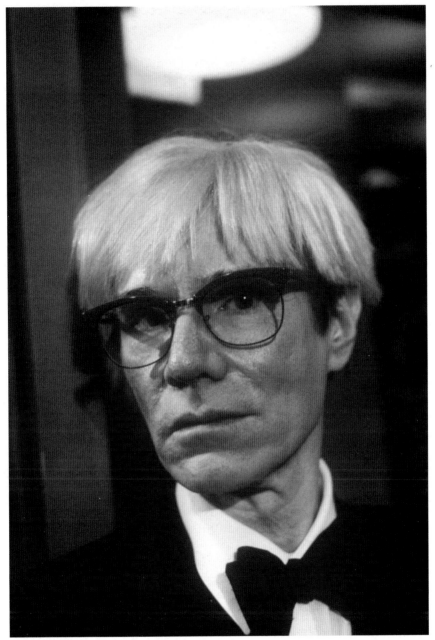

Figure 9.1. Warhol achieved one of his life dreams, appearing on a network tv show when he appeared as a featured guest on an episode of ABC's popular romance show, *The Love Boat.*
ABC/Photofest © ABC

On *Love Boat*, the ABC romance program, Warhol achieved a life dream of being on an American network show. The writers lovably lampooned Warhol and his reputation. When cruise director, Lauren asks a Warhol assistant, "how does an artist know when his work is truly successful?" the assistant responded, "when the check clears."[15]

Perhaps there would be no greater way for an artist to indicate, illustrate, or perform the self than through the act of modeling. Warhol, always hampered by body image problems, adopted the unusual wigged look to make an asset of his baldness. His management deduced after countless contacts had been made to use Warhol for commercials and to guest star in ads that it might be wiser to pitch Warhol as a professional model for gigs. He had his nose grinded in the fifties to make his appearance more attractive. It did little to reshape him. He wore contact lenses to look more attractive, dressed better, and adopted a more professional guise, using the best fashions of the era. In fact, he courted the odd appearance, ruffling his wigged appearance to look more bizarre. It was widely known that many successful executives in New York wore wigs, and outside of his wild-haired appearances, Warhol's presentation could be innocuous and blend in with other faceless business types in the metropolis. Finally, in the eighties after several ads had used him as a pitch man for products, he had an opportunity to do professional modeling. His odd look, ultrathin with the noticeable wig, had become a fashionable style, and people began to identify him with his look. However, by 1980 Warhol was getting so many requests to be a spokesperson for products that he actually became a model for the ultrachic Zoli modeling agency in New York. The work poured in, and Warhol's somewhat clumsy awkward body, sort of a Max Headroom combo Edward Scissorhands image, made him a star of the ad world. The ironic course of Warhol's career was that after thirty years of toil, he was no longer an illustrator for *Vogue*, he was a model in *Vogue*.

POSTMODERN WARHOL: REVERSALS AND DEEPER ADVERTISEMENTS

Part of the misreading of Warhol's work refers to the debate on postmodern aesthetics. Again, Warhol, knowledgeable of such debates eschewed any knowledge of the higher dimensions of his work. He sought to explain his relationship to his work as the craftsman, the cobbler, the artisan, and he often framed that relationship as the maker—to the product. But over time his role has become more crucial to debates over postmodern ideologies, particularly as we visit the eighties and culture wars rampant among cultural theorists. John Hill produced a significant overview of the varied debates that raged

over the concept of postmodernism during the era in his essay, "Film and Postmodernism." There were multiple theories that took on philosophical, sociocultural, and aesthetic dimensions, and Warhol's work can be seen as participating in all of them. First, generally, postmodernism avoided most totalizing and inclusive theoretical frameworks. Postmodern thinkers simply mistrusted such overwhelming and complex views of the world. Warhol often discounted the variety and density of his education, but at Carnegie Tech he was exposed to some first-rate thinkers and painters. When interviewed by Glenn O'Brien for *High Times* magazine in 1977, Warhol explained, "We had a wonderful teacher named Balcolm Greene. He gave slide lectures."[16] Balcomb Greene was a major painter and theorist of the era and probably framed many aesthetic problems for Warhol's generation at Carnegie Tech. It is likely that Warhol despite his repudiation of such ideas was conversant with notions of the postmodern debate. Hill explained that a major philosophical issue was "the heterogeneity and fragmented character of social and cultural 'realities' and identities as well as the impossibility of any unified, or comprehensive, account of them."[17] For Warhol, his early work participated in the only realities that he felt might be common in such a ruptured and unmoored society, products, and icons. Further in a social context, the class structure of society was breaking down. Warhol and his democratizing art could explore the commonality of all people through products, and even the elite could not dispute that they were part of this new less hierarchical system. Warhol, by his production of common products and common messages, reduced the influence of class distinction while he himself rose through the class ranks by earning money via marketing objects that appealed across classes: shoes, ads, popular faces. In a sense Warhol's celebrity portraits predated the power and influence of apps like Facebook where the audience looked for a repository of images. Warhol had already felt his task was to provide such repositories of images to circulate and sell.

By the eighties, in images like the *Oxidation* paintings and the *Shadow* paintings series, Warhol perceived the only way *out* of providing images for society would be to provide nonimages such as the shadows and oxidation canvases. Time and space were collapsing, and media images were becoming a key to reality. Warhol saw himself on an image treadmill and the expressionist nonobjective art that he began to produce violated the needs of that emerging system. His art started to resemble the more fragmented and abstract images of technicians working in the field of nonobjective painting and lyric color field. Charles Jencks discussed the crisis in postmodern architecture saying that the failure of functionalism was promoting a need for decoration and a mixing of styles to alleviate the monotony and incapacity of modern architecture to fulfill the society. Jencks saw the future of architecture

and society as this blending of forms and this natural hybridity of styles circulating at a time when many options and choices were available. He wrote that, "The two ideas behind this are plenitude and pluralism, the idea that, given the choice, people would rather have a variety of experiences and that, as history proceeds, a plenitude of values, a richness is created on which it is possible to draw. In short the content of our buildings is . . . the variety of cultural experience, the plurality of psychic, social and metaphysical states possible to people."[18] The postmodern impulse was toward everything from all times merged now. The chaotic mixture of times, styles, and forms was difficult to parse, but it provided a rich image atmosphere that was eclectic. Warhol was keenly aware that people in a market desired variety. He learned that he needed to be flexible and adaptable to prevailing changes in style. The neo-expressionist movement, and the artists that Warhol met in this emerging movement (the "kids" as he avuncularly championed them), began transforming Warhol from this avatar of blank impassive objective voyeurism to an engaged commentator regarding the changes and alterations in arriving pop content.

This brings us to Warhol's *Reversals* series where Warhol revisited items from his sixties' work and either redid the works, combined the work into a collage, or reversed the work using darker and more disturbing colors. This series is a radical revisitation and reassessment of his sixties' output, and truthfully, Warhol does not necessarily visit it with fondness but often with a vengeful hand in re-embellishing it. In 1980, the *Reversal* series took the famous Marilyn images from 1962 and transformed her into a reversed negative image. Instead of Marilyn being a beautiful icon of Hollywood here she is a hollowed out image of death and destruction. Print paint drips from her mouth and the colors that previously decorated an attractive colorful façade now decorate a transformed inside and out hollow image of emptiness. The eyes are dead and unseeing, the lips are puffy, and the hair fades into black. These Marilyns are an obliteration of Marilyn, yet we can still see the image of Marilyn waiting to pounce on us. This Marilyn is more striking because color has not been applied to make her more natural (she isn't wearing the thick gobs of pigment that Warhol lavished on her image, that is her *makeup* in this image), but here she is a dark gorgon, a ghostly spectral version. She is printed into a color background of flowing red, blue, and green with colors that seem to drip from her visage as if she is melting. There is more of the Wicked Witch of the West about this version of Marilyn, and one can't help but think that Warhol may have been envisioning a psychedelic *Wizard of Oz* image when he created this lewd and disturbing recreation of his famous *Marilyn*.

In Guy De Paoli's *Elvis + Marilyn*, Thomas McEvilley commented that, "they seem primarily to represent vulnerability, perhaps because both attained

their mythic status in the early to middle 1950s, just slightly before American military and geopolitical hegemony began to emerge from isolation."[19] Yet in Warhol's *Reversal* series, he strips Marilyn of her mystique, her beauty, and her allure. She is pictured here as an abstracted essence of absence and death. Here we definitely see a change in Warhol's tone and attitude toward the actress. No longer is she the overwhelming legend, she is now a transcendent figure of decay, a destroyer, or a Shiva/avatar to suggest the dissolution of the world of glamour. An idea lost to many critics is Warhol's constant reevaluation of his own ideas. It may be that Warhol found his pursuit of glamour wrong. Here he was chastened and determined to reject that life and idea.

Another issue that Warhol's eighties' work interrogated was the idea from Andreas Huyssen that, "eclecticism, an erosion of aesthetic boundaries, and a declining emphasis on originality," could be elements in the work of art. Consider his late *Last Supper* images including the Christ figure and ad logos together. Warhol involved eclectic images, advertising and high art, and images clearly appropriated from well-known sources. Warhol seemed to be setting up his work to be central to debates about postmodern values, the conflating of commerce with elements of Christianity, but sadly, he passed before being able to enter those dialogues.

Warhol's reception might have had something to do with the reception of postmodern theory in Europe and its derision in the United States. Many European postmodern theorists arose mostly from the study of architecture and were beginning to see the decline or transformation of modernism into a newer movement. Jencks's idea that borrowing needed to happen likely struck a chord with Europeans ravaged from the destruction of World War II. Little such ill effects in architecture were felt in the warm and soothing modernism installed by architects like Frank Lloyd Wright. Wright may not have been the only architect, but his reassuring humanism and smaller scale reassured America that borrowing and eclecticism were not as necessary in American architecture. A homogenous style of architecture prevailed in the United States more continuously than in discontented Europe. The insularity and lack of interest in radical postmodern approaches to art and culture might have dampened the reception of Warhol's work in general and certainly puzzled critics looking at his later transformative approaches to painting, collaboration, video, and the artist as performance persona.

Modernism's belief in progress and newness had become a mantra of hypernew styles and mediums and a collapsing of distinct genres and forms. Warhol's work merging painting, photography, printing, film, and auto-performance of the self as a vehicle for conceptual art was mercurial and proceeded subtly and quietly. Though viewed as a court painter to celebrities, Warhol was anxious to remain relevant and continued to pioneer art in

a variety of styles and formats. There was great difficulty in understanding and interpreting Warhol in the United States where he remained a controversial figure. In Europe his work was more widely accepted into the European tradition of the avant-garde. Thomas Crow (from England) summarized his impact as, "What this body of painting added up to was a kind peinture noire (black painting) in the sense that the adjective applies to the film noir genre of the forties and fifties—a stark, disabused, pessimistic vision of American life, produced from the knowing rearrangement of pulp materials by an artist who did not opt for the easier path of irony or condescension."[20] The failure of indigenous critics to perceive Warhol's stealthy criticism of the domestic scene deprived Warhol of a more socially conscious audience. Perception of Warhol always lagged behind his production.

DIVERSITY

Another aspect of Warhol's newer work was a more interesting acceptance of diversity. No longer the outsider seeking acceptance by the elite of New York society, Warhol, the establishment figure, began to reach out to other art and artists to make alliances and grow connections. His Wayne Gretzky images from 1984 were an example of the cross-cultural appeal of Warhol's later work. Warhol intended the Gretzky portraits to be a call to recognize Canadian art and artists. Gretzky, a phenomenal hockey player, was seen by Warhol as an entertainer and goodwill ambassador for that culture. Again, the advertisement proclaimed another aspect of Warhol's use of eclectic images in the eighties, something that he might have been deaf to, twenty years before. Warhol wanted the print to proclaim the arrival of Canadian art. The portraits of Gretzky in the upper right quadrant of the print were posed like a window display to allow Warhol to frame his number and hockey stick below as an indication of Gretzky's importance to the game. It is a full design with Gretzky's face on top, a downturned swoosh, and Gretzky's jersey and hockey stick penciled in below. It is also another indication that Warhol's art now included more examples of hand-drawn mark making.

Other signs of a rising social consciousness were Warhol's *Endangered Species* series of ten prints from 1983. The prints reflected Warhol's growing interest in ecological issues. Zebras, koala bears, elephants, apes, and bald eagles all reflected a new interest in the animal kingdom. The bright colors were a reminder that human beings have an obligation of kindness and protection for endangered wildlife from the ravages of man and his pollution. The coloring offered vibrant and bright hues with Warhol mirroring the beauty of nature while making it more stimulating and vibrant. The koala

bear is simply red and white. The butterfly is portrayed in iridescent colors of purple, orange, and blue. The butterfly almost reflects light on the stage back at the audience.

Warhol had comfortably returned to his roots in commercial art, doing pieces on demand, and in his new role as a celebrity and capable craftsman, the work was professional polished and often inspired. Warhol took the commissions as an opportunity to try new things. He could experiment in new media or approach objects in an abstract fashion. For Warhol some amount of bondage produced freedom. Probably one of the most notable collaborations and print/painting assignments that presented themselves to Warhol was the cross-cultural canvas work. Art dealer Bruno Bischofberger suggested that three artists Basquiat, Clemente, and Warhol work on canvases together. Warhol and Basquiat painted together, and Clemente in Italy was less active with the group. Although they did not always agree with strategies or styles, the three painters did trade work back and forth on canvases. Bischofberger recalls the way the collaboration project started with Basquiat visiting Bischofberger in Switzerland. Basquiat began painting with Bischofberger's four-year-old daughter. Bischofberger writes, "the baby-child primitive technique of my daughter and Basquiat's independently chosen, primitive" style were a perfect fit."[21] The art dealer suggested that Basquiat collaborate and generate some new product. Bischofberger also suggested that such collaborations elaborated the emerging ideas of postmodern thinking that many artists were using in new work. Artists like Basquiat were quoting other artists and freely appropriating ideas and styles. Hill writes that critic, Mike "Featherstone describes postmodernism as demonstrating a 'stylistic promiscuity,' . . . while other critics have placed an emphasis on its strategies of 'appropriation' and 'hybridization.'"[22] Secondly, the artists clarified their own conceptual ideas by collaboration. Ideas emerged and evolved. For example, in the Warhol/Basquiat work you can see Warhol steering the works toward appropriations of images from a lexicon of advertising and popular culture sources. Basquiat's technique thrives on a primitive brusque hurried quickly brushed style that looks like a snarl and an improvisation that is forceful, strategically unplanned, immediate, intuitive, rapid, and sloppy. Warhol, even allowing for mistakes, was always cautious and subject to planning. The works of the two men emerged as two distinctly different styles.

Basquiat was a surprising worker. The Factory style in the 1980s involved Warhol's business lunches with people for *Interview* and as perspective clients for portraits. At the lunch, Warhol screened appropriateness for a magazine article or potential willingness to pay for photographic portraits. Once Bischofberger suggested a lunch with Basquiat and Warhol. They took a Polaroid together (customary procedure), but remarkably within a few hours

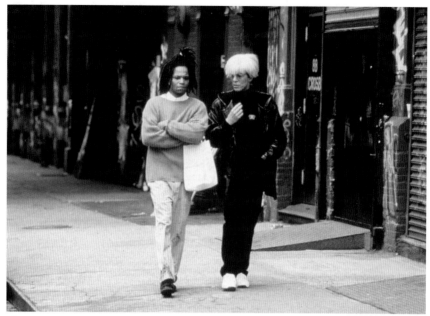

Figure 9.2. Warhol was portrayed by friend and admirer David Bowie in the 1997 film
Basquiat.
Miramax Films/Photofest ©Miramax Films

Basquiat knocked out a big painting of Warhol and Basquiat. This impressed
Warhol, and he decided to pursue a collaboration. For a third artist, Bischof-
berger suggested Clemente, an Italian artist who had international studios but
often resided in New York.

Warhol's studio craft in the eighties reflected prevailing conditions. As a
market artist he was required to do commissions to support his business orga-
nization; however, this activity could erode critical perceptions but maintain
a valuable public presence. Warhol's art probed a deeper and subtle political
style. Postmodern parody pervaded fine artwork that revisited his commercial
origins. The eighties' screen print paintings were more ironic and referential
than his famous sixties' series. His late work reflected a subtle ambivalence
about the making of art and the world of advertising. A once-unquestioning
devotion to advertising gave way to a problematized and interrogated rela-
tionship to the advertisement. Nothing was simple anymore.

Chapter Ten

Warhol: His Legacy Today

David Ehrenstein (*Film Culture Magazine*): What new plans do you have?

Warhol: Musicals.

Ehrenstein: Who will write the music?

Warhol: We don't know yet. The first musical will be tap dancing.[1]

It would be easy to say, now, thirty years after his passing, we know all about Warhol. We certainly have had enough accounts of his faults. He could make things up, he could be crude, and he could affect the guise of the spaced-out pop artist to mislead a gullible press. But overall, his varied faults merely assure us that he was human. It is unfortunate that we are a society obsessed with people's flaws: That Thomas Jefferson had slaves, that FDR was unfaithful to his wife, that Winston Churchill liked to walk about nude. "He that is without sin among you". . . Sadly these things do not make Warhol more remarkable, but there is much in Warhol that *is* remarkable and worth remembering. What we have discovered about Warhol the artist, worker, and creative person is much more interesting and worthy of discussion. For those interested in gossip about a dead person who can't respond to rumors and accusations, look elsewhere. Here we are concerned with achievements that are distinctive and render the uniqueness of the artist.

TECH WARHOL

Although Warhol's fascination with technology was acknowledged during his life, his lifelong interest in new electronica is worthy of discussion. Why was Warhol so addicted to technology? Probably for the same reason our society

is interested in technology now. It saves time and it harnesses the power of microprocessors and transistors to make doing many common and repetitive tasks quicker and easier. For one thing, Warhol remained famous for a fairly long time, for more than twenty-five years, he existed in the public eye and during that time, he became a popular subject for consumer research. Companies thought it would be a great endorsement, if a famous person used their products. They were probably right. Warhol bought a 16-mm camera in 1963 and began shooting movies. He bought several other cameras over time and continued to make films. He was also contacted by the Norelco Phillips company in the sixties to test out early videotape equipment. Actually, a stereo magazine was entrusted with the cutting-edge home video recording technology in the sixties, and Warhol was asked by the company to test it out. Again, the stereo magazine thought that if a noteworthy figure used their equipment and reported good things that would be a nice free endorsement. They believed it would be worth the cost of an experimental video rig. He would set up a camera in the back of the room in the Factory and let the videotape machine run for hours recording whatever passed in front of the camera. It may not have been the sort of data Norelco Philips wanted, but it pleased Warhol, and he could watch the playback of the tapes. It was cheaper and faster than making movies and eventually video equipment inspired him to become involved in video production in the late seventies and early eighties. The loan of equipment may have helped Warhol to become a pioneer in video technology. Consequently, his video experiments may have spurred the rise of YouTube and other technologies that have started to democratize broadcasting.

Perhaps one of his more obscure but noteworthy technological insights was his brief use of an Amiga computer. Chris Garcia writing for *CHM* said, "he'd been fascinated by popular culture for decades and computers had moved beyond being mysterious tools to become items encountered in everyday life. That alone would get Warhol interested in them as commodity objects, but add to that the artistic potential of such machines and its not at all a stretch to see his interest."[2] Garcia told the story that Warhol had attended a birthday party for Sean Lennon, son of the late Beatle, John Lennon. Warhol was routinely invited to important galas in New York. He went scouting for portrait commissions, but he also went for the food and the people. This time he had artist Keith Haring with him. Apple's CEO, Steve Jobs, was there as well. Jobs tried to show Warhol how to use a mouse and draw with a computer. Garcia writes that it took Jobs some time, but eventually he had Warhol using a mouse and within a few minutes he was drawing objects. Reportedly, he said to Haring, "'Look Keith, I drew a circle!'"[3]

Garcia continued by saying that Jobs tried to make Warhol interested in a Mac, but the artist never called back. However, a year later he did take

Figure 10.1. In later years, Warhol's influence grew by mentoring younger artists who shared his passion for popular culture icons. Among Warhol's young friends was Keith Haring, a clever street artist who transformed his tribal figures into paintings, prints, t-shirts, and these sculptures in Des Moines, Iowa.
Library of Congress Prints and Photographs Division, LC-DIG-highsm-39261

an invitation to do an on-screen demonstration of drawing with an Amiga computer, a new personal computer created by the Commodore Computer Company, a product tied into their creation of early video games. Warhol brought with him friend and colleague Deborah Harry of the pop group Blondie. Harry dutifully posed on stage with Warhol while he positioned her, photographed her with a digital camera, and then altered her image with a series of filters using an early graphics processor called ProPaint. Perhaps most interesting is that Garcia referred to Warhol's processing of the image as, "the piece would be easy to create today; in fact it might seem a bit primitive."[4] It is interesting that even in the mid-eighties when Warhol engaged a technology he tended to seek some simple and primitive aspect of that technology. This might be construed as a weakness, but one could consider it one of Warhol's strengths and perhaps one of his key contributions to the art world. Although so many people wish to exploit the highest end of the equipment they use, often tech and gadgets can render great results by placing things at their simplest levels. Warhol helped to teach us that using technology even in

Figure 10.2. Despite his origins in the city, his interest in technology, and his position in high society, Warhol remained drawn to tribal, primitive forms of art. His relationship to Haring, Clemente, Basquiat, and others attest to his interest in neo-expressionist and neo-primitive art, a sort of blending of high tech and low tech art forms.
The Metropolitan Museum of Art

a simplistic way might be beneficial perhaps even more beneficial than being able to use technology in a proficient way. Mary Shelley reminded us that Victor Frankenstein might be a bungling surgeon, but he still could come up with interesting results.

The master of this sort of limited capacity thinking is musician and producer Brian Eno who has had a successful career puttering about with objects in a nonsequential fashion. Eno mentioned in an interview with writer Michael Calore that, "I happened to start working in studios just at the time that multi-tracking became available, and I realized it made music-making a lot like painting in that you could add and take away colors, you could stretch things and turn them upside down and do all sorts of different things. So I thought of myself as a sonic painter rather than as a composer."[5] For Eno, it is exploring the *capacity* to make something that makes it creative. It isn't about pushing all the buttons and knobs to get everything to work, it is about finding a few operations that are *interesting* that provides the thrill of discovery.

Marshall McLuhan theorized that an overheated medium would have negative effects. Too much information. McLuhan pondered what caused this overheating of a medium and how it might harm our perceptions. He wrote that,

> In fact, it is not the increase of numbers in the world that creates our concern with population. Rather, it is the fact that everybody in the world has to live in the utmost proximity created by our electric involvement in one another's lives. In education, likewise, it is not the increase in numbers of those seeking to learn that creates the crisis. Our new concern with education follows upon the changeover to an interrelation in knowledge, where before the separate subjects of the curriculum had stood apart from each other.[6]

McLuhan sees the overload of knowledge as cluttering the information landscape. Eno sees the excess capacity of gadgets as another form of overload. Warhol's minimal use of computers and other gadgets may have helped to make his use of them perhaps more useful. Warhol also provided the reminder that it isn't how well you used such equipment that mattered, it is what you imagined with it. His early iconic films were made with a minimal camera. Most Americans have millions of times more processing power in their cell phones than Warhol had when he was filming is short analogue silent films. He reminds us that today, an idea may be just as important as the best technology.

MINIMAL WARHOL

Another interesting thing is Warhol's perception of art as activity, idea, or conception. Prior to Warhol, most people in the art world and particularly in the gallery business saw art as centered in specific art objects. Warhol's strategies transformed modern thinking about art and how and where it was

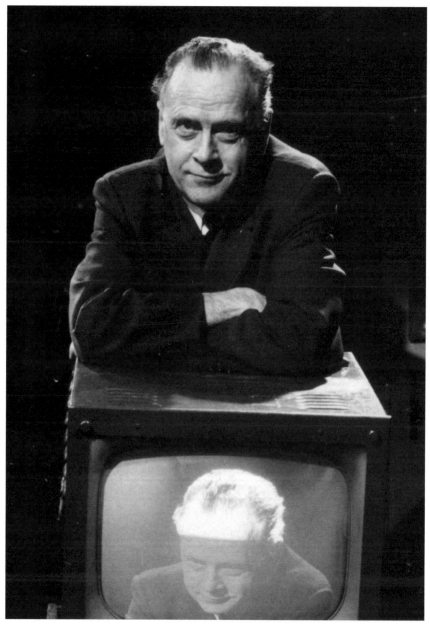

Figure 10.3. McLuhan was the principle theorist of new media in the sixties and Warhol's philosophical mind often correlated with McLuhan's thinking. They were both products of the same zeitgeist. Both saw the potential for media to change man's relationship to the world.
Library of Congress, Prints & Photographs Division, photograph by Bernard Gotfryd, LC-DIG-ppmsca-12442

located. Warhol was always interested in finding easier ways to make art. Often that approach was misconstrued as simply ease as in *less work*, but Warhol was thinking of ease in a different fashion. In 1968, he defined automation as, "automation is a way of making things easy. Automation just gives you something to do."[7] I don't think Warhol always thought of ease as easy as we think of it. I think he thought of it as new ways of doing art or experiencing art. Warhol also said, "nowadays I like to work a lot. It makes time go by fast."[8] Warhol seemed to like the idea of speeding up time or distending it. He wanted that feeling of being submerged in the experience and staying in that aesthetic place. I think we see in Warhol the transformation of art from merely objects on a wall to the street art of younger artists, to the creation of journals like *Interview* that survey the art community, to even sculptural items that exist or don't exist, and this continual quest for a format might include computer or video art such as memes or other devices that make the distribution and idea of art more democratic. For example, the program Photoshop back in 1990 simplified the ability of using a computer to process photographic information, but while it can pixelize an image, it doesn't necessarily make things easier. Photoshop is a deep and complicated computer program that helps artists and photographers change and modify photographic information, but it is not easy in the sense that looking at pictures on Facebook is easy, rather it facilitates the usefulness of the manipulation of pixel graphics, which is a whole other thing. David Hopkins argues that Warhol, "mercilessly debunked modernist protocols."[9] Hopkins argues that he used media (cameras, recording, photographic technique), devalued painting (by making it stencils and cow wallpaper and celebrity portraits), and commented on the intrusion of the media on our personal lives. For Hopkins and others, this completely transformed the public's relationship to the image and started the process of democratizing an image than had previously been the province of elite society. Maybe Warhol was an early adaptor of the idea of being in the zone, allowing the art activity to possess our consciousness.

At many times, Warhol expressed an anxiety to understand how to create objects for the market, although he was successful at creating artworks, he found the whole process confounding and argued that art would be so much easier without that process. In fact, the notion of conceptual art became an interesting reaction to art objects and transformed how people saw the marketplace of art. Hopkins reports that curators and art dealers, "saw it as a unifying practice such as 'land art' and 'anti-form' in a wave of dematerialization' predicated on resistance to galleries and the market."[10] The conceptual art movement was a reaction to people selling products. Warhol who had been in the business of art his entire career, understood the business aspect and saw the business as a complication. In fact, Warhol, though always

interested in sales and money, later in his career, engaged with this conceptual art movement. He participated in creating nonart or invisible sculpture, a small contribution to the conceptual art boom. One might say he had been involved in conceptual art all along. What were the Campbell's Soup Can, the images of Marilyn, the many portraits? These were images that already existed. Warhol made his modifications, his insights into these images part of the image lexicon. It is questionable that Warhol's versions of these images necessarily needed to exist to create the concept of such an image. Martha Buskirk wrote in *The Contingent Object of Contemporary Art*, that "thus there is a temporal gap built into the reception of work understood in retrospect, only through documents of inaccessible actions—unless of course, the work is identified as standing not in the initial actions but in the documents themselves."[11] So, if in fact Buskirk is right, the documentation itself might have been all that was needed to sustain Warhol's *Marilyn* project. In conceptual art terms, did Warhol really need the actual image or perhaps just a document? Warhol spent considerable time documenting a variety of projects that never occurred. He mentioned the creation of an Andymat, sort of chain of food stores like the Automats in New York where you could obtain food in a vending-style facility. Warhol made an invisible sculpture as an installation in 1985. The Whitney Museum online shop told the story. They reported that,

> The concept of his Invisible Sculpture was to show that the absence of something could be art. To activate the work Warhol briefly stood on a pedestal in the nightclub, Area, a popular night spot in Manhattan in the eighties. Warhol then stepped off the plinth and walked away leaving only the pedestal and a small wall label reading *Andy Warhol, USA, Invisible Sculpture, Mixed Media, 1985.*[12]

Versions of the display site, a plastic display space with an empty setting and lights where Andy would stand if he were there are available from the company Kidrobot for $225.[13] The idea was that Andy would stand on display at the Area night spot, and people would either look at his art in the gallery space or the artist himself. Perhaps in this way, Warhol helped us to redefine what we call art.

VOYEURISM

Another contribution Warhol made was in the field of visual landscapes. What do we look at and why and how does our relationship to what we see and regard relate to our lives? There are elements of psychology, semiology, and anthropology in such a pursuit, but Warhol understood that the visual field was complex and how we saw mattered to our consciousness of the world around

us. While looking has always been one of humanity's ways of sensing the world, Warhol privileged the act of looking as a fully realized practice. This is not the idea of casually observing something in passing but the idea of near ownership of the image through the gaze. It is the psychological devouring of an image by the use of the gaze, where the image is luxuriantly surveyed and cannibalized over time and colonized by the eyes. Some might call such an intimate relationship to the thing beheld as a form of leering or voyeurism. Alfred Hitchcock was another person who famously used his gaze to frame the image of people, and he believed he had power to not only make people look but to direct their gaze, their attention, and perhaps even their psyche through the use of a vision. Warhol's vision is perhaps more outrageous and more subtle simultaneously. First in the disturbing images in his *Death and Disaster* prints of 1963, Warhol presents us with shocking images from the news and dares the audience to look. There is an image of a suicide, a woman's crumpled fallen body that has caved in the roof of a car on impact. He shows the image repeated sixteen times with different registrations of each printing. There is an overturned car with bodies strewn about the car titled, *Five Deaths*. Different colored versions are named for the colors. *Five Deaths on Red*, or *Five Deaths on Orange*. There is a chilling diptych titled *Five Deaths Seventeen Times in Black and White*. On the left, the car crash killing five people is repeated seventeen times. The right panel is simply a print in total blackness. Stephanie Straine writing in *The Tate Introduction to Warhol* stated that, "his recalibration of profoundly disturbing images of death and disaster underscores his detached almost blank persona, which proved crucial to the work's production-line mentality."[14] Certainly, Warhol pursued a horror story level of detachment, but he also relished the presenting of the terrible. Perhaps, more than his blankness is his willingness to picture the horrific and to place it in a decorative environment such as dressing the prints in decorative colors. Warhol was himself fascinated that people might like a print of the Electric Chair in Sing Sing on their living room wall to match the couch. The Venus Gallery in New York displayed the Warhol little Electric Chairs in 2016. The actual exhibition catalog features a foldout dustcover that can be displayed as a 20-by-39-inch print of the *Little Electric Chairs* (full size from the exhibition) in pink.[15] We might be able to say that Warhol made it ok for us to look even at the most shocking, disgusting image.

THE END OF THE OBJECT

It may be impossible to say that objects exist in the same way after Warhol. Buskirk in her *The Contingent Object of Contemporary Art* commented that

postmodern copying and printing was different than printing and copying during the Renaissance. Then the copy related to the original and served as some sort of teaching tool to help the artist render better. Postmodern operations of printing or copying had a different objective, one that obscured the original. She wrote that "equally important is how the suspended process of assimilation serves to demonstrate that meaning is contingent and mutable, based on the relationship between a given element and the context of its presentation."[16] She gives examples of Warhol's striking race riots images from the *Death and Disaster* prints. Is the original meaning of the race riot pictures from the sixties communicated by Warhol's prints or is the meaning transformed? Are we so saturated by a world of images, many of these common images created and repeated regularly by artists like Warhol, through their constant bombing of images that in the end they become passe or no longer relevant to us? Can we go blind to the intensity of images? Can they fail to shock to concern or even move us anymore? The proliferation of gun deaths and the constant barrage of images of mass shootings continually escalating in size and intensity during the early millennial period suggest as much. Stuart Hall in 1980 suggested that the reception of images had already completely changed during Warhol's time. He suggested that in a loop system of messages that were encoded and decoded the process by which media messages were made and the way they were decoded could be radically different. For example, Warhol's *Race Riot* in 1963 might be seen by an elite class of gallery visitors as disturbing news in the press but not particularly a part of their day-to-day issues. An audience reading the image today might see it as a symptom of our endemic and continuing racial violence as a society or perhaps just a historical statement of conditions on the ground in America in the sixties. Different audiences may read the information in the print differently. Hall wrote that, "finally, it is possible for a viewer perfectly to understand both the literal and the connotative inflection given by a discourse but to decode the message in a globally contrary way. He/she detotalizes the message in the preferred code in order to retotalize the message within some alternative framework of reference."[17] Warhol through a mixture of his family origins, his education, his advertising practice, his unique relationship to icons, his film and video experiments, his devotion to technology, and his belief in ensemble creation created his own obscure but individual language that is still untranslated. He speaks a language that may be lost. A hieroglyphic.

Perhaps Warhol gifted us with his own imagistic code, one that was private that he made public. Over time, perhaps we can unpack his coding and reconstruct his meaning. Perhaps we will find a Rosetta stone to Warhol, but I doubt it. It is a private world far from us, and unlikely to manifest itself

clearly. Max Ernst said, "when reason sleeps, the sirens sing."[18] Perhaps we can best speak with Warhol's art through our dreams.

Tape Recording: What kind of comments do you get from people at these parties?

Warhol: Ohh. Aah. Ooh. Aah.

Tape Recording: Anything else?

Warhol: Aah, Ooh.[19]

Notes

INTRODUCTION

1. Alexis de Tocqueville, "In What Spirt the Americans Cultivate the Arts," in *Mass Culture, the Popular Arts in America*, ed. Bernard Rosenberg and David Manning White (New York: Free Press of Glencoe, 1957), 27–34.

2. Wayne Koestenbaum, *Andy Warhol* (New York: Penguin, 2001), 216.

3. Stephen Koch, *Stargazer: The Life, World, and Films of Andy Warhol* (New York: Open Road Integrated Media, 2000), 4.

4. Andy Warhol, *The Philosophy of Andy Warhol* (New York: Harvest, 1975), 7.

5. Robert Hughes, "The Rise of Andy Warhol," in *Pop, A Critical History*, ed. Stephen Madoff (Berkeley: University of California Press, 1997), 378.

6. Newsweek, "Saint Andrew," in *Pop, A Critical History*, ed. Stephen Madoff, 278.

7. Victor Bockris, *The Life and Death of Andy Warhol* (New York: Bantam, 1989), 262.

8. Gretchen Berg, "Andy Warhol My True Story," in *I'll Be Your Mirror*, ed Kenneth Goldsmith (New York: Carroll & Graf Publishers, 2004), 90.

9. Orson Welles and Herman Mankiewicz, *Citizen Kane* (RKO Pictures, 1941).

10. Gretchen Berg, "Andy Warhol, My True Story," in *On&By Andy Warhol*, ed. Gilda Williams (London: Whitechapel Gallery, 2016), 34.

11. Robert Kolker, "The Film Text and Film Form," in *Film Studies, Critical Approaches*, ed. John Hill and Pamela Gibson (Oxford: Oxford University Press, 2000), 13.

12. Peter Wollen, "Andy Warhol Renaissance Man," in *Who Is Andy Warhol?* ed. Colin MacCabe with Mark Frances and Peter Wollen (London: British Film Institute, 1997), 11.

13. Leonardo, Michelangelo, and others were deeply committed to new technologies of their era.

14. Wollen, "Andy Warhol Renaissance Man," 12.

15. The Miller Gallery, "Andy Warhol: The Early Years," Carnegie Mellon, The Miller Gallery. Available at: https://www.andrew.cmu.edu/user/jialunx/earlylife.html.

CHAPTER ONE

1. Lisa Kettell, *Altered Art Circus* (Beverly, MA: Quarry Books, 2009), 13.

2. Archeparchy of Pittsburgh History, Saint John Chrysostom Byzantine Catholic Church History. Available at: https://www.archpitt.org/place/pittsburghpa-saint-johnchrysostom-2/.

3. Archeparchy of Pittsburgh, Archeparchy of Pittsburgh History. Available at: https://www.archpitt.org/archeparchy-of-pittsburgh-history/#1.

4. Fred Kleiner, *Gardner's Art Through the Ages* (Boston, MA: Cengage, 2016), 271.

5. Andre Grader, *Art of the Byzantine Empire* (New York: Greystone Publishing, 1976), 59.

6. Dwight MacDonald, "A Theory of Mass Culture," in *Mass Culture, the Popular Arts in America*, ed. Bernard Rosenburg and David White (New York: Free Press of Glencoe, 1957), 59.

7. Leo Lowenhal, "Historical Perspectives of Popular Culture," in *Mass Culture*, ed. Rosenburg and White, 49.

8. Warhol, "Interview with Glenn O'Brien," in *On&BY Andy Warhol*, ed. Williams, 58.

9. Andy Warhol, "Interview with Gene Swenson," in *On&BY Andy Warhol*, ed. Williams, 31.

10. Walter Benjamin, "The Work of Art in the Age of Mechanical Reproduction," in *Popular Culture: A Reader*, ed. Raiford Guins and Omayra Cruz (London: Sage, 2005), 98.

11. Richard Brettell, *Modern Art ,1851–1929* (Oxford: Oxford University Press, 1999), 29.

12. Mashahiro Mori, "The Uncanny Valley," *IEEE Spectrum*. June 12, 2012. Available at: https://spectrum.ieee.org/automaton/robotics/humanoids/the-uncanny-valley.

13. Sigmund Freud, "The Uncanny," in *The Standard Edition of the Complete Psychological Works of Sigmund Freud* (London, Hogarth Press, 1953), XVII: 226.

14. Samareh Mirfendereski, "Puppetry Elements in the Works of European Surrealists," in *Dolls and Puppets as Artistic and Cultural Phenomena (19th–21st Centuries)*, ed. Kamil Kopania (Warsaw, Poland: The Aleksander Zelwerowicz National Academy of Dramatic Art in Warsaw, The Department of Puppetry Art in Białystok, 2016), 18–33.

15. Alyssa Fiorentino, "Candace Bergen Reveals Twisted Details about Her Relationship with Her Father," *Woman's Day*, April 7, 2015. Available at: https://www.womansday.com/life/real-women/news/a50235/candice-bergen-reveals-twisted-details-about-relationship-with-her-father/.

16. Victoria Nelson, *The Secret Life of Puppets* (Cambridge, MA: Harvard University Press, 2001), 386.

17. John Kasson, *The Little Girl Who Fought the Depression* (New York: Norton & Co., 2014), 1.

18. Kasson, *The Little Girl Who Fought the Depression*, 27.

19. Kasson, *The Little Girl Who Fought the Depression*, 133.

20. Veronica Hollinger, "Cybernetic Deconstructions: Cyberpunk and Postmodernism," in *Storming the Reality Studio*, ed. Larry McCafferty (Durham, NC: Duke University Press, 1991), 205.

21. Vincent Fremont, *Andy Warhol's Small World* (Koln, Germany: Jablonka Gallery, 2005).

22. Bockris, *The Life and Death of Andy Warhol*, 34.

23. Adrian McCoy, "Obituary: Howard L. Worner/Industrial artist Taught at CMU." *Pittsburgh Post-Gazette*. March 23, 2006. Available at: https://www.post-gazette.com/news/obituaries/2006/03/26/Obituary-Howard-L-Worner-Industrial-artist-taught-at-CMU/stories/200603260201.

24. McCoy, "Obituary: Howard L. Worner."

25. Kurt Shaw, "Modernist Pittsburgh Shows Educator Rosenberg's Impact," *Trib Total Media*. July 19, 2014. Available at: https://archive.triblive.com/aande/museums/modernist-pittsburgh-shows-educator-rosenbergs-impact/.

26. Samuel Rosenberg, *Painting 1967*. University Art Gallery, University of Pittsburgh, Henry Clay Frick Department of History of Art and Architecture. Available at: https://uag.pitt.edu/index.php/Detail/objects/7113.

27. Smithsonian American Art Museum, "Balcomb Greene." Available at: https://americanart.si.edu/artist/balcomb-greene-1930.

28. Balcomb Greene, *New Images of Man*, ed. Peter Selz (New York: Museum of Modern Art, 1959), 83.

29. Andy Warhol, *America* (New York: Harper & Row, 1985), 129.

30. Bram Stoker, *Dracula* (Garden City, NJ: Country Life Press, 1897), 2

31. Eva Thury and Margarey Devinney, *Introduction to Mythology* (New York: Oxford University Press, 2017), 772.

32. Stoker, *Dracula*, 17.

33. Stoker, *Dracula*, 19.

34. Santiago Lucendo, "Return Ticket to Transylvania. Relations between Historical Reality and Vampire Fiction," in *Draculas, Vampires, and Other Undead Forms: Essays on Gender, Race, and Culture*, ed. John Edgar Browning and Caroline Joan (Kay) Picart (Lanham, MD: Scarecrow Press, 2009), 115.

35. Matthew Beresford, *From Demons to Dracula* (London: Reaktion Books, 2008), 193.

CHAPTER TWO

1. Rosenberg and White, *Mass Culture*, 434.

2. Advertising Age, "History: 1950s," *AdAge Encyclopedia*. September 15, 2003. Available at: https://adage.com/article/adage-encyclopedia/history-1950s/98701.

3. Vance Packard, *The Hidden Persuaders* (London: Longman Green and Co., 2007), 1.

4. Packard, *The Hidden Persuaders*, 2.

5. Packard, *The Hidden Persuaders*, 11.

6. Barbara Klein, "Before They Were Famous," *Carnegie Magazine*. Summer 2015. Available at: https://carnegiemuseums.org/magazine-archive/2015/summer/feature-504.html.

7. Robert Short, *Dada and Surrealism* (Secaucus, NJ: Chartwell Books, 1980), 7.

8. Calvin Tomkins, *The World of Marcel Duchamp, 1887* (Alexandria, VA: Time-Life Books, 1966), 169.

9. Charlie Scheips, "Fabricology," in *Andy Warhol: The Bazaar Years, 1951–1964*, ed. Anthony T. Mazzola (New York: Hearst Corporation, 2009), 6–7.

10. Tomkins, *The World of Marcel Duchamp*, 37.

11. Marc Dachy, *The Dada Movement 1915–1923* (New York: Rizzoli, 1990), 11,

12. Dachy, *The Dada Movement*, 7

13. Tomkins, *The World of Marcel Duchamp*, 38.

14. Nathan Gluck, "The Transition From Commercial Art in to Pop Art," in *The Unseen Warhol*, ed. John O'Connor and Benjamin Liu (New York: Rizzoli, 1996), 28.

15. Sonia Massik and Jack Solomon, eds., *Signs of Life in the USA* (Boston, MA: Bedford, 2015), 161.

16. Rainer Crone, *Andy Warhol, A Picture Show By the Artist* (New York: Rizzoli. 1987), 38.

17. Charlie Scheips, "Foreword," in *Andy Warhol: The Bazaar Years*, 2.

18. Scheips, "Foreword," 2

19. Jack Solomon, "Masters of Desire," in *Signs of Life in the USA*, 167.

20. Scheips, "Fabricology," 8

21. Crone, *Andy Warhol*, 48.

22. Crone, *Andy Warhol*, 51.

23. Frances Pohl, *Ben Shahn: New Deal Artist in A Cold War Climate, 1947–1954* (Austin: University of Texas Press, 1989).

24. Simon Doonan, *Andy Warhol Fashion* (San Francisco, CA: Chronicle Books, 2004), 9.

25. Christian Demilly, *Andy Warhol Drawings*. (San Francisco, CA: Chronicle Books, 2012), 8.

26. Janetta Benton and Robert DiYanni, *Arts and Culture* (Boston, MA: Prentice Hall, 2012), 394.

27. Victoria Charles, *Rococo* (New York: Parkstone Press, 2014), 57.

28. Crone, *Andy Warhol*, 58.

29. Crone, *Andy Warhol*, 94.

30. Christin Mamiya, *Pop Art and Consumer Culture* (Austin: University of Texas Press, 1992), 72–73.

CHAPTER THREE

1. Stephen Mcinhenny and Peter Ray, "Inside Andy Warhol," in *I'll Be Your Mirror*, ed. Kenneth Goldsmith (New York: Carroll & Graf, 2004), 104.

2. Maria Pachon, *Andy Warhol* (Barcelona, Spain: Ediciones Poligrafa, 2001), 4

3. Pachon, *Andy Warhol*, 5.

4. Pachon, *Andy Warhol*, 4.

5. Irving Sandler, *Abstract Expressionism and the American Experience* (Lennox, MA: Hard Press Editions, 2009), 18.

6. Sandler, *Abstract Expressionism*, 83

7. Sandler, *Abstract Expressionism*, 134.

8. Steven Madoff, "Wham! Blam! How Pop Art Stormed the High Art Citadel and What Critics Said," in *Pop Art*, ed. Steven Madoff, 4–5.

9. John Paul Stonard, "Pop in the Age of Boom Richard Hamilton's 'Just what is it that makes today's dome so different so appealing,'" *The Burlington Magazine*, September 2007, 607.

10. Alistair Sooke, *Pop Art a Colorful History* (London: Viking/Penguin, 2015), 24.

11. Hal Foster and Mark Francis, *Pop* (London: Phaidon, 2005), 22.

12. Foster and Francis, *Pop*, 22.

13. Mario Amaya, *Pop Art . . . and After* (New York: Viking, 1966), 11.

14. Madoff, *Pop Art*, xiii.

15. Wolfgang Kaser, *The Grotesque in Art and Literature* (New York: McGraw Hill, 1967), 31.

16. S. T. Joshti, *Unutterable Horror* (New York: Hippocampus Press, 2012), 27

17. Mikhail Bakhtin, *Rabelais and His World* (Bloomington: University of Indiana Press, 1984), 197.

18. Freud, "The Uncanny," in *The Standard Edition of the Complete Psychological Works of Sigmund Freud*, XVII: 1.

19. E. T. A. Hoffman, "The Sandman." Available at: http://art3idea.psu.edu/metalepsis/texts/sandman.pdf.

20. Robert Bloch, "The Weird Tailor," in *Such Stuff as Screams Are Made Of* (New York: Ballantine Books, 1979).

21. Tomkins, *The World of Marcel Duchamp*, 166.

22. Tomkins, *The World of Marcel Duchamp*, 160.

23. Roselee Goldberg, *Performance Art* (London: Thames and Hudson, 1995), 90.

24. Mark Francis and Margery King, *The Warhol Look* (Boston, MA: Bullfinch, 1997), 127.

25. Stephanie Aquin, *Warhol Live* Exhibition Catalogue, 2009 (Montreal, Quebec: Montreal Museum of Fine Arts, 2009), 62.

26. Goldberg, *Performance Art* (London: Thames and Hudson, 1995), 144.

CHAPTER FOUR

1. Matthew Collings, *This Is Modern Art* (London: Weidenfeld & Nicholson, 1999), 67.

2. Including the DeMenil oil-connected family recruited by newfound wunderkind Fred Hughes.

3. Daniel Wheeler, *Art since Mid-Century, 1945 to Present* (Englewood Cliffs, NJ: Prentice Hall, 1984), 213.

4. Robert Morris, "Notes on Sculpture," in *Minimal Art: A Critical Anthology*, ed. Gregory Babcock (New York: E. P. Dutton, 1968), 228.

5. Frank DiGiacomo, "A Farewell to Dapper Fred Hughes, He Oversaw Andy's Factory Empire," *Observer*, January 21, 2001.

6. Warhol, *The Philosophy of Andy Warhol*, 92.

7. ArtInfo, "How Andy Warhol Turned a Love of Money into a $228 Art Career," *HuffPost*, December 16, 2010.

8. Artinfo, "How Andy Warhol Turned a Love."

9. Simone Solandz, "Raid the Icebox Now." RISD website. Available at: https://www.risd.edu/news/stories/raid-the-icebox-now/.

10. Glenn O'Brien, "Interview: Andy Warhol," in *On&By Andy Warhol*, ed. Williams, 63.

11. Sharon Koomler, *Shaker Style* (London: PRC Publishing, 2000), 13

12. Koomler, *Shaker Style*, 111.

13. Koomler, *Shaker Style*, 136.

14. Crone, *Andy Warhol*, 55.

15. Koestenbaum, *Andy Warhol*, 132.

16. Greg Whitmore, "Andy Warhol at the Tate Gallery, February 18, 1971." *The Guardian*.

17. Carter Ratcliff, *Modern Masters: Andy Warhol* (New York: Abbeville Press, 1983), 78.

18. Kenneth Baker, *Minimalism* (New York, Abbeville Press, 1988), 9.

19. Baker, *Minimalism*, 39.

20. Karen Jones, "The Time-Capsule Formula: Warhol at the Whitney," *artcritical*. Available at: https://artcritical.com/2019/06/04/karen-e-jones-on-andy-warhol/. Accessed September 8, 2019.

21. Simon Elmes, "The Secrets of Andy Warhol's Time Capsules," *BBC News*. Available at: https://www.bbc.com/news/magazine-29125003. Accessed October 29, 2019.

22. Kynaston McShine, ed., *Andy Warhol: A Retrospective* (Boston, MA: Bullfinch/Little Brown [MOMA], 1989), 350.

23. Marco Livingstone, *Pop Art: A Continuing History* (New York: Harry N Abrams Inc., 1990), 76.

CHAPTER FIVE

1. Gretchen Berg, "Andy Warhol My True Story," in *I'll Be Your Mirror*, ed. Kenneth Goldsmith (New York: Carroll & Graf, 2004), 90.

2. Joseph Campbell, *The Hero with a Thousand Faces* (Princeton, NJ: Princeton University of Press, 1948), xxii.

3. BBC, "The History of the York Mystery Plays." *BBC website.* May 7, 2006. Available at: http://www.bbc.co.uk/northyorkshire/content/articles/2006/07/05/york_mystery_plays_feature.shtml.

4. Ralph Rosenblum, "Warhol as Art History," in *Andy Warhol*, ed. McShine, 27.

5. *Here we Go Again*, featuring Charlie McCarthy and Edgar Bergen (RKO Pictures. 1942).

6. Patrick S. Smith, *Andy Warhol's Art and Films* (Ann Arbor: University of Michigan Press, 1986), 147.

7. Smith, *Andy Warhol's Art and Films*, 157.

8. Barbara Creed, "Film and Psychoanalysis," in *Film Studies*, eds. Hill and Gibson, 75.

9. Duncan Reekie, *Subversion: The Definitive History of Underground Cinema* (London: Wallflower Press, 2007).

10. Reekie, *Subversion*, 135.

11. Jonas Mekas, "Interview," in *Andy Warhol's Art and Films*, ed Smith, 414.

12. "Experience as Energy: A Pattern for Thinking," in *The Films of Stan Brakhage in the American tradition of Ezra Pound, Gertrude Stein, and Charles Olsen*, ed. Bruce Elder (Ontario, CA: Wilfried Laurier Press, 1998), 140.

13. Sarah Keller, *Maya Deren: Incomplete Control* (New York: Columbia University Press, 2015), 36.

14. Robert Kolker, "The Film Text and Film Form," in *Film Studies*, eds. Hill and Gibson, 10.

15. Susan Sontag, *A Susan Sontag Reader* (New York: McGraw Hill, 2014), 132.

16. Anna Malonowska, "Bad Romance: Pop and Camp in Light of Evolutionary Confusion," in *Redefining Kitsch and Camp in Literature and Culture*, ed. Justyna Stepien (Newcastle on Tyne: Cambridge Scholars, 2014), 11.

17. Sontag, *A Susan Sontag Reader*, 141.

18. Roland Barthes, *Mythologies* (New York: Noonday Press, 1957), 13.

19. Barthes, *Mythologies*, 14.

20. John Wilcox, *The Autobiography and Sex Life of Andy Warhol* (New York: Trela Media, 2010).

21. Kolker, "The Film Text and Film Form," in *Film Studies*, eds. Hill and Gibson, 20.

22. Antonin Artaud, *The Theatre and Its Double* (New York: Grove Press, 1959), 78.

23. Artaud, *The Theatre and Its Double*, 78.

24. Martin Esslin, *Theatre of the Absurd* (New York: Doubleday, 1961), 5.

25. Andy Warhol (with Pat Hackett), *The Philosophy of Andy Warhol* (San Diego, CA: Harvest Books, 1975), 5.

26. Warhol with Hackett, *The Philosophy of Andy Warhol*, 5.

27. Warhol with Hackett, *The Philosophy of Andy Warhol*, 6.

28. Lynn Spigel, *Revolution of the Eye* (New Haven, CT: Yale University Press, 2014), xii.

29. Maurice Berger, *Revolution of the Eye* (New Haven, CT: Yale University Press, 2014), 8.

30. Berger, *Revolution of the Eye*, 31.

31. Warhol with Hackett, *The Philosophy of Andy Warhol*, 101.

32. Lynn Spigel, "Warhol's Everyday TV." *Cairn Info*. Available at: https://www.cairn.info/revue-multitudes-2010-5-page-162.htm?contenu=article.

33. Christina Rouvalis "Andy Warhol, Revealed" Carnegie Magazine. Summer, 2014. Available at: https://carnegiemuseums.org/magazine-archive/2014/summer/feature-430.html.

34. Alexxa Gotthardt, "On His MTV Show, Andy Warhol Broke All the Rules." *Artsy*. November 21, 2017. Available at: https://www.artsy.net/article/artsy-editorial-mtv-andy-warhol-broke-rules

35. Spigel, "Warhol's Everyday TV."

36. Raymond Williams, "Television as Sequence or Flow," in *Media Studies: A Reader* ed. Paul Marris and Sue Thornham (New York: NYU Press, 1999), 237.

37. Marshall McLuhan, "The Medium Is the Message," in *Media Studies: A Reader*, ed. Marris and Thornham, 38.

38. Gina Palladini, "Nothing Special," Essay for the Television Shot by Artists Exhibition (Barcelona, Spain, 2000).

39. Warhol with Hackett, *The Philosophy of Andy Warhol*, 21.

40. Palladini, "Nothing Special."

41. Chris Andrews, *A History of Video Art* (London: Bloomsbury Publishers, 2014), 3.

42. Andy Warhol Museum, *I Just Want to Watch* Exhibition, 2010.

43. Curt Riegelnegg, "Andy Warhol Media Exhibit." *Pittsburgh City Paper*, 2010.

44. Gotthardt, "On His MTV Show." *Artsy*.

45. Koch, *Andy Warhol*, 250.

46. Koch, *Andy Warhol*, 250.

47. Jung, Carl Gustav. *Memories, Dreams, Reflections* (New York: Vintage Books, 1989) 282.

CHAPTER SIX

1. Robin Walz, *Pulp Surrealism* (Berkeley: University of California Press, 2000), 56.

2. Cathrin Kingsohr-Leroy, *Surrealism* (Koln, Germany: Taschen, 2008), 13.

3. Alfred Barr Jr., *Fantastic Art, Dada and Surrealism* (New York: Museum of Modern Art, 1936), 19–20.

4. Elsa Bethanis and Peter Bethanis, *Dada and Surrealism for Beginners* (Danberry, CT: For Beginners, 2006), 63.

5. Brettell, *Modern Art*, 46.

6. Bethanis and Bethanis, *Dada and Surrealism for Beginners*, 85.

7. Kingsohr-Leroy, *Surrealism*, 11.

8. Jan Greenburg and Sandra Jordan, *Andy Warhol Prince of Pop* (New York: Delacorte Press, 2004), 67.

9. Steven Watson, *Factory Made: Warhol and the Sixties* (New York: Pantheon Books, 2003), 167.

10. Joseph Ketner, ed., *Andy Warhol: The Last Decade* (Milwaukee, WI: Milwaukee Art Museum, 2009), 31.

11. Ketner, ed., *Andy Warhol*, 200.

12. Cue, Elena. "Interview with Francesco Clemente." Alejandra de Argos.(blog), October 3, 2016.

13. Kingsohr-Leroy, *Surrealism*, 10.

14. Lynne Tillman, "Like Rockets and Television II," in *Who Is Andy Warhol?*, ed. MacCabe, 145.

15. Kingsohr-Leroy, *Surrealism*, 16.

16. O'Connor and Liu, *Unseen Warhol*, 11.

17. Kingsohr-Leroy, *Surrealism*, 20.

18. Short, *Dada and Surrealism*, 110.

19. Kingsohr-Leroy, *Surrealism*, 19.

20. Kingsohr-Leroy, *Surrealism*, 19.

21. Kingsohr-Leroy, *Surrealism*, 62.

22. Carter Ratcliff, *Andy Warhol Portraits*, ed. Tony Shafrazi (London: Phaidon, 2007), 21.

23. Victor Bockris, *Warhol: The Biography* (New York: DeCapo Books, 1989), 83.

24. Brettell, *Modern Art*, 42.

25. Herschel Chipp, *Theories of Modern Art* (Berkeley: University of California Press, 1984), 237.

26. Sigmund Freud, *The Interpretation of Dreams* (New York: Basic Books, 2010).

27. Carl G. Jung, *Man and His Symbols* (New York: Dell, 1968), 232–33.

28. John Russell, *The Meaning of Modern Art* (New York: Harper and Row, 1981), 195.

29. Chipp, *Theories of Modern Art*, 370.

30. Edmund Swinglehurst, *The Art of the Surrealists* (New York: Sienna, 1995).

31. Dawn Ades, *Dali and Surrealism* (New York: Harpers/Icon, 1982), 105.

CHAPTER SEVEN

1. Claudia Kalb, *Andy Warhol Was a Hoarder* (Washington, DC: National Geographic, 2016), 50.

2. David Bourdon, *Warhol* (New York: Harry N. Abrams, 1989), 24.

3. Bourdon, *Warhol*, 17.

4. Bourdon, *Warhol*, 18.

5. Bourdon, *Warhol*, 18

6. Bourdon, *Warhol*, 17

7. Rhode Island School of Design, Museum of Art, "*Raid the Icebox* One with Andy Warhol," (Providence: Rhode Island School of Design, 1969), 18.

8. Simon Elmes, "The Secrets of Andy Warhol's Time Capsules," *BBC News Magazine*, September 10, 2014.

9. Terry Cook, "Fashionable Nonsense or Professional Rebirth: Postmodernism and the Practice of Archives," *Semanticscholar*.org, 17.

10. John Taylor, "Andy's Empire," *New York Magazine*, February 22, 1988, 36.

11. Stephen Smith, "He Loved Weightlifting and Buying Jewels: Warhol's Friends Reveal All," *The Guardian*, February 15, 2015.

12. Stuart Pivar, "Shopping with Andy Warhol," *ASX*, January 30, 2015. Available at: https://americansuburbx.com/2015/01/shopping-with-andy-warhol-1988.html.

13. Pivar, "Shopping with Andy Warhol."

14. John Kirk, *The Shaker World* (New York: Harry N. Abrams, 1997), 32.

15. Koomler, *Shaker Style*, 158.

16. Kirk, *The Shaker World*, 37.

17. Victory Turner, *The Ritual Process* (Ithaca, NY: Cornell University Press, 1969), 95.

18. Mori, "The Uncanny Valley."

19. Mori, "The Uncanny Valley."

20. Mori, "The Uncanny Valley."

21. Nelson, *The Secret Life of Puppets*.

22. Nelson, *The Secret Life of Puppets*, 270.

CHAPTER EIGHT

1. Thomas Hauff, *Design: An Illustrated Historical Overview* (Hauppauge, NY: Barrons, 1996), 10.

2. Hauff, *Design*, 11.

3. Hauff, *Design*, 12.

4. Marshal McLuhan, "Sight Sound and Fury," in *Mass Culture*, ed. Rosenburg and White, 490.

5. de Tocqueville, "Democracy," in *Mass Culture*, ed. Rosenburg and White, 29.

6. Goldsmith, ed., *I'll Be Your Mirror* (New York: Carroll and Graf Publishers, 2004), 88.

7. Goldsmith, ed., *I'll Be Your Mirror*, 294.

8. Guy Debord, *The Society of Spectacle* (New York: Zone Books, 1994), 117.

9. Gretchen Berg, "Andy Warhol: My True Story," in *I'll Be Your Mirror*, ed. Goldsmith, 88.

10. Jean Baudrillard, "Simulacra and Simulations." Available at: https://web.stanford.edu/class/history34q/readings/Baudrillard/Baudrillard_Simulacra.html.

11. Paola Varello, *The Magazine Work of Andy Warhol, 1949–1987*. Giorgio Maffei Gallery. Rare Books on Twentieth Century Arts. November 2016.

12. Varello, *The Magazine Work of Andy Warhol*, 70.

13. Varello, *The Magazine Work of Andy Warhol*, 35.

14. Varello, *The Magazine Work of Andy Warhol*, 48–49.

15. David Hopkins, *After Modern Art, 1945–2000* (Oxford: Oxford University Press, 2000), 99.

16. Glenn O'Brien, "Interview: Andy Warhol," in *I'll Be Your Mirror*, ed. Goldsmith, 247.

17. Lucy Mulroney, *Andy Warhol: Publisher* (Chicago: University of Chicago Press, 2018), 98.

18. Mulroney, *Andy Warhol: Publisher*, 93.

19. Bockris, *The Life and Death of Andy Warhol*, 276.

20. Bob Colacello, *Holy Terror* (New York: Harper Perennial, 1991), 258.

21. Pat Hackett, ed., *Andy Warhol Diaries* (New York: Warner Books, 1989), xiii.

22. Colacello, *Holy Terror*, 337.

23. Colacello, *Holy Terror*, 348.

24. Ashley Bassie, *Expressionism* (New York: Parkstone Press, 2008), 7.

25. Starr Figura, *German Expressionism: The Graphic Impulse* (New York: Museum of Modern Art, 2011), 10.

26. Jonathan Woodham, *Twentieth Century Design* (Oxford: Oxford University Press, 1997), 183.

CHAPTER NINE

1. Andy Warhol, "Andy Warhol: An Artist and His Amiga," in *I'll Be Your Mirror*, ed. Goldsmith, 339.

2. Andy Warhol, "An Interview with Andy Warhol," in *I'll Be Your Mirror*, ed. Goldsmith, 258.

3. Andy Warhol, "An Interview with Andy Warhol. Some Say He's the Mayor of New York," in *I'll Be Your Mirror*, ed. Goldsmith, 266.

4. Anthony Haden-Guest, "The New Queen of the Art Scene," *New Yorker*, April 19, 1982, p. 24.

5. Erika Doss, *Twentieth Century American Art* (Oxford: Oxford University Press, 2002), 165.

6. Haden-Guest, "The New Queen of the Art Scene," 25.

7. Warhol, *The Philosophy of Andy Warhol*, 98.

8. Vincent Freemont, "Andy Warhol, Ladies and Gentleman," Gagosian Gallery website, September 13-October 11, 1997. Available at: https://gagosian.com/exhibitions/1997/andy-warhol-ladies-and-gentlemen/.

9. Dietmar Elgar, *Expressionism* (Koln, Germany: Taschen, 2008), 9.

10. Elgar, *Expressionism*, 133.

11. Andy Warhol, "Modern Myths: Andy Warhol (interview with Barry Blinderman)," in *I'll Be Your Mirror*, ed. Goldsmith, 299.

12. "Andy Warhol interview; Pets." Thames Television. 1977. Available at: https://www.youtube.com/watch?v=NZkjWW-mENk.

13. Hugh Downs, "*ABC News 20/20*: Andy Warhol." *ABC network*. April 10, 1980.

14. Downs, "ABC News 20/20: Andy Warhol."

15. Andy Warhol, *Love Boat*. Season nine, episode three, October 12, 1985.

16. Warhol, "An Interview with Andy Warhol," in *I'll Be Your Mirror*, ed. Goldsmith, 236.

17. John Hill, "Film and Postmodernism," in *Film Studies*, ed. Hill and Gibson, 95.

18. Charles Jencks, "Toward a Radical Eclecticism," in *Theories and Manifestoes of Contemporary Architecture*, ed. Charles Jencks and Karl Kropf (West Sussex, UK: Wiley and Sons, 1997), 87.

19. Thomas McEvilley, *Elvis+Marilyn 2 X Immortal* (New York: Rizzoli, 1994), 11.

20. Thomas Crowe, *The Rise of the Sixties* (New York: Harry Abrams, 1996), 87.

21. Bruno Bischofberger, "Collaborations: Reflections on and Experiences with Basquiat, Clemente and Warhol." Jean-Michel Basquiat website (fan site). Available at: https://radiantchild.weebly.com/bischofberger-on-collaborations.html.

22. Hill, "Film and Postmodernism," in *Film Studies*, ed. Hill and Gibson, 97.

CHAPTER TEN

1. David Ehrenstein, "An Interview With Andy Warhol," in *I'll Be Your Mirror*, ed. Goldsmith, 69.

2. Chris Garcia, "Warhol & The Computer." *CHM*. June 25, 2013.

3. Garcia, "Warhol & The Computer."

4. Garcia, "Warhol & The Computer."

5. Brian Eno, "Interview with Brian Eno On, Full" (interviewer Michael Calore). *Wired*. July 2, 2007.

6. Marshall McLuhan, *Understanding Media: The Understanding of Man*, 36. Available at: https://hannemyr.com/links_mcluhan/um.html.

7. Andy Warhol, "Andy Warhol on Automation: An Interview with Gerald Malanga," in *I'll Be Your Mirror*, ed. Goldsmith, 62.

8. Andy Warhol, "Andy Warhol: An Interview with Glenn O'Brien," in *I'll Be Your Mirror*, ed. Goldsmith, 255.

9. Hopkins, *After Modern Art*, 141.

10. Hopkins, *After Modern Art*, 177.

11. Martha Buskirk, *The Contingent Object in Contemporary Art* (Cambridge, MA: MIT Press, 2003), 223.

12. Whitney Shop, "Andy Warhol: The Invisible Sculpture." Museum item for sale for $225 through the museum store. Available at: https://shop.whitney.org/andy-warhol-the-invisible-sculpture.html.

13. Kidrobot website. "Andy Warhol Invisible Sculpture Display." Area Nightclub. 1985. Available at: https://www.kidrobot.com/products/andy-warhol-invisible-sculpture.

14. Stephanie Straine, *Andy Warhol* (London: Tate Publishing, 2014), 17.

15. Venus Gallery, *Little Electric Chairs*. (New York: Venus, 2016).

16. Buskirk, *The Contingent Object in Contemporary Art*, 88.

17. Stuart Hall, "Encoding/Decoding," in *Media Studies*, ed. Marris and Thornham, 61.

18. Walter Schurian, *Fantastic Art* (Koln, Germany: Taschen, 2005), 10.

19. Richard Ekstract, "Pop Goes the Videotape," in *I'll Be Your Mirror*, ed. Goldsmith, 78.

Bibliography

"Andy Warhol interview; Pets." Thames Television. 1977. Available at: https://www.youtube.com/watch?v=NZkjWW-mENk.

Ades, Ades. *Dali and Surrealism*. New York: Harpers/Icon, 1982.

Advertising Age. "History: 1950s." *AdAge Encyclopedia*. September 15, 2003. Available at: https://adage.com/article/adage-encyclopedia/history-1950s/98701.

Alloway, Lawrence. "The Arts and the Mass Media." In *Pop Art, a Critical History*, edited by Steven Madoff. Berkeley: University of California Press, 1997, pp. 7–9.

Amaya, Mario. *Pop Art . . . and After*. New York: Viking, 1966.

Andrews, Chris. *A History of Video Art*. London: Bloomsbury Publishers, 2014.

Antin, David. "Warhol; The Silver Tenement." In *Pop Art: A Critical History*, edited by Steven Madoff. Berkeley: University of California Press, 1997, pp. 287–90.

Archeparchy of Pittsburgh History, Saint John Chrysostom Byzantine Catholic Church History. Available at: https://www.archpitt.org/place/pittsburghpa-saint-johnchrysostom-2/.

Archeparchy of Pittsburgh, Archeparchy of Pittsburgh History. Available at: https://www.archpitt.org/archeparchy-of-pittsburgh-history/#1.

Aquin, Stephanie. *Warhol Live* Exhibition Catalog, 2009. Montreal, Quebec: Montreal Museum of Fine Arts, 2009.

ArtInfo. "How Andy Warhol Turned a Love of Money into a $228 Art Career." *HuffPost*, December 16, 2010.

Artaud, Antonin. *The Theatre and Its Double*. New York: Grove Press, 1959.

Baker, Kenneth. "Art Review: Warhol's Jews." *SFGate*. October 10, 2008.

Baker, Kenneth. *Minimalism*. New York: Abbeville Press, 1988.

Bakhtin, Mikhail. *Rabelais and His World*. Bloomington: University of Indiana Press, 1984.

Barr Jr., Alfred. *Fantastic Art, Dada and Surrealism*. New York: Museum of Modern Art, 1936.

Barthes, Roland. *Mythologies*. New York: Noonday Press, 1957.

Bassie, Ashley. *Expressionism*. New York: Parkstone Press, 2008.

Baudrillard, Jean. "Simulacra and Simulations." Available at: https://web.stanford.edu/class/history34q/readings/Baudrillard/Baudrillard_Simulacra.html

BBC. "The History of the York Mystery Plays." *BBC website.* May 7, 2006. Available at: http://www.bbc.co.uk/northyorkshire/content/articles/2006/07/05/york_mystery_plays_feature.shtml

Benton, Janetta, and Robert DiYanni. *Arts and Culture.* Boston, MA: Prentice Hall, 2012.

Beresford, Matthew. *From Demons to Dracula.* London: Reaktion Books, 2008.

Berg, Gretchen. "Andy Warhol My True Story." In *I'll Be Your Mirror*, edited by Kenneth Goldsmith. New York: Carroll & Graf Publishers, 2004, pp. 85–96.

Berger, Maurice. *Revolution of the Eye.* New Haven, CT: Yale University Press, 2014.

Bethanis Elsa, and Peter Bethanis. *Dada and Surrealism for Beginners.* Danberry, CT: For Beginners, 2006.

Bischofberger, Bruno. "Collaborations: Reflections on and Experiences with Basquiat, Clemente and Warhol." Jean-Michel Basquiat website (fan site). Available at: https://radiantchild.weebly.com/bischofberger-on-collaborations.html.

Bloch, Robert. "The Weird Tailor." *Weird Tales*, July, 1950, pp. 6–17.

Bockris, Victor. *The Life and Death of Andy Warhol.* New York: Bantam, 1989.

———. *Warhol: The Biography.* New York: DeCapo Books, 1989.

Bourdon, David. *Warhol.* New York: Harry N. Abrams, 1989.

Bretell, Richard. *Modern Art, 1851–1929.* Oxford: Oxford University of Press, 1999.

Brodskaia, Nathalia. *The Fauves.* New York: Parkstone Press, 2011.

Browing, John Edgar, and Carolina Joan (Kay) Picart, eds. *Draculas, Vampires, and Other Undead Forms: Essays on Gender, Race, and Culture.* Lanham, MD: Scarecrow Press, 2009.

Buchloh, Benjamin. "Andy Warhol's One Dimensional Art: 1956–66." In *Andy Warhol (October Files)*, edited by Annette Michelson. Cambridge, MA: MIT Press, 2001, pp. 1–48.

Buskirk, Martha. *The Contingent Object in Contemporary Art.* Cambridge, MA: MIT Press, 2003.

Campbell, Joseph. *The Hero with a Thousand Faces.* Princeton, NJ: Princeton University Press, 1948.

Charles, Victoria. *Rococo.* New York: Parkstone Press, 2014.

Chipp, Herschel. *Theories of Modern Art.* Berkeley: University of California Press, 1984.

Colacello, Bob. *Holy Terror, Andy Warhol Up Close.* New York: Harper Perennial, 1991.

Collings, Matthew. *This Is Modern Art.* London: Weidenfeld & Nicholson, 1999.

Cook, Walter. "The Endless Influence of the Bauhaus." *BBC Culture.* November 10, 2017. Available at: http://www.bbc.com/culture/story/20171109-the-endless-influence-of-the-bauhaus.

Cook, Terry. "Fashionable Nonsense or Professional Rebirth: Postmodernism and the Practice of Archives." *Semanticscholar*.org.

Crone, Rainer. *Andy Warhol: A Picture Show By the Artist.* New York: Rizzoli. 1987.

Crowe, Thomas. *The Rise of the Sixties.* New York: Harry Abrams, 1996.

Cumming, Laura. "Henri Matisse: The Cut-Outs Review—'The Lesson of a Lifetime.'" *The Guardian.* April 20, 2014.

Dachy, Marc. *The Dada Movement 1915–1923.* New York: Rizzoli, 1990.

Dalton, David, and McCabe, David. *A Year in the Life of Andy Warhol.* New York: Phaidon, 2003.

Debord, Guy. *The Society of Spectacle.* New York: Zone Books, 1994.

Demilly, Christian. "An Advertising Artist, an Advertiser for Art." In *Andy Warhol Drawings.* San Francisco, CA: Chronicle Books, 2012, pp. 8–10.

DiGiacomo, Frank. "A Farewell to Dapper Fred Hughes, He Oversaw Andy's Factory Empire." *Observer.* January 21, 2001.

Doonan, Simon. *Andy Warhol Fashion.* San Francisco, CA: Chronicle Books, 2004.

Doss, Erika. *Twentieth Century American Art.* Oxford: Oxford University Press, 2002.

Downs, Hugh. "*ABC News 20/20*: Andy Warhol." *ABC network.* April 10, 1980.

Elder, Bruce R. "Experience as Energy: A Pattern for Thinking." In *The Films of Stan Brakhage in the American Tradition of Ezra Pound, Gertrude Stein, and Charles Olsen,* edited by Bruce Elder. Ontario, CA: Wilfried Laurier Press, 1998, pp. 100–45.

Elgar, Dietmar. *Expressionism.* Koln, Germany: Taschen, 2008.

Elmes, Simon. "The Secrets of Andy Warhol's Time Capsules." *BBC News Magazine.* September 10, 2014.

Eno, Brian. "Interview with Brian Eno On, Full" (interviewer Michael Calore). *Wired.* July 2, 2007.

Esslin, Martin. *Theatre of the Absurd.* New York: Doubleday, 1961.

Figura, Starr. *German Expressionism: The Graphic Impulse.* New York: Museum of Modern Art, 2011.

Fiorentino, Alyssa. "Candace Bergen Reveals Twisted Details about Her Relationship with Her Father." *Woman's Day,* April 7, 2015. Available at: https://www.womansday.com/life/real-women/news/a50235/candice-bergen-reveals-twisted-details-about-relationship-with-her-father/.

Foster, Hal, and Mark Francis. *Pop.* London: Phaidon, 2005.

Francis, Mark. *Pop.* New York: Phaidon, 2010.

Francis, Mark, and Margery King. *The Warhol Look.* Boston, MA: Bullfinch, 1997.

Fremont, Vincent. *Andy Warhol's Small World.* Koln, Germany: Jablonka Gallery, 2005.

———. "Andy Warhol, Ladies and Gentleman." Gagosian Gallery website, September 13–October 11, 1997. Available at: https://gagosian.com/exhibitions/1997/andy-warhol-ladies-and-gentlemen/.

Freud, Sigmund. *The Interpretation of Dreams.* New York: Basic Books, 2010.

———. *The Standard Edition of the Complete Psychological Works of Sigmund Freud.* London, Hogarth Press, 1953.

Funny2. "Henny Youngman Jokes 2." Available at: http://www.funny2.com/hennyb.htm.

Garcia, Chris. "Warhol & The Computer." *CHM.* June 25, 2013.

Goldberg, Roselee. *Performance Art.* London: Thames and Hudson, 1995.

Goldsmith, Kenneth, ed. *I'll Be Your Mirror.* New York: Carroll & Graf Publishers, 2004.

Gotthardt, Alexxa. "On His MTV Show, Andy Warhol Broke All the Rules." *Artsy.* November 21, 2017. Available at: https://www.artsy.net/article/artsy-editorial-mtv-andy-warhol-broke-rules.

Graber, Andre. *The Art of the Byzantine Empire.* New York: Greystone Press, 1967.

Greenburg, Jan, and Sandra Jordan. *Andy Warhol Prince of Pop.* New York: Delacorte Press, 2004.

Guins, Raiford, and Omayra Cruz. *Popular Culture: A Reader.* London: Sage, 2005.

Hackett, Patt ed. *Andy Warhol Diaries.* New York: Warner Books, 1989.

Haden-Guest, "Anthony. The New Queen of the Art Scene." *New Yorker.* April 19, 1982.

Hauff, Thomas. *Design: An Illustrated Historical Overview.* Hauppauge, NY: Barrons, 1996.

Here we Go Again. RKO Pictures, 1942.

Hill, John, and Gibson, Pamela. *Film Studies: Critical Approaches.* Oxford: Oxford University Press, 2000.

E. T. A. Hoffman. "The Sandman." Available at: http://art3idea.psu.edu/metalepsis/texts/sandman.pdf.

Hopkins, David. *After Modern Art, 1945–2000.* Oxford: Oxford University Press, 2000.

Jencks, Charles, and Kropf, Karl. *Theories and Manifestoes of Contemporary Architecture.* West Sussex: Wiley and Sons, 1997.

Jones, Karen. "The Time-Capsule Formula: Warhol at the Whitney." *artcritical.* Available at: https://artcritical.com/2019/06/04/karen-e-jones-on-andy-warhol/. Accessed September 8, 2019.

Joshti, S. T. *Unutterable Horror.* New York: Hippocampus Press, 2012.

Jung, Carl G. *Man and His Symbols.* New York: Dell, 1968.

Kalb, Claudia. *Andy Warhol Was a Hoarder.* Washington, DC: National Geographic, 2016.

Karp, Ivan. "Andy Warhol Interview (1966) Revolver Gallery" YouYube. Available at: https://www.youtube.com/watch?v=PvItHl7ZGes&t=220s.

Kaser, Wolfgang. *The Grotesque in Art and Literature.* New York: McGraw Hill, 1967.

Kasson, John. *The Little Girl Who Fought the Depression.* New York: Norton & Co., 2014.

Kaufman, Frederick. "Ben Shahn's New York." Aperture. 162, Winter 2001, 70–75.

Keller, Sarah. *Maya Deren: Incomplete Control.* New York: Columbia University Press, 2015.

Ketner, Joseph. Andy Warhol: The Last Decade. Milwaukee, WI: Milwaukee Art Museum, 2009.

Kettell, Lisa. *Altered Art Circus.* Beverly, MA: Quarry Books, 2009.

Kidrobot website. "Ansy Warhol Invisible Sculpture Display." Area Nightclub. 1985. Available at: https://www.kidrobot.com/products/andy-warhol-invisible-sculpture.

Kingsohr-Leroy, Cathrin. *Surrealism*. Koln, Germany: Taschen, 2008.

Barbara Klein. "Before They Were Famous." *Carnegie Magazine*. Summer 2015. Available at: https://carnegiemuseums.org/magazine-archive/2015/summer/feature-504.html

Kleiner, Fred. *Gardner's Art Through the Ages*. Boston, MA: Cengage, 2016.

Kirk, John. *The Shaker World*. New York: Harry N. Abrams, 1997.

Koch, Stephen. *Stargazer: The Life, World, and Films of Andy Warhol*. New York: Open Road Integrated Media, 2000.

Koestenbaum, Wayne. *Andy Warhol*. New York: Penguin, 2001.

Koomler, Sharon. *Shaker Style*. London: PRC Publishing, 2000.

Kopania, Kamil, ed. *Dolls and Puppets as Artistic and Cultural Phenomena (19th–21st Centuries)*. Warsaw, Poland: The Aleksander Zelwerowicz National Academy of Dramatic Art in Warsaw, The Department of Puppetry Art in Białystok, 2016.

Lippard, Lucy. *Pop Art*. New York: Praeger, 1973.

Livingstone, Marco. *Pop Art: A Continuing History*. New York: Harry N Abrams Inc., 1990.

Madoff, Steven Henry. *Pop Art: A Critical History*. Berkeley: University of California Press, 1997.

Malonowska, Anna. "Bad Romance: Pop and Camp in Light of Evolutionary Confusion." In *Redefining Kitsch and Camp in Literature and Culture*, edited by Justyna Stepien. Newcastle on Tyne: Cambridge Scholars, 2014, pp. 9–22.

Mamiya, Christin. *Pop Art and Consumer Culture*. Austin: University of Texas Press, 1992.

Marcade, Barnard. "Les polyphonies cartographiques et rastaquoueres de Jean Michel Basquiat." *Art Press*, October 1, 2010.

Marris, Paul, and Sue Thornham, eds., *Media Studies: A Reader*. New York: NYU Press, 1999.

Massik, Sonia, and Solomon, Jack. *Signs of Life in the USA*. Boston: Bedford, 2015.

Mazzola, Anthony T., ed. *Andy Warhol: The Bazaar Years, 1951–1964*. New York: Hearst Corporation, 2009.

McCafferty, Larry, ed. *Storming the Reality Studio*. Durham, NC: Duke University Press, 1991.

McCoy, Adrian. "Obituary: Howard L. Worner/Industrial artist Taught at CMU." *Pittsburgh Post-Gazette*. March 23, 2006. Available at: https://www.post-gazette.com/news/obituaries/2006/03/26/Obituary-Howard-L-Worner-Industrial-artist-taught-at-CMU/stories/200603260201.

McEvilley, Thomas. "Commentary." In *Elvis +Marilyn 2 X immortal*, edited by Guy Paoli. New York: Rizzoli, 1994, p. 11.

McLuhan, Marshal. "Sight Sound and Fury." In *Mass Culture*, ed. Rosenburg and White, 489–95. New York: Free Press, 1957.

———. *Understanding Media: The Understanding of Man*, 36. Available at: https://hannemyr.com/links_mcluhan/um.html.

McShine, Kynaston, ed. *Andy Warhol: A Retrospective*. Boston: Bullfinch/Little Brown [MOMA], 1989.

The Miller Gallery. "Andy Warhol The Early Years." Carnegie Mellon, The Miller Gallery. Available at: https://www.andrew.cmu.edu/user/jialunx/earlylife.html.

Mori, Masahiro. "The Uncanny Valley." *IEEE Spectrum*. June 12, 2012. Available at: https://spectrum.ieee.org/automaton/robotics/humanoids/the-uncannyvalley.

Morris, Robert. "Notes on Sculpture." In *Minimal Art: A Critical Anthology*, edited by Gregory Babcock. New York: E. P. Dutton, 1968, pp. 222–35.

Mulroney, Lucy. *Andy Warhol: Publisher.* Chicago: University of Chicago Press, 2018.

Nelson, Victoria. *The Secret Life of Puppets.* Cambridge, MA: Harvard University Press, 2001.

O'Connor, John, and Benjamin Liu, eds. *The Unseen Warhol.* New York: Rizzoli, 1996.

Pachon, Maria. *Andy Warhol.* Barcelona, Spain: Ediciones Poligrafa, 2001.

Packard, Vance. *The Hidden Persuaders.* London: Longman Green and Co., 2007.

Palladini, Gina. "Nothing Special," Essay for the Television Shot by Artists Exhibition. Barcelona, Spain, 2000.

Pivar, Stuart. "Shopping with Andy Warhol." *ASX*, January 30, 2015. Available at: https://americansuburbx.com/2015/01/shopping-with-andy-warhol-1988.html.

Pohl, Frances. *Ben Shahn: New Deal Artist in A Cold War Climate, 1947–1954.* Austin: University of Texas Press, 1989.

Ratcliff, Carter. *Andy Warhol Portraits,* edited by Tony Shafrazi. London: Phaidon, 2007.

———. *Modern Masters*: *Andy Warhol.* New York: Abbeville Press, 1987.

Reekie, Duncan. *Subversion: The Definitive History of Underground Cinema.* London: Wallflower Press, 2007.

Rhode Island School of Design, Museum of Art. "*Raid the Icebox* One with Andy Warhol." Providence, RI: Rhode Island School of Design, 1969.

Riegelnegg, Curt. "Andy Warhol Media Exhibit." *Pittsburgh City Paper*, 2010.

Rosenberg, Robert, and White, David. *Mass Culture, the Popular Arts in America.* New York: Free Press of Glencoe, 1957

Rosenberg, Samuel. "Painting 1967." University Art Gallery, University of Pittsburgh, Henry Clay Frick Department of History of Art and Architecture. Available at: https://uag.pitt.edu/index.php/Detail/objects/7113.

Rouvalis, Christina. "Andy Warhol, revealed." *Carnegie Magazine.* Summer, 2014. Available at: https://carnegiemuseums.org/magazine-archive/2014/summer/feature-430.html.

Rugoff, Ralph. "Albino Humour." In *Who Is Andy Warhol?*, edited by Colin McCabe, 97–105. London: British Film Institute, 1997.

Russell, John. *The Meaning of Modern Art.* New York: Harper and Row, 1981.

Sandler, Irving. *Abstract Expressionism and the American Experience.* Lennox, MA: Hard Press Editions, 2009.

Schurian, Walter. *Fantastic Art.* Koln, Germany: Taschen, 2005.

Shanes, Ken. "Musical Forms: Paul Klee's Playful Compositions." *Apollo.*

Shaw, Kurt. "Modernist Pittsburgh Shows Educator Rosenberg's Impact." *Trib Total Media.* July 19, 2014. Available at: https://archive.triblive.com/aande/museums/modernist-pittsburgh-shows-educator-rosenbergs-impact/.

Short, Robert. *Dada and Surrealism.* Secaucus, NJ: Chartwell Books, 1980.

Smith, Patrick S. *Andy Warhol's Art and Films.* Ann Arbor: University of Michigan Press, 1986.

Smith, Stephen. "He Loved Weightlifting and Buying Jewels: Warhol's Friends Reveal All." *The Guardian*, February 15, 2015.

Smithsonian American Art Museum. "Balcomb Greene." Available at: https://americanart.si.edu/artist/balcomb-greene-1930.

Solandz, Simone. "Raid the Icebox Now." RISD website. Available at: https://www.risd.edu/news/stories/raid-the-icebox-now/.

Sontag, Susan. *A Susan Sontag Reader.* New York: McGraw Hill, 2014.

Sooke, Alistair. *Modern Masters: Andy Warhol* (video). BBC, 2011.

Sooke, Alistair. *Pop: A Colorful History.* London: Viking/Penguin, 2015.

Spigel, Lynn. *Revolution of the Eye.* New Haven, CT: Yale University Press, 2014.

———. "Warhol's Everyday TV." *Cairn Info.* Available at: https://www.cairn.info/revue-multitudes-2010-5-page-162.htm?contenu=article.

Stoker, Bram. *Dracula.* Garden City, NJ: Country Life Press, 1897.

Stonard, John Paul. "Pop in the Age of Boom Richard Hamilton's 'Just what is it that makes today's dome so different so appealing.'" *The Burlington Magazine.* September 2007, 607–20.

Straine, Stephanie. *Andy Warhol.* London: Tate Publishing, 2014.

Swinglehurst, Edmund. *The Art of the Surrealists.* New York: Sienna, 1995.

Taylor, John. "Andy's Empire." *New York Magazine.* February 22, 1988, pp. 32–39.

Eva Thury, and Margarey Devinney. *Introduction to Mythology.* New York: Oxford University Press, 2017.

Tomkins, Calvin. *The World of Marcel Duchamp.* Alexandria, VA: Time Life Books, 1977.

Turner, Victory *The Ritual Process.* Ithaca, NY: Cornell University Press, 1969.

Varello, Paola. *The Magazine Work of Andy Warhol, 1949–1987.* Giorgio Maffei Gallery. Rare Books on Twentieth Century Arts. November 2016.

Venus Gallery. *Little Electric Chairs.* New York: Venus, 2016.

Walcott. Derek. "A Conversation" (Francesco Clemente) from Francesco Clement: A History of the Heart in Three Rainbows." Exhibition Catalog Deitch Projects. New York; Edward Cahrta , Milano, May 21, 2009.

Walz, Robin. *Pulp Surrealism.* Berkeley: University of California Press, 2000.

Warhol, Andy. *America.* New York: Harper & Row, 1985.

———. *Andy Warhol Drawings.* San Francisco, CA: Chronicle Books, 2012.

———. *The Philosophy of Andy Warhol.* San Diego, CA: Harvest Books, 1975.

———. 'Warhol In His Own Words." In *Theories and Documents of Contemporary Art: A Sourcebook of Artist's Writings*, edited by Kristine Styles and Peter Selz, 340–46. Berkeley: University of California Press, 1996.

———. *Love Boat.* Season nine, episode three, October 12, 1985.

Andy Warhol (with Pat Hackett). *The Philosophy of Andy Warhol.* San Diego, CA: Harvest Books, 1975.

Andy Warhol Museum. "I Just Want to Watch" Exhibition, 2010.

Warshow, Robert. "The Study of Man: Paul, the Horror Comics, and Dr. Wertham." In *Mass Culture*, edited by Rosenburg and White. New York: Free Press, 1957.

Watson, Steven. *Factory Made: Warhol and the Sixties*. New York: Pantheon Books, 2003.

Welles, Orson, and Herman Mankiewicz. *Citizen Kane*. RKO Pictures, 1941.

Wheeler, Daniel. *Art Since Mid-Century 1945–Present*. Englewood Cliffs, NJ: Prentice Hall, 1991.

Whitmore, Greg. "Andy Warhol at the Tate Gallery, February 18, 1971." *The Guardian*.

Whitney Shop. "Andy Warhol: The Invisible Sculpture." Available at: https://shop.whitney.org/andy-warhol-the-invisible-sculpture.html.

Williams, Gilda, ed. *On&BY Andy Warhol*. London: Whitechapel Gallery (MIT Press), 2016.

Wilcox, John. *The Autobiography and Sex Life of Andy Warhol*. New York: Trela Media, 2010.

Wollen, Peter. "Andy Warhol: Renaissance Man." In *Who Is Andy Warhol?*, edited by Colin McCabe, 11–16. London: British Film Institute, 1997.

Woodham, Jonathan. *Twentieth Century Design*. London: Oxford University Press, 1997.

Index

About the Author

Stuart Lenig is a professor of media studies at Columbia State Community College in Columbia, Tennessee. He trained as a humanities major at Northern Arizona University, exploring a broad arts curriculum in performance and design. He focused on theatre at the University of Virginia, earning the MFA in Drama and studied directing with Professor George Black in the small competitive program in Charlottesville. Lenig's work was engaged with performance art, performance studies, and theatre in alterative spaces. He performed programs and plays in theatres, buildings, and converted classroom spaces. His work blended movement, dance, biomechanical acting, and installation art works. He attended Tulane University and acquired a PhD in English, focusing on performance studies, critical theory, and postmodern media and mythology.

He directed, acted, and created art, ads, and displays while in Columbia, seeking to alter the visual environment of students who received most media through the four-inch display of a cell phone. He returned to graduate school and attended the arts program at Drury University producing watercolors, films, documentaries, and sculptures.

He completed a series of manuscripts on the arts. In 2006, he composed a text for speech students called *Communication Journeys* with colleagues Professor Lacey Benns-Owen and Professor Daniel Johnson in the communication program. In 2010, he wrote a study of the history and performers who pioneered the field of glam rock, titled *The Twisted Tale of Glam Rock*, a hybrid of rock performance and theatre that has remained popular unto the present day due to performers like David Bowie, Peter Gabriel, Bjork, Lady Gaga, Janelle Monae, Madonna, and David Byrne, who integrate theatrical elements into complex rock theatre shows. In 2017, he assembled a series of

articles and observations on the theatrical and cultural implications of reality television, focusing on the genre's appeal and its deviations from reality, blending documentary and more subtle forms of performance couched in seemingly real settings. Lenig perceives reality programming as another step in the theatricalization of everyday life and experience as more people are the subject of our auto-surveillance society.

Professor Lenig continues to lecture, perform on the stage, and bring lecturers, audiences, and performers together in the COVID-19 metatheatrical educational environment. He is engaged in using technology to integrate people via performance in the times of the pandemic.